Praise for *Making the Mummies Dance*

"Hoving's cocky, conceited, self-assured account of his controversial and turbulent tenure as director of the Metropolitan Museum is guaranteed to offend most of his former colleagues but is fascinating reading for anyone, like myself, who has ever wondered what goes on behind the scenes in that vast Central Park palace of art. I couldn't put it down."

—Dominick Dunne

"A skillful piece of work, highly readable and very entertaining in its irreverent treatment of some rather well-known millionaires and captains of industry."

—Calvin Tomkins, *The New Yorker*

"[A] frank and fascinating memoir in which Hoving relates failures as well as successes. . . . Hoving is a sprightly, gossipy writer whose book not only has value as art museum history but also will enthrall the layman and teach him that his own local museum doesn't just sit there like a monolith, but has an incredible lot of hubbub going on inside."

—Lawrence Clay, *Denver Post*

"In a deliciously dishy and compulsively readable memoir of Hoving's ten years as director of New York City's Metropolitan Museum of Art, Thomas Hoving chronicles his crusade to transform a stuffy, tradition-bound institution into a modern museum. . . . *Making the Mummies Dance* . . . is the book everyone in the art world has been waiting for, and it more than lives up to expectations that the always candid Hoving would rip off the Met's Beaux-Arts facade to reveal the wheelings and dealings within. . . . [a] vastly entertaining account."

—Wendy Smith, *Chicago Sun-Times*

"True, it's a behind-the-scenes story—but a fascinating one that unveils the dog-eat-dog business of running a museum."

—Fran Wood, *New York Daily News*

ALSO BY THOMAS HOVING

DISCOVERY
MASTERPIECE
KING OF THE CONFESSORS
TUTANKHAMUN: THE UNTOLD STORY
THE CHASE, THE CAPTURE

Thomas Hoving

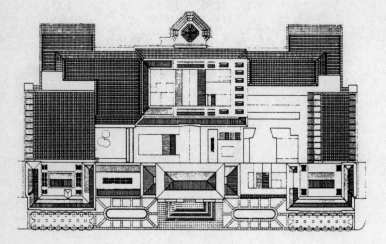

INSIDE
THE METROPOLITAN
MUSEUM OF ART

MAKING THE MUMMIES DANCE

A TOUCHSTONE BOOK
Published by
Simon & Schuster
New York London
Toronto Sydney Tokyo Singapore

TOUCHSTONE
ROCKEFELLER CENTER
1230 AVENUE OF THE AMERICAS
NEW YORK, NEW YORK 10020

FIRST TOUCHSTONE EDITION 1994

TOUCHSTONE AND COLOPHON ARE REGISTERED TRADEMARKS
OF SIMON & SCHUSTER INC.

DESIGNED BY EVE METZ
MANUFACTURED IN THE UNITED STATES OF AMERICA

3 5 7 9 10 8 6 4

LIBRARY OF CONGRESS CATALOGING-IN-PUBLICATION DATA
HOVING, THOMAS, DATE.
MAKING THE MUMMIES DANCE: INSIDE THE METROPOLITAN
MUSEUM OF ART/THOMAS HOVING.
P. CM.
INCLUDES INDEX.
1. HOVING, THOMAS, DATE. 2. ART MUSEUM DIRECTORS—NEW
YORK (NY)—BIOGRAPHY. 3. METROPOLITAN MUSEUM OF ART
(NEW YORK, NY)—MANAGEMENT. I. TITLE.
N600.H68 1993
709′.2—DC20
[B] 92-31460
CIP
ISBN 0-671-73854-2
ISBN 0-671-88075-6 PBK.

ACKNOWLEDGMENTS

In the preparation of this volume I relied most heavily upon written documents. I conducted interviews with a number of key players but found that, except for rare instances when the individual had kept precise written records, the recollections were not as keen as the documented materials.

The documents I used were gathered together by several assistants and, most significantly, by my chief administrative assistant, Cecilia Mescall. The records are exhaustive and chronicle every action of every day of my decade-long tenure. Every letter, each memo in and out, every phone call and its contents, the minutes of every trustee meeting, every press announcement and clipping were preserved and filed by day, subject, and name. In addition, in the case of critical subjects, especially the crises, I dictated daily at least a half hour on tape, spelling out every detail of what was going on, including direct quotes, conversations, and discussions. Those tapes, all of which I personally transcribed, run to hundreds of hours.

Following the suggestion first published by Richard Clurman in *Beyond Malice,* I took the precaution of sending every part of this book while in first draft to the people who in my judgment knew best about each section or chapter. I asked them to correct any errors or misconceptions. These people included Arthur Rosenblatt, Hubert von Sonnenberg, Inge Heckel, Allon Schoener, and, for the entire manuscript, C. Douglas Dillon. Their help in checking is profoundly appreciated.

The book would never have been possible without the intelligent

and dogged editing of Eric Steel and Alice Mayhew, especially Alice, whose word-by-word, page-by-page analysis over months must stand as one of the most dedicated scrutinies in the annals of the profession.

And the warmest of thanks are due to Robert Lescher, my literary agent, who once again, for this fifth time, did it all.

This book is dedicated to all those members of the staff, trustees, volunteers, and friends of the Metropolitan Museum who supported the revolution that changed the institution so markedly, and to my wife, Nancy, who, thankfully, never quite became a proper museum wife.

CONTENTS

INTRODUCTION

The Metropolitan Museum of Art is the most diverse and dazzling art museum in the world and, odds on, the richest in history. When it comes to art treasures, in quantity or quality, old or modern, the Met puts most fabled art repositories of all other cities to shame. Few museums on the globe have amassed more art or showed it off in a more vibrant way. It's rather like having the best of London's National Gallery, the British Museum, the Tate Gallery, and the Victoria and Albert all rolled into one incomparable art metropolis.

Why the Met became so rich probably has something to do with America's deep-seated cultural inferiority complex. New York, having started with little more than a few Indian beads and some Dutch silver and crockery, was driven to possess a slice of every culture on earth. The oligarchs and the affluent gave unstintingly with money and works towards the goal of making the Met nothing less than an encyclopedia of mankind's visual history. How well the Met succeeded! Today the museum "owns" some three million works of art,

artifacts, and cultural implements spanning fifty centuries, housed in a seventeen-and-a-half-acre palace. Not a single decade of any civilization that took root on earth is not represented by some worthy piece, be it a delicate gold necklace made for a Neolithic princess or a salon from a 1913 summerhouse designed by Frank Lloyd Wright. The Met has it all. Achaemenian daggers, an ancient Roman bedroom, baroque arquebuses, New England weather vanes, crosses, Stars of David, Buddhas, Zen scrolls, Art Deco settees, stables of Italian masters, platoons of Rembrandts, stone carving from the Maya, Incas, and Aztecs, hundreds of Limoges tureens, a host of Picassos, and a historic Jackson Pollock.

But the Met is more than a fabulously wealthy art showplace and storehouse. The museum is a special, immensely influential community. It possesses a power that is out of proportion to its size and mission. It is inhabited and run by singular sorts of people—trustees and patrons, curators, educators, conservators, guards, and maintainers. The institution reeks with history. Its richness was created by the passion of hundreds of art-addicted collectors and donors, both private and professional, and nourished by hundreds of millions of visitors, many of whom look on the museum as the most vital element in their lives. Like the Vatican, the Met is greater than and more fascinating than the sum of its myriad parts—it is an aura, a style, a presence, and a set of beliefs.

To serve on the board of trustees of the Met—there are only thirty-five members—is to gain the apex of the social, intellectual, and artistic position in the nation. Becoming a trustee is to follow in the footsteps of the likes of Frederick W. Rhinelander, Henry Gordon Marquand, J. P. Morgan, Horace Havemeyer, Nelson Rockefeller, Brooke Astor. The public impression of the Met trustee is a person of privileged rank moving in a serene and elegant world of impeccable manners, one devoted to the encouragement of beauty and taste. And to a certain extent the image is true. Yet, beneath their glistening social veneers, the trustees can also be human beings afflicted with feelings of greed, envy, and ambition. Since the Met *is* in a sense the combination of the Vatican, Versailles, the Sultan's Court, and the Cave of Ali Baba, it can be hurly-burly—and dangerous—for trustees and especially for the director.

Up until 1967, there had been only six directors of this complex institution. Two retired happily, one died shortly after leaving the post, and two died on the job. One of the latter was my predecessor,

James J. Rorimer, and he succumbed to a cerebral hemorrhage at home hours after a brutal meeting of the museum's board of trustees. That meeting contributed to his death. I know, for I attended as Parks Commissioner of the City of New York and saw what happened to him and listened to his anguished reaction.

Less than a year later, I was elected Rorimer's successor. Because of the harrowing experience the evening of his death, I came back to the Met acutely aware of the deadly jungle it could be. I knew that beneath the calm surface of the institution, there was a battleground. I also knew that a director had to be more than a gifted connoisseur, a well-trained scholar, an aesthete, a patient diplomat, a deft fund-raiser, an executive, and a conciliator. To be effective—and to survive—the director had to be, in addition, part gunslinger, ward heeler, legal fixer, accomplice smuggler, anarchist, and toady. As Arthur Houghton, the president of the board who hired me, once said, "To bring about this revolution of ours, you're going to have to become a different breed of troublemaker."

I was—more than Houghton, his fellow trustees, or the staff ever expected.

1

A
VERY
DANGEROUS
PLACE

I became a trustee of the mighty Metropolitan Museum of Art overnight. One day I was a curator; the next I was on the board. For the six and a half years after receiving my Ph.D. in Art History from Princeton University, I had worked my way up the museum ladder, from curatorial assistant to curator of the Medieval Department and The Cloisters, but in the summer of 1965, I took a leave of absence to join the mayoral campaign of John V. Lindsay, the dashing congressman from New York's Silk Stocking district. When Lindsay was elected, he asked me to become his commissioner of Parks and I accepted eagerly, walking casually away from a promising career in the museum profession.

The commissioner is the chartered "landlord" of every cultural institution in New York that receives a cent of tax money, eleven in all, and serves on the board of each, ex-officio, which means he can talk but cannot vote. Usually, city officials attend one board meeting for show and then send a staff member. But I didn't delegate. I

attended every meeting of everything from the Zoo to the Natural History Museum, and I haunted the Met. In the nine months I spent in Parks, I missed only one of its meetings. I was there on the afternoon of May 11, 1966, the day its director, Jim Rorimer, died.

Full board meetings are not where the big decisions are made. Those are made in the Acquisitions or Executive committees. The full board, meeting quarterly, is expected to ratify purchases and gifts that have already been accepted and to approve reams of legal and financial boilerplates. Under standard procedure, gifts are approved when the president suggests that the trustees vote the entire list. Someone utters "Second" and the chorus of "Ayes" follows. On that particular May afternoon, the former president, Roland L. Redmond, asked to pose a question or two to the current director, James Rorimer.

Redmond, then in his eighties, was a Hudson Valley WASP with chiselled features and a classic old-family Yankee accent. His handsome face, marred only in his later years by his rheumy eyes, which looked like day-old oysters, seemed set into a benign expression. A distinguished lawyer, "in counsel" at the aristocratic firm of Carter, Ledyard & Millburn, a New York clubman and church-going pillar of the community, he had caused a minor scandal in the fifties when he had left his wife of many decades to marry a socialite who happened to have been my mother's roommate at the Farmington School for Girls in Connecticut. "Rolie," as he was called by intimates, was rounding out his career by sitting on various boards. He had served as Met president for seventeen and a half years before he was at last forced out by some of his exasperated peers. That was in 1965. There was no stipulation in the museum's bylaws and constitution that called for the ex-president to remain on the board, but Rolie had somehow wheedled his successor, Arthur Houghton, into allowing him to sit in on all meetings, with a "voice, but no vote."

Redmond's questions that afternoon baffled everyone. He sought the "truth about a most serious matter," a gift from Rorimer to the Medieval Department of a bronze and enamel Christmas card showing the Three Magi that had been sent him (and hundreds of others) by a German art auction house. Since the object had a value of under a thousand dollars, the director had the right to "accept" his own gift and report it later to the board. What was the big deal?

Redmond wanted to go on the record that he felt it had been "very bad judgment" for Rorimer to have taken the gift, "no matter how insignificant it might seem to be in value or how worthy his giving it

to the museum might seem to be.'' Rorimer replied that he had given the plaque to the department as a sort of measuring stick for the detection of enamel forgeries.

Despite Rorimer's attempt to make light of the incident and keep a polite tone of voice, Redmond continued talking about "ethics" and "morality" and finally attacked Rorimer about the "appearance of impropriety." Rorimer got redder and redder. The rest of us sat frozen. Why didn't Houghton—or some trustee—do something and shut the old fool off, I wondered.

Finally, the member next to me, J. Richardson Dilworth, the financial advisor to the Rockefeller brothers, said, "Move acceptance of the gifts." "Second!" Manning Brown, the president of New York Life, quickly added. There was an immediate chorus of "Ayes." But Rorimer's face was purple as the meeting rapidly came to an end. Rolie ambled among the trustees with a vacant smile on his face and made a point of bidding Rorimer a pleasant good evening. Rorimer's face reddened more, but he seemed calm.

James Rorimer made a particular impression. He was a portly man who wore custom-made suits from Madrid or London and always appeared slightly dishevelled. He wore army boots no matter how formal a suit he was wearing. He had black hair and a pair of flashing brown-black eyes which darted about constantly. When Redmond left the room, he walked over to me and moved his eyebrows as if to say "What a fool!" Arthur Houghton strolled over, theatrically nonchalant. "Jim," he said to Rorimer, though he was gazing at me, "is it against museum rules to allow a city official in on an art matter?"

What the hell was this, I wondered. Typical, mysterious Arthur Houghton, I thought, a man who seemed to express himself in riddles. I had been wary of him ever since I had sat next to him at an Acquisitions Committee meeting and he had rambled on about how, if he had the authority (and he sounded as if he had), he would redesign the whole interior of the uptown medieval museum, The Cloisters. The place could be made more appealing to the average visitor by weeding out the "welter of objects." He himself would pick a dozen objects and put them into a "masterpiece" gallery so that the average Joe could taste the cream and leave. From that moment on, I had looked upon Houghton as a loose cannon.

When Rorimer indicated it was not against the rules, he said, "Commissioner, do you have the time to attend a rump session of the Acquisitions Committee?"

"You bet!" I said, thrilled to be invited into the inner sanctum. I

called to say I'd be late to a string of Parks drop-ins scheduled for the early evening.

A quorum had been gathered by Houghton. One was board member Charles B. Wrightsman, oil millionaire and collector of old master paintings and French eighteenth-century furniture and objets d'art. He was accompanied by his fashionable wife, Jayne, whose coiffure and whispery voice indicated a devotion to the image of Jacqueline Kennedy. Another was an old friend of mine, the philanthropist Brooke Astor, an ebullient and witty woman in her sixties who looked far younger. I admired her for her sense of fun and her intelligence and spirit. She had funded a series of adventure playgrounds in the Lower East Side, and we had been talking about her foundation giving the Parks Department sizable amounts of money for my cherished vest-pocket parks.

Rorimer had asked for the meeting to obtain a vote to buy "an extraordinary acquisition" for The Cloisters. He punched up some slides, and I was delighted to see that they were of a sensational medieval sculpture, a twelfth-century Auvergne Madonna and Child, a piece I had come upon by chance just before leaving the museum.

The owner had sent me a photograph of the beautiful wooden statue, which I thought was probably by the same artist who had created the Madonna that J. P. Morgan donated to the Metropolitan years before. It was one of the rare times in history when two works by the same early medieval master had ever turned up. I had been eager to obtain the statue before I left for city government, but there hadn't been time. The statue was in France, in Clermont-Ferrand, and the owner had been asking my advice on how to get the treasure out of the country. I had left before anything could happen. Clearly, Rorimer had followed up.

He described how he had studied the statue, which had been sneaked into Belgium (a country that was unfortunately almost as strict as France). It was from the chapel of Notre Dame de Montianeix in Puy-de-Dôme. I preened as my former boss threw me a bouquet: "The work is exceptional, and as Tom here first pointed out, it was carved by the master of our rare Morgan Madonna. We must have it. It's not expensive—only four hundred and fifty thousand."

Wrightsman was the first to speak, "Impressive. Buy it, Jim. Doesn't sound like much money." Impressive as the sculpture was, that was not a bargain. In those days it was virtually unheard of that

a work of medieval art would cost more than two hundred and fifty thousand dollars.

Houghton inquired, "Okay? All approve? That's it."

I smiled to myself. In minutes, and casually, the trustees had unwittingly voted to acquire a work that had obviously been smuggled out of France and would still have to be spirited out of Belgium —no easy matter. And Rorimer, who was a commander in the French Legion of Honor, knew what he was doing and relished it. He whispered to me, "Join us downstairs—in the rooms under construction Charlie and Jayne are giving for eighteenth-century French furniture—please!" It was both a plea and a command, and I followed even though my waiting Parks audiences would be furious.

As Brooke Astor and the Wrightsmans wandered through the bare chambers, which were covered in lath and plaster, and then departed, Rorimer motioned me to stay and closed the door to one of the galleries. He sat on a workbench, his short legs dangling, his army boots swinging faster and faster, and burst into an astonishing tirade. Using swear words I'd never heard from him, Rorimer cursed Redmond. He was almost screaming about how the trustee hated him, how he had harassed him over the years. The afternoon's scene was not an aberration. When he had been president, Redmond had complained continuously about Rorimer. He'd continued even after his retirement.

When I asked him why, Rorimer said something about anti-Semitism.

"The man's just petty, mean, and insulting. It's as if he's trying to kill me. I hate the bastard—I hate all of them!"

As his face became purple and the veins on his forehead stood out, I became alarmed. I thought he was going to have a seizure. I wondered if I should call a guard. I kept repeating that Redmond had, after all, been thrown out; he no longer mattered. He was a "nothing" and should be ignored. But Rorimer kept on for a while before he got control of himself and his face began to lose its purplish hue. Now he became quite pale. His stocky frame appeared to collapse. I became even more concerned. He looked as if he might pass out. But after some deep breaths, he slipped from the table and stood unsteadily before me.

"I tell you he's . . . they're . . . going to kill me!"

I woke up several times that night, thinking about Rorimer. Around seven o'clock, his executive assistant, Harry Parker, called.

"Brace yourself, Tom. Jim died last night. They think it was a cerebral hemorrhage. We all knew he wasn't in the best of health in recent months—he's been acting listless for months—but Jesus . . ."

Of course, Roland Redmond's attacks alone didn't kill James Rorimer. The unrelenting grind of the job had contributed to his ill health, as had the whole board of trustees, but I was convinced that Rolie's blows had been decisive.

His memorial service took place at The Cloisters on a beautiful June afternoon. Brooke Astor had asked me to accompany her, saying she had something important to discuss. As her limousine sped past the museum, she waved a white-gloved hand at the fleeting view of the ugly brick expanse of the north facade and remarked, "Imagine, the country's finest art museum looking like a slum! Jim never could quite get it into his head that *something* had to be done with the unfinished building. I finally persuaded him to hire Ed Barnes," she said, naming one of the country's finest architects. "But I suppose my harping on it didn't help. Harry Parker told me that Jim had looked like death-warmed-over for months. I hate to say that I didn't notice. Now, Tommy, I have a plan to discuss with you."

I was hoping she was going to tell me that the Astor Foundation was going to fund another Parks project. She surprised me. She thought it was time for me to leave the Lindsay administration.

"Leave now while you are looked upon with such favor. John Lindsay's having such serious problems. There are doubts about his ability to administer the city. He's brilliant when it comes to publicity, but I am not so sure about his skills in governing—or dealing with finances and the like . . . Nelson has grave doubts."

What she said wasn't new. She was parroting what had become the stock newspaper editorial line of the moment.

"Tommy, you will look back on the park post as an amusing adventure. It's not what you were trained for—the degrees in art, I mean. You must think of your real career."

It was quite natural for Brooke Astor to call me Tommy. In my adolescence, I had spent summers at my father's country house in Stockbridge, Massachusetts. Brooke, then editor of *House and Garden* and married to a genial advertising executive, Buddy Marshall, had a cozy place in the hills of Tyringham. I had gone there a number of times for lunch with my father and stepmother and had been seduced by the informality and gaiety of Brooke's home. And she

had taken a shine to me. I was precocious and chatty. I told her outrageous stories about how I sneaked out of "prison" for night-long pool-shooting or gambling parties. The fun of sharing secrets remained with us.

"Tommy, you are my candidate to succeed Jim Rorimer. Would you leave the Parks to become the director of the Met?"

I told her I couldn't imagine walking out so soon on Lindsay, my team at Parks, and "my constituents." With her next comment, I realized I had not given her enough credit for political acumen. Beneath the smile and the charming manners, she was a calculating opportunist.

"I suppose you've heard. Some of John's inner circle resent the way you're shining so brightly, just when he is receiving so much criticism."

At that moment we arrived at The Cloisters. A guard instructed Brooke's chauffeur to proceed up the curving cobblestone drive. We got out as the portcullis gate rose and were directed into the twelfth-century apse from Fuentiduena in Spain.

The two hundred or so chairs were filled. Luminaries in the arts, in museums, and in city government had come to pay their respects. Brooke was taken to the trustees side of the aisle; I was ushered to the section set aside for state and city politicians. I took my place beside John Lindsay.

The New York Pro Musica played a composition from the *Play of Daniel*. Rorimer's family entered. As Kay Rorimer passed, she happened to glance directly at me. Her expression was far from friendly.

During the long service I didn't pay much attention to the words of praise. I was casting my eyes around the apse and the objects displayed in it, remembering James Rorimer. How he had always insisted on rubbing the edges of a new wooden pedestal with the shaft of a screwdriver so that it would look sufficiently aged for The Cloisters. How he'd say that the best way to patinate a showcase or a bench was to wash the thing down with dirty water from the mop buckets used to clean the stone floors. How, once, as we walked up the long flight of stairs from the main entrance, he said, "When you have control of this, you can put in the modern things—escalators and the like. But as long as I'm around, the public will have to walk." It was a typically oblique reference to his intention of making me curator of The Cloisters.

I never knew for certain what Rorimer actually thought of me and

my accomplishments. When I pulled off my best acquisitions, he was reticent and seemed almost resentful. The higher I climbed the curatorial ladder, the more distant he seemed to become. When I left to go to Parks, he acted so petulantly that any guilt about leaving vanished. Later on I heard that he was calling me "an ungrateful opportunist" who had betrayed him to "grab the brass ring." Indeed, he wasn't the only member of the Metropolitan who resented the "selfishness" of my leaving Rorimer when he needed all the support he could get. Several curators voiced their shock, and his wife, Kay, went out of her way to criticize me to trustees.

Rorimer always claimed that he had discovered me and had all but salvaged my career, talking me out of the dead-end road of art dealing. In fact he had. I had been about to take a job at Wildenstein & Company. When he heard about it, Rorimer warned me. "Don't do that! If you become an art dealer, you'll never be able to work in a museum. If you come to the museum and decide you don't like it, you can always go into art dealing."

I became Jim Rorimer's fair-haired boy the moment I entered the museum in August 1959. He made me his confidential assistant. He instructed me to sit in on every meeting he attended with the exception of trustee meetings. In some of the sessions highly sensitive issues were discussed—intimate details about staff members and confidential information about pending acquisitions. I remained in his office for six months and learned more about the Met than any other curatorial employee. Next, in the Medieval Department and at The Cloisters, I became known as a dynamo in acquisitions. I relished hunting down art and spending The Cloisters' lavish restricted funds, almost a million dollars a year. My collecting style was pure piracy, and I got a reputation as a shark. Three or four times a year I'd be on my way to Europe on buying trips of several weeks' duration. My address book of dealers and private collectors, smugglers and fixers, agents, runners, and the peculiar assortment of art hangers-on was longer than anyone else's in the field.

The more I became absorbed in this work, the more distant James Rorimer became—except when we met in Europe. There he was transformed into a keen connoisseur and witty raconteur. The pomposity of rank and office vanished, as did his temptation to drop names or weave conspiracies. I would never get used to the change that came over him once he returned to his office. It seemed to me after his death that James Rorimer had suffered each day he had

been director. But I thought he would have suffered even more had he not been chosen.

As the service drew to a close and Arthur Houghton praised the man and his achievements in a voice full of emotion, I cast my eyes over the works Jim had cherished—the magnificent apse itself, the fourteenth-century iron candlestick he adored, the Spanish Romanesque fresco he had personally installed—and then I turned my head to Brooke Astor.

2

THE SEARCH COMMITTEE CALLS

Brooke Astor was right, at least about the Lindsay crowd. My Parks team had created a joyful revolution. They had made me a folk hero, the Clown Prince of Fun City. Some of the Lindsay inner circle resented our successes. I sweet-talked the reporters and became a regular on television. Hardly a day passed when I wasn't in the press —rowing in Central Park, playing capture the flag with some ghetto kids, hiking along the Staten Island Greenbelt, fixing up a playground, building a bocce court, repairing a golf course. My middle initials, *P.F.,* were said to be short for "Publicity Forever." As the mayor dealt with the hard issues, I gambolled about town, smiling, laughing, quipping, gaining headlines for all the good works.

In the early summer of 1966 the *New York Times* ran a story about the search for and speculation about the new director of the Met. It mentioned seven names as being under most intense scrutiny. They were James Biddle, the aristocratic curator of the Met's American

Wing; Theodore Rousseau, Jr., the dashing curator of European Paintings; Sherman Lee, the conservative head of Cleveland's great art museum; J. Carter Brown, the socialite assistant director of Washington's National Gallery; John Pope-Hennessy, the scholarly director of London's Victoria and Albert; Evan Turner, the head of Philadelphia's art museum—and me. When my staff asked, I laughed it off and said I didn't intend to "go home again." But I was brooding about Brooke's comments. I wanted to be courted even if I didn't want the job. Soon another article appeared about the progress of the Search Committee, this one mentioning four prime candidates: Sherman E. Lee, Sir John Pope-Hennessy, James Biddle, and Theodore Rousseau, Jr. I had been cut from the list and I was furious.

As fall came, I was convinced I would never make anybody's list. I had flown the nest. Arthur Houghton was cool to me at board meetings and drifted away when he saw me at museum openings.

Then I got a phone call from Ted Rousseau. He was one of the city's most accomplished social smoothies, so strikingly handsome it was said that Douglas Fairbanks, Jr., had gotten a face-lift to look like him. It was also said that he had many current lovers, one of whom was a top international hostess married to the head of Lazard Frères in France. Ted said he wanted to meet me for lunch.

At the table, Rousseau came at once to the point. Born in Paris and educated at the Sorbonne and at Oxford and Harvard universities, he was not known for bluntness. "Consider me a runner between the lines in no-man's-land," he said. "I have been asked to contact you by certain interested parties to find out who you think might be the next director of the museum."

I told him how thrilled I was that someone had finally come to me. I said I rather supposed that *he* was the logical choice. Rousseau shook his head. He could not imagine anything more amusing than being the curator of the most fashionable and glamorous department in the greatest museum on earth. Whom would I suggest? I told him I was convinced the Search Committee should pick an executive over an art historian, someone "street-smart," someone from the "real world." It was stock Lindsay administration jargon, something I had heard the mayor say a dozen times. But at least I believed it.

I asked him who was on the Search Committee and how it worked. He said the committee was "for show." The actual candidate would be chosen *in camera,* by Arthur Houghton and his inner circle. As

Rousseau described it, the time-honored custom was to form a committee of at least five members, no more than seven, so that there would be a ready quorum. No women were allowed. The chairman had to be in the president's pocket. It was ritual that "the entire world be searched." It was equally sacred that the committee spend as much time finding the new director as it had the last one. To be avoided at all costs was a candidate who might turn down the offer. Thus the question had to be popped very carefully. It was taboo to consider a bachelor, a homosexual, a foreigner, or a woman.

Rousseau confided that frictions had developed between Chairman Rogers and Houghton. Houghton had already made up his mind, but Rogers was intent on carrying through the extended motions.

Did that mean the nine months it had taken to choose Jim Rorimer? He said he'd find out. As we parted, Ted told me how helpful I had been. He said I might hear from someone else.

Two weeks later he called again, wanting to see me in my Parks office. It was late in the evening when he arrived, and I was alone in the baronial chamber. Rousseau was amused by the room, which had been built into one of the round turrets of the old Arsenal building. He smiled at the barkings of the seals playing in their pool just outside. It was, he said, the perfect office for a fun-loving Parks commissioner. He told me that the curators in a historic—and rather brave—act had formed a council over the objections of both Houghton and the Met's operating administrator, Joseph Noble. The Curatorial Council had demanded, gently but firmly, that they be informed of the proceedings of every board meeting. Houghton had been furious at first but eventually had calmed down. He had agreed with the warning that he would not tolerate the curators' imposing themselves upon the board or impinging upon policy.

When Rousseau finally got around to telling me why he had come, I was overwhelmed. The curators wanted me. What did I think of that? I told him I was filled with pride to be so honored, but I said I was too deeply involved in city affairs and my love for politics and, besides, neither the Search Committee nor Houghton appeared to have much interest in me.

I was not being honest. I had come around fully to the Brooke Astor point of view. The Lindsay dream was faltering. There was more rhetoric than substance. And that imbalance was something I recognized in myself, too. I was beginning to fake it in the Parks Department. I had become addicted to the cheers, the back pats, the

requests for autographs. I had begun glibly to tell community audiences that the ball field or the swimming pool or the master plan of all of Coney Island would take but a little time to carry out. Many of my projects, only I knew, were faltering just as Lindsay's were. I had pressed far too many funds into the pipeline for the jobs to be completed within the promised time.

I wanted to be asked to return to the Metropolitan Museum, to an idyllic, activist-scholar's existence as I described it, falsely, to myself. The only problem was no one in a position of power wanted me.

I didn't dare discuss any of this with anyone on the department staff, and I even tried to avoid talking about it with my wife, fearful of her reaction. When I finally did, I insisted to her that all I wanted was to be seriously considered. Nancy was suspicious. We had been married when we were both just out of college, both twenty-one. We had had two days' "honeymoon" on the way to the Marine Corps officers' training camp. Shortly after the truce in Korea, we had been shipped out to Camp Pendleton in California for a year of playful existence in what was then the quiet town of San Clemente. Then I entered graduate school at Princeton and became a virtual monk. The only relief to the grind of graduate school was an adventurous year in Europe primarily in Rome and Sicily, on an archaeological expedition. On our return to the United States, Nancy gave birth to our daughter Trea. Without our child my wife might have become overwhelmingly bored by her overly studious husband. Once I had gotten my M.F.A. degree, I took a few weeks off and started the grind all over again for the Ph.D., which I received in 1959. Then I started at the Met.

Nancy had a somewhat jaundiced view of the museum profession. No wonder. Bright, blessed with profound common sense, Nancy—the only child of Elliott V. Bell, editor and publisher of *Business Week* magazine, former superintendent of banks of the state of New York, and close confidant of Thomas E. Dewey—had been brought up in the political arena and had a sensitive political touch. The thought that she might be thrust once again into the restricted life of the art museum and, worse, become a slave to ceaseless social events didn't appeal to her. When I tried to assure her, reminding her that I was not on anyone's list, she scoffed. "Who else do they have?" I didn't believe her.

In early October my secretary told me that Frank Rogers wanted

to speak to me "urgently." He asked if I would make myself available to the members of the Search Committee at a meeting a week hence to advise them—"in informal discussion and in general, philosophical terms"—about the directorship.

Calmly, I told him I'd be delighted. The meeting would be at the stuffy Union Club. I was elated.

I wanted to make an indelible impression, so in the week before the meeting I crammed hard. I had my Parks lawyer and his assistants prepare detailed briefing papers on the museum, concentrating on issues such as labor relations, the budget, and legal matters. I got together the annual reports for the previous five years and made lists of the trustees and the staff, categorizing the key players by their strengths and weaknesses. I needed some dirt. I pushed my researchers to dig up anything about the museum the trustees might not know about. And they came across a gem—the relentless State Commissioner for Human Rights, Eleanor Holmes Norton, was preparing to hit the museum with a series of legal charges alleging massive abuses in the hiring practices and promotions of women employees. Astonishingly, it seemed that none of the museum's administration or board members knew anything about the ongoing investigation. I was jubilant. It was just what an alert city official ought to know.

On the day of the appointment, at five o'clock, I arrived at the club in my official car and bounded up the marble stairs to the oak-panelled bar. They had arranged the black-leather upholstered chairs in a semicircle in front of the chair in which I was to sit. Frank Rogers, a rumpled man with a shock of dark hair, greeted me with a quiet smile and introduced me to the members. There was Daniel Davison, perhaps three years older than me, an acquaintance of mine from ocean racing, dressed in a Brooks Brothers banker's uniform —he was with Morgan Guaranty as was his father before him. Then there was Roswell Gilpatric, a nattily dressed and manicured lawyer, head of the powerful firm of Cravath, Swain & Moore, and recently the Under Secretary of Defense. The next gentleman was tall and balding with an easy smile—J. Richardson Dilworth, the top financial advisor to the Rockefeller brothers. Next there was a short, moon-faced man with silver hair, Manning Brown, chief executive of the New York Life Insurance Company, who looked downright nervous. The last member was James Hester, the president of New York University. Arthur Houghton was absent, which confirmed my suspicions that he had something against me.

I sat down in front of the men, lighted a cigarette, and took the measure of each one of them. I knew three of them and had researched the others.

I knew more about Daniel Davison than he would have expected. He was a close friend of one of my ocean-racing crew partners, Charles Lord, then president of the Connecticut National Bank. Lord had told me that Danny, an heir to a sizable banking fortune, had unexpectedly come into a large amount of money from an older man, an "honorary uncle" who lived in Wyoming on an isolated ranch. As a young man Davison had spent several weeks of every summer on the lonely spread, relishing the pure, simple life and the companionship of the down-to-earth rancher who seemed content to live modestly. On his "uncle's" death Danny learned that he was the sole heir to the estate—worth many millions. Davison had invested the sum separately from his own money and had confided to Lord that he intended to spend it only on "good works." As I sat there, about to launch my performance, I wondered if the Met was, to him, a good work. Davison was key—an intimate, as Rousseau had told me, of Houghton's. I decided to direct much of my pitch to him.

I also knew Dick Dilworth. As financial advisor to the Rockefellers, he had attended several functions at The Cloisters. My father-in-law knew him well and had characterized him as "strictly an opportunist," someone who had chosen the easy path of becoming "a Rockefeller servant" rather than running his own company or becoming the head of a bank. Something told me that he might be against me, although I was hoping my acquaintance with the governor would help.

Ros Gilpatric was one of the most powerful lawyers in town, a heavyweight in Democratic politics, who did not suffer fools gladly and could be vindictive. He, too, was key. He was Houghton's closest friend on the board. James Hester was in my opinion a bumbling lightweight. We were not even cordial. I had fought bitterly with him on a number of occasions over his desire to erect a monstrous library designed by Philip Johnson in Washington Square. Manning Brown, the quiet chief executive of New York Life, was unknown to me, though my father-in-law knew him and had praised his sound judgment.

Danny Davison introduced me with the cliché "the man who needs little introduction." Frank Rogers crawled his fingers into the bowl of his pipe and asked, "Where, as a former employee and as

cultural commissioner, do you think the museum ought to be going next?''

I was determined that my performance would be unforgettable. I brandished a sheaf of yellow legal-sized papers and replied, ''Coming up from City Hall in my car, I jotted down a few notes. I'm not sure whether you're going to like hearing them, but they are the straight stuff.'' Consulting my ''hasty'' notes frequently—actually a point-by-point distillation of my staff's week-long research—I launched into a monologue of fifteen minutes' duration.

''The museum needs reform. Sprucing up. Dynamics. Electricity. The place is moribund. Gray. It's dying. The morale of the staff is low. The energy seems to have vanished. You've been missing all the finest exhibitions. But you already know that, since the *Times* has said it over and over. Great acquisitions seem to be going elsewhere. The Met seems to me like a great ocean liner, engines off, wallowing in a dead calm, moving only because of the swell. The ship has got to get moving. You've got to get yourselves a skipper who can deal with these and other, far more dangerous, problems. I think the most severe problem facing you in the future will be unions —not the guards and maintainers, but a curators' and educators' union. The attitude of the Met is a problem—people think it's inhospitable, elitist, and inactive.''

I blamed the trustees for having allowed the institution to come to a standstill. I complained that the Met seemed to have no goals for the remainder of the twentieth century. What bothered me and many others, I said, was the lack of any ''crusading spirit,'' something all but mandated by the times.

I calmly told them about the impending human rights suit. The news was, as I knew it would be, a shocker. Dilworth asked Gilpatric if the legal committee had any wind of the problem. No. Gilpatric wondered aloud if he could discuss the matter with Arthur Houghton. Then he asked, in a slightly strangled voice, what I would advise.

''Settle at once,'' I told him. ''Pledge to correct every inequity, no matter what the cost. Hire an outside management consulting firm to deal with this.''

I concluded my remarks by telling them that if the Met were to regain its position of leadership in the United States—the place it *should* occupy—the institution would have to be entirely worked over, spiritually as well as financially. It needed to be made popular,

to communicate the grandeur of the fifty centuries of art the Met possessed.

"What would you do first?" Rogers asked.

"The human rights stuff and salary imbalances. Next, blunt the union movement. Get a good labor lawyer."

"What exhibitions are we losing?" someone asked.

Not having a clue, I said, "Make your own. Blaze your own trails. Let others pick *yours* up. The Museum of Modern Art has been the spearhead for two decades. Now's the time to wipe them out and take command. Become the center of art excitement worldwide."

"As you know, we are planning our Centennial. What should be the thrust of our forthcoming celebrations?" Ros Gilpatric asked.

"I have no idea about specifics, but the attitude should be one of *evangelism*. The museum should cry out: we will teach you about great art of all civilizations. Speak directly to all the art lovers in a way they can understand. Teach about quality, what's great, what's spine-tingling. Don't be ivory-tower."

The questions continued for another quarter of an hour, and when they began to get too detailed, Frank Rogers said, "Gentlemen, I've a feeling that the commissioner should be spared every problem of the museum. I want to thank you, Mr. Hoving, it has been instructive and singularly frank." As we shook hands, the members seemed to me to be strangely passive.

I walked home the three blocks to our apartment on Lexington and 73rd Street and described the meeting to Nancy who remarked, "I've a feeling that's what the committee wanted to hear. After this, they might offer you the job. How are you planning to handle that? I hope you say no."

"Don't worry. Trustees don't like hearing hard facts. Besides, Arthur Houghton didn't come. He's got his own agenda."

Arthur Houghton called me two days later to ask if I could drop by his house at Sutton Place that evening.

I said "Okay" without even looking at my schedule. We were to meet at five-thirty. Houghton's house—now the official residence of the Secretary General of the United Nations—was a handsome brick neo-Georgian mansion on the corner of Sutton Place and 57th Street, the very image of wealth and power. When my Parks Department Buick pulled up in front of the townhouse, my driver whistled in admiration. The red brick was so covered with ivy it looked like a

Harvard building. The door was ivory white and recently scrubbed. The brass knocker and handle gleamed.

I rang. And suddenly almost lost my nerve. What was I doing at Arthur Houghton's? A butler opened the door to the entrance hall, which was bedecked with flowers. The decor conjured a lived-in look and a sense of home. The English eighteenth-century furniture was stunning. Through a corridor I caught a glimpse of a bright, airy chintz-filled living room with French windows which looked out onto a lovely garden with some old trees, a high wall, and beyond—the power plant in Queens. I had to smile.

The butler led me up a narrow stairway hung with English sporting prints. I entered a spacious reading room with exquisitely bound books, clearly the library of a dedicated rare-book collector. The fireplace glowed. Houghton was standing in the center of his private lair, looking very much on edge. A tall man, with a long, rather mournful face, he carried himself like a former athlete. Perhaps he'd rowed competitively, I thought. His smile was crooked and he looked at me a bit askance. He was not the kind of man one feels at ease with, but at that moment he seemed friendly enough. He smiled at me and thrust his hand out to grasp mine.

"Welcome, welcome. Drink? My martinis pass muster."

"Delighted."

He went to a bar and carried out a well-practiced ritual of stirring martinis in a silver pitcher that looked Paul Revere. He handed me one, straight-up.

Houghton sat beside me in a leather easy chair, our knees almost touching. He smiled in an awkward way and said straight off, "We want you to become our next director. What do you say?"

The question was both unexpected and unsurprising. I felt no reaction, no flush on my face. I had the calm, lazy realization that *this* was what I had been pursuing all along. My answer—which I heard as if I were listening to someone else—was meant to sound almost casual. "I'll do it." It seemed the most natural thing in life.

"Thank God that's over," Houghton said. He downed his martini and gestured for me to do the same. I did. I saw for the first time that he was a touch tipsy. He had undoubtedly had a martini before my arrival. My mind raced for a few seconds and I thought of blurting out "Wait, what do you have in mind for the job?" or "I'd like to think this over." But I didn't say a word.

I was inflated—*bloated* is a better word—with pleasure. The most

powerful man in American culture, whom I had thought didn't like me, *needed* me. The realization was like an aphrodisiac. I felt triumphant and unbeatable. In the space of just over a year the mayor had sought me out and now the trustees of the mighty Met. I realized that I wanted to be accepted into the prestige and power of the Metropolitan far more than I really cared about the institution or its needs. I had given no thought to whether I could accomplish what I had so boldly said in my performance two days before.

Houghton strode over to the bar to mix another batch of martinis. He seemed to have been lifted by the exchange. He handed me the glass. Without warning his tongue emerged from his mouth and ever so quickly slid down almost to his chin and then was sucked back into his mouth. I was shocked. He didn't notice the extraordinary tic. I looked at him as evenly as I could as he sipped his drink and gave me a bashful grin. He reached into his inner coat pocket and pulled out an envelope, gazing at it for a few seconds.

"I have here a list of names of possible directors. You're on top of the list. Someday, I'll show it to you. But your name's on the top. You may have had the feeling that I've been snubbing you in recent months. I was. I didn't want my feelings to influence the work of the Search Committee."

Houghton put the envelope back in his pocket—I never was to see his list—and we touched glasses.

"We'd like to start you in the spring—April. You've got to keep this a total secret until we're ready to make the announcement. I have to get the full board of trustees to ratify this. I'm rather worried how Lindsay might take this. Will he keep quiet? He'll talk? I shall try to get an appointment to see him as early as I can . . . to ask for your hand. The salary is fifty thousand plus a decent expense account. We're willing to buy the director an apartment. I've found the perfect one—a duplex uptown on Fifth and 93rd—which we'd like to have, say, Billy Baldwin decorate, and we'll fill it with works of art from storage. Naturally, we'll pay the maintenance, but that's income and you'll have to pay taxes. The apartment will be a perfect place for entertainment. I can see a car and driver, too. I'm so pleased. We have to announce the plans for the Centennial shortly, and that kicks off in less than three years . . ."

The search for a new director, Houghton went on, had turned into the opportunity for a special group of trustees—Houghton, Gilpatric, Davison, and Dillon—to study how the entire governance of the

institution should be changed, from the existing constitution and
bylaws to the officers of the staff. Many of my comments at the
Union Club had coincided with the preliminary feelings of those
select trustees. Houghton seemed not in the least concerned about
the possibility of a staff union, and the Eleanor Holmes Norton
investigation seemed almost peripheral, although he did mention that
Gilpatric was going to pursue the problem.

The conversation turned to staff. The Search Committee had de-
cided to create an administrative structure of a number of vice-
directors. One had already been voted into power. Another was
about to be. They were the two people in the upper ranks of the
museum hierarchy that I appreciated the least.

One was Joseph Veach Noble, who had been appointed vice-
director for administration. When I had arrived at the museum in
1959, Noble had recently joined the museum from CalTex Corpora-
tion as operating administrator. My first impression was unfavor-
able. Noble wore a black homburg and a suit with vest. He had called
me into his office and lectured me on the proper way to dress in the
museum—in a suit, *not* in my blazer, which he thought was too
casual. He informed me that he had been hired by the board to keep
Jim Rorimer in line "operations-wise." When I achieved a rapid
promotion to assistant curator, Noble called me in to his office again
to tell me, "I happen to agree with Jim about your capabilities."

But what most annoyed me about Noble had occurred a year later.
In my second year in the Medieval Department, a man—a former
G.I. who had married a Greek woman at the end of the war—had
popped up one morning at the information desk carrying a heavy
cardboard box. He said he had a head inside—an early Christian
marble head—and he wanted to show it to the appropriate specialist.
I was called and helped him heft the box to my office. He had found
the head imbedded in an old well on his property near Corinth, he
said. The marble was dramatic, larger than life-size, a compelling
image of a heavily bearded, bald man in the prime of life. The butter-
colored surfaces of the marble were superbly polished, and the work-
manship was superior. The most arresting feature of the head was
the eyes—huge, wide-open, staring eyeballs that almost hypnotized
—the eyes of a zealot. The style was obviously late fourth to early
fifth century A.D. He wanted three thousand five hundred dollars, a
fraction of what an antiquities dealer would have asked. But he
didn't want to have to wait too long.

I called Rorimer, who instructed me to "roll this head on up." The department helper put the marble on a cart, and we wheeled it up to Rorimer's office. I expressed my conviction that the piece was a rare early Christian Greek sculpture. Corinth, I reminded him, was where St. Paul had founded a church. Rorimer promised to give me an answer early the next morning. He always liked to ponder an acquisition overnight, but I could see he was impressed. I returned to my office and told the owner that I was "ninety percent sure the museum would purchase his head," made out a receipt, and told him I'd call him at his hotel the next day.

Rorimer called me at nine o'clock the next morning. I was flabbergasted to hear he'd decided "to pass." He explained that Joe Noble had studied the head and disapproved of it. Noble, who was a collector of Greek vases and who had been instrumental in unmasking the famous Etruscan warriors as fakes a year before, had branded the piece a forgery. The popping eyes had made him suspicious as had the lopsided face and the way the heavy beard looked like a cliff. Angrily, I told Rorimer that everything Noble thought was wrong proved the piece was *right*—all were hallmarks of the early Byzantine style. I said Noble was an idiot. Rorimer told me to leave.

When I telephoned the owner, he said, "How the hell would anybody want to fake a head and plant it in my wife's family's well for thousands of years?" I advised him to take the piece to Boston. In my fury, I called a competitor, curator of classical art Cornelius Vermeule. I urged him to take a look. The grateful owner called me two days later to say that he had made a deal with Boston. Not long after, the head, identified as coming from St. Paul's Basilica in Corinth, was called the rarest early Christian treasure found in the past fifty years.

I didn't tell Houghton now about my contretemps with Joe Noble. I figured I could handle him. Then Houghton mentioned the name of my other nemesis, Kenneth Loughry, the treasurer. Houghton said he had not yet been given the post of vice-director for financial affairs, since Dick Dilworth had a low opinion of him. I suspected that Loughry manipulated the finances of the museum to keep salaries down. He was well known for somehow, each year, at the last moment, "finding" the money needed to overcome the annual deficit. He would joke he'd found it in his bottom drawer.

"I am not very fond of Loughry," I told Houghton. "Partly because of him, Eleanor Holmes Norton is about to sue the museum."

"Let us deal with him, then."

Houghton began to talk with remarkable candor about the trustees and "who really runs this place." *He* did, along with the officers of the corporation, Gilpatric, Douglas Dillon, and Danny Davison. Another member of the "ruling class" was Harry Morgan, the chairman of the nominating committee and the man who had been instrumental in helping to oust Roland Redmond.

He then described his feelings about Brooke Astor and Charles Wrightsman.

"Brooke is a fine person. Slightly scatterbrained. Always believes the last person she's talked to. She'll be a significant donor, I think. Was one of your staunchest supporters. Charlie Wrightsman's a nasty son of a bitch, but at least he's frank. He always lets you know when he doesn't like what you're doing. I've put Ros in charge of him—Ros has a small house near Charlie's in Palm Beach—and Charlie loves to tell Ros about his will. The museum is in it—right now—for his collection. I've got to tell you a funny story about the time I went on one of Charlie and Jayne's cruises. He charters the *Radiant II,* owned by Stavros Mavroleon. Charlie sends all his guests a detailed itinerary, including how to dress—whites or pastel colors *only*. Well, I came on board in Venice—we were going to cruise down the Dalmatian coast—with Ros, as a matter of fact. And as we left in the evening out the Grand Canal in the sunset, I came up to the bar on the open afterdeck in purple slacks and a Hawaiian shirt I'd found someplace. Jayne got the joke, but Charlie got upset. Didn't like my passion for crossword puzzles either."

"What about Bobbie Lehman—and his collection?" I asked.

"I hate to say it, but I've all but given up on that collection ever coming to the museum."

"We *have* to get it," I said. "Failing to land his old masters and drawings will be a blow the museum might not survive. I should talk to Lehman as soon as possible."

"Go ahead," Houghton said. "Remember, no one thinks he can be persuaded."

We both fell silent, exhausted. Houghton escorted me from the opulent townhouse, and we parted as if we had been friends for life.

I was so elated I could barely breathe. I dismissed my car and walked home some twenty blocks.

"I've just been with Arthur Houghton," I told my wife. "He asked me."

She looked stricken.

"He offered an apartment—big duplex—and a limo. Fifty thousand bucks, too."

"And?"

"I said I'd take the job."

"I *knew* you would," my wife said, deeply upset. "I think I'm going to hate this. All those social climbers. You'd have done better to stay in city government. That way, at least, you'd be connected with real people. Will we really have to move into a museum apartment?"

"We'll have to entertain—fund-raisers. Supposed to be decked out with works from the storerooms."

"Doesn't sound like . . . us. Do you know what you are going to do with the Met?"

"A revolution. I plan to stay no more than five years, then back to politics."

"The museum will kill your political image."

"Not me. I'll always be in the news."

I got to Lindsay before Houghton could, at Gracie Mansion, where he was changing into formal clothes for a political dinner.

"Leaving so soon? Christ, you've barely begun. Well, it's a great opportunity. Best of its kind in the country. I can see that. But . . . have you considered the boredom? Seems to me the place is dead. But, Hoving, you'll make the mummies dance."

His words struck into me like arrows. Suddenly, I felt I had made a fatal mistake, leaving impetuously—selfishly—the man who had made me. I felt like a heel.

"Maybe I'll be back," I said.

"What? Politics? I'm not sure the genteel museum world and politics can mix. I advise you to run as fast as you can."

I told my Parks staff before any news leaked, but my publicist, Mary Nichols, spirited the story to Jack Newfield of the *Village Voice*. He criticized me for "selling out" the people by leaving them to enter the walls of the most elitist institution in town.

Houghton organized a meeting of the museum staff in the auditorium, where I got an ovation. After Houghton introduced me, I came out on the stage in shirt sleeves, at a trot, and said, "You all know me. You know what I've always stood for—connoisseurship, collecting, educating, scholarship. But I've changed since I left you . . ." They laughed. "So expect a bit of fire and flash. This has

been the finest Christmas present I've ever received. Happy New Year to you all.'' It was the twenty-eighth of December, 1967. I was thirty-six years old.

First in line to congratulate me was Noble: ''I'm confident we'll make a great team.'' After Noble came James Biddle of the American Wing. ''It's such a relief to know it's someone from the family. Congratulations.'' Henry Geldzahler, curator of the modern paintings, bounced over and asked for an early appointment—''urgently.'' Then I was overwhelmed by the members of the Medieval Department and The Cloisters. Vera Ostoia, the elderly research curator, whispered, ''I always knew our star would come back in our skies.'' That made me happier than anything anyone would say.

I asked Harry Parker to join me in Rorimer's office. He waited until Noble had left and said hoarsely, ''I had my doubts, but they did the right thing, after all.''

Rorimer's stolid desk had been moved to the center of the widest wall. A large round table was placed near the window. I asked Parker if he could have Rorimer's desk removed—I found it an unsettling presence—and have the round table centrally placed. That was to become my desk. ''Knowing how temperamental and fractious the curators are, I think it's best to start off with the round table,'' I quipped.

He asked me when the trustees wanted me to begin. I surprised him by saying, ''Trustees, what do *they* have to do with it? I'm starting now.'' I had decided to come to the museum at least two days a week and run the Parks Department at the same time.

I asked the secretary to get Robert Lehman on the phone. When he came on, he sounded distant. I explained that I wished to see him as soon as possible to tell him about my plans for the future of the museum.

He grumbled, ''I can give you ten minutes tomorrow afternoon at three-thirty. Here, at One William Street.''

I replied that I'd take only five minutes.

Lehman Brothers in the late sixties was one of Wall Street's most powerful private investment banking firms. Its headquarters is one of the most handsome buildings in town. When I arrived on the third floor, I was ushered into a tiny, cramped office, which turned out to be the private workplace of Chairman Lehman. The room, not larger than ten by six feet, had a modest desk near a small window in which an air-conditioning unit had been planted. The paintings, for such a

connoisseur, were modest—French primitive landscapes—Bombois and the like. There were also a bunch of "trophy" photographs, with the slightly built, balding Lehman smiling shyly with presidents Eisenhower, Kennedy, and Lyndon Johnson. One well-worn leather chair was placed next to the desk. A comfortable couch sat on an angle against one wall. Shelves of books, mostly art books, lined the library. They were far from the standard Skira or other coffee-table publications. Lehman's library contained volumes by Bernard Berenson and the Renaissance scholar Millard Meiss. I also spotted Richard Krautheimer's hefty study on Lorenzo Ghiberti. The door opened, and a very pale, delicate man with hunched shoulders slipped into the chamber. Lehman was dressed in an immaculately tailored dark suit and wore, curiously enough, a white-on-white shirt. His tie was the color of mother-of-pearl.

Bobbie Lehman glanced up at me, his mouth opened, and he seemed actually to stagger a bit. Feebly, he motioned me to sit on the couch as he sat down at his desk.

I launched into a fast-paced explanation of what I wanted to do as director. I hoped to expand, to modernize, to acquire—to do everything necessary to make the Met a complete artistic encyclopedia. I talked about the gaps—in Renaissance art, in Oriental art, even in contemporary art. I told how I wanted to make the place vibrant and exciting, to have it *say* to the visitor what curators and collectors *feel* when they encounter a masterpiece. I talked about "that surge of energy, that bang!" I glanced at my watch. Seven minutes had passed. I hurried on telling him that things would be different under my guidance, and perhaps he wouldn't like every move I made, but I would always be thinking of excellence. I got up to leave and Lehman asked me to stay, to tell him more.

"I want great exhibitions," I said. "Novel ones. Do you realize that from now on, in the museum's schedule, not a single show has been booked? I find that depressing. Coming down in my car, I got an idea for one I'd like to see organized, based upon an article I wrote last year for *Apollo* magazine—royal patronage, works commissioned and/or owned by kings and queens of all countries and all times." There was a muffled knock on the door, and Lehman's secretary stuck her head in the door. "The conference, sir." He waved her out. "Go on," he urged.

I told him about how I hoped to bolster the scholarly programs of the institution by arranging seminars and starting up a scholarly jour-

nal to supplement the monthly members' bulletin. I was making it up as I went along, trying to talk about what I imagined an immensely wealthy art collector would want to hear. I could see that the man who had had only "ten minutes" for me was entranced. Several more times his secretary poked her head in the door to tell him that someone was on the phone—I thought I heard Senator Javits' name. Robert Lehman was shaking off some pretty important people to listen to me. He asked me about my education in art. I told about my years at Princeton.

"My distress really," he said, "is that I didn't get graduate training in art history. Too late now, I imagine, and anyway I've seen a lot of art. *My* art upbringing will amuse you. I was a sophomore at Yale. That spring my father told me, 'Now is the time to get deeply involved in art.' He explained to me that he had booked a, ah, palace in Venice and had signed on two tutors—specialists in art to guide me. What a summer! I spent a full week on Carpaccio alone, sitting every day in the Scuola degli San Giorgio Schiavoni. I can close my eyes and take you through a good bit of the Frari. I am familiar with the Accademia. It wasn't all art. There were some memorable parties, too. Florence, Siena, of course. Rome. All of Italy. My father started our collection, you know. My role has been somewhat humble. I never got into art. I joined the firm. Never regretted that. When my father had his sixty-fifth birthday, I found and bought for him a certain Botticelli. I looked at five or so. Most were repainted. I found a pristine Annunciation. He was moved."

I was scarcely breathing. I had not only gained entry into Robert Lehman's inner sanctum, but here he was telling me stories I guessed he had told precious few people in his life.

There was another quiet knock on the door, and his secretary this time entered and told him she had to leave. It was five thirty! I had this vision of a platoon of bankers and guards all waiting for Mr. Lehman, and me, to depart. We chatted a few minutes more about how Jim Rorimer had recruited me. Then it was time to go and I decided to gamble.

"Mr. Lehman, I hope you won't take offense, but when you walked in here to greet me, you seemed . . . stricken. Do you mind if I ask why?"

Lehman sighed. His pale, delicate face turned away and then back to look at me. "I was, as you know, opposed to your becoming director . . ."

I hadn't known.

"I owe you an apology. I was a bit stunned to see you. I had not connected your name with the young man I had known from The Cloisters. I thought you were some politician Lindsay was forcing on the museum, not the former curator of The Cloisters. I apologize. I'll try to make it up to you."

He got up, took me to the hallway, retrieved my coat from the closet, and helped me into it.

"I tell you it's going to be great fun getting back to being an active trustee again," Lehman said. "May I offer you a lift uptown?" I told him I had my car. Before he pushed the button on the elevator, I turned to him and said, "What I'm going to say is brash, but I have to ask, does the museum have *any* chance at your collection?"

Lehman chuckled. "I shall say nothing more now than what I just said: it's going to be fun to be a trustee once again."

3

MOVING
AND
SHAKING

From the moment I leaped out of my city limousine and dashed up
the steps of the Met, I was picking the place apart. I was shocked at
its condition. The only part of the interior that looked in the least
inviting was the enormous Oriental hall on the second floor north.
Joe Noble told me it had been renovated under "scandalous circum-
stances," which he promised, conspiratorially, to tell me all about in
a quiet moment. Hadn't anybody noticed the mess—none of the
trustees, these rich folk who kept country estates? Only Brooke
Astor seemed to have cared, but she had been reticent, not wanting
to ruffle feathers.

I had no illusions about the museum's architecture—it was es-
sentially ugly. The one-thousand-foot Fifth Avenue facade was im-
posing, but to like it, one had to be a devotee of half-baked, late-
Victorian neoclassic, "World Exposition" architecture. The then
fashionable Richard Morris Hunt had designed the central building
and facade, completed in 1902—and it looked rather like what the

Baths of Caracalla must have looked like in their heyday. It was a stage set; it had nothing to do with being inviting to the public. The stones had been cleaned by city money some five years before, but the Hunt facade had never even been completed. On the huge cornice were four unfinished piles of stone that resembled fetal pyramids. They were supposed to have been carved into statues of the four liberal arts. The entrance was downright dangerous. A semicircular drive, intended once for horse carriages and now for taxis, cut through the pedestrian path from the sidewalk. The steep, narrow stairs ended not with a majestic Roman-style portal, but with a dingy, battleship-gray wooden temporary storm door, dubbed the doghouse by the employees.

Walking around the museum was not exactly a pleasurable perambulation around a historic landmark. On either side of the Hunt central building were two identical long wings—the boring work of another fashionable architectural firm of the twenties and thirties, McKim, Mead & White. The plaza in front of the outstretched wings, if one could elevate it with such a name, consisted of a dishevelled patchwork of semi-seeded grass and dirt plots surrounded by unkempt hedges, which strolling dogs had ravaged. The museum gave the impression of something worse than incomplete; it seemed forgotten and forlorn.

The Great Hall was magnificent, I had to admit. Hunt and his son had created a soaring space, with three domes hanging some sixty-five feet in the air, and three grand entrances into the galleries with staunch, impressive columns and a broad mezzanine above. The space was supposed to be light and airy; an observer at the unveiling had called the hall "a bride garbed in white." But coal dust had obscured the whiteness and the stones were coffee-colored. Despite its aesthetic grandeur, there was one tiny cloakroom. The hall was cluttered with shopworn mahogany showcases filled with unattractive items for sale.

Aside from the Great Hall the interior of the Met was distressing. The walls of most galleries were dirty, the cases dark brown, the pedestals painted from faded pink to dirty turquoise. No continuity of design or graphics existed. There were virtually no places for a visitor to sit. And there were far too few public toilets. In fact, the only part of the Metropolitan that was in decent shape was the old restaurant at the south end, which had been created by Rorimer's predecessor, Francis Henry Taylor—to the jibes of the staff. Taylor

had hired a fashionable interior decorator, Dorothy Draper, to transform what had been the centerpiece of the Greek and Roman galleries into a black-and-gold dining area around a pool with a singularly mawkish, pseudo–Art Deco bronze Bacchanalia in the center. The place was called, derisively, the Dorotheum. The shallow pool (into which a number of visitors had stumbled over the years) was swept regularly for coins which had been thrown into the stagnant waters and produced income sufficient to clean it.

Some of the galleries in the American Wing looked as if they might tumble down. One of the wing structures, on the west side of the museum, was actually falling in and had been made into a storage area and a workroom for the conservators. The museum was like one of those old western towns where grandiose store fronts concealed a humble series of chambers. The building had seven and a half acres of roof, mostly glass, much of it routinely leaking. There were over two hundred and fifty galleries and service areas. The building housed one of the larger electrical power plants in the city and had a special Fire Department station. There were an infirmary, two staff restaurants, and an armory with its own forge, where the World War II steel helmet had been perfected.

Slightly more than eight hundred people worked in the building. There were nineteen curatorial departments plus conservators and a group of educators. To my embarrassment, I realized that I didn't know much about the Met's artistic holdings. The General Catalogue, handwritten on three-by-five cards in files stored in the basement, tallied up to something like three *million* works—from archaeological bits and pieces to masterpieces of Italian painting. Oddball and abandoned curatorial dynasties, like the ones devoted to musical instruments or like the Islamic Department, were ninety percent stored away, out of sight to the public. Then, there were the "Balkan" departments, as I called them—Drawings, Prints, Arms and Armor, Primitive—kept so secret that most curators didn't know what they were. (I didn't.)

I tried in those first weeks to examine as many works in all departments as I could, and I tried to visit most of the departmental storerooms. The most intriguing was a low barrel vault—eight feet from floor to ceiling—a quarter of a mile long, slicing diagonally from north to south deep beneath the museum. It was a vast storm drainoff built in the mid-nineteenth century for the north Central Park reservoir and had long been obsolete. This was the place where the

truly unwanted art had been dumped—ghostly platoons of nineteenth-century American sculptures, each piece shrouded in plastic. Water had dripped for years from the vaulted brick ceiling through some of the plastic coverings. But there were worse conditions elsewhere. As the physical condition of the museum screamed for my attention, so did my other responsibilities.

In early January I was invited to my first session of the Curatorial Council. Since the group had not been granted formal status by the trustees, the meeting took place after hours.

We met in the offices of the curator of Western European Arts, John Goldsmith Phillips, the pro-tem chairman. Jack Phillips, a rumpled bear with a kind round face and a bald head, was one of the Met's true eccentrics. His clothes were a mess. When he wasn't grunting, he sounded as if he were humming an aria. Jack's field was the Florentine high Renaissance. In academe he was all but dismissed for his lack of scholarly publications, but most curators respected him. He was an "object" man. I considered him an ally because he had been extremely helpful in my researches in 1964 on the Bury Saint Edmunds ivory cross that I had acquired after a long quest.

He had made a number of singular acquisitions for the Metropolitan, and a large measure of his charm was his admission that he had "blundered" into many of them. One was a masterpiece he had bumped into in a minor sale at Parke-Bernet on Madison Avenue. It was a four-foot-long terra-cotta lunette covered by slick blue and white glazes depicting a baby-faced Archangel Michael brandishing a sword and a pair of scales. Though the piece was lauded in the catalogue as a great work by the Florentine Renaissance sculptor Luca della Robbia, all the experts had laughed—it was at best a nineteenth-century replica; at worst, a fake, and a bad one. But Jack Phillips believed in it.

"I had a feeling! And I went to the cocktail party the night before the sale and edged up to this Angel with my Swiss Army knife hidden behind my back. While the folks passed by, I'd say hello and scrape away at that shiny glaze. I sawed and filed away for maybe five minutes and sneaked a look. Well, by God, *underneath* that was *real* fifteenth-century glaze. I swear. I bid on the piece the next day and got it for six hundred dollars or so. *My* Luca della Robbia turned out to be the real one. What's on the Hospital in Florence is the later copy. Trust your gut!"

Phillips formally opened that curators' meeting by drawling, "We are all kind of overjoyed about your appointment, uh, considering what might have happened. You know, Joe Noble."

I started by explaining that I believed that the only way to run an institution as complex and creative as the Met was by participatory democracy. The curators must play a substantial role. But I said also that I would be the executive director, not merely an administrator, and I would make all final decisions. That remark caused a slight chill. The curators realized for the first time that their friendly former coworker had changed.

I told the group that I had been hired at the pleasure of the board, but that I was going to act as if I were a full partner with the trustees. My philosophy was reformist, though I didn't yet know what my specific programs would be. I was in favor of modernization and scholarship. I also wanted to make the institution visible and engage the public in every possible way.

"I want the museum to be humanistic," I told them. "Remember what Francis Henry Taylor used to say? That the Met is the 'midwife of democracy.' I want to use every device, every technique available for public education—electronic media for lectures, new lighting—preparing visitors in all age groups and in every way conceivable to receive and enjoy what they are about to see, preferably before they actually walk into the galleries."

I expected the curators to make as many people as possible experience that spontaneous enthusiasm professionals have when they look at a great work of art. I urged them to communicate the thrill of the work itself, the excitement of the time in which it was made, the excitement that impelled its creator to fashion it.

"A superb painting pinioned in its frame or a sculpture plunked on a pedestal or a beautiful small bronze isolated in a glass case *without* the explanation of why it's so perfectly the spirit of its times is a sort of mad silence. We must break through and communicate the full life of a work. We do very well in collecting and preserving. We do less well in communicating. To me the happiest experience in the museum field is to be able to give back to an ignored and 'silent' work its own resounding eloquence."

I turned to the subject of special exhibitions. Not a single show had been scheduled for the future, with the exception of a minor travelling show organized by the Turkish government. I was shocked, particularly since the newspapers had been pointing out

that marvelous exhibitions were bypassing New York. Dietrich von Bothmer, the craggy curator of Greek and Roman art, explained that it had been Arthur Houghton's wish. He hadn't wanted to shackle the incoming director with projects he might not like. I told the curators it was vital that there be a decent show soon after I arrived officially in March and suggested that the exhibition committee meet with me the next day to get moving. Phillips said such a committee didn't exist. Form one now, I urged, and four curators raised their hands.

To my delight the ad hoc committee fully approved of my idea of a royal patronage show culled exclusively from the museum's holdings. Helmut Nickel, the aptly named associate of the Arms and Armor Department, started citing from memory a list of works commissioned by or made for royalty through the ages—from Egyptian jewelry to suits of armor to paintings like Rembrandt's *Noble Slav* and Antoine Watteau's *Le Mezzetin*. We quickly assembled a list of some fifty pieces including the blue velvet and gilt wood doghouse made for one of Marie Antoinette's puppies.

In those first months I was intent on getting the Costume Institute completed and a show on fashion into the works before monetary support from Seventh Avenue disappeared. The Costume Institute had been conceived some fifteen years before by Dorothy Shaver, the dynamic president of Lord & Taylor. Over the years a worthy permanent collection had been acquired and an adequate space had been set aside for the galleries, but nothing had been constructed. I glanced at the plans, such as they were, and instructed the museum's architect, Geoffrey Lawford, to open up some standard gallery spaces in the north end of the basement. A miniature bulldozer was moved into the galleries, and several weeks later the place had been knocked into shape. I instructed the Costume Department's curator, a feisty woman named Polaire Weissman, to start arranging a grandiose show to be called "The Art of Fashion." And to keep the living designers in line, I hired the fashion public relations expert Eleanor Lambert, who became the first outsider to work on a major show in the history of the museum.

To fill out the exhibition calendar, I agreed to almost any kind of an exhibition without much thought. That's how "Harlem on My Mind" came to the Met. Allon Schoener of the New York State Council on the Arts petitioned me through Harry Parker. I knew Schoener's work, especially his smash hit at the Jewish Museum,

"Portal to America: The Lower East Side." Schoener had used early photos and lantern slides animated on large screens to show the history of the Jewish immigration into New York in the nineteenth century. His new idea was a multimedia exhibition of the culture of Harlem—Marcus Garvey, Langston Hughes and other poets, the clubs, the jazz, the churches, the writings of the people who had lived there in its heyday. It was to be a show about high creativity, about gifted people who triumphed over deprivation—at least in the arts. The title "Harlem on My Mind" came from the Irving Berlin song.

"I'll buy it," I told him. Back then there were no committees, no one I had to consult. Alone, after only a few minutes of conversation, acting like a public official, not a museum director, I committed the Met to one of the watershed experiences in its history.

I plunged into acquisitions with gusto, also very much on my own. Ted Rousseau popped in from a European jaunt and persuaded me to make a play for one of the most important works on the market, Leonardo da Vinci's early portrait of the Florentine beauty Ginevra dei Benci. The picture was in the collection of the Prince of Liechtenstein and was being hotly pursued by John Walker, director of the National Gallery, who was backed up by his billionaire patron, Paul Mellon. Rousseau thought the deal had stalled, and he begged me to rush over with him to Vaduz and make a play for the picture. How much? Something over five and a half million dollars! I gasped. I was in the Big Time. I couldn't leave Parks but I let him go. Rousseau returned in a few days, sad that he had "just missed" the painting: Mellon had spent the then astronomic sum of 5.6 million dollars. I was furious, I knew that the chance for a Leonardo would never come again.

When Rorimer died, the acquisition of the radiant twelfth-century Auvergne Madonna had been shelved, though the money had been voted. I got in touch with Harry Sperling, one of my favorite smugglers from my Cloisters days, who told me he could get the piece out of Belgium and into Zurich in four days—at the usual four percent commission. In ten days it was sitting in the Met's main storeroom.

Starting the wheels rolling on acquisitions was almost as exciting as gaining them. In my curatorial days I had had to jockey for position, to cajole and persuade and wait nervously for Rorimer to allow me to present the work to the Acquisitions Committee. Now I had the power to buy almost anything I liked. In late February I received a handwritten note from a certain Father Leonard of Oscott College

in Sussex, England, accompanied by a black-and-white photograph that set my heart pounding. The picture showed an enormous brass lectern of the late fifteenth century with Gothic turrets and towers and an eagle with outspread wings—to hold up the Bible—that seemed as large as a commercial jet. The piece had been made around 1500 by the Flemish master Aert van Tricht for a church in Louvain. It cost only one hundred seventy-five thousand dollars. The college had to sell it to repair the roof of the church. To the surprise of the good father, I phoned and said, "We'll buy it, if the condition is as good as the photo seems to show." He was speechless. I asked whether he had offered the lectern to anyone else. No. Was anyone in England interested in it? I was alarmed to hear him say that John Pope-Hennessy, the director of the Victoria and Albert Museum, had examined the work several years before and had offered ten thousand pounds.

"I don't like the sound of *that*," I told Father Leonard. "Maybe he's trying to establish it as a national treasure." But I wanted to buy it and promised to pass the proposal through my trustees. "In a month you'll have the money to repair your church."

"Bless you!" he said. "I was so surprised when you called. I expected you to bargain and I couldn't have stood for that. No place on earth deserves this more than The Cloisters." It all sounded so straightforward, but neither he nor I knew how difficult the deal would become.

A few days after the announcement Joe Noble came to my office in the Parks Department as a petitioner—a special pleasure. With him was Henry Fischer, the tall, Lincolnesque curator of Egyptian art. They implored me to have the courage to make the most unusual acquisition in the history of the Met, perhaps in the history of all museums. It was an *entire* ancient Egyptian temple. The structure, known as the Temple of Dendur, was made up of a sanctuary carved with sunken reliefs, a pylon, or gateway, and a stone platform; it had once been constructed on the edge of the Nile like a giant wharf. The temple and its sacred pylon had been dedicated to two ancient martyrs—Ptesi and Pihor—who had fallen into the river and drowned. When plans for the Aswan Dam indicated the temple would be inundated by the ascending Nile, the stones were carefully dismantled. Fischer had a file of photos showing the structure before, during, and after it was disassembled; the fragile stones—six hundred and eighty-two of them—were stored under tarpaulins on an island in the river.

"The United Arab Republic pledged the temple to the United States in thanks for American support—some sixteen million dollars in assistance funds—for the rebuilding of Abu Simbel," Noble explained. "But now there's a terrible problem."

Noble explained that they had been assured that the temple had been awarded to the Metropolitan, but that without warning Lyndon Johnson had formed a committee of scholars to decide where the monument would go. It seemed that every city in the country with an Egyptian-sounding name wanted the temple, including Memphis, Tennessee, and Cairo, Illinois. Noble had heard that the powerful Smithsonian Institution was under some pressure to try to win the temple for Washington.

I studied Fischer's photographs. The carvings, which covered most of the sanctuary like a needlepoint sampler, were impressive, but they did not look all that early. When I asked Fischer the date of the structure, he hemmed and hawed and said it had been built during the reign of Emperor Augustus in the first century A.D. I asked him if the Met *really* needed a building that was so late in the history of Egypt.

"I have doubts that any other complete temple will be coming our way," he said dryly. "Egypt had long traditions. This is not far in overall shape from commemorative temples built thousands of years before. And it's beautiful. You have to admit that."

He placed before me a striking colored engraving. It was a romantic mid-nineteenth-century image of Dendur with a group of handsome Bedouins gathered about the portal to the sanctuary.

How much to get it to America and re-erect it, I wanted to know. Fischer looked calm. No more than two million dollars, he said. "And I may have a donor," he added.

"Tell me," I said.

"It's premature to reveal the name," he said.

"Henry, who do you think I am—one of the enemy?" I said. I sat there poker-faced. What a stupid thing for him to have said. I sat there shuffling through the photographs. I had half a mind to tell them I wasn't interested in such a ponderous structure that would bring me, I was sure, a great deal of grief and sweat. After Fischer's silly remark, I didn't have much regard for him. As for Noble, anything he wanted I wasn't so fascinated with. Maybe now was the time to pay him off for his rejection of that grand early Christian head. But I let my petty feelings fade away.

Having "matriculated" at The Cloisters with its profusion of ar-

chitectural elements that helped to explain the smaller pieces, I knew the value of having large-scale remnants of the past. I was sympathetic to the temple for that reason alone. But I had another, stronger, reason to be in favor. Ego. I wanted to impress Joe Noble and Henry Fischer with what a Parks commissioner could do.

"It's going to cost a lot more than what you say, Henry," I said. "And, you're going to need massive city funding."

I sat looking glum, wanting to make them think I had decided against.

"If I say yes, then Houghton and the board will go along," I added. "If I say yes, then I might be able to muscle some moneys into the capital budget, which closes in a few days."

I let them stew a while longer.

"Okay, I say yes."

"Why, Tom, that's *marvelous!*" Noble gushed. Fischer looked dumbfounded.

"Henry, my advice to you is get moving on that donor, while I get moving on mine—the city of New York."

When they left I showed the photographs to my chief architect, Arthur Rosenblatt, and he laughed, "For New York City, you ought to change the name to the Temple *el* Dendur. You *have* to put this thing under glass. The climate here will tear it apart if you don't."

I asked him to estimate what it would take to bring it from Egypt and build it up again in the glassed structure. A few days later Rosenblatt told me that it might take a million and a half to move it across the sea and another three to four million to rebuild it and house it. I instructed him to add—quickly—to the Parks Department capital budget request, which was about to go to the city fathers for approval, an additional million and a half. He asked delicately whether stuffing the budget with moneys for my next job might not be considered a conflict of interest.

"Who'll stop me?" I challenged.

Rosenblatt shrugged.

A few moments later I was on the phone to one of the most influential members of the City Planning Commission, a body which held the key vote on the capital budget. The commissioner was Elinor Guggenheimer, who I knew longed to replace me as Parks commissioner. I told her about my desire to acquire the phenomenal temple for the city and asked for her support. She agreed without hesitation. In due time the city voted the money.

4

NERVOUS
IN
THE
SERVICE

When I returned officially to the Met as its seventh director, on the seventeenth of March, 1967, the kick-off show, "In the Presence of Kings," was desperately behind schedule with only a month until its opening. Curator Helmut Nickel had found a mind-boggling number and variety of "royal" materials—paintings, ancient sculptures, gold coins, costumes, guns, crossbows, tables, chairs, series of tapestries, jewels, illuminated manuscripts, architectural plans for sumptuous palaces, images of pharaohs and their queens, gilded bibelots, ceramics of rococo twist—an array of mouth-watering goodies dating from the second millennium before Christ to Vittorio Emmanuel II, the last king of Italy.

In the last weeks the pace was killing, but no one complained. The work actually exhilarated everyone involved, and other curators offered Nickel a hand as we came down to the wire. But one member of the staff detested the show. He was in the Design Department. He moped around, he complained about too little time, too little assis-

tance, about how no one had bothered to tell him what the idea of the show was. I finally got him to my office. "Things for kings" had to have "a lot of design zap . . . I don't want it to look clinical." I favored lots of rich colors for the walls, for fabrics in showcase, purples, vermilion, azure, crimson. I wanted a huge purple banner with gold letters hanging out in the central arch of the facade. I had gotten that idea from a charming *New Yorker* cartoon which showed the Met's facade in bird's-eye view, the plazas thronged with happy people, hot-dog and Good Humor pushcarts, and the like. An immense banner over that arch proclaimed "Welcome Mr. Hoving." I told the designer that our real banner should read "In the Presence of Kings" and that it would be the first of a series, one for each significant show. Joe Noble had costed the banners out at three thousand five hundred dollars—pretty cheap publicity.

The designer shouted at me, "Don't expect *me* to get involved in this vulgar circus. I quit!" I escorted him to the door, shook his hand, and smiled vapidly. Then I asked my secretary to send up the person in command of the Design Department. "They say there *is* no one in command," she laughed. "Send up anybody!" I ordered.

Within minutes a short, tubby young man with a wispy beard showed up, wearing sneakers, no socks, and a soiled gray smock. His moon face was placid, but his eyes were full of mischief.

His name was Stuart Silver and he was an assistant designer. He explained that he had graduated from Pratt Institute and had been there at graduation when I had made the commencement address. He told me he revered what I had done in the Parks Department— "take that as flattery," he said. I told him I wanted him to become the head of the department and design the "Kings" show installation. Could he do it?

"Sure," Silver said with no hint of concern. "But I want one thing straight from the start. I will be the design brains around here—not you. If you don't like some of my ideas, then tough. I've got to have full freedom."

I promised though I told him I had already hired one outside designer, James Lamantia of New Orleans, for the "Art of Fashion" extravaganza. Silver accepted that. He paused and suddenly asked, "Do you *really* mean to make me—right now—the chief of all exhibition design in this place?"

Yes.

"How much do I get?"

I had to find out from Kenneth Loughry what the salary was—eighteen thousand dollars. Silver grinned broadly. He'd take it. I explained what I wanted for "Kings." He said, "See you in a few days with a model or two," and then, at the door, he added, "I guess you'll want me to change the way I dress." I told him I didn't give a damn what he wore as long as his designs excited me.

Four days later Silver bounded into my office without announcing himself (which didn't bother me, although Joe Noble, who was with me, was taken aback). "I've got a model for 'Kings' for you. You'll love it. Got the banner designed, too. Wait'll you see the treasury."

It was like having one's own dollhouse museum. The paintings were rendered by paper cutouts, the sculptures by pieces of Styrofoam.

"I concluded that the problem with 'Kings' was *not* design, but organization," Silver said breezily. "You gotta make sense out of the stew. So, I grouped things and labelled the galleries. The show kicks off with a thunderous royal presence in the form of a circular chamber right off the elevators. The walls are purple, your idea—I thought it was good. There you'll see Rameses, then Gudea king of Lagash, then that huge head of Constantine in the middle and a bust of Louis XV. The other galleries are categories: royal gifts, the royal banquet (lots of beautiful eating implements), the royal hunt (great stuff!), the royal armory, the royal collector (Queen Christina of Sweden, for one), the royal artist (we've got some Chinese emperors who were legit artists), and my favorite, the royal treasury. Look at the design for the treasury. It's the grand finale."

I saw a separate model with the most unusual vitrines I'd seen in any museum—tall, rectangular cases made out of Plexiglas, suspended by invisible wires from the ceiling. Silver explained that the treasury would be a pool of darkness with the cases shining like sunbeams.

I was dazzled by the design. Would it make budget? Absolutely. Silver stood there smiling. He was clean-shaven now and wore a shirt and tie over freshly pressed chinos. I almost hugged him. The design was lavish, yet clean, with enough drama and zap to appeal to a large public. The royal banquet even gave it a sense of humor, something almost nonexistent in art museum shows. I congratulated him and his assistant Vince Ciulla. A third man was hovering outside

the door, and Silver introduced me to him. He was Lamar Terry, the Prince of Darkness—Terry was his lighting designer. "I'm going to make the Met famous," Silver said. And he did.

"Kings" opened on the annual members' day, Wednesday, the nineteenth of April, and the like of it had never been seen at the Met. The festivities began at five o'clock, when the normal daily visitors had departed. A cocktail lounge had been set up in the medieval sculpture court in front of the Spanish choir screen, with dozens of small tables and chairs. A special menu was served in the restaurant. From the balcony overlooking the Great Hall, the New York Brass played a "royal repertory" of music dating from the sixteenth to the nineteenth centuries. For the first time in the Met's history, there was a small gift shop established near the entrance to the exhibition selling facsimiles of four ancient Near Eastern gold coins. At five-thirty I started to circulate among the members. I dashed from gallery to gallery in the show. I was like a politician possessed. Joe Noble joined me, and together we received the growing "box office" from the Membership Department. The year before, members' evening had attracted a record five thousand visitors. At seven-thirty, Noble informed me, "Already eight thousand are in!" The total attendance would eventually come to just over eleven thousand guests, which was three-quarters of the entire museum membership.

Since television had not yet awakened to the dawn of my new museum age, there were no camera crews. But the New York Times sent its general cultural reporter, Richard Shepard, who wrote a cheerful piece about my "coming out party."

I was worried about how the prickly senior art critic of the Times, John Canaday, would review the show. Eleanor Falcon, the woman in charge of public relations, had confided that Canaday had sniffed disdainfully upon hearing I had been elected director and had said, "I am going to keep careful watch on Mr. Hoving. I'm not pleased with his freewheeling publicity." But the review was glowing—even rather breathless—saying that the show "brings the Metropolitan back into operation again and does it with a great big glorious, golden, bejeweled bang."

During members' night we had a host of lecturers in the auditorium giving talks ranging from "The King of Egypt" to "The Royal Patron" and "Pictures That Please Royalty—and Why." I kept track of the attendance. In the eight weeks of the show, 247,000 visitors came to "Kings," while 900,000 entered the museum. A third was

not bad, I thought. I used the opportunity to give special tours in the evening for hundreds of members of the city government, at all levels. Hundreds of civil servants from the Department of Buildings, from Parks, and from Landmarks attended to be dazzled. Years later, I think my invitations paid off handsomely.

Now most of my time was consumed with preparing our pitch for the Temple of Dendur to President Johnson's commission. The more I thought about it, the more worried I got. Not about losing it—but about winning it. The one and a half million we had been given by the city would never pay for more than the shipping of the stones from Egypt to New York. We would have to store them—God knows where—for as long as it would take to raise additional funds, anywhere between three and five million dollars, to rebuild the temple and construct the structure to house it. I was worried, too, about spending that kind of money for something of questionable aesthetic and historical value.

Henry Fischer was in charge of preparing our arguments. His draft statement emphasized the Met's superlative Egyptian collections. His paper spilled out a solid bunch of Egyptological facts but was woefully inept for appealing to Washington bureaucrats. The idea that the temple would enhance or be enhanced by other nearby centers of Egyptology seemed irrelevant to me. The temple was mere stage-setting. When I pointed out to Fischer that I needed a pitch that romanced the educational benefits of the temple and made reference to schoolchildren, he became gloomy.

''School groups?'' he asked.

Somewhat sourly I told him that no one on the commission was going to give a damn about the ''scholarly benefits'' of having the pile of stones in the center of New York. I added that I myself couldn't understand what the temple had to do with scholarship. It was something for popular instruction and the casual visitor. I insisted he hit upon the benefit to children and conservation.

I had concluded that we had to put the entire temple and its pylon and podium under a huge glass showcase. I had made a sketch and sent it to Arthur Rosenblatt at Parks, who had laughed. He had messengered back my crude drawing redrawn ''so the thing won't collapse in five minutes.'' He had also given me the name of the cleverest architectural renderer in the business and advised me to order up two renderings of my glass house—one in sunlight showing the ancient structure gleaming through the glass and the other, ''the sexy one,'' at night.

The night scene, showing the golden sandstone shimmering under floodlights, was as captivating as the Taj Mahal would be during a *son et lumière*. Everybody was impressed. So what if the structure housing the temple had virtually no means of support? So what if it looked like a two-foot-long glass case—blown up? I knew the drawings would sell. And I was willing to bet no other city or institution would come up with anything like it. This was sheer theatrics.

Henry Fischer didn't change a word in his proposal. He added nothing about kids or conservation in his final draft for the Washington hearing. But since time was short, I had no time to pressure him, not that Fischer could be swayed anyway. By that time I was frantically trying to garner endorsements from politicians. Senator Jack Javits and Governor Nelson Rockefeller were quick to give their consent.

Then I tried Senator Robert Kennedy. It was never easy to get through to him, unless he recognized a clear political benefit. Besides, the senator didn't like me. He believed I had "stolen" a vest-pocket park site away from him and had given it to John Lindsay in the early days of his administration. During the row Kennedy had been cold and nasty with me and had had his hatchet man, Richard Goodwin, phone to berate me for my sins. Kennedy returned my call eventually, and I told him what I needed. He was icy. "You'll have to talk to Mr. Goodwin about that." I attempted to be amusing, reminding him of the incident when he had entered a seminar on open spaces at the last moment and had asked me to help him on what to say. I had handed him my notes, which he had uttered as if he had written them, and then he had disappeared in a gale of clapping, leaving me with little to say. He wasn't amused.

I didn't want to talk to Dick Goodwin. I found him tough, unpleasant, and one of those brilliant people who didn't understand their full powers. This time, Goodwin surprised me by being gentle. Gone was his I-am-trying-hard-to-be-tolerant attitude. He sighed and said, "I don't think you can count on the senator coming up with a letter. He's in a bind on this temple. The fact is that his sister-in-law has a strong feeling about this temple. She feels it ought to be in Washington. Listen, I wish I could help. But I'm in a squeeze, too. Do you know Mrs. Kennedy? Why don't you call her and convince her?"

I did not know Jackie Kennedy very well. I had once spent a mysterious lunch in her apartment with her and the historian and John Kennedy aide, Arthur Schlesinger, Jr. I had gotten the impression they were feeling me out as a possible head of the Kennedy

Center in Washington. I must not have said the right things, for I never heard from them again. I called and explained what we hoped to do with the Temple of Dendur and asked her help in obtaining a letter from Senator Kennedy. I hadn't thought of keeping notes when I started to listen, but within seconds I was taking it all down verbatim.

"I know the senator has obligations and constituents in New York, but I don't care about them," she said in a clear, firm voice. "I won't let him write a letter to stick that temple in some dusty museum in New York. Jack got that temple for the United States. If Jack had not helped out Egypt at the critical moment, the temple would never have been awarded to us. I don't want it in some museum. I don't care if you are going to put glass over it to protect it. I resent the way Johnson is shopping it around the country. I don't care if the temple crumbles into sand, but I want it to be built in the center of Washington as a memorial to Jack. I don't care about the Met. I don't care about New York. Or Bobby's senatorial duties. Or his constituents. Or scholarship. Or this conservation business. Or Lyndon Johnson. It's going to be built in Washington."

I mumbled, "Thank you, Mrs. Kennedy, for your frank opinion." But I stomped around the room almost foaming at the mouth. After five minutes, I ducked into my washroom, splashed cold water on my face, and joined Fischer, Rousseau, and several other members of the staff in Noble's office, where a rehearsal session for the Dendur presentation was in progress.

I described briefly what had just happened and said, "I'm sure we can land this thing without Kennedy's letter." Noble was nervous, feeling that Kennedy's lack of support would tip the scales in favor of the Smithsonian.

"But Dillon Ripley, the secretary of the Smithsonian Institute, assured me that he is *not* in this deal!" I said.

"Now he probably *is*," Noble said. "They'll have to follow Jackie's wishes."

I felt like saying, "The hell with this temple! Let them have it. Let it crumble away on Massachusetts Avenue." At that moment my secretary entered the room and told me dramatically that *she* was back on the phone. She hadn't dared transfer Mrs. Kennedy.

I raced back into my office.

"I didn't want you to have any . . . misconceptions about our conversation," Mrs. Kennedy said, her voice now soft.

I waited.

"I want to stress that I think President Johnson is doing a superb job in allowing various cities around the country to compete for the temple. I want to emphasize that I have no personal interest in where it goes. I feel Bobby should work on behalf of his constituents. I would never try to influence him to do anything else. I profoundly admire Lyndon Johnson's commission. I want Bobby to have the temple where he wants it."

I managed a weak "Yes."

What had caused her about-face was, I figured, that she had called her brother-in-law and had described what she had told me. I could almost hear him saying, What if Hoving talks to the press? The senator must have all but commanded Jackie to get me back on the phone and smooth over the conversation.

I tried to reach Senator Kennedy again, but he never returned my calls. I wrote to him, asking again for a letter of support. Richard Goodwin finally telephoned to say that the senator would "definitely" support the Met's push for the temple. He never did.

Just before making the trip to Washington, I had to show our plans to the trustees' architectural committee, chaired by Frank Rogers. I was surprised to see the architect Edward Larabee Barnes walk in with him. I was told Barnes had been invited to "advise me" on how I should make my presentation. I was livid, although I kept quiet. Rogers had rounded up the full committee—Arthur Houghton, Roland Redmond, and an ex-officio member of the board, the president of the National Academy of Design, Alfred Easton Poor, whom I considered a stuffed shirt. Poor suggested that we should do away altogether with the glass structure. "Gangs of ruffians will smash the glass." Thanks! I thought. Here we were a day away from our show-and-tell, and this idiot wanted us to redesign what was nothing but fluff at best. Barnes observed that the architectural drawings were so "flimsy" (an apt word, I had to admit) that he wondered if the commission was going to be "taken in." I tried to point out that we were submitting only a concept. Later on the design would be radically changed.

"That sort of glib thinking, frankly, disturbs me," Redmond said. "Putting on a show cannot become typical of this administration's efforts. On another matter, I have it on the best of information that the Smithsonian has committed its full resources to capture the temple. Perhaps, with such ambiguities as this design and the unknown costs, we should withdraw."

I wanted to reply "I agree!" Maybe I should have. But, because I

so disliked him, I defended our plans. The board had approved. A hell of a lot of work had been done. Henry Fischer had bet his career on landing the thing. I mentioned the city money I had raised. I told them my good friend Dillon Ripley had assured me he was "completely uninterested" in the temple. Redmond smiled patronizingly and said, "I wish I had the time to instruct our new director in the complexities of museum infighting."

Houghton stepped in diplomatically. "Nothing to lose in an attempt," he said.

The next day at the National Endowment for the Humanities, Fischer and I were kept waiting almost an hour. A last-minute candidate had been shoehorned in ahead of us, we were told, and to my astonishment it was Dillon Ripley and a team of Smithsonian staffers who emerged from the conference room. Ripley greeted me without any embarrassment.

My presentation was thorough and detailed, a combination of scholar's speech and populist entreaties. I got through the boilerplate fast and concentrated on the big benefit—"Face it, gentlemen, it's the reaction of the kids"—and I hammered hard on the need for protecting the "precious stones." I went so far as to accuse *any* plan that did *not* completely enclose the temple as irresponsible. I lingered over the conservation report we had hastily assembled on the exterior of the Fuentiduena apse at The Cloisters, which was, of course, unprotected, and confessed that there, the limestone, of a type far more sturdy than the Dendur stone, was crumbling into powder day by day. I concluded by throwing a sop to Henry Fischer, vowing that the study of Egyptology would be significantly enhanced by the temple's erection in New York, hinting that the discipline would stop dead in its tracks if the stones were not awarded to the Met. I closed with some appropriately snide and hypocritical remarks about those cities that wanted the grandiose structure purely for touristic reasons and carried on a bit too much about how important The Cloisters architecture was to the public's understanding of medieval art.

On the way back to New York, I had to buck up Fischer's spirits. He was positive the Smithsonian had won his beloved temple. I tried to convince him that Ripley's appearance was only for the record. I was tempted to but didn't say, "Who the hell else but *us* would be so obsessed with such a white elephant?"

Nonetheless, I was slightly surprised two weeks later to receive a

letter from President Johnson: "It gives me great pleasure to inform you that the Egyptian Temple of Dendur is being awarded to The Metropolitan Museum of Art for its permanent location."

Victory gave birth to a whole new set of problems. Having won the lumbering temple, I was faced with actually receiving it, storing it, and putting it back together. I called upon Arthur Rosenblatt for advice. I told him I had decided to embark upon a massive building program. But I had no idea whom to sign on as the architect for a total renovation of the museum and its expansion. I had the feeling that the current architectural firm of Brown, Lawford & Forbes wasn't the choice, and I was fearful of what Frank Rogers and the trustee Architectural Committee would come up with. Rosenblatt told me that there was only one firm in the world—Kevin Roche–John Dinkeloo. The names did not make much of an impression. He pointed out that they were the designers of the grand Ford Foundation building with its glass atrium, a structure not yet completed but much talked about in the architectural press. "Kevin's Irish; John's Dutch—perfect for your stodgy trustees," Rosenblatt added.

Rosenblatt explained all of their credentials and accomplishments —as well as a few failures. One of their pluses was intelligence—the firm, Rosenblatt said, had refused to work for Parks. But the real reason Rosenblatt, a man sensitive to PR, finally told me was that the architectural critic of the *Times,* Ada Louise Huxtable, "loved" them. I asked him why not Philip Johnson or I. M. Pei. His answer was that they were sensational, but Roche-Dinkeloo was on the way up and they might just push themselves to an extra level.

"I'm going to need a pro to carry this out," I said on impulse. "How would you like to leave the Parks and work here?"

He was ecstatic. The new commissioner, August Heckscher, the distinguished former Carnegie Foundation executive, was, in Rosenblatt's words, "a putz who wants to dabble in all the design decisions." He asked me what I had in mind, and I told him, vice-director for Architecture, which had him laughing at the pomposity of the title. How much would he get? Thirty-five thousand dollars a year I said, without any idea of how to obtain the money.

"When do I start?" he asked. I told him in a month or so, or when I raised the money.

"Hurry."

I recalled that the curator of the American Wing, James Biddle, had been talking with Kevin Roche about planning his new depart-

ment. I asked him to get Roche down to the museum so I could meet him.

Several days later the architect, a shy, balding young man with an elegant Irish accent, came to my office. He seemed stunned when I told him I wanted to plan for a new American Wing, but wished to do so within an enormous framework—the master plan for the entire museum. I allowed Biddle to sit mute as I described the complex architectural demands facing me. When he left, I wondered if I should have bothered. Roche seemed so unresponsive. Only later would I learn that the man was literally struck dumb by my verbal assault. He had arrived expecting to talk preliminarily about one small section of the museum only to hear about a crusade that, if true, might take a decade of unrelenting work. Nonetheless, I made an appointment to drive up to his offices in Connecticut to discuss the scheme further.

Kevin Roche introduced me to John Dinkeloo, a tall, solid Dutchman, older than Roche, who grasped my hand in a fierce grip and spoke in a bass that made the room reverberate like a hollow drum. I was ushered into a clinical conference room, given a cup of coffee, and asked what I really had on my mind.

I took off—the total refitting of the Metropolitan Museum of Art, the building of at least three new wings, an approximate doubling of the space, from seven to nearly seventeen acres, the redesign of the thousand-foot facade, and the renovation of *all* of the more than two hundred galleries. I wanted a comprehensive plan to indicate where the new additions were to be placed, where the new infrastructure would be located. I wanted an architectural armature for a "new" museum.

"Through architecture, I want a new attitude," I explained. "Hospitality above all. The 'new' Met must proclaim in a very loud voice, 'Welcome.' I want the place to become not only a place for exhibitions, but a living forum for communication and teaching and education and celebration."

The pair nodded and said nothing. I went on to describe what I thought of the Met physically and aesthetically. If anything, I exaggerated the dismal condition of the place. "I suspect some of the galleries violate the city public-occupancy code. The place is dangerous."

During my performance I paced around the conference room, never coming to rest. Roche later described what I did as "Hoving's

flying thing—most of the time he was three feet off the ground—totally in the air.''

Roche's face showed no emotion. His eyes sometimes closed, head bowed forward, he looked, to my annoyance, to be deliberately dialing out. Eventually, I learned that this was how he concentrated. He'd abruptly come to and start talking, hesitantly, grinding away in a quiet, insistent voice. Usually what he had to say was vital. At our first meeting he eventually gave me his personal impression of the museum. In many ways it was more perceptive than mine.

''The most distressing aspect of the Metropolitan—I got to know it quite well in 1950 when I had been laid off a job in the city and visited the place every day—is that there's an appalling absence of continuity. A visitor can go from Egyptian art to Japanese armor without any indication that a civilization—and thousands of years—have changed. The Met is actually a bleeding mess; it's more an open storeroom than a series of public galleries. I would concentrate on solving that *lack of continuity*. I'd look carefully at the traffic flow in the place—how easily the visitor can find his or her way, how intelligently the works are paced. I can't tell you now what the changes might be or what they'll look like, but I tend to think they'll be monumental.''

I was impressed with Roche's focusing in on the interior and his ''philosophy.'' I was struck also by his hesitancy. This was a guy who didn't claim to know all the answers. I remember being taken by the array of architectural models in his drafting room. On rows of tables were arrayed a host of little buildings—from entire skyscrapers to the interiors of offices—all so perfectly crafted in cardboard and paper, painted, and finished that I felt like Gulliver. I looked down on a tiny, cardboard Ford Foundation with its striking courtyard planted with trees and ferns. I peeked into the elegant office of the Ford Foundation director, McGeorge Bundy. I saw a project for an arts center at Wesleyan University and a model for the tower for the Knights of Columbus building in downtown New Haven. What particularly caught my attention was the model for a museum of the Air Force planned for Dayton, Ohio, with exhibits of war planes in an interior space no less than five acres in size. The details of all these projects were astonishing. I poked my fingers into tiny doors and through little windows to touch desks, chairs, and even paintings on the walls.

During lunch Roche came alive with schemes. He would first go

behind the scenes and do the needed research, lots of it. He'd interview the key curators to discover their *needs* and desires. He'd want to reduce the problems of the institution to a numbers point of view —how many civilizations? how many works of art? what were the finest and most important ones? were they the curatorially important ones? were they the "emotional" ones? He'd hope to identify the separate cultures represented in the place so as to solve that oddity of what he called the "wandering galleries." He would stress the educational thrust of the museum. He'd focus on getting the visitors to understand what they were looking at. Circulation—"traffic control"—would be a vital element. As would be how to get the people in—safely. He'd worry about that taxi drop-off road, which conflicted with the pedestrian entry. He'd concentrate on the narrow main stairs.

"I'd tend to look at the audience of an art museum in three categories," he said. "The young and relatively untutored, the educated museum-goer, and the scholars. The permanent exhibitions have to be set up with a thought to pleasing all three constituencies. But most important, even more so than the circulation or practicalities, is how to enhance the emotional aspects of this great museum."

I sped back to New York elated, just in time for a meeting of the Executive Committee. At the end of the session I took Houghton into my office to tell him what had happened in Hamden and urged him to hire Roche-Dinkeloo for a comprehensive architectural plan for the future of the museum. I told him I refused to allow the Architectural Committee to interview a bunch of architects or travel around the country looking at their works. I was candid about my lack of faith in Frank Rogers' aesthetic judgment. I told him that we didn't have time to fiddle around. There was Dendur; there were the American Wing people and James Biddle pushing us; and we had Bobbie Lehman to snare. What would people think of the Centennial if it took place in a dump? Once his cherished Centennial was mentioned, Houghton reacted at once.

"Can you be certain that *any* architectural work will be finished before the Centennial? Shouldn't we wait until *after* the festivities," he asked.

"No! Every month, the parks and environmental groups are gaining power," I said. "We're going to make plenty of enemies by expanding into the park. The community planning boards just instituted might become strong enough to block us, if we hesitate. Our

chances of success right now are sixty-forty. In a year they'll drop to fifty-fifty. A year after that, the percentages turn against us.''

''How are we going to pay for all this?''

''Out of the endowment,'' I said glibly. ''It's capital expenditure. For planning, we'll need something like a hundred thousand. And we'll need an in-house architect, someone to keep Roche-Dinkeloo in line, someone who'll deal with community problems. I have the man. He's Arthur Rosenblatt, the architect I brought in to work in Parks. We can bring him on as vice-director for Architecture—thirty-five—same salary as the others.''

''Agreed. On second thought, I think you should deal with Frank Rogers yourself,'' Houghton said with a smile.

I phoned Rogers at his office minutes after Houghton had left. We met the next day and I tried to steamroller him into supporting Roche-Dinkeloo. He wouldn't, or at least not without a formal presentation. So Roche brought a slide machine and talked about the projects he was working on. Again, he seemed ill at ease, not the man who had spoken with such conviction only a short time before. Later, I found out he was fearful that Rogers' ghastly work would come into the conversation and that he'd blurt out something uncomplimentary. (''Jesus, I kept thinking,'' Roche told me, ''what if that freaking hospital of his comes up?'') Rogers asked one question—about the ''design'' for the Temple of Dendur. Roche answered diplomatically, ''The final design will be a challenge, especially how the modern building links to the neoclassical entablature.''

In such an almost casual way, the architects were hired for the most significant task the museum had initiated in its history. The fact that I had been allowed alone to name the firm was an indication of my power at that moment, as well as Houghton's desire to cut through the museum bureaucracy and get moving. At the press conference to announce the appointments, Ada Louise Huxtable confided to me, ''Kevin and John are the perfect choices.''

5

THE
CURATORS

I studied the curatorial staff as rigorously as I had the buildings, but not quite in the same way. With curators you have to be delicate. You cannot dash around them, crawl over them, thrust a light in their eyes as you can storerooms, roofs, or the exteriors of a bunch of buildings. Curators are touchy; sometimes they are even prima donnas. Despite the fact that they constitute less than half of the Metropolitan's professional community, they consider themselves the heart of the institution, and I agree. Certainly, I recognized the vitality of the rest of the staff—the guards, maintainers, educators, registrars, photographers, conservators, librarians, the people who worked in the bookshops and reproduction studios and in public relations or membership, the auditors, restaurant managers, nurses, and telephone operators. But the curators were the elite corps. And I wanted to encourage the worthy members of that corps and replace lesser members with my own team.

Art museum curators are a singular breed, even more ostrich-like than university professors. I found the more talented they were in

professional activities, the more uncomfortable or temperamental they were as human beings. Academically, they tended to be selfish, refusing access to the works of art in their care until they and no one else could exhibit or publish them. Yet, most art curators possessed a surprising knowledge about other fields—music, dance, literature. Many were movie addicts. Most couldn't go to sleep without looking at yet one more photo of a work of art. They made it their business to know about every affordable, excellent restaurant on earth. The majority spoke a foreign language or two and could read three or four. There wasn't a travel trick they hadn't tried or invented.

Aggressive collecting curators were more than a little larcenous. To land something great, they were perfectly willing to deal with shady characters. Though they wouldn't, they could tell you every smugglers' ploy ever concocted. In extralegal matters they could be sophisticated, but they were often naive about the subtleties of bargaining. Curators could be lazy. All too many arrived late in the morning, enjoyed a long lunch, and left early. They had a deep-seated, instinctual dislike for authority and, on principle, were suspicious of museum directors, even one who had sprung from their own ranks. Fund-raising was anathema to most of them. And most recoiled at having to ask anybody for a gift of money or art.

Dietrich von Bothmer of Greek and Roman wanted everything, but especially the collection of the trustee Walter Baker, and so I wanted Dietrich. He was one of the most brilliant, amusing, and frustrating members of the staff. A chunky man in his early fifties, he spoke with a heavy accent despite having lived in America since just before the Second World War. Dietrich and his brother Bernard had slipped away from the Nazis and fled to America. Bernard had dropped the aristocratic "von" in honor of the democracy that had embraced him. Dietrich emphasized it. Bernard became the curator of Egyptian art at the Brooklyn Museum and had a family. Dietrich was a bachelor until 1966, not wanting any commitment to distract him from becoming the most knowledgeable expert in the world on Greek vase painting. He was a man of exceptional gifts in his chosen field—he could spot a tiny fragment in some flea market and tell you where it fit into a vase in the Louvre—yet his eye for sculpture and bronzes, for Hellenistic and Roman art, was, to put it kindly, myopic. He was a dictator with his employees. Like many strong-willed people who are talented in a narrow area, unconsciously he did not recruit staff members who might someday succeed him.

Walter Baker, a New York banker married to a woman of great

means and a sympathetic heart, Lois, had also developed a passion for Greek and Roman objects, and Dietrich had helped him assemble the treasures, gently, never acting pushy. When I was a curator, my impression of Baker was that the slight, handsome aristocrat was just a dandy. But in Acquisitions meetings I was surprised to see that Baker was perceptive about art. By the time I returned as director, Baker was ill and Dietrich had begged me to join him at the banker's apartment for a look at the collection and to raise his spirits. He was sadly no longer the sharp-tongued expert who could pass judgment correctly on a Greek vase and minutes later sound off: "Modern art is a communist conspiracy." Walter Baker had, of course, long ago committed his fine things to the Met, but Dietrich wanted that final visit just to be sure. It is the mark of an excellent curator to keep nudging the donor.

I knew less about the Islamic holdings. I had never seen them. Few had for years, since ninety percent of the works had been hidden away in storage. But anybody who knew anything in the museum told me that the Islamic holdings were probably fabulous. To be sure, I asked the curator of the department, Maurice Dimand, who was due to retire in months, for his assessment.

Dimand was the very stereotype of a Middle Eastern rug merchant —short, dark, slightly oily, with deep-socketed eyes that seemed like slits with dark gray smudges underneath them, and a raspy, accented voice. He looked distinctly ill at ease when he came to see me, but after I had flattered him and indicated that I had all the time in the world for him, he grew bold.

"I don't know what you thought of Jimsie Rorimer—I suppose you didn't know Taylor—but both of them went out of their way to belittle me and the Islamic collection. I don't mind. The point is that this is the exceptional collection in all America, and it is being neglected. I urge you to make the reinstallation of Islam your highest priority. If you were to create an Islamic wing, you'd find that our holdings—splendid bronzes, excellent silver, majestic tiles, gorgeous carpets, intricate wood carving, masterful pottery, and glorious *miniatures*—would become as popular as the European paintings. You laugh?"

I did not laugh. He went on to say that unlike most of the other department heads in the museum, he had made arrangements for his succession, hiring the best young scholar in the United States, Dr. Ernst Grube. He was ready and eager to carry on the crusade. He

would fill in the few gaps in the collections. He begged me to affirm Grube's appointment as full curator on his retirement and urged me to let Grube run after the single most beautiful and important— Dimand *always* stressed the beauty of an object over its historical importance—Islamic work in the country. It was an illuminated manuscript of some five hundred pages called the Shah-nameh, commissioned in the early sixteenth century by King Tamasp of Persia. The work was owned by Arthur Houghton. He had planned to give it to his rare book library at Harvard but was becoming irked by Harvard's delays in publishing a book about the manuscript. Grube could get it, Dimand claimed.

I promised him that I'd struggle to raise the funds to build the necessary galleries as soon as possible and told him I'd have a chat with Houghton about his Shah-nameh. When he left, I told him that I was truly saddened that just as I had come back, a curator of his vitality was leaving. His dark eyes got very soft.

If Dr. Maurice Dimand was the stereotype of the rug merchant, Dr. Emmanuel Winternitz, curator of Musical Instruments, was the mad Viennese fiddle player. Despite his courtly manners and the way he would lunge into a hand kiss, Winternitz had a nasty disposition at times. When it came to the defense of his beloved department, he was like a female bear with cubs. With good reason. Musical Instruments was held in the least regard of any department in the museum. Francis Henry Taylor had helped the department come into being but soon tired of it. Jim Rorimer had been keen but had done nothing with it.

Despite promises, Winternitz was never given any permanent galleries. When his pleas became too strident, he was allotted a few cast-off dark mahogany cases and permitted to mount a show in a narrow corridor near the entrance to the auditorium. He'd create the most entrancing and witty exhibitions—miniature violins used by ballet dance masters or hurdy-gurdies or flutes and French horns, one made unexpectedly of porcelain.

By the time Winternitz finally obtained a hearing with me—he was not uppermost in my priorities—he had all but convinced himself that I thought of him and his department as alien. His spirits rose when I told him I believed musical instruments had as much right to be in the Met as any of the decorative arts, but they fell when I added that he shouldn't expect much permanent gallery space soon unless he found a donor to pay for an installation. He was being

treated no differently than any other curator, I told him. It was my standard challenge. If I didn't hear from him, I'd ease him out.

Only a month later he had secured an "angel," a certain Mrs. Andre Mertens, the widow of a world-famous classical concert impresario.

He had her prepped. Now I had to clinch it. He insisted I meet her personally over lunch in my office. Winternitz was positive that she would give the money for the galleries—*all* of them!

I knew it would take more than an intimate lunch or two. We had to have a complete analysis of the holdings of the Musical Instrument Department. I had to get some idea of the dimensions of the problem. Winternitz drummed up the information in a week. As I suspected, the holdings were vast, more than a thousand pieces, most of high quality, ranging from grand pianos to exotic items like Tlingit and ancient Peruvian instruments. There would be more conservation work needed than we had expected. The ballpark sum for constructing the galleries and putting the prime instruments into playing condition would be just over a million dollars. More, I surmised, than Mrs. Mertens or any donor would be interested in giving.

Mrs. Mertens was charming but a little boring. Tall, angular, prim, she held her head at a slight angle and seemed to look down at me disapprovingly. The day I met her I was irritable about some petty disaster. I decided to tell her the bad news about the money right away. Maybe she'd go away.

"The new, glorious Musical Instruments galleries—we figure we've got to have no fewer than fifteen of them—will be built in *the* prime space in the entire museum, between the Impressionists and the American paintings galleries. They're not going to be cheap. Grand galleries never are. And we want to have all the instruments shown back in playing condition. And it'll cost one million two hundred thousand dollars," I said brusquely.

Poor Emmanuel Winternitz looked like he was going to faint.

Mrs. Mertens inclined her head a little more, looked down at me with one eye, and without hesitation said, "That is understandable. I am entirely willing to contemplate such an undertaking, although I will want to ponder your proposition and discuss it further with my lawyer. But in principle I am inclined to agree. How big will the name, Andre Mertens, be?"

"Big!" I said. "Very big."

"I feel even better, then."

It was my turn to feel faint. But the months dragged on while Mrs.

Mertens delayed giving us a formal agreement. Clara Mertens had already made up her mind, although I didn't know it. She was stalling because she was afraid the museum would drop her once the money was in our hands.

When, at last, Mrs. Mertens pledged the money in writing, the construction of the Musical Instruments galleries was rushed into the schedule. They were dazzling. Stuart Silver had come up with stunning layouts combining elegant open space with floor-to-ceiling showcases jammed with every imaginable kind of instrument floating on almost invisible wires. We installed an innovative French sound system on which visitors could listen to recordings of the pieces they were looking at. Silver's design was one of those rare moments in museum installation in which the art, the furniture, the labels, and the educational material all worked harmoniously and effortlessly with one another.

The second-in-command of the department of Western European Arts, Olga Raggio, a voluble, excitable young Italian, knew that the trustee Judge Irwin Untermyer had most definitely pledged his incomparable collections to the museum. Nonetheless, she badgered me to give up several months of Sundays to engage in noontime tête-à-têtes.

On those countless Sunday visits, I would arrive precisely at ten o'clock, sometimes accompanied by my wife, and be greeted by the distinguished octogenarian jurist. His collections of English furniture, Italian bronzes of the fifteenth through seventeenth centuries, and hoards of marvelous porcelains and ceramics ranked among the finest in the world. He lived in a duplex apartment at 78th Street and Fifth Avenue hemmed in by his art. He would wander through rooms outfitted like a private museum fondling and muttering to his "children," occasionally picking up a special favorite and bestowing it with a kiss.

Untermyer, like Lehman, had his own curator, Yvonne Hackenbroch, an emaciated sparrow of a woman who was a refugee from Germany. She had a crackling, hoarse voice and an impenetrable accent and was highly respected in Europe as a scholar in metalwork and jewelry. I had known her when I was curator, and one late afternoon in the dirty old Medieval Department storeroom, she had told me a story about her employer that had made me shiver. The judge had forced her, with the clear threat that she might lose her job, she claimed, to cut his toenails every week.

On those Sundays I saw him, Untermyer, looking like a character

out of Lewis Carroll—powdered and bleached with wattles wagging beneath his chin—would murmur adoringly and for the most part incomprehensibly about each bronze, ceramic, or piece of furniture. All the while Hackenbroch hovered close by, firing off cutting remarks that only I could hear about his lack of knowledge.

No matter where we were on the tour at noon, the judge would stop and guide us to the magnificent salon overlooking Central Park. Once we were seated, a butler and maid entered the chamber carrying trays with crystal bowls filled with fresh caviar. Champagne and vodka were served. Lunch was only caviar, which made the Sunday sessions a little easier to take. But, of course, Olga Raggio was never invited on those privileged tours. In time the Untermyer collections did come to the museum and along with them came a grateful Yvonne Hackenbroch.

Henry Geldzahler, the curator of Contemporary Arts, laid ambush to me more than any other curator in my first months. I saw him no fewer than nine times in my office, always first thing in the morning. He would chatter on about the many exhibitions he was going to mount, the host of catalogues and books he was going to write, the donors he would snare. It was impossible to resist Henry's energy, and it was impossible to dislike him, even though in time I came to the sad conclusion that, stripped of the flash, the humor, the rush of words, he never said anything I had not already heard or read about somewhere else.

One reason I liked him was his crusading zeal to land the incredible pop art collection of Bob and Ethel "Spike" Scull. Henry nudged me into their orbit. The two of us were going to kill to get that collection.

Bob and Ethel were the ultimate 1960s New York nouveau-riche, social-climbing art couple. Or so the trendy, bitchy press claimed. They also happened to be vibrant, funny, raw, and invigorating—a welcome antidote to many of the stuffy types I had to pursue. With Ethel's money, Bob had parlayed a handful of taxicabs into the city's first radio-equipped fleet, called Sculls Angels, and with the profits had begun to collect the work of young and promising artists. Unerringly. The guy was a natural. So was "Spike."

I'd walk in the apartment on Fifth Avenue to be confronted by an artistic three-ring circus. There'd be a days-old painting by Andy Warhol—in all likelihood with Andy standing proudly beside it—a brooding "pinstripe" picture by Frank Stella, a fresh Larry Rivers

or Robert Rauschenberg or Claes Oldenburg. After a slapdash dinner and radical political discussions, one might be asked to screen Warhol's just-completed eight-hour-long movie, *Sleep,* in which the only action was when the sleeper twitched in his sleep. After just such a mindless film presentation—I can't recall what it was—I fled into the Scull living room to have a solitary drink, my head dizzy from the ubiquitous marijuana smoke. For the first time, really, I studied Scull's art, piece by piece. There must have been a half dozen paintings, three or four sculptures, and a handful of handsome bibelots spread out on glass tables. I was stretched back in a pure white low settee looking directly at a most entrancing piece, which dominated the glass table in front of me. What a strange thing! It was a box bristling with thousands of common straight pins and looked like some sort of devilish cubistic porcupine, as threatening as a military arsenal. Suddenly, Bob Scull was there; he'd plopped himself down beside me.

"Whaddya think of all this?" he asked, waving an arm across the room.

"I like *this,*" I laughed, pointing to the box with pins.

"Great! A contemporary reliquary. Get it? Good enough to be in the Met. It's by Walter De Maria. I discovered him. I'm his patron, his—ha!—Lorenzo de' Medici. I find these artists, see—I crawl into more lofts than fire inspectors—and when they're good, I pay 'em a living wage. Enough, anyway, so they don't have to drive trucks all night long or whatever. Whaddya think of my stuff? Tell me, I can take it."

"Some of it is pure shit," I said gravely. He guffawed. "That dumb movie for instance," I went on. "But Mr. De Maria is brilliant. I think some Warhol is gifted though I think he's beginning to flatten. I'm not much for Johns. I am for Rauschenberg. Stella's a mystery to me. Pop art? Yeah, well. I like Rosenquist. For example, I was in Castelli's last week and found something astonishingly good by Rosenquist—this huge, wraparound painting called *F-III,* with the nose of the jet, a young girl under a hair dryer, a bunch of spaghetti. I think he's put his finger on the pulse of today somehow. I also admire Warhol's big painting of Ethel . . ."

"Yeah, *Ethel Scull Thirty-Six Times.* Andy took her all over Times Square in and out of those passport photo booths, and he'd silk-screen each image. I happen to think that's one of the more powerful portraits of the half century."

"So do I," I told him.

"You *do?* Hey, I may give it to you when I croak. About the *F-III*, would you believe I just bought it? You know, Castelli was going to sell it in pieces—it's on fifty-one panels! So I saved it. How about showing it at the Met?"

"I'd love to."

"Listen, if things work out, I'll give my whole collection to you."

Shortly after this promising encounter, the *New Yorker* published a snide, mocking, and tasteless profile of the Sculls. They became even more the butt of jokes. . . . I defended them. For that, and because, I guess, he liked my style, Bob did in fact lend Rosenquist's startling *F-III* to a special show. And he did lend the striking *Ethel Scull Thirty-Six Times* to the most flamboyant art exhibition the Met had ever mounted. In both instances Henry Geldzahler's nose was put out of joint so much he almost quit. Both times I was sorry he didn't.

One of the most troubled curatorial departments of all was the American Wing and the Department of American Paintings, Sculpture, and Watercolors. Sometime back in the twenties, the American period rooms and decorative arts had been assigned to the Wing and the paintings, sculptures, and watercolors handed over to a separate department. I wanted to bring both sections together under one leadership and start planning and building a new American Wing, before our patrons and donors fled to other museums.

The essential problem with the Wing and the American Paintings Department was that too many curators detested each other. No one person could take charge and withstand the feuds that would ensue.

The senior member of the American Paintings Department was Associate Curator Albert Ten Eyck Gardner, an aristocratic paintings scholar and connoisseur who was also an alcoholic. To make things more complicated, Al's wife, Elizabeth, from whom he had split, was an associate in the European Paintings Department. Rorimer had steadfastly refused to promote Gardner perhaps because of his drinking problem. I interviewed Gardner, who was incoherent most of the time, and he revealed his principal interest in life was to argue with his assistant, Stuart Feld. Feld was a bantam cock of a young man with a shock of jet-black hair and an insatiable drive. He was a stiff-backed, strutting fellow with a biting wit and an explosive ego. His mother ran a successful art gallery. Of course, Stuart Feld could not stand Al Gardner.

James Biddle, the curator of the American Wing, had been men-

tioned in some of the gossip columns as a candidate for the director-ship, but I thought he was a loser. He was tall, balding, somewhat ripe, but good-looking, a few years older than me, with eyes set close together and a fey demeanor. He was the scion of the famous Biddle family from Philadelphia and prided himself on his great estate, Andalusia. He was gifted at raising money and charming potential donors, but something of a dunce when it came to works of art. He was not my candidate to take charge of the twin departments, and it was my hope that since he had been spurned as director, he would leave. But he stayed.

He was constantly pushing for his dream of a new, expanded American department composed of the Wing and the American Paintings Department.

According to Biddle, direction and new galleries were desperately needed, especially for paintings and sculpture, most of which were hidden down in that old tunnel deep beneath the museum. As for staffing, two alternatives presented themselves, Biddle told me portentously. He was "prepared to take on the double post." Or, there could be two equal curators. He urged "a distinguished name from the *outside,* as a neutralizing force." Biddle suggested that the "infirm" Al Gardner be sent up and out by his being named research curator.

I asked Biddle what he would suggest for Stuart Feld. Make him an associate curator, he advised.

"He isn't going to be terribly pleased with being an associate curator. Thinks a lot of himself—probably justifiably. His record is dazzling. He claims to be doing the first volume of the paintings catalogue . . ."

" 'Claims' is about right," Biddle snapped.

"He also claims he did all of the organization of the big painting show back in sixty-five. And he says it was his idea to have the nineteenth-century American show become the centerpiece of the Centennial . . ."

"That was just as much *my* idea and Berry Tracy's!"

"Stuart also told me that had it not been for his ongoing personal insistence that art is more important than red tape, certain fine acquisitions would never have come to the museum," I said, amused at Biddle's growing anger. "Stuart argues that without what he calls his 'evangelical spirit' the loyal donors we have now would have never come to the museum."

"Now let me tell you about the other side of Mr. Stuart Feld,"

Biddle said, "*All* these things have been a cooperative venture. Stuart has virtually savaged Al Gardner. He stabs everyone in the back. I know he wants to be the chairman of the new wing. He told me so . . ."

"I must say he's *not* one of your fans," I interjected. "He told me that he would find it difficult to work under you."

Biddle's eyes seemed to move closer together. His fists were clasped.

"Stuart Feld wants to have total authority and complete responsibility for the entire American picture collection," he said. "He feels that only *he* should judge. Not you. Not me. Not Al. Not Henry. Not even the trustees! We have all talked to him, but he stamps his feet and says 'No.' You know what he says to us? 'I haven't time. I don't care about a title. I want *authority!*' " Biddle leaned forward and whispered, "Tom, Stuart is a pushy, conspiratorial little . . . little . . . Do nothing more than make him an associate. On trial. Be sure to say 'On trial.' " He sighed. "You do realize it'll never work out. Stuart will keep on demanding more and more authority year after year."

One by one I called in the staff of the two American departments and learned that Biddle had been subdued when it came to describing how Stuart Feld worked with his colleagues.

In mid-June, Feld came to see me. He entered the office, his head cocked, all smiles.

He wanted to know who was going to be in charge of the new American department. "Frankly, I think I have all the qualifications. I am truly the only candidate, and if I do not get, very soon, an indication of who will have the job, I shall have to assess my future at the museum."

I told him to come back in two days. When he returned, I told him he was never going to be my pick for the curatorship of the whole new department, that I was not inclined to promote him to full curatorship for another year during which time I would evaluate his cooperative efforts. Feld, white with anger, said what I expected.

"What you are telling me is that I am to be on trial. I am a young man with a highly developed sense of integrity. Frankly, Tom, in light of my record over the past five years, I do not care to be put on trial any longer. I am inclined to leave the museum."

I slid a piece of paper across my round desk towards him.

"What's *this?*"

"Stuart, it's a green termination blank."

"You mean . . ."

I told him to sign it and leave the museum. He was bright, aggressive, and brilliant, but that wasn't enough to lead a department. He was too selfish, too apt to put down his colleagues. He'd terrorize his coworkers, I told him. I advised him to become an art dealer—he'd be an instant success and, someday, a millionaire. He refused to sign and stalked out of the office. He wrote me a three-page letter outlining his accomplishments and informed me that he was leaving. I had the assistant treasurer send him another green termination blank. This one he signed.

Feld went on to become a highly accomplished and wealthy art dealer, eventually gaining control of the house of Hirschl & Adler. The museum had the pleasure of purchasing several superior pictures from him. Several days before Feld left the Met, Al Gardner was found dead in his apartment. And Jim Biddle began to hint that he was looking for a post outside the museum. The slate was clean and I preferred it that way. I had decided that young Jock Howat had to be the choice to take over the American Paintings and Sculpture Department. And finding Biddle's replacement at the Wing was no problem either; I chose Berry Tracy, one of the most capable curators on the museum staff.

My old home base, the Medieval Department and The Cloisters, if not as messy as the American sections, desperately needed a new face. The Medieval Department was being run by William Forsyth, a pale-faced bundle of nerves who shrank away from contact with most human beings. Wags said he preferred the company of virgins —as long as they were French, made of stone, and were two or three hundred years old. Genteel, gentle, unambitious to a fault, Forsyth buried himself in the back office of the department and worked diligently on the galleys of his monumental study of French tomb sculpture, which he had been preparing for fifteen years.

Both of Forsyth's seconds-in-command were women, each tough and uncompromising. One worshipped him. The other never let a day go by without disparaging him. His fan was Vera Ostoia, a Russian woman in her early sixties, grim-faced, but also mischievous, tense but with a surprising smile, hair in a black bun, who was one of the most cultured and literate individuals in the museum. Vera carried out the most drudging research with pride. But if asked for an opinion on a work of art, she avoided saying a substantial word.

Vera looked upon her colleague, Carmen Gomez-Moreno, with contempt.

Carmen was one of James Rorimer's more distinguished staff blunders. She was the youngest daughter of Spain's most illustrious art historian, Don Manuel Gomez-Moreno, who had embarked on a twelve-volume history of Spanish art in his late eighties and finished it just before he died. Rorimer had hired Carmen to ease the acquisition of the Fuentiduena chapel. He had in mind that she should remain in New York for two or three years but somehow never managed to persuade her to leave. Carmen was an olive-skinned, handsome, dedicatedly opinionated woman who had a curiously powerful sexual appeal. I'm sure Carmen expected me to promote her to head of the Medieval Department when I returned as director, but nothing was further from my mind. What I really wanted to do was recruit the most qualified medievalist in the world to head both The Cloisters and the Medieval Department. This was a gifted scholar and prolific writer, Hermann Fillitz, an Austrian in his late thirties who was then associate curator of medieval and early Renaissance decorative art at Vienna's Kunsthistorisches Museum.

To woo Fillitz, I enlisted the aid of two aristocrats of the international art scene, Werner and Peggy Abegg. Werner, a dryly amusing Swiss patrician, was one of the richest men in the world. A connoisseur with a probing eye, Werner had met Peggy when she was working in the Metropolitan's Print Department and had swept her off her feet. Peggy, who looked like a Gibson girl, had coaxed her shy husband into the limelight. The couple spent most of their time travelling from one of their great estates or apartments or from one luxury hotel to another. They had the best seats at Bayreuth and Salzburg. They knew every museum director in the world and had instant access to the newest acquisitions and the innermost sanctums of conservation studios.

The Abeggs promised to pay for Fillitz and his wife to fly to New York. All I had to do was to pay the couple's expenses. Together with the Abeggs, I prepared to impress my guests. We arranged a heady schedule of dinners, concerts, and soirees and invited the most dazzling people. We promised him all that we could imagine, from seats in the best box at the opera (the Abeggs would allow the Fillitz family full use of theirs any time they wanted) to tickets to New York Rangers hockey games. I offered him a forty-thousand-dollar salary, which was almost two times that of any curator in the

museum, an apartment, three months' vacation a year, and a hefty expense account. I was crushed when Fillitz turned me down. It was my first serious defeat. I suspect we had overwhelmed him with the high life. If *that* was American museum activity, he wanted no part of it. Eventually, we hired another brilliant medievalist, Florens Deuchler.

The high life was more for the curators of the European Paintings Department. They seemed always to be surrounded by the epitome of the international elite. Ted Rousseau was beyond chic. He travelled back and forth to Europe five or six times a year and was sought after for every cosmopolitan dinner party. He recruited associates who were reflections of himself—Beau Brummels who were charming, polite, handsome, who spoke several languages, and who could fit into the social worlds of New York, London, Paris, and Rome.

The curators of European Paintings considered themselves a cut above "book scholars" and university professors. Digging through archives, poring through books and articles was menial work, for other people. They were the most tradition-bound members of the curatorial staff. When I once suggested I'd like to change the French look of the old master galleries for something cleaner, more modern, there were cries of alarm. In no other department were rivalries and jealousies more pronounced. Egyptologists could be mean to each other; paintings curators were downright cruel.

I made perhaps my most significant blunder by forcing Ted Rousseau to take the new position of vice-director—curator-in-chief of the museum. "I know you want nothing more in life than to remain as curator of paintings," I told him. "But I need you. I don't have 'my man.' Houghton has Noble. Point is, I want you to be my right hand, my top curator, the shaper of all the collections—the filter through which *all* acquisitions will pass, no matter what."

Seeing him struggling with the idea, I should have stopped right there and let it go. If I had, the matter might never have come up again. But, foolishly, I kept pushing, giving him no chance to extricate himself from the situation.

"I'd be honored," Rousseau said. "I'm not all that sure I'm qualified . . . but I do know something about works of art."

In an instant his idyllic existence came to an end and with it, too, his effectiveness, though I would not understand that for some years.

In pressuring Rousseau, I turned away from reality and, in so

doing, I failed as an executive. In elevating him to a position of leadership beyond his skills and in agreeing all too rapidly to his choice of a successor, I set off a disastrous chain of events, a series of bitter confrontations that would lead to one of the most severe chronic problems in my entire tenure—my inability to find a professional curator of European Paintings, except for my last appointment to the post.

6

HIGH SOCIETY AND THE REVERED PATRONS

My social life exploded. The grandiose duplex apartment that Arthur Houghton had purchased for the director was quietly sold. My wife had asked one evening, "Is *that* the way we want to live? Won't it become a gilded prison?" I informed a disappointed Houghton that my wife and I would be remaining in our modest apartment where lavish entertaining was not possible. But that did not stem the tide of invitations for every conceivable luncheon, dinner, gala, gallery or museum opening, for the opera, the ballet, long weekends, and even for Mediterranean cruises with trustees.

I was well prepared for high-society life. For I had been, in a sense, a member of society all my life. My mother, Mary Osgood Field Hoving, nicknamed "Peter," was a descendant of an illustrious old New York clan.

"Hoving" is a Dutch name, but most of my father's family lived in Sweden. My father was one of three children of Dr. Johannes and Helga Hoving. Johannes was an able physician—King Gustav of

Sweden was a patient—who was obsessed with his lineage. He commissioned a multivolume genealogy in which the author claimed as our descendants Rurik, the semilegendary ninth-century "czar" of Russia (who had tortured and then slaughtered hundreds of thousands of his subjects who didn't want to convert to Christianity), and King Harold II, defeated by William the Conqueror in 1066. My father, not entirely in jest, would lament the fact that, but for a nasty ruse on the part of William the Conqueror, we might have sat on the British throne.

After Brown University my father entered the first executive training course at Macy's and found he was a natural genius in retailing. The Strauses, the family that owned the great department store, befriended him. The head of the firm, Jack, looked upon him almost as a surrogate son and introduced him to New York society. There he met Mary Osgood Field. The love affair between Walter Hoving and Mary ("Peter") Osgood Field lit up New York and Long Island. The attractive pair became the party couple of the twenties.

They moved to America's fanciest suburb, Lake Forest, Illinois. My father had been recruited by Seward Avery, the bull-headed president of Montgomery Ward, then the nation's largest mail-order company. The palatial house they rented came with eight bedrooms and four servants, including a butler. A sweeping drive curved from an imposing entrance flanked by two marble pedestals. A sea of evergreens encompassed the property. The rolling lawns of the house were studded with grand oaks and maples. There was a large pool and a tennis court. Across the street was the fashionable Bell School and not too far away was the famed Deerpath Inn. My father joined the country club and golf club. He took up riding and purchased a horse, a sixteen-hand-high jumper.

Life was relentlessly gay and slightly dissolute. The sugar-rich Jelkes lived next door. The "Royal Russian" Prince and Princess Cantecuzenes came for dinner. The upper crust of Chicago society house-partied for long weekends. Prohibition only made the booze flow faster. Wife-swapping was the game of choice, as popular as charades or getting tipsy. My mother's favorite lover was a socialite of movie-star looks; my father played the field. Walter seemed never to be slowed down or impaired by the liquor; my mother became alcoholic and a drug abuser. The inevitable cruel divorce came in five years.

Though it was the heart of the Depression, no one in our family

suffered all that severely. My mother, my older sister Petie, and I moved into a spacious eleventh-floor apartment at 933 Park Avenue on 84th Street, and I entered the fashionable Buckley School.

Overnight, my way of life changed. My nanny soon departed and a stepmother, Pauline van der Voort Steese Dresser Rogers Hoving, seemed in my mind to take her place. I developed an instant hatred for my father's new wife. A handsome—definitely not pretty—dark-haired woman, she married for the first time at the age of seventeen to Charles Steese. He was followed by Carl Dresser, an Oklahoma wildcatter from the Pennsylvania family that supplied most of the oil pipeline couplings in the world. She had hired an interior decorator —a first for Tulsa—and dazzled her social set with the lavish style of her mansion. Soon everyone else had to have a decorator, too. Although she never admitted it, the best decorating ideas were hers. She had a passion and a genius for selecting that perfect harmony of fabric and furniture and cluster of objets d'art strewn invitingly on small tables. She pored over books devoted to fine things, committing everything to memory.

Pauline's "salon" was the center of Tulsa's world of social activities, and she counted amongst her friends every big name in society. She had a penchant for befriending younger men. One such, an impetuous and vulgar wildcatter, was Charles B. Wrightsman.

Within months of Dresser's death, she had snared one of the nation's wealthiest men, "Colonel" Henry Rogers. He was an heir of one of John D. Rockefeller's partners in the original Standard Oil trust. Rogers' income ran to the tens of millions in the days of no income taxes. The wedding ceremony was historic, the life-style of the couple profligate. Pauline knew how to please and, for the few years Rogers would live, she brought him great pleasure. They indulged in every high-priced adventure mandatory for millionaires in those days: trips to London and Paris, a yacht in the Caribbean. But Rogers spread tens of millions around in Long Island on an estate called The Port of Missing Men near Southampton, a piece of property three thousand five hundred acres in size. Off the beach on the estate was a fifty-five-room "cottage." The Port was one of the most splendid—and vulgar—pleasure domes on all of Long Island.

After the death of Colonel Rogers, Pauline ran the Port as long as she felt she could afford it; the income from part of Rogers' fortune was also hers until she died.

I spent a number of summers growing up at The Port of Missing Men, and that was where Pauline and two governesses taught me how to live "in society." The discipline was severe. If either my sister or I didn't bow or curtsy correctly—looking Pauline directly in the eye when we shook her hand—or if we messed up a thank-you note or showed up with unshined shoes, we were sent straight to bed with no supper. The regimen continued in New York, too. My father and stepmother lived in a palatial apartment at the exclusive River House on 52nd Street and the East River. It was there at least once a week that my sister and I would have to show Pauline that we were learning our social lessons.

On entering her apartment, I'd be inspected—my clothes, shoes, fingernails, and hair. At dinner my sister and I were expected to demonstrate that we could properly use the right silverware and glasses. We had to practice sweeping the doily deftly from underneath the finger bowl while lifting it aside just so. We had to practice small talk—which was, Pauline said, a vital asset—a formula no less rigid than an Oriental tea ceremony. Equally important was how to flatter. But more important than small talk or flattering was *listening*. "Listening," Pauline would declare, "is *the* way to be most socially acceptable." Pauline taught us how to keep careful track of how long a dinner table conversation was so that we would know precisely when to turn to the person on the other side to equalize the evening's banter between right and left partners.

Once I'd arrived at the social pinnacle of the Metropolitan Museum, Pauline was *very* proud of me and would smile and chuckle when I described my calendar for the next month. She never failed to say, "Remember, now, flatter and *listen!* and then the museum will be flooded with treasures." She may have been right, especially about listening. When you listen, you can coast and recharge your batteries. If you listen, everyone calls you "wise" or "a statesman" and you can actually go home after a three-hour-long dinner party feeling rested.

The social activities were divided into two categories: fun affairs with the museum family and working sessions with outsiders whose collections I was pursuing.

I soon learned that the museum's board was divided into social cliques and power structures and that, following Pauline's advice, I'd have to be careful to spend equal time with the members of each group so as not to offend. The most powerful group was, as ex-

pected, Arthur Houghton's gang: Ros Gilpatric and Manning Brown. Almost as powerful was the old J. P. Morgan crowd, in power since the early 1900s, which included Harry Morgan, Robert Pennoyer, and Minnie Fosburgh, one of the famous Cushings, whose sisters were Babe Paley and Betsy Whitney. Minnie's social status on the board was complicated by the fact that she had been married to Vincent Astor, as, of course, had Brooke Astor. Roland Redmond had a clique, too, though its power was fading. In it were a grande dame by the name of Mary Whitehouse, Malcolm Aldrich, and the lawyer Francis T. P. Plimpton. The most secret clique belonged to Nelson Rockefeller, who, although he was not an active board member since he had entered government, still possessed enormous clout. Rockefeller's cronies were Dick Dilworth, Douglas Dillon, and Brooke Astor. Then there were the independents—Walter Baker, Judge Untermyer, Bobbie Lehman, and Charles Wrightsman, whom few on the board could stand but who was tolerated because of the superb character of his art holdings.

It was mandatory to attend every one of Brooke Astor's black-tie dinners—an average of one a month during the season. At Brooke's I had to utilize every one of Pauline's lessons.

To be invited to one of Brooke's dinners was a sign of entry into the highest level of social recognition in New York. She prided herself on an incandescent mixture of guests. Everyone was expected to be intellectual, but not overly; anecdotal, but not too much so. It was good to be droll. The dinner never ended without a series of witty and flattering toasts on behalf of the hostess and the evening's distinguished guest. Brooke never engaged in outright fund-raisers for the museum, yet in subtle ways she would pitch the benefits of being associated with the institution. She had a favorite line—one I used continually myself—"There's something profoundly satisfying in giving money to a great institution, because you can be certain good money isn't going down the drain." Every wealthy head would nod in agreement. Not only did Brooke give the museum tens of millions of Astor Foundation money, but she must have triggered gifts twice that amount.

I lunched or dined at Arthur Houghton's once every two months, and although his wife Betty was bright and beautiful and gay, these social events, at least for me, were dreadfully hard work. I appreciated Houghton's brilliance, but he still made me nervous. He was conspiratorial, manipulative, and mercurial. He fretted about the

details and problems of the museum's Centennial celebrations. "If my tenure's going to have one triumph," he'd tell me over and over, "it'll be this celebration. Do you think the staff is going to take it seriously enough?"

I'd reassure him that the curators loved the idea of a year-and-a-half-long Centennial. He never seemed quite convinced. Nor was I. When any plan changed or when one of his dreams had to be shelved —inevitable events—Houghton would brood for days and would complain about the welter of little failures that would surely upset his grand scheme.

Houghton once called me at dawn to say that he would understand why I might resign after I read the morning *New York Times*. The story concerned several of his educational foundations that had laundered money for the CIA. I told him I didn't care what he did as long as the museum was not involved.

Among the Houghton allies, I got along best with Ros Gilpatric. He once confided to me that Arthur was one of the most peculiar men he had ever met, willing to work like hell on something and then drop it overnight and barely mention it again. Houghton abruptly divorced Betty, his wife of many decades, to marry a younger woman, a marine biologist he had met walking on the beach in Boca Raton. She was tending a wounded dolphin, and he had fallen in love on the spot. He marched into his Sutton Place mansion and told Betty curtly, "I want a divorce. I want you to leave." And she did, the same evening.

Of course, there were those moments that were genuinely fun. Such as dinner at Minnie Fosburgh's or soirees at Jack and Drue Heinz's, who also owned a gracious home outside of London where we stayed a few times.

Jack was a scion of the Heinz 57 fortune.

Drue was a peppy, intellectual Irish woman with a talent for poetry and people. Her passion was literature. She was a financial backer of the literary magazine *Antaeus* and an active member of the editorial board. Drue was fascinated with the Met not because of who the board members were—though most of them were acquaintances— but as an institution. Sometimes I'd have the honor of sitting on her right. I'd let all Pauline's rules lapse and chatter on about my dream of the great crusade at the museum. Drue would ask sharp questions about some of my wilder ideas and instantly deflate the pompous ones. Jack Heinz was a great host, a virtual magnet. The Heinzes

lived in a Tudor-style apartment house across from River House and would throw energetic dinner parties, with more people arriving afterwards for coffee and drinks. It was at the Heinz establishment that I met a painfully dissolute Princess Margaret, a trim Mick Jagger dressed like an investment banker, and a pale and pockmarked William Buckley, Jr., who sat me down to chat about the museum. I laughed when he used the word *'jejune.'* Buckley never spoke to me again. I was so impressed with Drue that I approached Arthur Houghton about having her become a board member. He told me, "Sorry, too late, we've already made arrangements for all our female board members." I should have fought for her.

By far the most heavy-duty social types in the museum were Charles and Jayne Wrightsman. I started off attending their fashionable events because it was strictly museum duty—to guarantee that his excellent collection of French furniture, decorative arts, and old masters remained in his will for the Met. Then I got hooked on the glamour and luxury. Dinner meant the best of everything. Visiting the estate in Palm Beach meant butlers and maids to unpack and pack your clothes and instantly serve you whatever you wanted. The swimming pool, heated to ninety degrees, was available at all hours of the day and night.

The Wrightsman apartment at 820 Fifth Avenue was one of the most gracious in the United States, decorated by the distinguished Paris firm of Jansen. Virtually everything in it was museum quality, from the Aubusson carpets to paintings by Vermeer, El Greco, Boucher, and Pissarro. The library was a treasure house of Meissen and Sèvres, including a dramatic series of Kaendler birds. French eighteenth-century *boiserie* formed the walls of the dining room.

The conversation was part scripted, part free. It would start out "veddy veddy" effete—with heavy doses of elegant and happy small talk. Or art, art, art. As the evening progressed, the poses began to melt. Conversation could even become scintillating, once or twice raucous. A radical pronouncement by the host frequently would cause gasps and "Oh, Charlie!" He loved to hold forth on the intrinsic benefits of the Soviet system over democracy when it came to discipline—law-and-order-keeping-streets-clean—or the necessity to "rein in the damned, leftist American press." When politics came up, the discussions got fevered—to my distinct pleasure. It was the kind of household where men and women were separated for after-dinner liqueurs and brandy, but always the affected tones

of voice would return and the nice standard chitty-chatty would end the evening.

Wrightsman was the most immaculate man I ever met. His silver hair was perfectly coiffed, his voice was gentle and cultured, his smile was gracious, studied, and he moved with a languorous grace as if participating in a minuet. His only truly real characteristic was an infectious, short bark of a laugh. Jayne was a fabulous contrivance—fashionably on the edge of too-thin, tall, her posture balletic. She preferred her hairstyle in a "Jackie" bouffant. Her voice was "Jackie" too—whispery, intimate, sweet. The only part of her that seemed genuine was her teeth, pleasingly flawed by tiny overlaps. Jayne also seemed to dance through life, slightly on tiptoes, ballooning and gushing around her guests, her head held slightly to one side, a well-planned stylization, an American geisha.

I knew a lot about the Wrightsmans, although I never let them in on what I knew. Pauline had told me all the stories, sometimes cackling over the tales. According to her, Charlie was a fast-driving, womanizing, polo-playing (he cheated at polo, she claimed), drunken, foul-mouthed roughneck. She claimed he had made his fortune in the late 1930s—some fifty million—by defrauding the other shareholders in an oil company—Humble Oil—he partially controlled. She said he had manipulated the common and preferred stocks of the company so the shareholders thought they were receiving voting common shares but actually wound up with a load of nonvoting preferred shares. There were a number of suits, and one group of angry shareholders pushed the alleged injustice all the way to a congressional subcommittee. "Guess what?" Pauline would say, her eyes glittering, "The week before the committee was scheduled to meet, the statute of limitations ran out on Charlie's deal."

When he got rich, Charlie dumped his first wife, the mother of two glamorous daughters. He started romancing Jayne, who was a salesgirl in one of Los Angeles' best retail stores. Eventually, Charlie married Jayne, and the couple bought a grand mansion in Palm Beach. One of the first couples the Wrightsmans invited were my father and stepmother, who had visited the lovely house on a number of occasions. Charlie was eager to get advice on what to change in the house.

Pauline told me with relish how she entered the grand salon of the house her first morning and glimpsed Charlie perched on a stepladder scraping away with a trowel at the edges of the gorgeous French

eighteenth-century chinoiserie wallpaper. She shouted "Stop!" and told him what he was about to destroy. Charlie admitted sheepishly he was about to have the precious wallpaper removed. It looked worn out. He left it as it was.

The next day Charlie took my stepmother into the dining room where a dozen place settings and silver patterns were laid out in rows on the table. "Pauline, Jayne doesn't know anything about this kind of stuff; *you* pick out what we ought to have." My stepmother told him that even if his wife picked the most horrid design imaginable, that's what he would have to live with. As it turned out, Jayne picked out the most tasteful patterns wholly on her own.

Pauline's most amusing tale was how the Wrightsmans had gotten into art. They were avid golfers. Charlie could hardly break a hundred, but Jayne was gifted. My father and Pauline were playing a foursome with the Wrightsmans when Charlie hit his ball into the water. Jayne was already on the green. Charlie blew up and shouted at his wife, "Never play golf again! Do something else. Take up . . . art."

And Jayne did. Soon after, she obtained her first art history book and started teaching herself. The Wrightsmans began to collect, starting haltingly. Then, aided by experts, they acquired some breathtaking pieces. Although Charlie never actually left the oil business, he began to devote more and more of his time to art. Within a decade after he had started collecting, he claimed to the IRS that his real vocation was art collecting. He began to write off every conceivable expense to his new business. No one, even in the Met, knew about this practice until years later, somewhat to his embarrassment, when the IRS refused his claim of business expenses for art and challenged a long list of expenses—yachts to Greece and Turkey, trips to Europe to visit museums, dinners for art historians, even flowers in the guest rooms at Palm Beach when I or another museum director would stay. The court case, reported in detail by the *Wall Street Journal,* recorded a host of the niggling expenses. In time the IRS struck down the majority of his attempted deductions.

Much as I enjoyed Charlie and Jayne, it was a job. To make the work easier, I had metamorphosed them into something they weren't —amusing, clever people with an unquenchable passion for the fine arts. In reality Charlie and Jayne Wrightsman were cardboard-thin, moving through life by rote. Both had a fierce grasp of the *facts* surrounding a painting or a piece of furniture or an object, but they

had little comprehension of the spiritual sense of art. Everything they knew seemed to have been committed to memory.

One trustee and potential patron I enjoyed socializing with despite the sometimes exhausting circumstances was Joan Payson, the lively owner of the Mets, and a Whitney. She owned a formidable collection of French nineteenth-century pictures, ranging from one of Camille Corot's best—a poetic view of the Tiburine island in Rome—to an electric Douanier Rousseau and some stalwart Renoirs and Manets. Joan, a heavy-set, striking woman with an infectious laugh and magnetic charm, possessed a steely mind. In meetings of the Acquisitions Committee, her questions were the most trenchant. No one else could penetrate so well the confusing art jargon and arrive at the nub of an issue. In the middle of a curator's presentation Joan would exclaim, "Why is it good, anyway?" Or, "Isn't this ridiculously expensive?" Or, "Don't we have something *much* better?"

Joan adored Ted Rousseau and favored dinners with him and me at El Morocco, the then chic nightclub, where we would hang around until after midnight sipping champagne, dancing, and, oddly enough, talking serious museum matters. While the band played on, Joan would probe and probe. "Why is education so damned important? Shouldn't people *know* before they come?" "Why do we have to care about minorities—I mean, of course, we *care,* but at an art museum?" Or, "Is it really necessary to collect another thing?" In the hubbub of El Morocco, slightly tipsy, I'd find myself with my lips near Joan Payson's ear, explaining, defending, instructing. In time she became one of my strongest supporters and an extravagantly generous patron.

Pauline's rules not only prepared me for high society, they also helped make most potential patrons shower the museum with largesse—but not all of them.

One day I received word that ex-governor Averell Harriman wanted to talk about giving the museum his collection—I knew he had a superior early Picasso, *The Woman in White*—as well as his townhouse across from the museum on 81st Street just off Fifth Avenue. The next morning I was ushered into a smallish living room where the elderly patrician sat in a chair, bundled up against the cold like some character out of a Dickens novel. His wife, Pamela, was at his side. In his eighties, Harriman was an elegant and surprisingly dashing man, his cracked voice the sole betrayal of advancing age. He wanted the Met to have his paintings and his elegant townhouse,

too, with but one proviso—that both collection and house be reserved *only* for the use of the trustees and certain highly selective members of the staff. No public. The paintings could not be sent across the street for viewing even on a temporary basis. I told him I couldn't recommend his elitist proposal since it wasn't in the best interests of the museum. He reddened but said nothing. Subsequently, the paintings were given to the National Gallery and the townhouse sold.

Serious art collectors fall into three basic categories: those who get professional help, those who buy every piece themselves, and those who amass collections formed by other connoisseurs. In the museum profession, the third category tends to be looked down upon. It may make a good deal of sense to conglomerate art, but there's the danger of being tabbed as greedy or even vulgar. No potential patron I ever socialized with was more criticized for conglomeration than Dr. Arthur Sackler, multimillionaire, curmudgeon, and genius.

I had heard lots of stories about how Arthur Sackler made his money, but I could never get him to verify the tales. One story had it that when he and his two brothers—also medical doctors, both, like Arthur, married to doctors—were about to graduate from Columbia's Physicians and Surgeons College, they held a conference about what they wanted to do next. Private practice didn't much appeal, and one of the Sackler brothers suggested they invent something or make something better. They pounced upon Argyrol, a disinfectant created by the art collector Alfred Barnes, which was in general use in the twenties and thirties. They succeeded in removing the toxic properties in the solution and patented it as Betadyne, which became the surgical scrub used in virtually every modern operating room worldwide. The Sacklers made millions.

Arthur started collecting art as soon as he'd made his first one hundred thousand. He retired in his fifties, an exceptionally wealthy man. In a month he was bored. In the middle of the night he awoke with the revelation that there was no medical newspaper in the United States. He started one and became even wealthier. With part of his wealth he collected Oriental art, although he had some respectable old masters, a classical bronze from Turkey, and a few Impressionists. In less than ten years, with advice from the top specialists in Chinese and Japanese art, Sackler had accumulated a huge collection. His bronzes were equal to or better than those in most museum

collections. His lacquers were the best in private hands. His paintings were rumored to be finer than many in the Freer Gallery in Washington. Sackler had bought whole collections seemingly with one glance. It was said that he could enter a shop bursting with objects and within minutes buy everything except for the weaklings. After the deal had been struck—or after the dealer *thought* so— Sackler would invariably start bargaining. To those who respected him, he was shrewd. To those who detested him and his practices, he was slippery. And slippery was how he was regarded at the Met, particularly by Joseph Noble, who relished telling me about what he described as "the biggest giveaway scandal in the history of the museum."

The "scandal" had begun in the lean days of the early sixties, when Jim Rorimer had found it daunting to raise funds for the much-needed rehabilitation and air-conditioning of the galleries. Sackler approached Rorimer with a novel fund-raising plan. He would give the one hundred and fifty thousand dollars for the total renovation of a majestic hall on the second floor north of the Great Hall, to be named the Sackler Gallery. It would display the museum's finest monumental Chinese sculptures and a grand early wall painting.

In exchange, Sackler demanded what Noble termed some "nasty" paybacks. Sackler would buy the works in question—all masterpieces—at the prices the Met had acquired them back in the twenties, only to give them back to the museum under his name to be designated "Gifts of Arthur Sackler." The doctor would take a tax deduction based upon the current, real, values. But that wasn't the only demand. He asked for a large storeroom inside the museum to house his private collections, an enclave—rent-free—to which only he and his personal curator would have access. Sackler had figured that he would actually make money on the tax loophole he had discovered—his deduction would be far more than the costs of the works and his donation. It was all legal, but "shifty," as Noble described it.

Desperately needing the money, Rorimer agreed. As Noble told me, "he must have already been ill." Sackler then "insinuated himself into Jim's life," Noble added. Noble urged Jim to "throw him out as soon as you can."

Had Sackler ever told Rorimer, or anyone, that he planned to give the contents of the storerooms to the museum, I asked? Noble scoffed. I asked Ted Rousseau, but he had no idea either. "That was

Jim's territory. I stayed clear,'' he said. I invited Sackler in for a little chat.

Within a few minutes after he sat down at the round table and after carrying out Pauline's regimen, I could tell he liked me and knew also that I could work with him. He was touchy, eccentric, arbitrary —and vulnerable, which made the game much more fascinating. Sackler's accent was cultivated, clearly manufactured. He seemed to parade his voice as a clear sign of his achievements, but his tone wasn't phony or affected. He was proud of the way he talked. I liked that.

His first words were, ''I used to spend some marvelous hours here with Jim. He'd put his army boots up on the desk, and we'd talk for hours of pure scholarship and connoisseurship. Like two ancient Chinese gentlemen-scholars. I sometimes think I was the only true friend Jim had. You know, it was *his* idea to renovate the gallery in the way we did. He suggested the enclave. He wanted my collections to stay inside the museum, making it harder for me to go elsewhere with them.''

Casually, in his soft, cultured voice, pronouncing all the Chinese names very distinctly, he described for me the nature of his holdings. They were even more extensive than I had been told. Sackler told me that he wanted ''to cement good relations'' with me and had decided to establish an acquisitions fund of one hundred and fifty thousand dollars, which I could use freely. He also planned to donate the funds needed to design and construct a special exhibitions gallery adjacent to the great gallery that bore his name to be named after his wife, Marietta. I was speechless, for in an hour I had raised more from Sackler than poor Jim Rorimer had raised in years. And with no strings. When I announced my good fortune to Joe Noble, he said sourly, ''Watch out!'' I was almost as jubilant at having bested Noble as I was in the windfall. I told Noble to stay in the office, while I ostentatiously phoned Arthur Houghton to tell him about how I had just landed the great Arthur Sackler.

The most important social events of my museum career were the lunches and dinners with Bobbie Lehman. Ted Rousseau and I would join him for dinner every two weeks or so either at ''21'' or at a charming French restaurant he favored with a private room and a fireplace that almost gave me heat prostration. Under my continual flattery, Bobbie opened up like an orchid, and then closed down. I was dismayed to see him becoming increasingly frail. What if he died

before I could snag him? In that event his foundation trustees would call the shots. The thought chilled me since the Lehman foundation included some pretty unsympathetic people.

When his mind was clear, Bobbie would grill me about museum matters, especially the trustees, asking what they really thought of him. To Lehman, the trustees were an anti-Semitic club. I had to defend the "good guys" like Houghton, Danny Davison, Gilpatric, and Dillon against the charge. Slowly, I allayed his fears, and Lehman began to talk about how open-minded Houghton was and how gratifying it was to have him after Roland Redmond. It was getting close to the time I had to land him or lose him. To my growing consternation, nothing I said at our soirees seemed to goad him to say "the collections are yours."

7

THE
BIG
STUFF

Bobbie Lehman called one morning at the beginning of my second year. "What do you think of the work of Andrew Wyeth?"

To anyone else I would have replied breezily that I admired a few of Wyeth's early works—*Christina's World* or the knife-edged portraits of that Pennsylvania farmer and his wife—but hated the beached boats in Maine and all those barns. But I mumbled something.

Lehman was going to the Wyeth exhibition at the Whitney. "Care to join me? I've been thinking for some time of . . . possibly . . . buying one of his drawings. I think he's a fine draftsman, though maybe a little tight. But I'm not certain. Then, these days, I have a hard time making up my mind."

When we met in the Whitney's main hall, I suggested we play the curators' game. We would go through the exhibition separately and each choose our five favorite pieces—"The ones we'd steal." He seemed to enjoy the idea. I watched him set off through the maze of

galleries, suddenly anxious that I might not find five works I could get excited about. I did though. Our choices were all but identical, and number one was the same, a huge brooding pen-and-ink drawing of some dead crows nailed to the side of a barn—a powerful and compelling piece. Sadly, it was not for sale, but Lehman told me he had made up his mind to purchase a Wyeth drawing. I said I'd call Knoedler Gallery to ask if there were any great drawings available.

When I brought it up again, a few weeks later, he said he still wanted to think about it. Lehman never did buy a Wyeth drawing, but Ted Rousseau's spirits were lifted and he told me he thought I'd made an important breakthrough. "He trusts you."

For years Lehman had admired two late Renaissance paintings— gems really, the size of playing cards—by the Venetian master Giacometto da Veneziano. They were owned by the old master gallery Wildenstein & Company. One tiny panel represented the nobleman Alvise Contarini, his proud, hawklike profile set against a lyrical Venetian seascape. On the other side was Contarini's coat of arms. The other panel depicted an unidentified, beautiful young woman in a revealing costume. Actually, she was a nun! The panels fit cleverly into a small box that Contarini had kept with him at all times. The portraits were hidden and set so that only if one knew how to slide the portrait of Contarini along the grooves would the secret panel with the mistress's picture be revealed. Probably, only Alvise knew how to make the device work. I imagined Contarini fingering his secret box or surreptitiously sliding the panel out at some family gathering just for a peek at his beloved.

Rousseau told me that Lehman had coveted the paintings for years but had been put off by the "outrageous" price—seven hundred and fifty thousand dollars. Rousseau urged me to see the panels and to persuade Daniel Wildenstein to lower the price "just for Bobbie." If I did, Lehman might be so impressed he'd buy the panels "and come to a decision."

I went immediately to the Wildenstein Gallery, in a townhouse on Madison and 64th Street, and asked the president, Louis Goldenberg, to show me the Giacomettos. I was struck by their delicacy and their unblemished condition. Then we went to Goldenberg's favorite restaurant, and I told him I wanted Wildenstein's help. "Jesus, I know Lehman's so close." I was begging. "I swear that the entire collection coming to the Met rests on you—and Daniel. I swear I'll make it up to you over the years."

Goldenberg groaned. "Daniel loves these paintings. He has no

desire to sell them. From three-quarters of a million down to a half million? That's quite a drop. But I'll talk to him. Tom, I'm not hopeful. Since we're together, let me bring up a more fruitful subject, Colonel Michael Paul. He's an eccentric old duck, but he's passionate about collecting and wants nothing more in the world than the Met to become the greatest treasure house of sculpture in the West.''

Rousseau had warned me about Michael Paul. Paul claimed that in his youth he'd been a Czarist soldier of exceptionally high rank. After the revolution Paul had escaped to Europe and had finally arrived in America and had married one of the great ladies of society, Josephine Ulrick Bay, a woman of prodigious wealth. When she died, Paul received a modest income and the bulk of the estate ended up in several foundations of which he was to serve as president. Paul had an apartment in Manhattan, a house in Palm Beach, and a spectacular villa, La Leopolda, on the Riviera, and he delighted in throwing grandiose parties.

Paul soon guided the funds into collecting French and Italian sculptures of the seventeenth and eighteenth centuries. Curiously, the only sculptures he admired were owned by Wildenstein & Company. Paul had already given to the Met three marbles—a vase by Jean-Baptiste Pigalle decorated with the attributes of Autumn, a bust of Samuel Bernard, a banker to Louis XIV, by Guillaume Coustou the Elder, and a sensuous *Andromeda Chained to the Rock* by the Frenchman Pierre-Etienne Monnot, which the Earl of Exeter had commissioned around 1700. I had seen the pieces in the Western European Arts storeroom and had not found them exciting.

What was so touchy about having a dedicated, if eccentric, donor lavish his attention and his money on the museum and donate works that we would never have bought? It was that the prices he had paid were far higher—ten times higher—than any comparable sculpture on sale any place on earth. They ranged from three hundred thousand to seven hundred thousand dollars. Why were the prices so high? Rousseau said that Wildenstein had virtually cornered the market. Besides, he suspected that the Colonel participated in a finder's fee from Wildenstein. I couldn't have cared less.

Goldenberg arranged a meeting with the Colonel, and he turned out to be trim and handsome in a pixieish way, dark with luxuriant white hair, loquacious, overpoweringly Continental with a trace of a Russian accent. The man had charm. Besides, he controlled all that money.

Then Goldenberg guided me to the converted firehouse on the

Upper East Side where the works were stored. The white-walled brick interior was stuffed with baroque, rococo, and nineteenth-century sculptures. I simply threw my arms out wide and told Goldenberg, "I'll take the lot." I figured the gesture would make Daniel Wildenstein sufficiently happy for him to lower the price of the Giacomettos.

A week after the visit, Goldenberg asked if he could stop by the museum, after hours. He informed me in hushed tones that Daniel had agreed to offer the Giacomettos to Bobbie for five hundred and twenty-five thousand.

I called Daniel in Paris and told him he'd made a historic move on behalf of the museum. I made arrangements to have dinner with Bobbie and asked Ted Rousseau and Danny Davison to join us. I waited until the end of the meal before confiding to Lehman that I had taken it upon myself to "beat up on Wildenstein" to force the dealer to get his price of the little pictures down "to reality." Bobbie leaned forward. To half a million and a quarter, I told him.

When he smiled, I charged ahead.

"Bobbie, have you made up your mind what you're going to do with the collection?" Danny Davison almost fell out of his chair.

"The Giacomettos will look good in the collection, won't they?" Lehman replied.

Two days later he told me he had purchased the "enchanting little paintings." I thought he said—but I wasn't positive and I didn't dare press him—"When the collection comes to the museum, the Giacomettos will have a prominent place . . . and if not, I assure you they will come anyway."

A few days later while at Lehman's office briefing him on the agenda of the Acquisitions Committee meeting which was scheduled a week hence, I asked him if there was anything I could do to make it easier for him to make up his mind about the collection. I was disheartened by his reply, "I'm not sure. I'll put my mind to it. I owe you that."

At the next Acquisitions Committee meeting in May, special money appropriations that had been made were enumerated. Colonel Michael Paul's donation of five hundred and fifty thousand dollars to buy the *Andromeda* by Monnot was mentioned. Joan Payson rasped, "Isn't that a hell of a lot to pay for *that* sort of thing? Why so much?" I turned to Ted Rousseau and he winked at her, "In the past five years, the prices of this kind of thing have soared."

"Why Wildenstein?" Payson asked. "Has Wildenstein cornered the world market on these things?"

"I suppose old Georges Wildenstein did," Rousseau said weakly. "But the point is that Michael Paul's foundations pay the bills."

"I still cannot help but think that something fishy's going on," Joan Payson said softly.

Houghton swiftly cut in to move ratification of two appropriations for Greek and Roman purchases made before my arrival, the last remaining objects in a hoard of Greek sixth century B.C. silver found in Turkey—$14,500 for a gold ring, a silver alabastron, and a silver beaker, and $25,500 for two marble sphinxes that had come from the tomb in Anatolia where the treasure had been unearthed. Curator Dietrich von Bothmer explained that the works constituted the final pieces of what he described as the "Lydian hoard."

Then it was my turn to take the floor and invite the curators to defend the works they yearned for. In alphabetical order. American Paintings and Sculpture through Western European Arts, the curators were expected to deliver their sales pitches with brio. Rorimer's advice had been to "speak from the heart" and avoid scholarly arguments. Facts were less persuasive than feelings. "Describe the piece quickly. Tell us about its condition, describe why it's vital to the collections, and conclude—quick!—with an explanation why the price is right." It was also smart to point out how much one had haggled with the vendor or to point out that a restricted fund existed for this piece and only this piece.

Most curators resented the fact that people who knew nothing about art could interrogate them and decide what their department should acquire. The relative ignorance of the trustees was a given. Only Lehman, Judge Untermyer, and Joan Payson were considered halfway qualified to pass judgment. That May evening Jimmie Biddle raced through the presentation of a soup tureen, a silver cup, and a Newport card table. Vaughn Crawford meandered over a description of a fragmentary and insignificant Iranian bronze bull's head of the seventh century B.C. Henry Fischer argued on behalf of a stela of a personage named Wenen-khu, worth eighteen hundred. Why bother? I thought.

Then rumpled Jack Phillips dragged himself to his feet and said, "Well, I have a real masterpiece for you—a sculpture by the neoclassic genius Antonio Canova representing *Perseus Holding the Head of the Gorgon*. It's in Germany. Mind you, this piece is nearly

eight feet tall. Mind you, it is *only* one hundred thousand dollars. And we have the proper export papers. The piece is great. And historic. It was made by Canova for Princess Tarnovska, who had so admired his Vatican *Perseus*. The dealer Piero Tozzi told me about it. He's been authorized by the direct heirs of the family to sell it—but only to a distinguished collector or institution. This piece couldn't be better—we've nothing like it, it's got a great history, it's fabulous, it's big!''

The trustees beamed. So did I. I had suddenly experienced a minor revelation. The hell with the dribs and drabs—the little Egyptian pieces, the fragments, the also-rans. From then on I'd acquire only the big, rare, fantastic pieces, the expensive ones, the ones that would cause a splash. With the incalculable number of treasures already in the museum, *why* bother with the footnotes? It would serve the Met more to collect nothing for years to save the money to obtain a single piece if it were one of the world's finest masterworks. The days of relatively inexpensive acquisitions would soon be over. We had to drive for the best now.

The presentations were followed by cocktails and a lavish dinner. After coffee the curators left and the trustees remained in session to vote, looking to me for guidance. Since liqueurs and brandy were served during the executive session, some trustees were slightly tipsy and spoke out about some of the pieces. Joan Payson crowed, "Do we really need some of these things?"

Bobbie Lehman spoke up in a thin voice, "I don't much like Canova personally, but I do think that it's the kind of stature we ought to seek." Joan Payson, mishearing him, laughed and said half-aloud, "That's good! *Stature—statue!*"

"Does anybody feel the way I do? That some of the things this evening were not for the Met?" I asked.

"God, *yes!*" several answered. "Nothing but the big stuff!" Joan Payson said.

When the meeting was over, the secretary of the museum, Dudley Easby, asked to drop by my office. Easby, the in-house lawyer, seemed to be losing it. More and more he muddled the agenda, sending Arthur Houghton and Ros Gilpatric into rages about his incompetence. But what he told me that evening stunned me and changed his life forever.

"Best meeting I've seen in years!" he said. "Forget about all the dull nothings. Okay, I'm here to tell you that my wife and I have almost *done* it! We've been working on it for almost fifteen years—

you don't know about it, hardly anybody does—a treaty between the Met and the entire goddamned Mexican government. To put a stop to what we all do and shouldn't any longer—buy smuggled and stolen pre-Columbian goods.''

What Easby had hammered out on his own was brilliant—a broad, long-term agreement under which the Mexican nation through the Ministry of Culture would supply the Met with boundless amounts of first-rate materials in exchange for objects they did not have—American paintings, Impressionists, and, especially, Egyptian works.

For years Dud Easby had been the unofficial curator of primitive art. What I didn't know was that he had managed virtually to sneak into the museum a surprisingly large number of works of art which in fact had little right to be there. He had, for example, persuaded Jim Rorimer to purchase, with money from one of the restricted funds, a mammoth stone warrior of Olmec-Toltec origin dating to around A.D. 900, which he boasted had come from an illegal excavation near the Candelaria River in Mexico. Easby and his wife, Elizabeth, also a keen expert in pre-Columbian art, had become intimate friends with Alice Bache, the widow of a Wall Street banker, and cleverly combining museum funds with her money, had acquired some exceptional Olmec jades and some startlingly beautiful gold and enamelled jewelry. The ''noncurator'' had, in fact, collected as well as, or better than, any official curator.

A few days later Easby showed me the Met's virtually unknown primitive art collections. I was astounded at the number and the quality of the works. The Easbys had kept most of it a secret because they feared someone on the board would ask why these pre-Columbian things were not in the Museum of Natural History. The thought drove Dudley crazy. To him, the Natural History was a place where great works of art became mere ethnological specimens. To him, Olmec jade masks or Tlingit wooden sculptures from Alaska were just as important as Greek marbles. And I agreed.

''Tom, this 'treaty' is not totally altruistic. We're on thin ice when it comes to what pre-Columbian things we've collected,'' he confessed. ''More than just one of our things is hot. The Mexicans know and they might be forced politically to do something about it. There's a new wave of patriotic feeling coming out of Mexico and Guatemala. They're going to come after us for stealing national patrimony. My exchange treaty will get the Mexicans off our back on our present holdings and guarantee that in the future we get fabulous pieces on regular loan that we'd never be able to acquire.''

I congratulated him and urged him to press forward on the treaty. I also revealed what Houghton and Gilpatric felt about his work as secretary. Easby smiled in such a way that I wasn't sure if he had not messed up deliberately. I hinted that I intended to create a new department, Primitive Art, and make him the first curator. In several months, he came up with a reciprocal loan agreement that would stand up in the courts of both nations. I accompanied him and Elizabeth on a trip to Mexico and took part in a heady week of functions and parties, late-night revels with mariachi bands, multiple hangovers, and promises of loan largesse of a kind the civilized world had never seen.

Nacio Bernal, the genial head of the splendid Museo de Antropología, told me one boisterous night, "You will become a historic cultural figure in Mexico for your courageous move in halting—at least at the Met—the theft of cultural property." In the press conference I pointed to Dud Easby as the sole architect of the scheme, praising his vision and his legal genius. I then announced the creation of the new department, and in time Easby became the first curator of the new department and excelled.

It didn't take Daniel Wildenstein long to ask for a favor in exchange for lowering the price on Lehman's Giacomettos. Would the museum host a gala dinner for his friend and client, the multimillionaire collector Florence Gould? he asked. Knowing Florence and her collections of Post-Impressionists, I was eager to do it, despite the fact that the museum had never before allowed such an affair. Wildenstein insisted that the hosts be Estée and Joseph Lauder, the cosmetics tycoons. I felt it odd not to be the host myself. But as Wildenstein explained, "Estée has become one of Florence's closest friends in the south of France. She'll be so honored that she may become a generous patron. By the way, Florence has almost decided to announce that she'll give you her spectacular Bonnard."

When I was Rorimer's special assistant, I remember him sounding off about Mrs. Gould. "She's disgusting, a spoiled, dissolute woman covered in emeralds who at all times of the day or night wears sunglasses with purple lenses and is so damned boring! Oh, those parties! One is expected to drink and drink and drink. Makes me sick!"

But he went in pursuit of the Bonnard nevertheless and returned with lurid stories. A year later—in 1962—I met Florence Gould. I

had been to an auction in Europe and had taken a few days off skiing in Austria when Rorimer commanded me to pass by Nice on the way back to meet her. On my last day on the slopes, I had sprained a thumb, and I met Florence with my hand in an aluminum splint.

The woman floored me. Short, plump, with enormous lips slathered with ruby-red lipstick, her eyes hidden behind the purple glasses, she was loaded down with what must have been, nestling in rock crystals of diamonds, a kilo of the darkest emeralds I had ever seen. She looked like a Mafia mistress, and I braced myself for something indescribably vulgar. But Florence Gould was as gracious as any hostess I had ever met. I was given the honor of sitting on her right. The champagne never flagged; the meal was scrumptious; the guests were either nobles or intellectuals or gigolos chattering on in French. Every time one of the guests asked me, "And what is it you do?" and I said I was a curator of medieval art, the guest fled.

After dinner Florence took me on a tour of her villa, which was dominated by libraries, the shelves filled with French volumes—all dedicated to Florence by their famous authors: Cocteau, Sartre, Camus. Suspended over the rows of books on silk ribbons were the paintings, magnificent Manets, a powerful van Gogh, a grand Toulouse-Lautrec, and the Bonnard landscape. She looked upon the pictures as just decor. She would sweep one aside to grab a book. When I murmured something about her "great" paintings, she laughed and said, "I buy them to make dear Daniel Wildenstein happy."

She asked me to look over her medieval collection, which she described as "not much, just personal fetishes, not the quality of The Cloisters." I agreed, giving her a rapid critique. When I put out my injured arm to help her to her feet—we were sunk down in an overstuffed couch—I winced in pain. Gould escorted me out of the party to her limousine, which whisked me to my hotel.

No sooner had I undressed than I heard a knock on the door. There stood Florence with her emeralds, the glasses, the gown. Following her was a waiter with an ice bucket and a bottle of champagne. She had come, she said, to dress my wound, explaining that in the war she had been a nurse. She tightened the bandage on the splint expertly, popped a Demerol into my mouth, and poured a glass of champagne.

"Sleep soundly. Tomorrow there's a dinner in your honor. Would you like me to stay?"

I told her I'd be fine.

"I just adore you," she said. "You know, I think you'll be the director of the Metropolitan some day."

The party in 1968 in her honor was lavish and wonderful. Florence came early and made the rounds of the Medieval hall in a wheelchair —I was pushing. One of the high points was a stop in front of a set of tapestries she had given while Rorimer was alive. The dinner was held in the Western European Art Department. The next day one of the society columnists reported amusingly, "A guest turned to Mrs. Gould, full of sympathy, 'When you took down your big Bonnard and gave it to the museum, what did you ever find to put in its place?' Florence Gould answered quite simply, 'I just hung another one there.'"

———————

In June, Ted Rousseau told me that Adelaide Milton de Groot had died at ninety-one and had left the museum her collection of paintings—old masters to Post-Impressionists—and a sizable endowment fund. Ted had been genuinely fond of the eccentric heiress and had actually looked forward to her dinner parties and evenings at the opera and ballet. But, in her last years, she had become demanding and forgetful. As she aged, Rousseau had tried to get her to decide which paintings she should give to the Met and which should be sold or given away to other institutions. The old lady had avoided the discussion and left the whole assortment to us.

I wanted to know if the collection was really up to the Met's standard. Since my "revelation," I wanted no dross, just top quality. Rousseau shocked me by saying that only half a dozen paintings out of more than one hundred were superior—a Rubens, a Jacob Jordaens, a monumental Eugène Delacroix basket of flowers, and a sketchy self-portrait by van Gogh. Many of the other pictures were not even worth showing. What were we going to do with them? I demanded. Put them in storage or sell them was his answer.

The de Groot affair had made me furious with Rousseau. I railed in private about his casual handling of the donor. How could a man who had demonstrated such courage in the war have acted so weakly in the face of an elderly donor? I knew in my heart that he had simply shied away from the awkward refusal of a stubborn, perhaps addled old lady to listen to the right advice. I was angry not only because of his mishandling of the de Groot donation. I had learned that my second-in-command was almost fatally indecisive. Twice after agree-

ing to become curator-in-chief he had tried to get out of the job.

Just before he told me he was off to Europe for the summer to examine the art market in June and relax at his farm in Spain throughout July, he handed me a memo which he insisted I countersign "only if you think it's really necessary for me to be curator-in-chief."

The memo was clearly a plea for freedom. He demanded to be the director in my absence, a guarantee that he would be able to attend *all* board meetings, my agreement in *writing* for responsibility to prepare all Acquisitions Committee meetings, a say in all curatorial staff changes, to become the sole liaison between the curators and the architects, to be the only contact with the conservator of paintings, and, finally, to have the right to be able to return to his old post in two years should the new arrangement prove to be unsatisfactory.

I had half a mind to tell him forget it since his stringent demands told me that he was clearly unwilling to assume his new powerful position. But, realizing that the demands had probably come from the curators and not wanting to make them nervous and not wanting him to get off the hook, I agreed to all of the points.

He shrugged as if he knew that I knew the tough memo was all a sham and took up a far more important subject—Charles Wrightsman's collection.

He told me how eagerly he was looking forward to being with me and Charlie and Jayne Wrightsman in Poland and Czechoslovakia in August. My wife and I had been invited to join the millionaire for the entire summer. We were supposed to board the *Radiant II,* a chartered yacht, for a luxury cruise—from Venice to Yugoslavia down the Adriatic, into the Mediterranean, up to Naples, to the Côte d'Azur—followed by a two-week jaunt behind what was then the iron curtain.

I had mixed emotions about the trip. I wanted to cruise the Adriatic, but I was worried about spending so much time with the high-powered socialites. I was on the verge of begging out because I was needed in the museum.

Rousseau raised his eyebrows about my staying in New York City and told me it was "a demand bid," for Wrightsman had lately been singing to him the praises of the National Gallery. It was imperative that I pin the wealthy collector down for the Met. I told him I was confident I could, but in fact, I was not. The big stuff was upon me and, suddenly, I didn't think I could deal with it.

8

TOADYING

Everybody is a little bit of a toady in the face of the very rich. Even the rich to other rich. With Charles and Jayne Wrightsman, I went beyond toadyism—I was a courtier in their throne room.

I had received by messenger a detailed deck log for the "Voyage to Antiquity," with instructions on attire. Whites. No black tie needed. A white suit for semiformal activities would be appropriate. The guest list was provided: Ambassador and Mrs. William Mc-Cormick Blair (buddies of the Wrightsmans), Cecil Beaton, the British fashion and social photographer, and a socialite who never was to show. Charlie told me "in the strictest confidence" that there'd be another guest "on a secret mission." This turned out to be Katharine Graham, publisher of the *Washington Post,* who came especially for the first part of the voyage from Venice to Corfu, hoping to gain an exclusive interview with Marshal Tito at his summer estate on the island of Brioni. The other "secret" guests might be King Constantine of Greece and his mother, Queen Frederica. Heady stuff.

I went to Brooks Brothers and bought the clothes. I had heard that Charlie habitually wore white gloves when he went ashore to tour various monuments, but I thought I'd forget those. Nancy bristled but bought the appropriate wardrobe.

The deck log described the vessel and each leg of the trip by the half hour. The steamship was 188 feet long, weighed 690 tons, had a crew of thirty-eight, and a draft of 12 feet. It was outfitted with the most modern leveling devices. Owned by a Greek shipbuilder, Stavros Mavroleon, it was considered the choice charter of the summer. I had to chuckle. Being a seasoned offshore sailboat racer, I had always dismissed such boats with contempt. I packed in some ocean-racing equipment just for show—foul-weather gear, Top-Siders, and red racing shorts. I fell short of packing my rigging knife and marlin spike and a pair of seaboots, though in retrospect, that stuff might have been chic.

I was, deep down, dreadfully anxious. How would my wife and I be able to live so long with the Wrightsmans and their guests? We had signed on for almost two months. The proposed trip to Czechoslovakia and Poland after the cruise at least had a more convivial ensemble—Ted Rousseau plus the director of London's famous Wallace Collection, Sir Francis Watson (one of Charlie's collecting advisors), and his wife, Jane. I had discussed being away from the museum for the extended length of time with Arthur Houghton, but he had shrugged and said, "Okay by me. I'm off until after Labor Day. Joe Noble is around to handle it." That remark didn't make me altogether happy.

I worked every night until midnight trying to wrap up the load of work. I was trying to pin down the acquisition of the magnificent brass lectern from Oscott College, a photo of which had come to me in the mail from a Father Leonard. I didn't have the time to carry out the painstaking research so I had asked Bill Forsyth, the associate curator of the Medieval Department, to drum up all the facts about it. "Why not book yourself on a plane to London," I told him, "see the thing, compare it to all others in the world, make a recommendation about how much we should pay for it—the works."

"Oh, Tom," he said, sounding faint, "I hope I won't disappoint you."

I thought he would. But in a week his memo hit my desk and it was exemplary scholarship in the field. I invited him to lunch to go over it, point by point.

"Tom, it's magnificent. I do hope it's not too late to save it for us."

"Save it? I thought this deal was all wrapped up! Father Leonard asked fifty-five thousand pounds, I accepted. What the hell is going on?"

Barely looking up over his lunch, the elderly curator told me, "Father Leonard begs you to swear you'll keep what I say hush-hush. The root of the difficulty is that a 'British museum' matched our price. Father Leonard wants us to come up with a price definitely above fifty-five thousand pounds. He says 'not appreciably higher, but not a minimum raise' either."

"How much, Bill?"

"I favor seventy thousand to seventy-five thousand pounds—at the lowest. I must impress you that he thinks there's danger in too low an offer. The cathedral in the same diocese removed a rood screen by Pugin recently, and the Victorian Society attacked them in the press. Father Leonard fears a publicity attack and an export contest—between us and this 'British museum.' And only Father Leonard and Father Foster, the head of the college, know about both offers."

"It's got to be the Victoria and Albert Museum and John Pope-Hennessy. Right?"

"Right. Father Leonard wants an easy, uncomplicated deal without drawn-out arrangements. I told him we can pay quickly. By the way—if we win—he wants the lectern out of the college before the students return in September. Tom, I have a feeling we'll get it; they like my description of the religious atmosphere of The Cloisters. The only trouble is that there are no lecterns like this in England."

Before leaving for Venice and after consulting with Arthur Houghton, I sent a letter with our new bid of sixty-five thousand pounds. To my delight Father Leonard phoned to tell me that "the trustees of the College and the Chapter of the Cathedral St. Chad—our overlords—voted Friday to accept your offer. But they are concerned that we might have to pay the insurance and shipping." Don't worry about that, I assured him. I felt secure in the knowledge that I had—once again—pulled off a major collecting coup. But a day after his call, he sent a letter. "I suggest that July 14th be given to the other parties as the date when the best offer will be accepted."

The day before I was to leave for Venice, Olga Raggio, the associate curator of Western European Arts, begged me to make a quick

side trip to Florence. There was a late Renaissance sculpture that was being offered to us for the second and last time. Rorimer had turned it down years before, and Raggio implored me not to miss it again. Perhaps there was a way I could see the work and get the trustees to authorize enough money so the dealer would at least put it on hold. The price was between sixty and eighty thousand dollars.

"Oh, that's nothing," I bragged, for Houghton had assured me he'd stand behind any purchase of mine up to a hundred thousand dollars. I told her I'd be delighted to go. Olga, eyes burning with enthusiasm, told me the story.

Back in 1962 she had been working in Florence and had received a photo from Rorimer of a large marble statue said to represent Temperance, attributed to Pietro Francavilla, a follower of the sixteenth-century Florentine master Giovanni Bologna. The dealer was Ugo Bardini.

"So, I saw Bardini," she said. "His place is near that amusing little museum his father gave to the city. He's a charmer—tall, I suppose in his mid-eighties, courtly, clearly accustomed to dealing with English and American clients. He seemed to find it awkward somehow that I spoke Italian. The life-sized piece was almost hidden away in a crowded storeroom next to the battered fragments of an eighteenth-century coach and some not-so-good Renaissance furniture. I couldn't see it on all sides, but what I could see was a strongly classicizing, Junoesque figure holding a horse's bit and bridle in one hand and a ruler and pair of dividers in the other—symbols of restraint, typical for an allegorical sculpture of Temperance."

She had adored it. The marble, covered with moss and lichens, was so sharp that Raggio could see an extraordinary cascade of flat folds down her back. It was a melodiously composed statue, classical, stately, but she doubted it was Francavilla since his style was more nervous and linear. Where had Bardini gotten it? All he would say was "It comes from a Florentine garden." The price had actually gone down—from eighty thousand to sixty thousand dollars. But even more exciting, Raggio had found the real artist.

She had discovered another Temperance, in Genova, that was astonishingly close in style and that had been attributed to a Florentine master named Giovanni Caccini. Raggio had gone to the central library in Florence to see what had been written about Caccini by the two preeminent Florentine art historians of the sixteenth and seventeenth centuries, Raffaello Borghini and Filippo Baldinucci.

"Tom, you will appreciate this!" Olga said. "Within minutes I found a passage in Borghini's *Il Riposo* which said that Caccini 'is now working on an over life-size marble figure for Monsignor Giovannibattista del Milanese, Bishop of Marsi: it is meant to represent "Temperance" '! And in Baldinucci, I found a reference to the sculpture, placing it in Bishop Giovannibattista del Milanese's garden in his palace on the Via Larga."

It was, as Olga remarked, a rare instance when documents gave you a quick answer.

She had pleaded with Rorimer to go after the sculpture. He had been "preoccupied" and turned it down. But she had never forgotten the piece. As soon as she could, she had returned to Florence and had set out immediately to find the bishop's house. She discovered that in the seventeenth century, the house had become the property of the Covoni family. Raggio acquired an early eighteenth-century map of Florence and found the Covoni house. The map even showed a small garden in back.

"Tom, I was mad with curiosity and went searching for the villa along the Via Cavour, which, I knew, was once the Via Larga. Then, right *there*—in front of the Medici Palace—I spotted the bishop's coat of arms. His mitre was on top. Right on the facade of an elegant sixteenth-century house. Pure classical taste. It was the perfect match in architecture to the style of Caccini's statue. I talked my way in. I found the garden where the statue once stood. We've got to buy this piece! I just hope that no one else has found out what I have learned."

Not long afterwards I stood in a gloomy warehouse looking at the striking Temperance. It was, as Olga had told me, "still covered with its Florentine moss and lichens but with not a speck of its delicate marble missing." I closed with Bardini at sixty thousand dollars, though I thought the chances of getting it out legally were slender since all those documents were lying about. To my great surprise it was waiting for me in New York on my return.

———

Venice was the perfect port of embarkation for my first Wrightsman cruise. Nancy and I had been installed in a Canal-side room in the Gritti Palace, where we were to stay for four days prior to boarding the *Radiant*. Ambassador William Blair and his fashionable, cool wife, Deeda, had also arrived. I liked Bill at once for his bluntness.

One day our party of six was supposed to follow lunch at Harry's Bar with a guided tour of San Marco to see the great enamelled altar and the treasury where there were some fabulous Byzantine and Gothic reliquaries. Bill chortled, "Not me! I don't like those brown things." From then on, I have always called medieval reliquaries "brown things."

To my horror, I almost didn't make the trip. Charlie was furious. We were supposed to leave the Gritti at ten or so. I always put my passport under some papers in the drawer of the bed table, but when I opened that drawer, it was gone. I had my luggage brought back to the room, and I searched frantically through every recess, every pocket—nothing. Wrightsman sent an acid message back to me that my wife and I might as well start planning to stay in Venice. He had an aversion to tardiness and took my loss as a personal insult. Soon I became convinced that the passport had been stolen by one of the hotel's chambermaids. I summoned the manager and warned him that if he didn't get my passport back in a half hour, the Wrightsmans would never come to his hotel again. Within minutes he returned with my passport.

We rushed to the yacht, and I turned the episode to my advantage. Charlie was delighted with my handling of the "Cassinis" as he referred to Italians he didn't appreciate (one of his daughters had been married to Igor Cassini, once the gossip columnist Cholly Knickerbocker). Still, it was a very close call.

To cruise with the Wrightsmans was to live in a floating, high-tech Versailles. One was surrounded by modern technology but expected to play at an eighteenth-century pace, sedate and dreamy. Surrounded by servants, hanging over the railing of the grand deck of the *Radiant II* as the yacht eased away from its anchorage opposite the Piazza of San Marco, one felt very aristocratic. The *Radiant* was about as nautical as the Ritz Hotel moving along on huge rubber wheels. Charlie and Jayne had brought along their own servants to supplement the sizable Greek crew. There was Hampshire, the British butler who snapped into view when any one of us had barely thought of something to eat or drink. There were so many maids that I'd leave a sports shirt on my bed for a fifteen-minute swim and by the time I returned, it would be laundered and ironed and laid out on my bed.

Once past sight of the "Serenissima," we met in the luxurious grand salon to chat with our fellow passengers. Katharine Graham

was an intense woman with a tight smile who seemed nervous from the moment we met her. Only when we were under way did Charlie announce that she had received permission to interview Tito. Permission? I had to laugh. The canny dictator must have been gaga at the idea of an interview with the owner of the *Washington Post*.

The eighth member of our party, Cecil Beaton, was a living encyclopedia of social small talk, titillating anecdotes, and major-league gossip—all in flowery good taste. Cecil never stopped flitting around or chattering. His eyes never quite focussed on you, so busy was his search for someone else of greater benefit to him.

He was a wonder at finding little doodads wherever we stopped, which he presented to Jayne as gifts. The moment he alighted on board, he handed her a record album. "Not even issued yet, but Mick Jagger got it for me," he boasted. It was the Beatles' *White Album*. That evening at cocktails in the grand salon it was hilarious to hear Charlie, goaded by Beaton, sound forth about the musical excellence of "these Beatles, equal to some of the great composers of the past." "Good marketers, too," he added, which, I thought, was more to the point. Kay Graham winced and kept her smile fixed firmly in place.

The first day we got to Brioni, and Mrs. Graham departed for her interview. We sailed on to Pula, a town the ancient Romans had developed as a naval base and trading center. We dashed off to have a look—an hour only—at the numerous Roman remains. We were whisked around town with Charlie giving an animated guided tour. He turned to me with a smile and said, "Hoving, from now on the art's your game." From that moment on, I was *it*. When we returned to the yacht, I grabbed every guidebook available in the ship's library. Nancy and I looked at each other in some dismay.

"What are we going to *do?*" I whispered.

"We're stuck," my wife said gloomily. "This is what a cruise is all about—boredom and smiling and small talk and saying 'to die.' "

Thank God, things got better. The evening turned out to be enchanting. We got under way from Pula at six in the evening—to the second—and steamed out to the Adriatic. We sailed down the coast in a full moon watching the beautiful islands dotting the coast of Dalmatia pass by. It was a fairy-tale world, island after island, resting on windless waters. Dinner was at a fashionable nine o'clock. When I sauntered out on the fantail, the *Radiant* was slipping along at a peaceful ten knots. The moon was majestic, and I had to sigh in

contentment when the butler offered a tray with a glass of champagne. Suddenly, Charlie was there at my side. We stood at the rail for a few minutes drinking in the beauty of the shoreline in the moonlight.

"Have any children?" he asked me abruptly. I told him about Trea, my young daughter, my only child.

"I had two daughters," he mused. I had heard about them from my stepmother and the story of their lives was tragic—one had married the actor Helmut Dantine and the other the columnist Igor Cassini. Both had committed suicide.

"Funny," he said suddenly. "They both turned out badly. It was their mother's bad blood."

I was chilled. But, playing the role of the proper museum toady, I smiled and chattered on about the beauty of the night.

The order of the day and night on board the *Radiant II* was charm. One was absolutely never to broach a difficult or unpleasant subject. Kay Graham returned from her meeting with Tito and at dinner that night we experienced a touch of the nasties. Charlie in an offhand way remarked that maybe Mrs. Graham was being "taken advantage of" by Tito because of her powerful position in the press. She bristled and reacted sharply, crying out, "Oh, *Charlie!* It was *my* request, a legitimate interview. *Really!*" But I could see she was wounded by his remark—it was not long after the tragic death of her husband and before she had demonstrated her own journalistic skills. There was a deadly silence and not even the chirpings of Cecil Beaton dispelled the lingering smell of conversational sulphur in the air. I don't think Kay Graham ever forgave Charlie for his remark. But she admired Jayne and Deeda Blair. When Nancy remarked about the frivolousness of Jayne's and Deeda's conversation, Graham retorted, "You and I could learn a lot from women like that!"

On the way to Corfu, by a long nighttime pull way off shore, Charlie became skittish, filling our ears with horror stories about luxury yachts being fired upon by Albanian gunboats, captured, and lost forever with all guests on board. I must say when the captain confirmed one seizure, I became slightly edgy myself. Once we were away from the clutches of the Albanian navy, though, another period of high excitement began. Charlie told us at dinner that "a royal party" was about to join us. "So look good; don't do anything I wouldn't do!" The young king Constantine of Greece, his wife, his two sisters, and the queen mother Frederica would join us for lunch

when we arrived at Corfu, their summer retreat. Cecil Beaton blurted out, "How amusing! 'Mum the Hun' for lunch—oh, how chic, Jayne!" "Mum the Hun" referred not only to the steeliness of the ex-monarch but to her lineage as well. Like most European royalty, she was German, a member of an ancient family from Braunschweig. Jayne was ecstatic. The cruise had been made! Imagine, real *royals!*

A white and varnished lighter nudged alongside at noon the next day, and the two royal ladies emerged, accompanied by several security police. Constantine was off waterskiing and came an hour and a half late, much to his mother's annoyance. Once we were seated at lunch, it was clear why the royals had accepted the invitation. All three turned their attention to one person alone—Kay Graham. Throughout lunch and over coffee, Constantine, but mostly "Mum the Hun," directed a steady soft sell about how stable and enduring was the new government of fair Greece. This was not long after the tyrannical colonels had suspended parliament and had dismantled much of the constitution. I was amazed to hear the king and his mother arguing subtly but unmistakably on behalf of what had been a coup d'état against them. After they left, I made the unpardonable gaffe of expressing my shock at the royals' toadying to the colonels. I went so far as to say that they all seemed to me to be petrified that if they didn't suck up to the rightists, they'd be ousted. Kay Graham was furious at me. Months later, when the royals fled Greece, I had a tiny moment of triumph. Toadying never worked in the end, I ruminated. But I kept right on doing it.

Suddenly, we were immersed in a real crisis: the Six-Day War, which unleashed the Israeli forces against Nasser's hapless troops. Though we were far from the conflict, Charlie was frantic that we would get bombed or torpedoed or that we would run out of fuel and become marooned. The cruise was rerouted, and the captain steamed west to the straits of Messina—the Mediterranean was far safer than the lower Aegean. New plans were made to go to Stromboli, Capri, Sardinia, then Naples, before ending the cruise with the long leg up to Antibes. But even that truncated plan was abbreviated. We stopped briefly at Capri and entered Naples only for oil. I had so much looked forward to wandering around Naples and Pompeii, but it was not to be. We forgot Sardinia and dashed up to the safety of the south of France and departed the luxury yacht at the end of July. Leaving the *Radiant II,* my wife muttered, "You're never going to catch me on that again!"

The Wrightsmans went to Paris, and we tarried for a few days before meeting them a week later to join Ted Rousseau and the Watsons and start the next leg of the sojourn into Czechoslovakia and Poland.

Paris was my opportunity to make up with Ted. At dinner one evening I drummed up the courage to tell him of my concerns about having forced him to take on the job of curator-in-chief.

"I keep worrying that you're too genteel to refuse this curator-in-chief post," I said. "And I don't want that. I'm a very hard, driving, and cold man. I'm bursting with ambition. The people I trust and admire are going to help me, but I expect they will be sent through hell. Ted, there's still time to get out. Claus Virch hasn't been named curator of European Paintings yet. I've got to tell you I've been upset by your attitude and your actions. It almost seemed that you became . . . insouciant . . . or were belittling me. Christ, I don't know. What's the deal? You've got to put aside those Ted Rousseau manners, that pleasant Rousseau smile, and *tell* me what you really want to do."

"I was confused and in shock when you asked," he said. "I lost my bearings, which made me indecisive. I do want to be chief curator, especially under you. To be asked is a distinct honor. I no longer have any doubt that I can do the job. It will be exciting and highly entertaining."

I would never regret my ill-conceived decision again. It was not that Ted Rousseau had the best eye in the world or that his executive abilities were stellar. He was lazy and disorganized when it came to getting jobs done. He could be duplicitous with colleagues. He could, at times, simply disappear into himself and become utterly uncommunicative, though he seemed to be listening eagerly and to be alert. But he would always pull me back when I was going over-board, which I tended to do more and more as the years went on, and give me a shove forward when he saw I was flagging. Ted Rousseau was neither an effective instrument nor a noteworthy piece of music, so to speak. But he was my conductor, my impresario. His diplomatic skills were exceptional and his contacts throughout the world impeccable.

My relationship with Ted became the most profound alliance I have ever achieved. In time I talked to him about things I had never spoken to anyone about—not even my wife. At the first sign of trouble I would be on the phone to him, no matter where he was in the world, and get his immediate reaction, which always changed

what I planned to do. We laughed for hours, we partied, even, at times, womanized together. There was simply not a single decision at the museum—nor many personal ones—that I made without Rousseau. We were both right together and wrong together.

Rousseau was a dedicated bachelor and a lover of women. He seduced women not because of some Casanova complex, but because he delighted in pleasing them. He adored women of every class, age, and nationality—from grande dame to bar dame. I found his success with women astonishing. I noticed many times, when entering some gala function with him, that every female head would turn. But when he *spoke,* it was even more devastating—some women would almost swoon. I never heard any woman say anything but the most gracious word about Ted, even those who no longer enjoyed—and would have enjoyed—his favors. Perhaps one reason I was so fond of him was because I yearned to be him.

We spent three days in Paris dashing around the art dealers and museums. Rousseau had been working hard on his two-month vacation. He had been on the road almost nonstop: Madrid, Barcelona, twice to Paris, Milan, London, Berlin, and Brussels. He had been feeling out the museum directors in those cities about loaning spectacular works to a Centennial show he had dreamed up. He called it "Masterpieces of Fifty Centuries," and it was to be a collection of some of the most famous art works on earth, lent in homage to the Met on its birthday. One of the key lenders would have to be the Louvre, but although the officials there had been keen, they had told him only the minister of culture himself, the imperious André Malraux, could approve truly historic loans. Rousseau had put the machinery into motion.

He had heard a most amusing tale about the eccentric Malraux. The Louvre had just been offered for purchase a silk scarf which was elaborately decorated with gold embroidery, beads, and jewels and had a conspicuous dark stain in the center. The owner claimed it was ancient Greek. Malraux had been told about the silk and had it sent to his private apartment in the Palais Royal. He then called for his medium. Once the woman grasped the fabric, she fell into a trance and mumbled about "seeing" a young man in silver armor who was holding in one hand the harness of a white horse and in the other a gilded lance. The young man suddenly started choking. A great dollop of bile shot from his throat, and the young warrior fell dead on the sand.

"Alexandre!" Malraux had reportedly cried out. The scarf no doubt belonged to Alexander the Great, who had, according to legend, collapsed after some sort of seizure. Malraux had wanted to buy the relic for the Louvre but had been unable to raise the funds.

Then in London we spent three more days visiting museums and galleries, dining at all the most fashionable places—including the Wrightsman flat, a gracious apartment in the exclusive Albany. We teamed up with our other travelling companions. Francis Watson was a balding man with large, expressive eyes and bushy eyebrows that reacted like antennae to what he was hearing. Although he was the director of the prestigious Wallace Collection, he was also writing the entries on the Wrightsman French furniture for a series of catalogues the Metropolitan planned to publish. He was affable and witty and either laughed raucously or chirped like a bird. His wife, Jane, was the sort who brought along her own tea and a heater to cook up boiling water wherever she travelled. Jane's perpetual expression was one of faint disdain for her hosts, the rest of us, and at times her husband.

We flew from London to Prague and enjoyed the charms of one of Europe's most beautiful cities. Looking aristocratic and learned, our party sped to Hradcany Castle in two Mercedes limousines and walked for hours among the museums and St. Vitus Cathedral. I had discovered a section of the disparate and sprawling "National" museums devoted to the art of the 1400s, including some striking works by a monk, the Master Theoderic, who painted monumental icons with saints of compelling human power—almost to the point of caricature. Our guide was Olga Pumanova, the curator of the European collection, a vibrant young woman of the upper class with a wry sense of humor. I had never seen Charlie so peppy and full of jokes. He ribbed Jane Watson and bantered with her incessantly, a treatment which she took stoically. One late night at dinner the subject of the Oscott lectern came up, and before I could stop him, Charlie spilled out the entire story, boasting how the Met would surely snatch the piece out of the arms of the British.

The next stop was Warsaw. I found the shattered city compelling, less for art, which was mediocre, than for the grisly museum filled with photographic displays and even some film on the Nazi destruction of the Ghetto—film clips taken by the Nazis of SS officers beating and prodding the Jews into vans to be sent to their deaths. In Poland, we were allotted two state guides, Marek, an art historian

in his early thirties, and Maria, a stunning young woman in her mid-twenties, who took one look at Ted Rousseau and fell in love. Within a day they were inseparable.

Charlie had planned to remain in Warsaw for two more days and then travel on to Krakow for a day and a half. I suggested we hire a couple of cars and stop at the university where Copernicus had made many of his astonishing discoveries. To my surprise, the Wrightsmans applauded the scheme—they hated to change anything on a schedule. The roads were rough, the conditions were primitive, but the trip was fascinating. The land looked like an eighteenth-century French landscape painting. The first evening at dinner Jane Watson made some disparaging remarks about the luxuriousness of our "caravanserai" and followed by attacking me for my "cynical and arrogant manipulations" surrounding the Oscott lectern.

"But, as a loyal British subject, I have moved against you," she announced. "Before we left this morning, I alerted the officials at the Victoria and Albert Museum, who will tell Pope-Hennessy of your bid of sixty-five thousand pounds. He will most definitely raise more than that and will forbid the export!"

When Jane Watson stalked off, Ted, Charlie, and I tried to figure out how to foil her. Suddenly, it occurred to me that we ought to take advantage of a loophole in the British export regulations. What if we changed our offer and simply outbid Pope-Hennessy? I asked my host if, as a member of the Acquisitions Committee, he received a letter from me requesting much, much more for the lectern than what he'd already voted for, would he go for it?

"I get it," he said. "We have the money. Under their export regulations, the British have to match our offer. Now the V and A is sure to raise an amount slightly over our bid of sixty-five thousand pounds. And, I guess you're suggesting going way above our own bid to put the lectern out of reach! How much?"

I said I was thinking of asking every member of the Acquisitions Committee for permission to bid one hundred and five thousand pounds.

"I'll endorse it," Wrightsman said. "Say that in the letter."

I datelined the five letters "August 13th, Between Warsaw and Krakow" and wrote them all in longhand on a yellow legal pad. I telephoned our London representative, John Partridge, and told him I'd be showing up in London to go to Oscott with him to talk to Father Leonard. I also managed to reach Houghton by phone and he agreed.

We left Poland and accompanied the Wrightsmans to Vienna for a few days—"So that the bitch won't tail you in England," as Charlie put it. Jane Watson barely spoke to me on departure, while Francis shot me a broad wink.

On our last night in Vienna, Charlie asked me to join him in his suite for a last glass of champagne.

"I like you," he said. "I had my doubts when you lost your passport down there in Venice, but since then, you've been pretty sharp. I've decided, I like you. I want you and Nancy to join Jayne and me next summer for another cruise—in the Greek islands, down to Israel, and then to the Turkish coast. Jayne likes you, too. Now, don't take this wrong, but you ought to work on your wife a bit— you know, to make a proper museum director's wife out of her. No offense. But Jayne and I are happy. I feel comfortable about my collection going to the Metropolitan, savvy?"

I was elated but I didn't mention his advice to Nancy, who flew home while I flew off to London to meet John Partridge. Partridge was one of the most elegant and intelligent art dealers in London. In his early forties, trim, with large, bright blue eyes and flamboyant eyebrows, he looked like a cultured owl. His gallery, started by his grandfather, was located at a prime address on Old Bond Street. He specialized in the finest pieces of English furniture and decorative arts and French pieces of the eighteenth century. I descended a narrow flight of stairs to his subterranean office. He had a spaniel on his lap, which made me like him at once. I was to learn that he was normally a calm, forgiving human being with a smile always ready to illuminate his face, but at that first encounter he was grim and angry.

"I am outraged at the behavior of the Victoria and Albert Museum. Four years ago one of the curators went to Oscott College and offered fifteen hundred pounds. Their current attempt to block it is a bit cynical."

"Are they blocking it?"

"I expect they will."

"I have an ace."

His bushy eyebrows rose.

"I'll tell you my plan when we're face to face with Father Leonard," I said.

Partridge's Bentley whisked us down to the college. Father Leonard, looking concerned, all but ran us over to the lectern. Partridge and I were both overwhelmed. Partridge growled, "It is not going to

be easy arguing *this* masterwork out of the nation. There's none better in the land.''

I turned to Father Leonard. ''Friend, I'm here to tell you that I'm not going along with the offer of sixty-five thousand pounds.''

''Dr. Hoving, you know I mustn't bargain!''

''I will not pay,'' I said, ''a shilling less than one hundred and five thousand pounds.''

Father Leonard's mouth opened as if to protest. Then he smiled and said softly, ''I believe my board will knuckle under to this kind of bargaining. Well done, Dr. Hoving.''

Partridge turned to me, blue eyes glinting. ''I must say, I wouldn't have thought of that—and if I had, I wonder if I'd have dared suggest it. I don't think they will reach that price, but they may try. In my opinion, once Pope-Hennessy hears this sum, he'll back off. Perhaps we won't have to meet the Board of Trade after all, but I shan't make a firm prediction.''

I thought we were in. But Pope-Hennessy had fallen in love with the piece. At his request, the Board of Trade blocked our export license. His passion was confirmation of my sense of quality, but it wasn't much solace. Partridge had formally complained to the board that it was ''unseemly'' for the museum that had so offhandedly offered fifteen hundred pounds to block the piece. Pope-Hennessy remarked archly that fifteen hundred pounds was *all* the money the V and A had at the time and thus an indication of how highly the museum thought of the lectern. The board decided to hear the case in September and asked both parties to submit a written argumentation.

Cool-tempered Partridge drafted a hot-headed letter, which I toned down just slightly.

Partridge attended the meeting and kept his remarks to the minimum. Pope-Hennessy was uncharacteristically flamboyant. He stated that the lectern was one of the greatest treasures in England, equal to any one of the nation's masterpiece paintings. While the Board of Trade was deliberating, Pope-Hennessy happened to come to America, and I met him at the Wrightsmans for dinner. Charlie kept needling him about the lectern: ''If Hoving here hadn't gotten excited about this, you would have never been interested yourself.''

''*Not* at all, Charlie,'' Pope-Hennessy protested, quite rightly.

''Oh, come on! Why did you *do* this to the Met?'' Wrightsman went on.

"Charles, I *had* to. It's a political matter, too."

Wrightsman's voice dropped into a conspiratorial tone. "Do you know who messed it up for you? Jane Watson! Hoving's our own secret service," Wrightsman said. "Hoving, here, got permission from his board to bid you out of the contest. I think he succeeded, don't you?"

After dinner Pope-Hennessy drew me aside. "Tom, I hope you do understand I had to do what I did. The piece is magnificent. Simply the best thing I've seen in years. Now, this Partridge is trying to intimate that I'm some sort of an unpleasant chap about all this. But, Tom, surely you'd do the same if you were me."

The process took until the beginning of 1968, when Parliament failed narrowly to vote the necessary hundred thousand pounds. Pope-Hennessy wrote to say, "While I very much regret that it will not have a permanent home here, I feel bound to say that it will find an appropriate and worthy setting at The Cloisters."

I felt invincible.

9

TO HELL
WITH THE
CRITICS

I returned to New York, which was slowed to a near standstill by the heat. But the first caller had my blood racing. Robert Lehman asked me to come that very day to "discuss the future." We met in his limousine, with the air-conditioning running full blast, at a pier downtown, where his yacht was waiting to ferry him to his estate in Mamaroneck. The "future" never came up, and I wondered if I had misunderstood. He asked politely about my trip, about the Wrights-mans, even about the state of the museum. After about a half hour Roland Redmond's name popped up and triggered an astonishing tirade.

"He's a menace to the museum," Lehman said. "He's the ring-leader of the anti-Semite group on the board. He's personally vetoed every individual I ever wanted to join the trustees. He doesn't un-derstand art. One of the things that's been holding me back from giving all my works to the museum is the presence of Roland and those other anti-Semitic people on the board. Oh, there are other

reasons, too. I became a member of this board in the early 1940s. I'm the longest-serving member. I became a vice-president. That's all.''

He leaned back against the seat and abruptly changed the subject. ''Did I ever tell you about my first board meeting? I was scared to death. The members . . . oh . . . I can't remember, but they were all very powerful and very much older. They were talking about a scandal. Trustee Harold Bache had died in his mid-eighties—in the arms of his twenty-two-year-old Negro mistress. The city tabloids ran headlines for days. Before the meeting was called to order, the members were discussing Bache's death. How shocking! one said. What disgusting behavior, someone else said. The museum's reputation would be tarnished! And so on. Suddenly someone—I don't recall who now—said, 'And what does young Mr. Lehman think about Mr. Bache's indiscretion?' Without thinking, I said, 'What a way to go!' ''

He laughed and then came to the point.

''Over the years I've always felt like an outsider. You know, they never had the grace to make me president, not even for a day.''

I sat there in the softly purring limo. ''Bobbie, if somehow I could change all that, what then?''

''I might be very interested,'' he said without looking at me. By God, he had been negotiating.

As soon as I could, I got to Houghton, Danny Davison, and Ros Gilpatric and told them I knew how to land Lehman. We had to make him the president, and we had to elect someone, anyone, whom Bobbie would appreciate having on the board. Houghton reacted instantly. ''Make him president. I'll step aside. Make me the executive vice-president, whatever, and I'll still run the show.''

I had a better idea: why not promote him above the president? We would make Lehman the first chairman of the board.

Houghton and Gilpatric smiled.

Danny Davison was given the task of finding out whom Bobbie revered that the trustees could live with. In a few days, he had selected Andre Meyer, the chief of Lazard Frères, a powerful and respected financier who, it was said, never slept more than three and a half hours a night in order to keep on top of both European and American stock markets. Meyer's name was given to the nominating committee.

Three weeks later Lehman's secretary called and said he wanted

me to come down and ride from One William Street the few blocks to his yacht. He looked even frailer. Again, we sat in his limo, engine running and the air-conditioning on, chatting about inconsequential matters.

"Bobbie, Arthur Houghton asked me to convey to you that unless you object, he will present your name to the Executive Committee for election as the first chairman of the board of the museum in its history . . ."

He looked puzzled.

"Arthur was perfectly willing to step down as president and give it to you," I said. "But since the president has to make lots of speeches and knowing you don't like that . . . well . . ."

Lehman nodded his head slightly.

"I have a request from Danny Davison. There's a chap he's interested in nominating as a trustee. He doesn't want to move until he gets your approval. Andre Meyer."

"They would put Andre Meyer on the board of the Met?"

"Only if you like."

"Like? Andre is the most qualified man in the world for the board. *They* would do this? Houghton approves? Redmond can't block it?"

I nodded.

Lehman closed his eyes for a few seconds. He pushed himself forward and turned to look at me. "I told you I wanted to do something for you—you remember. I have decided to give the Metropolitan my collection—all of it."

Before I could react, he continued, "Where are you going to put it? You know the collection and the house where I keep it . . ."

I nodded again. It didn't seem appropriate to tell him I'd never seen his collection.

"But you may not have been at my apartment. I can't remember. I have some interesting paintings there. Why don't you and Ted come for dinner this next week? The collection is yours. I am relieved."

I got out while Bobbie Lehman was escorted up the gangway to his yacht by a crew member. First I called Rousseau and told him I was on my way to his office.

"Ted, you better be right about Bobbie's stuff!" I said.

Seconds later I was on the phone to Arthur Houghton, who remarked, "Well, I guess I have a new boss."

Two days later Bobbie's secretary informed me that Mr. Lehman

felt I might want to see his collection again—"He knows, Dr. Hoving, that you've already had the opportunity," but he thinks a "refresher" might be "fruitful." I had to laugh. Somehow Bobbie had figured it out. I asked Ted to join me and arranged an appointment with Lehman's curator, George Szabo.

Szabo turned out to be a dour Hungarian, a specialist in late-medieval illuminated manuscripts. His primary duty was to compile a complete catalogue of the hundreds of paintings, drawings, bronzes, and pieces of furniture. Lehman wanted him to publish a popular book on his materials. I was suspicious the moment I met Szabo. He was about as genial as a drillmaster. I had wanted to wander through with Ted alone, but he insisted on coming with us.

As we ambled through, ignoring the curator, I discovered I knew much of Lehman's collection, remembering several of the more famous old masters from the days when they had been on view at the Met. This time, however, I was not just enjoying the art. The early Netherland and French pictures by such masters as Dirck Bouts, Hans Memling, and the Master of Flémalle were incredible. Comparable pieces were to be found only in Europe's most ancient museums or in cathedrals. The Italian pictures were like so much caviar. The Botticellis were sensational, especially a small Annunciation, the one Bobbie had given his father on his sixty-fifth birthday. The impressive El Greco *St. Jerome* was finer, I thought, than the version in the Frick. I was finding it hard not to let out a war whoop. What a moment in the history of the museum—and I had done it! This would make everything Rorimer had done seem insignificant.

"The drawings are even finer," Ted whispered. "The only discouraging thing is that little Hungarian valet comes with the collection. But I'll deal with Szabo."

The narrow rooms and corridors were completely inadequate for the proper display of the magnificent drawings. I saw a matchless drawing of a bear by Leonardo, a wonderful ink self-portrait by the German Renaissance master Albrecht Dürer, and a gorgeous, silky Raphael. I began to worry where the hell we were going to put it all. Although he had said nothing about the disposition of the works, I assumed Lehman would demand all his pieces be kept together—in perpetuity. Why not, I said to myself. Bobbie Lehman could have *anything* he wanted.

With Lehman in the fold—or about to be—I had to push Roche-

Dinkeloo to hurry up their work on the master plan, and determine where Lehman might fit into the new architectural scheme of the museum. Arthur Houghton hurriedly called all the members of the board with news of the architectural announcement and spent hours refining his remarks for the forthcoming meeting of the museum's corporation.

As the streetwise Rosenblatt saw it, we had to move quickly and clandestinely to get our approvals from the city and build as fast as we could.

The press conference to announce the building program was scheduled for a Thursday at the end of September. We gave the *Times* architectural critic Ada Louise Huxtable a full briefing before the rest of the newspaper and television press. It was mostly philosophy since we had no designs. She wrote a glowing front-page story and followed up with a favorable editorial. She reported that the museum was about to embark on the most comprehensive plan for growth in its ninety-seven-year history. "The construction will be in Central Park, within boundaries previously allotted by the city, a section of the park given to the museum under state enabling legislation of 1876."

In fact there was no "city allotment" or "enabling legislation." Rosenblatt had simply made it up, hoping to deflect a spate of criticisms and lawsuits. But the ploy bought us months of peace, during which we moved fast. Huxtable had pressed me on the issue of encroaching into the park, and I had assured her, "We have to deal with the park with utmost sensitivity. Anything we build will be, in some manner, a sympathetic extension of the park, a blend of landscape and building."

Roche explained that he wanted to organize the collections and the space around certain "turning points in the history of man that are like tremendous anchors, around which works of art revolve." I had no clear idea what he was talking about, but I grinned when I saw Huxtable nodding her head approvingly.

I finished the press briefing with my now habitual flamboyance: "This building is a work of art. Archivists are doing research on the main hall now. It will be cleaned, restored, and lighted as great architecture. We can't replace the thirty-two bronze urns that were melted down for the war effort, but the doghouse at the entrance will go. This plan is for our future. We will be going through a massive reappraisal for changing times, needs, and objectives."

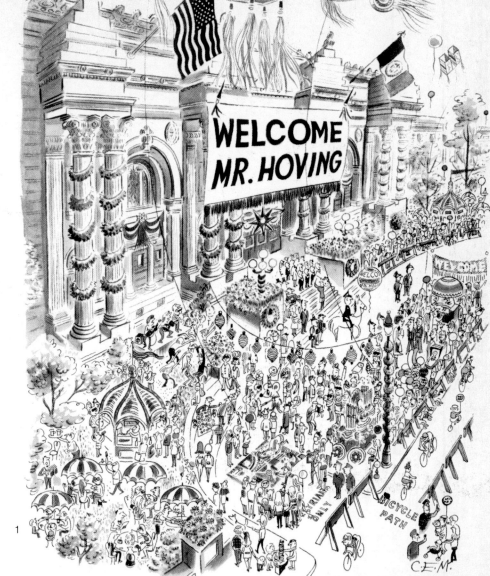

Drawing by Charles E. Martin; © 1967
The New Yorker Magazine, Inc.

A *New Yorker* cartoon heralded my arrival—and inspired the exhibition banners that became a Met tradition.

When I told Mayor John Lindsay *(at right with his wife Mary)* that I was resigning my post as New York City's Parks Commissioner to become the Director of the Met, he predicted I would "make the mummies dance."

3

Roland Redmond *(above left)*, former president of the Met, made life unbearable for my predecessor, James J. Rorimer *(below with his wife Kay)*.

Arthur Houghton *(left)* and C. Douglas Dillon *(right)* served consecutively as Chairman of the Board. Houghton was a dreamer who envisioned the museum's centennial celebrations, and Dillon wanted to run the place like a well-managed corporation.

5

6

Joan Payson *(above)* was a clever, generous trustee. Her favorite place to talk business was the nightclub El Morocco.

Brooke Astor *(right)* picked me for the job and was a great supporter—and a political sharp-shooter on the board.

Charles and Jayne Wrightsman invited Nancy and me on a lavish Adriatic cruise. Cecil Beaton shot this photo in Dubrovnik. *(From left to right)* Katharine Graham, publisher of *The Washington Post;* Nancy; collector Bill Blair; his wife Deeda; myself; and Jayne and Charles Wrightsman.

7

8

John Pope-Hennessy, then the director of London's Victoria and Albert Museum, vied with the Met for the dramatic fifteenth-century brass lectern. The Met won. Later I persuaded Pope-Hennessy to become curator of paintings.

In 1967, the Met purchased Claude Monet's masterpiece, *La Terrasse à Sainte-Addresse*, for the then-shocking price of $1.4 million.

2

Only four years later, Dillon and I approved the purchase of Velázquez's *Juan de Pareja* for $5.4 million. Theodore Rousseau *(below left)* curator of paintings, my dear friend and second-in-command, and Hubert von Sonnenberg *(below right)*, the painting conservator, helped convince me it was worth it.

14

3

15

16

Henry Geldzahler, curator of Twentieth-Century Art, wasn't thrilled when I chose to exhibit Jim Rosenquist's monumental *F-111 (above)*, and I wasn't happy with his work on the "New York, New York" show *(below)*, which enraged critics and blunted his reputation.

17

Wen Fong, curator of Oriental Art, a true gentleman and scholar, spent enormous sums for C. C. Wang's collection of Chinese paintings, including *Summer Mountains (above).*

Joseph Noble *(rear center),* Operating Administrator, made headlines by "proving" the Met's famous Greek horse was a fake—but subsequent tests showed it was genuine.

19

20

21

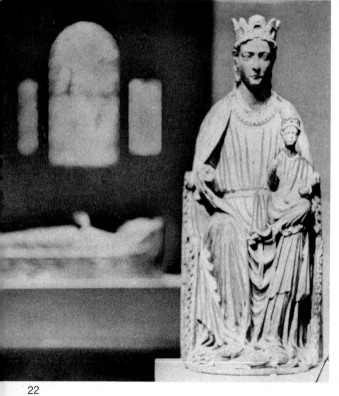

22

I brought the "blockbuster" exhibition to the Met, including "The Great Age of Fresco" *(above)* and "The Year 1200" *(left)*, but designer Stuart Silver *(below)* brought them to life.

23

24

The Met's theatric exhibition "The Art of Fashion" *(right)* was the museum's first fashion show.

The Andrew Wyeth show *(left)* drew attacks from conservative critics and little in the way of donations from its sponsor, movie mogul Joseph E. Levine.

25

Nothing prepared me for the outcry over the controversial "Harlem on My Mind." Some of the trustees wanted me fired, but the Black Panthers loved it.

26

27

28

I wooed trustee Robert Lehman *(above right)* to donate his collection of Old Masters and Impressionist paintings and to build a pavilion *(left)* to house it.

30

Arthur Rosenblatt *(left)* and John Dinkeloo helped resolve the museum's plan for expansion.

29

Vice-President Nelson Rockefeller *(above)* gave the Met his beloved collection of Primitive Art and promised to pay for the construction of a new wing.

Douglas Dillon with Clara Mertens, donor of the Musical Instruments galleries, an "angel" who wanted to see her husband's name inscribed on the walls.

31

32

Lila Wallace *(right)* of *Reader's Digest* fame and funds, the single most generous and unassuming donor in the museum's history.

Dr. Arthur Sackler *(left)* gave $3.5 million for the building of the Temple of Dendur *(below)*.

33

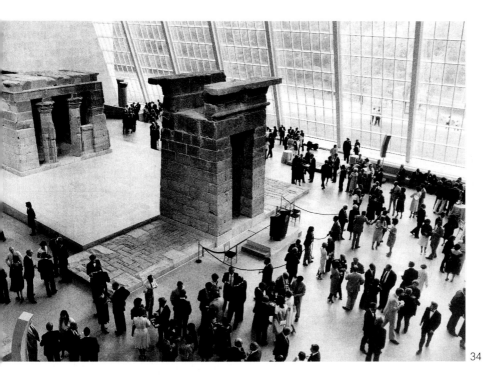

34

A model of the north wing, part of my master plan to expand the museum.

35

The Met's centennial celebrations drew star-studded revelers. Barbra Streisand asked for a personal tour through a fashion gala.

The eccentric donor, Florence Gould, swept through the Egyptian rooms wearing her signature purple glasses.

37

The imperious nabobs of ancient Cyprus undisturbed by chic New Yorkers, sixties-style.

38

The Grand Staircase
made for great entrances.

First Lady Pat Nixon
came to the opening of
the Centennial's banner
show, "19th-Century
America," and was given
a tour by the exhibitions
curator, Berry Tracy
(*far right*).

40

The Egyptian Wing was
transformed into a
nightclub on the Nile by
interior decorator
Angelo Donghia.

41

42

Jacqueline Kennedy Onassis at Pavlovsk. The Soviets wanted to call her Mrs. Onassis Kennedy and allowed her to wear Czarina Alexandra's white swansdown opera costume.

44

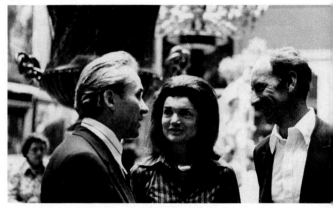

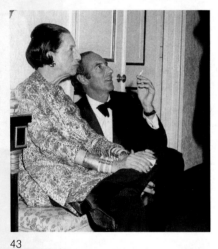

Diana Vreeland, one of the finest curators the Met ever had, organized the blockbuster show "The Glory of Russian Costume . . .," and Mrs. Onassis was a persuasive negotiator on our behalf. She delighted Victor Suslov (left) of the Hermitage and insisted that the sleigh of Princess Elizabeth with its velvet lap robe (below) be allowed to come to America.

43

45

The brilliant but restless billionaire Walter Annenberg wanted to give the museum $250 million for an educational center, but was foiled by critics of the plan.

From the moment I saw the Euphronios krater in a restorer's garden in Zurich, I knew the Met had to have it. I was dazzled by its beauty and the asking price of $1.3 million. Curator Dietrich von Bothmer *(right)* knew it was a priceless treasure, but questions about its provenance earned it the name "the Hot Pot."

47

48

Even though I did more of the leg work, "Tut" made its first stop in America at the National Gallery in Washington, D.C., where my archrival, J. Carter Brown *(far right),* used his political connections to steal away some of the biggest shows.

49

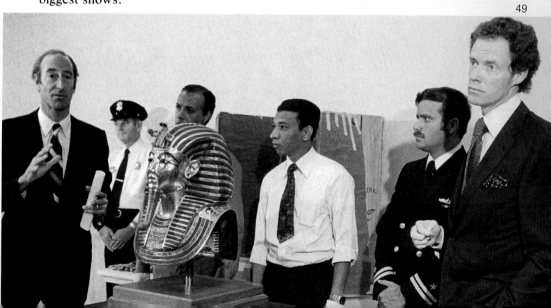

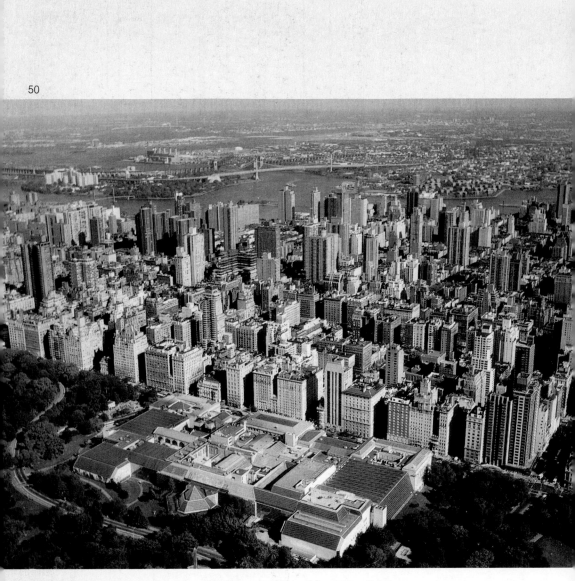

The Metropolitan Museum of Art

I thought the announcement marked the beginning of a grand new phase, but actually it was more the beginning of a struggle that would embroil the Metropolitan in the worst turmoil in its history. A day after the press conference the most articulate Parks spokesman weighed in against us. He was the lawyer Robert Makla, a man who could massacre you with respect and righteousness. He had been an important ally when I was at Parks. When I left the department, Makla had called me "a man of historic importance in all of New York's Parks." He was, he kept telling me, one of my "lifelong admirers."

With the announcement of the master building plan, he became my most tenacious foe. Several weeks after the press conference and just before the museum's annual corporation meeting, Makla attacked, first in a letter to the *New York Times* and then by contacting a number of my park-loving board members. Word spread that I had stopped "saving" the park, that with my expansion plans I had sold my soul to the director's post and the museum's social glitter. None of this ever appeared in print or on TV, but it was like rust, silently corroding my reputation.

Makla's letter was a classic piece of propaganda and became the doctrine against the museum. He attacked at our weakest spot, equating our desire to expand the museum into Central Park with a dangerous change of policy, away from establishing beautiful satellite museums such as The Cloisters, which had so blessed the area around Fort Tryon Park. Makla praised me effusively for having gained Dendur and condemned me for not wanting to place it in some other part of the city, along with all our Egyptian holdings and Cleopatra's Needle, and thus create the nucleus for a new cultural center. He raised the flag of decentralization and pledged allegiance to it. He wrote, "Cultural decentralization is the only worthy policy to pursue today . . . entire communities are still untouched by the cultural explosion which has enriched Manhattan while the museum's stupendous ten acres of buildings, stretching from 80th Street, saturate Fifth Avenue with art."

He pointed out with some emotion that the park was threatened on all sides and stated that the park's creators had deeply regretted the intrusion of the museum "as an offense to the free, open space which the city paid dearly to build." Makla closed with another compliment, saying that the Met was surely fortunate in having me at the time when expansion was contemplated because I was such a

park lover. "James Rorimer's collaboration with John D. Rockefeller Jr. produced The Cloisters. Mr. Hoving's greater opportunity is at hand to shape the future of the city itself."

Ada Louise Huxtable reversed herself and wrote an ominous editorial.

"What has been raised is a much larger issue—the way the Temple could be used to enrich the city far beyond making it one more jam-packed treasure in Fifth Avenue's awesome super-mart of art. . . . It is not enough, today, for the museum merely to keep clutching newly accumulated glories to its ample bosom. . . . The 'rethinking' of the museum's collections that is to start the Metropolitan's expansion program should start right here."

Arthur Rosenblatt said she'd turned into an enemy. I tried to calm him, but he said I'd be crazy *not* to worry. He claimed I was losing my political nerve ends, my acumen, now that I'd come to the "enemy." I reminded him that he was now the enemy, too.

"I know, I know," he cried out and then laughed. "Hell, we can do it. Just get moving, Hoving!"

He was right, I realized. No matter what rationalization I was bringing to the thrill of expanding the museum beyond anyone's imaginings, I had—in a sense—sold out the Parks Department.

Bobbie Lehman was as disturbed as Rosenblatt. To allay his concerns, I brought Kevin Roche to One William Street. He was surprised at the modest office, and his eyes kept darting to the old, dirty air-conditioning unit that was shuddering in the frosted-glass single window. Lehman smiled wanly at Kevin and me and then dropped a bomb.

"I appreciate all the efforts you have made on my behalf—my chairmanship and the nomination of Andre Meyer to be a trustee—but before I make the final decision on my collection, I must tell you that I insist my works must all be kept together in a separate series of galleries—never to be moved around—and I also insist that the feeling and appearance of the space I have provided for it be reproduced in the Metropolitan."

I didn't hesitate. "I pledge it will be done." Lehman produced a photograph of the townhouse. Roche stared at it and his knuckles got white.

Lehman produced a large, leather-bound volume. "Here are pictures of my galleries." Roche turned the pages as if in a trance. When he glanced at me, there was pain in his eyes. He mumbled,

"Mr. Lehman, it's an honor to meet you, and all this bears thinking. I must excuse myself. I have an appointment back in my office—near New Haven." He shook hands and was off. Later on, Roche would describe the moment as one of the most shattering in his career. "Here was Hoving," he would say, "twittering away like a crackpot, and I am looking at this stupid tenement with a fake French facade and 'rich-man's' ugly interiors with red velvet and blue-flocked fabric and pedestrian plaster moldings, and this little character is smiling like the Cheshire cat." Roche drove back to Hamden and practically collapsed when he got there, hardly daring to tell Dinkeloo what had gone on. Finally Roche told him, and Dinkeloo just laughed. "Take it as a challenge," he told him.

I hadn't noticed the extent of Kevin's distress. The idea that the willful financier might want to recreate his galleries didn't strike me as all that odd. My Cloisters training came to the fore once again. The thought of a few period rooms didn't faze me—even if they were only five years old instead of five centuries.

When Bobbie and I were alone, he dropped another bombshell.

"I want the planning for my museum within the Met to be the highest possible priority. You can understand that. I am not feeling as well as I did a few months ago. I want this done quickly. I personally want to see what your architect comes up with. Only then will I say yes. *And,* of course, I must have written assurance that my works will always remain in one place. Yes, and another point—a minor one—I will want the Lehman Foundation board to be able to decide how moneys are to be allotted. What are we going to call it?"

Without thinking, I said "The Lehman Pavilion!" But even before the words came out, I was afraid he'd think it would sound too much like a hospital wing.

"Yes! The Philip and Robert Lehman Pavilion. How soon can the plans be drawn up?"

"Bobbie, I have no money. The Executive Committee voted—a couple of days ago—only twenty-five thousand dollars."

"How much money might it take to plan *my* pavilion?"

I had no idea. I was wishing Roche was there.

"One hundred and fifty thousand dollars ought to do it," I ventured. "I'll ask the board to vote the money at once."

"No!" he said. "This has to be kept a secret."

He went to his desk, wrote out a check, and handed it to me. It was for a hundred and fifty thousand dollars, made out to me.

131

"There's the money. Deposit it in your personal account and draw checks as necessary to the architect. Of course, I must have an accounting of the expenditures."

"Bobbie, I can't do this," I said. "What's my accountant going to say? This may not even be *legal*. What will my bank say? I have less than five hundred bucks in my bank account. Bobbie, I can't!"

"No one on the board must know about my donation. Someone will cancel the pavilion if it's known I'm behind this money. Take the money. It's a gift."

I collapsed on his tiny couch.

"This is crazy. You've got to do it my way. Bobbie, please tear this up. Write out another to the Met. I'll see to it that *only* Arthur Houghton knows—after all he *did* make you chairman. And we'll state in the board minutes that this is an anonymous donation for, call it, Project X."

He smiled. "You're right. I'm being childish. Tear it up. Make it Project X, then."

We shook hands and I left the Lehman bank dancing a jig.

––––––––––

Of course, life as director of the Met was not all euphoria at the landing of one of the greatest collections ever formed, or gallivanting around. There was the burden of housekeeping chores—thinking up exhibitions, raising funds, recruiting. I had been able to find a replacement for Kenneth Loughry in Daniel Herrick, affable and unflappable and brilliant with numbers. He established a system of paying the employees by mail or directly to their banks, doing away with the time-consuming and humiliating procedure in which the staff had to line up at the assistant treasurer's glass window to receive their checks.

I also promoted my special assistant, Harry Parker, to the exalted post of chairman of education, replacing him with young Jim Wood, who would go on to a distinguished career as director of Chicago's Art Institute. Parker would eventually become director of the Dallas and San Francisco museums. I finally found my Cloisters chairman, a Swiss specialist in medieval manuscripts, Florens Deuchler, an apple-cheeked, enthusiastic scholar-teacher who was dedicated to my dream of making The Cloisters into the center of medieval art studies in the country. Another appointment I found personally satisfying was a Sicilian who had worked in the excavation I had partic-

ipated in back in 1956. Filippo Suffia suddenly showed up in my office begging for a job. We got him working papers, and eventually he became head of guards. I liked the way he saluted me when I passed his post.

In those days I was interested in anything that made a news splash or changed the public perception of the stodgy, gray old lady of the Metropolitan Museum of Art, whether in statements to my colleagues or flamboyant exhibitions or, the most fun, acquisitions.

The exhibition schedule of 1968 opened with "The Art of Fashion," which was praised by the *New York Times* but heavily censured by *Women's Wear Daily*. The galleries were laid out chronologically and showed off the best of our own Costume Institute collections. The final large hall was devoted to living designers chosen by our consultant Eleanor Lambert. The night before the opening I was working late and decided to have a quiet, appreciative view of the show. I heard this strange bumping and scraping sound in the last gallery, and when I peeked in, I had to suppress a laugh. There was Lambert pulling and wheeling, rearranging mannequins so those garbed with the clothes of her clients just happened to be in front.

I was on the road almost continually making speeches—to school groups, the members' organizations, professional groups. The two most important of the latter were the American Association of Museums and the Association of Art Museum Directors. The last was a snobbish club to which directors had to be invited—even if one happened to run the largest institution in the country. I looked upon the organization with disdain. I was surprised that the group bothered to elect me and had thought of not accepting. The first meeting was in Houston, where I was snubbed by the more conservative members like Sherman E. Lee of Cleveland. I distinguished myself by blowing up at a meeting on the final day. I had learned that the social club had no bylaws, had never formulated any goals, and had never lobbied for the aims of art museums despite its tax-deductible status. I told the membership that unless the organization was given a professional footing and ceased to invite its members, I would quit. The AAMD changed its ways, but I was never to feel welcome.

I was more friendly to the AAM, which at least had a hard-working Washington lobby. I gave the keynote speech in New Orleans urging them to get in the swim. I called upon the organization to become relevant and for museums to throw their weight into the task of

curing the agonies of the nation—"to help soothe, humanize, provide reason, sense, a balance of quality to the process of cure." What other role was there for art museums, I asked, especially since museums had been called the "midwives of democracy"? The progressives applauded, and the conservatives, after hearing my dangerous words, lashed out at me from that time on.

I am not sure who came up with the idea to mount a week-long public seminar on art forgeries—perhaps it was one of those flashes sparked off in one of the regular Monday staff-policy meetings. Harry Parker was highly enthusiastic about the idea and started organizing an event to be held in the fall.

Several years before, Joseph Noble had proved that the museum's vaunted terra-cotta Etruscan warriors were modern fabrications. He was keen on exposing some of the other well-kept forgery secrets. Up to that moment, the Met's policy about fakes was to brush everything under the rug and hope the press wouldn't find out. Unfortunately, the press often did. As soon as the idea for a forgery seminar came up, Noble asked to talk to me "in deepest confidence." He spoke in a low voice, all but peering around in my office to avoid eavesdroppers.

"I know—and no one else knows—the most important fake in the *world*. Now's the opportunity to expose it," he said. "It's one of our most prized objects, and my revelations will cause a scholarly explosion."

He told me that only six months before, he happened to be walking through the Greek and Roman galleries on his way to his office when he glanced at the little, world-famous seventh century B.C. Greek bronze horse.

"Suddenly, I noticed a *line* in the bronze running right down the center of the forehead through the chest of the creature. That line proves the horse is not authentic."

"The great Greek *horse?*" I cried out.

"The line—actually a minuscule ridge line—proves the bronze was made by a sand cast. In ancient Greece there were no sand casts. Bronzes were all cast by the lost-wax technique!"

He was positive about the meaning of the line. He had persuaded his friend Dietrich von Bothmer to remove the statuette from exhibition so they both could examine it. Von Bothmer had agreed with Noble's assessment and, of course, had kept quiet about it.

"Imagine the Greek horse as the focal point of the seminar—to be

announced by me the first day!'' he said. "It'll make the front page of the *New York Times*." Then Noble became even more conspiratorial. He thought he knew who the forger was. He had confronted the man about the horse, and the man had "turned white." Noble named the famous American realist sculptor of the 1930s Paul Manship. "In the twenties he had been in Paris as a sculpture student, and he *did* make some pseudo-Greek and Roman bronzes. I asked him what could he tell me about the Greek horse, and he said, 'I cannot! I cannot!' Interesting, eh? It fits. I looked in the files of the department and guess what? It was Paul Manship who brought the horse to the attention of the dealer who sold it to the museum.''

I congratulated him and promised to make the horse the star of the seminar. Afterwards, very quietly, I began to research the bronze. I thought about Noble's theory and examined the horse in the storeroom, but I couldn't shake my gut feeling that it was ancient. But I decided I'd let Noble take center stage and then if the horse turned out *not* to be a fake . . . well, good-bye Joe Noble.

Two weeks before the forgery seminar, I found in my mail a Christie's sales catalogue, and on its cover was an illustration of a painting that I had encountered and coveted years before. And now it was to be sold. Claude Monet's *Terrasse à Sainte-Adresse* was lot number one.

I had stumbled on the masterpiece in 1960. The Reverend Theodore Pitcairn, its eccentric owner, whose father was a founder of the Pittsburgh Plate Glass Company, had built a series of garish stone mansions and a huge "church" in the fashionable Bryn Athyn suburb of Philadelphia. He was the pastor of the church dedicated to the Swedenborgian faith. Jim Rorimer had ordered me to visit Pitcairn to give my opinion of some medieval sculptures and stained glass the reverend had acquired in the thirties.

I had gone expecting a modest, private chapel and was amazed to find a minicathedral, in fine granite, as superbly crafted as any French Romanesque church, with a transept that soared sixty feet to a vault, built for a congregation of one, Pitcairn.

He was a stringy-looking, white-haired man, old for his age of late sixties with sallow, caved-in cheeks and a doleful pair of eyes. He waved his hands to the expanse of the cathedral and mansion combined and said, "Have a look at whatever you like."

The stained glass was decent Austrian or Rhenish, thirteenth to fourteenth century. The sculptures were not much. I had made notes

in about a half hour, and I found myself alone in that sepulchral space. The next train was in hours. I had plenty of time, so I wandered up the majestic stairs and through Mr. Pitcairn's bedrooms and salons. In one I spotted a startling portrait by van Gogh. In another there was an excellent El Greco, of Christ on the Cross with Toledo in the background. In an empty guest room, there was the finest painting of all—like a blaze of light and a fresh sea breeze—a joyful depiction of two people sitting on chairs and two others strolling, one holding a cream-white parasol in a lush garden by the sea whipped by the wind into chilly whitecaps. A sailboat race was in progress. Four banners snapped on flagpoles. The garden was choked with ripe, red flowers and bowers of greenery. The painting was signed and dated by Claude Monet—1867. I sat down on the bed and stared at it for what must have been an hour. Finally, I pulled myself away and left, but I never forgot that glowing picture.

Now, I had a shot at it.

When Rousseau saw the catalogue, he said, "It's *more* than a Monet—this is a great landmark in the history of landscape. I remember it very well . . . from the Monet show William Seitz organized at the Modern in 1960."

"Let's go for it."

"Sure. But let's see it, first."

"The price will probably be near a million and a half," I said. Christie's high estimate was $1.2 million.

Rousseau shrugged.

"We don't have the money," I reminded him.

"Well, now's the time to pass the tambourine, isn't it?" he said.

We saw Arthur Houghton that afternoon at Steuben Glass, and he urged us on. "We need a canny professional to handle the auction for us, someone who has his ear to the ground in London . . ."

I had thought Ted or I would pop over and do the bidding to save commission money.

"We definitely need a pro," Houghton insisted. He recommended Geoffrey Agnew of London and urged we sign him up. Reluctantly, we did.

Three days later—November 17—Rousseau and I arrived in London at dawn. I insisted on a three-hour nap: I wanted to be rested and fresh when I saw the painting. At eleven in the morning we met at Christie's and went up to the office of the chairman, Sir Peter Chance, a dull, red-faced Britisher with one of those upper-class

stutters. I had hoped to see the painting alone and incognito. Ted had scoffed. What difference did it make, he said; every museum director in the world with any money would be waiting in line. And he was right, of course.

I was expecting a plush, velvet-lined chamber, but this was England. The masterpiece was hanging in a tiny, musty room in the attic. It was almost impossible to see it. We could step back only about five feet, and a virtual flood of light raked across the picture from a large window directly adjacent, all but obliterating it. I couldn't believe Christie's would show such an important work so poorly. I found another, larger room nearby and suggested to Ted we simply move it. We carried the masterpiece across the threshold and set it on the floor.

The painting came alive in a rush. Where the colors had seemed flat and lifeless in the raking light, they suddenly snapped into lyrical harmony. The sunlight dazzled. The sea moved. The view across the water to the flotilla seemed endless. I saw a work of art transformed from mere paint into what I can only describe as an overpowering slice of nature.

We spent the rest of the day looking at Monets in galleries and museums and had to agree that the *Terrasse* was easily as good as any Monet in London and not far away in quality from the finest Impressionist painting in the city, Manet's bravura *Bar at the Folies Bergères* on display in the Courtauld Gallery.

On Sunday, we flew to Paris for the day to compare the *Terrasse* with the bounty of Impressionists in the Jeu de Paume. Only *one* Monet, slightly later in date, seemed to be of equal stature. Even in the rush, Rousseau had done some research on the painting. The pennants belonged to the Spanish royal family, who were vacationing at Sainte-Adresse. Monet, only twenty-seven, had painted his landscape confident that the jury of the official Salon would be impressed by the vivid colors of the sunlit out-of-doors. The year before, 1866, he had enjoyed a success with a portrait of his model and mistress Camille Doncieux. But the jury had rejected the *Terrasse,* and the critics had attacked it. Monet had been so despondent that he had contemplated suicide and had never again painted in the same flamboyant, almost brutal manner.

In New York I made my presentation to the Acquisitions Committee, trying to be as exuberant and upbeat as the painting. "As Monet himself said about the *Terrasse:* 'I threw myself *en plein air* with

body and soul. I was trying to do something that was a dangerous innovation, effects of light and color and the *full outdoors* that shocked accepted customs.' "

I projected a fresh slide so that the *Terrasse* appeared on the screen exactly life-size. Joan Payson said, "I love it. How much do we have?" Houghton explained that with the funds "in the kitty" and with the amount he felt safe in borrowing from the endowment, there was only half a million dollars. There was silence.

"What will it take?" Payson asked.

"One million four hundred thousand dollars," I said. Agnew had advised that as an upset figure.

"I pledge two hundred," said Lehman.

"I'm in for three," said Joan Payson.

"I suppose the president should do the same," Houghton said.

The rest of the money was raised within four days.

Houghton and I badgered Agnew several times a day about the bidding strategy. We decided to sit quiet at first, then enter at a million dollars—Agnew believed a late, strong entry would unsettle our opponents. I started rumors that we would not be a contender—after all, we already owned a Monet, also from Sainte-Adresse, dated 1866. A day before the sale Houghton seemed to be having second thoughts. Had I gotten the opinion of William Seitz, the Monet expert, he asked. I called Seitz and he wrote, "This is a *must* for the Metropolitan, an epoch-making picture, pure, tense, strong, intense. It would be a magnificent acquisition." With that, Houghton felt encouraged, saying "because if we win this thing, we're going to catch hell for this—hell!" He phoned the members of the Acquisitions Committee and some of the "friends" who had put up the money to ask one more time for their final approval. An irate Joan Payson called Rousseau to complain, "What *is* wrong with that man?"

The day of the sale—a Friday—I fretted, certain that we should have gotten approval for a million five. The sale was in the evening and by two-thirty in the afternoon New York time, seven-thirty in London, we had heard nothing. I was certain we'd lost out. I was in a meeting about some minor budget matter, and I couldn't concentrate. My secretary came in and handed me a note. It was from Ted. "The picture went for 1.4. Congratulations."

To my delight, the *New York Times* ran a front-page story on the record sale, accompanied by a photograph of the Reverend Mr. Pit-

cairn gazing wistfully at the canvas. The headline was: "$1.4 Million Paid, Possibly by Hoving, For Monet Canvas."

I had hoped we would not be suspected. The great forgery seminar was about to start, and I didn't want the news about the Monet to blunt the publicity.

Agnew called, bubbling with excitement. "What a drama! I had no idea so many people could fit into that little sales room. Imagine, a picture going for 588,000 pounds which Monet had sold for 17 pounds because he needed the money! Our strategy worked. I allowed the two—I think there were two others—bidders to believe *they* were in a dual competition, and then I pounced from the back of the room. It was over in seconds. For the past two days I've been able to keep the purchase secret. I shall go on denying, but it's getting difficult."

I decided to break the news to the press, feeling it would be dumb to continue the charade. I instructed Agnew to ship the Monet by air on Monday and told Rousseau to get it on view as soon as possible. We toiled over the press release, especially since Arthur Houghton had become even more nervous about the huge amount of money we had paid. His anxiety made me overreact. So, our announcement was pathetically defensive, even shrill in its boosting of the picture —Ted Rousseau called it "the beginning of modern art"—infuriating a number of critics.

The same day we announced the Monet, Joe Noble marched to center stage of the Grace Rainey Rogers Auditorium, and before a full house of enthralled scholars and visitors, whipped aside the black velveteen cloth covering the "Greek" horse on a pedestal. By comparing technical slides of the object and true Greek horses, Noble showed the museum had been classically duped.

The day after the explosive Monet story, the *Times* ran an enormous front-page story on the fake plus a man-in-the-news box, "Museum's Detective, Joseph Veach Noble." With the stories on the horse and the Monet, the Metropolitan became the biggest, richest —and loudest—museum in the cosmos.

And I was furious. Not just because Noble was getting star treatment, but because now I would never be able to get rid of him.

A few days later the associate conservator for objects, Kate Lefferts, asked to see me "in confidence." Kate, a bluff woman in her early fifties, had worked at the museum for over twenty years. I admired her.

"It's about the horse—and Noble," she said. "You know he hardly let any one of us in the conservation studio examine the piece. He's so sure, so arrogant!" Her voice dropped to a whisper. "But he's wrong. Tom, you've *got* to keep this a secret. And you've *got* to give me and my team permission to study the horse—to prove him wrong. I beseech you. I know you'll support us. He's dead wrong!"

"Why?"

"The horse is *not* a sand cast. The famous Noble 'line' that proves the piece was made in two pieces is not an ancient line. The line comes from *our* casting the thing to make reproductions for sale. What I know, which Noble doesn't, is that the horse was heavily waxed, back in the late twenties, to protect it to make our reproductions."

The scrutiny took a very long time, and the results weren't announced until five years later. The horse was irrefutably ancient: a thermoluminescence test proved it. But it was not archaic Greek. It was, amusingly enough, in all likelihood a Roman fake of a Greek original made for the gullible Roman art market perhaps during the time of Hadrian.

The Monet and the forgeries opened up a hornet's nest. We were accused of everything from "making a spectacle" out of the museum, to "hype," to buying a "mediocre Impressionist." The last attack disturbed me more than any of the assaults. Had I been led astray on the *Terrasse?*

One evening I waited in my office until the museum had closed and all the employees had gone. Only the night guardian staff patrolled the empty galleries and corridors. I walked for several hours through the huge, incredible super-mart of art, reflecting on what it was, what it meant, who I was, what I wanted to become. It was the first reflective moment I had experienced since being sucked into the whirlwind of the "contemplative life of scholarship," as I had once described my life-to-be as director. I ended my tour with the gallery where the *Terrasse* was hanging. I peered at it defiantly. Are you any good? Or, are critics Kuh, Canaday, Kramer, and the slick detractors right? I challenged the picture itself to provide me with the answers. Every time I tried to denigrate it, the fresh, bold, odd painting struck back. Its essence was a cry of joy, a disruption—all that was what young Claude Monet was seeking and had achieved.

The next day I called a meeting of my "cabinet," Rousseau, Harry

Parker, George Trescher, Rosenblatt, and Noble. I described my experience the evening before and said: "The painting's great. The critics are full of crap. I am not going to slow down on the publicity. We ought to increase it. The only way we're going to get this museum imbedded in the public imagination—and public affection—is to talk, talk, talk and proclaim, proclaim. I don't think we ought to bother *fighting* the critics. Let's just steamroller them. The public will be on our side, and we need *them* to win. This revolution I want to pull off around here *is* a fight. So, let's charge. Blow the dust out of this place. And to hell with the critics!"

10

"YOU'LL NEVER
SEE THEIR
LIKES AGAIN"

What better way to tell the world that we were blowing the dust off the old gray museum than to establish a department of contemporary art and abolish the policy that forbade one-man shows of living artists (a policy broken once to allow the exhibition of the paintings of Winston Churchill)? Henry Geldzahler had effectively lobbied to split his department away from American Paintings and to lift the restriction on living artists.

Days after the word had gotten around town about the stunning new direction the museum was taking, Robert Scull came to see me and took me up on a suggestion I had made idly and forgotten. It was to show James Rosenquist's mammoth painting entitled *F-111* at the Met. Scull bulled into my office and pronounced, "It's all set. We'll lend the *F-111* for that show you talked about a while back. You know I think you're going to get roasted by the critics. So what! They're assholes. I'll lend it with two provisos. First, Rosenquist gets to hang the painting himself. Second, I want to be involved. Whadda ya say?"

I didn't say anything.

"Hey, Tom, this isn't the beginning of the old curatorial fakeroo, is it?"

"When I make a commitment I stand by it," I murmured. "It's just that I want the picture shown in the right way. I'll let you know in a day or two what I plan to do."

In fact, I felt ambushed. Yet I still felt the painting was important enough to enter the collections. Geldzahler was away so I had to make the plans for the show myself.

The work—eighty-six feet long, ten feet high—depicted the controversial fighter-bomber in profile surrounded by and interrupted by a number of bits and pieces of contemporary civilization, all painted in billboard-bright colors, ranging from a close-up of an automobile tire, to some light bulbs, to a three-year-old girl under a chromium hair dryer, to the hydrogen bomb, to air bubbles emerging from a scuba diver's mask, to some wet spaghetti. No matter that it was a mélange of images, *F-111* was a history painting, like those of the Renaissance and the nineteenth century.

My idea was to show the *F-111* along with a few classic examples. I called Rousseau to ask how many traditional "history paintings" we had in the collections. There were many. By the end of the day we had come up with three rather startling comparisons. One was Jacques-Louis David's *Death of Socrates,* showing the philosopher drinking the fatal hemlock with his followers huddled around him. The second was Nicholas Poussin's colorful *Rape of the Sabine Women*. And the third was a sketch by Emanuel Leutze for his *Washington Crossing the Delaware* (the painting was on loan to a small museum at Washington's Crossing in Pennsylvania). Like the *F-111,* each picture was a contrived and exaggerated moment in history.

Scull was enthusiastic about the idea, so I invited him to write an article for the members' bulletin. I took the precaution of tracking Geldzahler down. Scull and Rosenquist both wanted the painting displayed as soon as possible, I told him. Henry said, "Go ahead. I don't know if I'm all that much in love with Rosenquist—he's the weakest link in the pop chain. But the idea is fascinating. Does this mean that the *director* is going to invent every show in my department?"

"Henry, I don't want to 'invent' anything. But I do hope that I've got the right to be an opportunist when it comes to hooking a potential donor. I want that picture. *And* the Warhol and a few other pieces."

The show went ahead, but it had to be jammed into the only available gallery, a chamber near Gothic sculpture.

Scull's "article" recounted his first meeting with the artist in 1961, "an ill-at-ease ex-North Dakotan of about twenty-eight who spoke in a painfully abstract manner." Until recently, he had made his living as a billboard painter. Rosenquist had shown him three recent canvases. All were figurative, but Scull found them unlike anything he had ever seen. One large canvas in acid-bright colors, entitled *The Light That Won't Fail,* juxtaposed a large part of a television screen, part of a Spam sandwich, and the profile of a girl's mouth, chin, and neck.

Henry Geldzahler wrote an essay on pop art, including a tribute to the *F-111.* "Is it art? Will its impact last?" and answered himself, "For the moment the painting makes a big statement and makes it convincingly."

The gala opening mixed elderly museum members, young mini-skirted socialites, and the stars of the pop movement. The Sculls hosted a dinner for fifty at their nearby apartment. And after dinner hundreds more made the trip downtown to Bob Rauschenberg's studio and danced until early morning. The art press gazed open-mouthed at the epic-sized *F-111,* the David, the Poussin, and the Leutze and got very upset.

Hilton Kramer in the *New York Times* called the *F-111* "irredeemably superficial." The critics' acid feelings were more than matched by the show's visitors. We had hundreds of letters and phone calls of protest. "Debauched and dilettante," "the Skull horror," "a purely repulsive waste of canvas!", "garbage" were some of the assessments of this "milestone" of civilization.

Arthur Houghton pretended to be unconcerned, but I could see he was rattled, worried that we might even lose members. He thrust in my face a letter from a certain Rudolph J. Heinemann, Ph.D., the "private curator" to the art collector Baron Heinrich von Thyssen —and one of the biggest stuffed shirts in town—denouncing the *F-111* as "against the interest of a serious art museum" and threatening that unless the policy of showing such works changed, he would neither give to the Centennial nor contribute "important gifts to the museum." Both Houghton and I tried to assuage him, but he never forgot or forgave. He eventually gave his personal fine collection of drawings to the Morgan Library.

When I thought the hubbub had died down, Nancy and I took off

for a four-day weekend at the Wrightsmans' Palm Beach house. On our second day Wrightsman asked me, "Shouldn't there be some sort of press embargo on curators?"

In my absence Geldzahler had made comments to reporters regarding the *F-111* show. "This adventure, forced down my throat by the director, is the kind of administration meddling that's damaging to the cause of contemporary art at the Met."

I tried to reach Henry in New York, and when I didn't, I found a more dramatic way than the telephone to tell him how I was feeling about him. John Walker, the suave, English-accented director of Washington's National Gallery, had come down to spend a day with the Wrightsmans. He remarked to me, "I imagine you've heard Henry's . . . ah . . . bold . . . statement. Under the circumstances, I don't suppose you'd mind if I picked him up. He's quite . . . ah . . . stunning, you know."

"Take him," I replied. "He's disloyal and opportunistic. I, of course, cleared everything about the show with him. Call Henry. Tell him I said that he should resign from the Met—at once."

Quite soon after, Henry called.

"I've been desperately trying to contact you all day," he said. "I'm horrified at the misquotations. I talked with Bob Scull and he knows these are misquotes, all a mistake."

"Fine, Henry," I said coolly.

"I thought you'd understand."

From that episode on, my relationship with Henry Geldzahler changed forever. I began to plan how and when—to get rid of him. It occurred to me that Tom Hess, the most perceptive modern art critic in town, might make a fine replacement.

I was also trying to blow the dust out of the board of trustees. But there, I was foiled. Houghton listened to my recommendations stonily and went about the business he believed was his alone. My principal candidate, Drue Heinz, was ignored, and Houghton's nominee, Mrs. McGeorge Bundy, was appointed. To me, Mrs. Bundy was all too academic and had rather a sour attitude about life. I had also urged Houghton to consider Estée Lauder, but his judgment was that she had been "too pushy," and he didn't like her "flamboyant cosmetics aura." But when I protested his selections, he told me that the board was not my business. Houghton believed, naively I thought, that appointing Arthur O. Sulzberger, publisher of the *New York Times,* would insure favorable coverage from the mighty paper.

My point was that having him would only aggravate the already touchy situation, for reporters and critics were not known for automatically going along with publishers and owners. I also complained about the trustee candidate Congressman Peter Frelinghuysen, a vapid descendant of the Havemeyer family, the grand donors of many of the museum's finest Impressionists. I had wanted his brother George, a passionate lover of art, albeit a somewhat eccentric one. Houghton wanted no eccentrics on his board.

Luckily, I made no complaints about Houghton's idea to create honorary trustees—or with his choices. They included Professor Craig Smyth of New York University's Institute of Fine Arts and Professor Millard Meiss of Princeton's Institute for Advanced Study. Meiss was an ebullient, outspoken expert in Italian painting of the thirteenth and fourteenth centuries. He was so pleased with his appointment that he came in from Princeton specially to thank me. "I'm going to call all my Italian debts to pay you back for this, and I have one helluva exhibition in mind."

A few days later an exultant Meiss called to tell me the show was the cream of the Florentine Renaissance frescoes. After the devastating floods in Florence, frescoes had been removed from church walls all over the city to preserve them. Meiss had convinced Florence's Superintendent of Antiquities, Ugo Procacci, and Dr. Umberto Baldini, the chief conservator who had saved many of the endangered frescoes, to send to the Met up to one hundred pieces dating from the fourteenth to the sixteenth centuries, most of them monumental in size.

But there were a few hitches. Although Procacci had the authority to choose the show, he had to tiptoe carefully through the mine field of Florentine academia opposed to sending *anything* artistic abroad —especially to America.

When the word began to filter through Florence that Procacci had lined up most of the officials in favor of the fresco show, opposition groups formed. I wasn't about to give them a chance: most Florentines had been dazzled by the help American scholars and institutions had given in the dangerous aftermath of the flood. Meiss had adroitly formed a committee of honor that included some potential troublemakers. By the time the professor had escorted Procacci into my office in March for an intimate lunch with Bobbie Lehman, Arthur Houghton, and Governor Nelson Rockefeller, Procacci told me he had obtained "absolute assurance" from his colleagues in Italy to approve sending us seventy pieces.

After our "summit meeting," I kept harassing everyone to act fast. I knew the Italians were fearful that things would bog down once the grand scheme had been achieved. Procacci had been vague on which seventy pieces were sound enough to make a transatlantic crossing. I had jotted down a dream list of every spectacular fresco by every famous name in the Florentine High Renaissance— Uccello, Bramante, Ghirlandaio, Masolino, Masaccio, Verrocchio, Andrea del Castagno, and Piero della Francesca. The weeks dragged on. There was nothing but silence from both Procacci and Baldini.

So I instructed Ted Rousseau to assemble a team, fly to Florence, and invade the cavernous Belvedere, where the conservation studio and storerooms had been established, and just grab what we wanted. Rousseau took the Paintings curator Claus Virch; Everett Fahy, a young expert in Italian painting; and designer Stuart Silver.

Within a week, Silver returned utterly in love with Italy—it was his first trip—and described the chaotic activities in Florence.

"The scenes in the Belvedere, a cold, drafty ancient building, were wild. None of the Italians knows what's going on, which is good for us. Hundreds of frescoes and fragments of frescoes are stacked helter-skelter on the floor or leaning, sometimes upside down, against the walls. It's a circus! I had the impression that everything was mislabelled, mismarked. Naturally, *only* the Italian curators and conservators could touch the stuff. Ted was marvelous! He'd walk around like a Medici prince in those great suits of his and point to something fabulous and say, 'Can we have this?' 'Sure,' somebody would cry out and would write down the fresco."

Silver had arrived at the train station and, lugging his bag, stopped in at every church and cathedral he passed on his way to his hotel. He had been amazed by the Gothic chapels with their delicate groin vaults and the subdued light which seemed to emerge from the fabric of the arches themselves. "You may think this is a bit crazy, but what I design may make this exhibition more memorable than the art." I looked at him doubtfully, and he whispered, "Believe me!"

By late spring we were all obsessed with the "Frescoes." George Trescher, the secretary of the Centennial, had taken command of the fund-raising for the exhibition so that he could "practice up" for the Centennial exhibitions. Trescher had been recruited by Roswell Gilpatric, and I found him bright, congenial, and refreshingly political. He was delicately handsome with a pockmarked face and sleek, light brown hair. He had a distinctive way of raising his eyebrows and abruptly throwing back his head when he laughed,

which was frequently, for he had an alert sense of humor and, at times, a wicked wit. I liked him and was wary of him, too. He was blunt, no-nonsense, and a pro. He'd been a Navy supply officer and for the past nineteen years had been at Time, Inc.—in promotion.

In a memorable three-hour brainstorming lunch, Trescher invented a new approach to corporate fund-raising.

"Let's *tailor* the show and its programs for the possible funder. Frescoes, what is it? It's Italian. It's rare. It's got a sense of *salvation* in it because of the preservation of these things from the flood. It's cultured. It's . . . the-likes-of-these-is-never-to-be-seen-again."

"What about Fresca," I laughed. "You know, the soft drink. The Great Age of Fresca!"

"Not exactly what I had in mind."

After several consultations with Italy's Consul General in New York, Trescher thought he had the target. Olivetti-Underwood. The electronics giant was creating a new image in Italy and wanted to make a significant presence in the United States market. The company was trying to project an image that was modern, beautifully designed, gutsy, part-traditional–part-contemporary: a high-tech organization with a humanistic point of view, dedicated to excellence, steeped in public service. Gian Luigi Gabetti, the United States president of Olivetti, was an ambitious intellectual and a financial wiz.

I was still trying to get the final list of frescoes together, but I suspected that we wouldn't know what we were getting until the cases were opened. The only definite pieces sounded spectacular— fragments by the fourteenth-century painter Orcagna, a fresco by Andrea del Castagno, plus a fresco by Andrea del Sarto. An incomparable fragment by Piero della Francesca was also a possibility. Trescher was less interested in the list than in what he would offer Olivetti.

He urged me to put myself in Olivetti's place. The company would be less interested in the specific works than in how big the name Olivetti would be in the promotional material and how prominent that name would be "on the marquee."

"If you're Gabetti," Trescher said, "you'd want to know how many times Olivetti will be mentioned—and praised—in the catalogue. You'll be interested in how many openings, dinners, and receptions you're going to get for your clients and executives and sales people. You'll want to know if the president of the United States is going to show up opening night. Can you advertise the show? How

long and strong will the publicity fallout be? How much press coverage will there be? Can he expect special stories in magazines like *Fortune, Business Week,* and the like?"

Everything Trescher said was on the mark. But I knew that to allow a company to push its image and its products on the back of the Metropolitan would cause an uproar in the art press. Would the agony be worth it? I came to the conclusion that the flak would *definitely* be worth it.

Trescher went to see Gabetti, gave him the pitch, and was told on the spot that Olivetti would put up the six hundred thousand dollars. When he outlined the package of privileges to be provided for Olivetti, Gabetti took them all, asking for only one additional, a supply of exhibition catalogues at cost. Olivetti planned a national ad campaign.

On the artistic front, however, little seemed to be happening. Ted Rousseau returned to Florence to assist Claus Virch. A few days later he telephoned, breathless. The final, final list had been settled on in a hectic all-day session. "I've been able to convince Baldini and Procacci to weed out the scraps and substitute them with truly grand pieces. It's going to be astounding."

There would be seventy frescoes and some dramatic *sinopie,* the Italian art historical word for "under-drawings." A mid-thirteenth-century Crucifixion measuring ten by fourteen feet. A Giotto fragment. An exceptional *Annunciation* by Ambrogio Lorenzetti; parts of a famous *Last Judgment* by Orcagna; an entire Gothic vault; *two* works by the early Renaissance master Andrea del Castagno; the head of an Angel by Piero della Francesca; a whole tabernacle by Benozzo Gozzoli, fifteen feet tall; nine dazzling frescoes by Andrea del Sarto; and, most precious of all, the *Annunciation* from Santa Felicità by Jacopo da Pontormo, perhaps one of the most beautiful Mannerist paintings in all of Florence. Ted's Telex was like the table of contents of some lavish art book on the masterworks of Florentine fresco painting.

I held a press conference to announce the show, hoping that the story would keep the Italian authorities working. The *Times* gave the story a nice play, but I should have kept my mouth shut. A number of top American art conservators formed an ad-hoc committee and, through Craig Smyth of the Institute of Fine Arts, sent me a snarl of objections. The roster of conservators included those from the Museum of Fine Arts in Boston, the Freer in Washington, the Isabella

Stewart Gardner Museum in Boston, and the conservators at the New York Institute of Fine Arts. The group, totally against the show, threatened to mount a public campaign in Italy to stop it. I was furious. None of the eminent specialists had bothered to find out which frescoes were coming or what their colleagues in Italy felt.

Smyth was sympathetic to the show but told me that if the committee's concerns were not immediately answered, they planned to hold a press conference. And *that,* I knew, would effectively kill the finest paintings show ever to come to the Met.

The committee raised several concerns, about vibration and the drying-out of the calcium calcinate in the glue that bound the frescoes to their canvas supports and changes in humidity. The only way to prevent the "greatest disaster in art history," they proposed, would be to apply a substance called mithacrilate to the surfaces of the frescoes. I begged the committee through Smyth to give me time to obtain answers from the Italian experts and not to go to the press until then. I got it.

The chief Italian chemist, Malagussi, muttered, "Sounds like their fresco experience has been limited." He and Chief Conservator Baldini prepared exhaustive scientific answers to why there would be no damage from vibration or humidity and why mithacrilate wasn't needed. I transmitted them to Smyth and had to suffer through a week of uncertainty before I learned that the committee had decided "at this time" not to make a formal protest or try to halt the show. Rousseau reported the process had been complicated by the presence of John Pope-Hennessy, the director of the Victoria and Albert Museum in London, who thought he was making the list. "Just get the damn job *done,*" I complained, "before another group shows up to stop it."

I was due to leave in early June for another Wrightsman cruise and was frantic to complete all the arrangements. I badgered Stuart Silver to come forward with a design scheme. In a week he entered my office with two aides. He looked pugnacious. He unveiled a large model of the fifteen galleries we had set aside.

"The overall motif is the Gothic groin vault, to be made in white nylon," he said. "I'm going to float them in the ceilings of the galleries like umbrellas, softly lighting them from above. I want to recapture the spirit of the Florentine churches and chapels and emphasize that these frescoes were designed for a particular chapel within a particular church. The walls are designed as sort of cruciform centerpieces. The general impression will be mysterious and ethereal.

The purity of the design puts the individual frescoes back in their architectural homes."

I had never seen a more sensitive museum design.

The fighting look dissolved from Stuart Silver's face. "If you hadn't liked this one, I was willing to just walk out that door. I was thinking when I came in here, If this guy doesn't get this, I quit."

I left for the cruise alone. My wife didn't join me—she really didn't want to go—but she was recuperating from her third miscarriage in our fifteen years of marriage. I told myself I needed the excitement to divert me from my grief and that this was museum business. We planned to follow an archaeological route from Athens to the Aegean—Santorini, Crete, Cyprus, Rhodes—then on to Israel and eventually Turkey. This time the guest list included friendly faces, Craig Smyth and his charming wife. After he helped to keep the conservators quiet, I had come to admire him. He was soft-spoken, amusing, and, best of all, refreshingly unimpressed with the trappings of wealth.

We had some rare experiences—special tours of Cyprus; an unforgettable, two-day dash through every historical site in Jerusalem, guided by Mayor Teddy Kollek and the head curator of the National Museum of Israel, Karl Katz (Kollek drove a jeep at top speed all the time); the splendor of the precipitous climb up the narrow path to the heights of Santorini; the Minoan ruins of Crete (much too restored for my liking), and on to exotic places like Ephesos, Magnesia, Priene, Miletus, Didyma, and Aphrodisias.

Just as we were leaving Crete, Ted Rousseau cabled from London:

FRESCO EXHIBITION MUCH CHANGED STOP. NO BOTTICELLI, UCCELLO OR BALDOVINETTI STOP. REDUCED FROM ABOUT HUNDRED TO ABOUT SIXTY . . . FEEL WE MUST ACCEPT IN SPITE CHANGES STOP. STILL BEAUTIFUL EXCEPTIONAL SHOW STOP. MEISS CONCURS STOP. HAVE STARTED PACKING AND CATALOGUE STOP. MY BEST TO ALL STOP. ROUSSEAU RITZ LONDON.

"The hell with that," I yelled. I charged up to the communications center on the yacht and got Ted on the phone. I finally got him to admit that the show had been gutted. All newsworthy pieces—*all* masterpieces—vanished. I ordered Ted to get Arthur Houghton to inform the Italians that unless some "dazzlers" were returned to the list, we would refuse the show.

Houghton's official communication stunned Ugo Procacci, and he

told Claus Virch he'd go back to the Consiglio Superiore. It was obvious to Procacci that if the Met didn't take the show, England and Holland might not either. When Millard Meiss heard, he went wild and rushed off a cable to Houghton, a copy of which reached me in a tiny coastal hotel in Turkey.

CANNOT BELIEVE NEWS STOP. MUSEUM FEELS FREE TO RECONSIDER EXHIBITION OFFERED IN GRATITUDE BY ITALY AND WHICH HOVING ACCEPTED JOYOUSLY WITHOUT QUALIFICATION IN MY PRESENCE STOP. HIGHEST ITALIAN STATE AND CHURCH AUTHORITIES HAVE DEVOTED THREE MONTHS TO PREPARATION STOP. CONSEQUENCES OF AMERICAN WITHDRAWAL EXTREMELY GRAVE. MILLARD MEISS.

I just laughed.

I called Rousseau back to have him inform the Italian authorities that I had to have at least six "grand pieces." With that, I disappeared into the hinterlands of Turkey with the Smyths and a most unusual guide and remained blissfully incommunicado.

Wrightsman had established the schedule and hired a guide, Mohammed Korhan, a beefy fireplug of a man, an ex-wrestler with an oiled bald scalp, a "connoisseur of nothing but the best in life!" Korhan, when addressed, would bellow the word "Pasha" at me or Smyth, a title which pleased us both immensely. Nothing made Mohammed prouder than having been an extra in the James Bond film *From Russia with Love*. Mohammed swore that not only had he been a close confidant of Sean Connery, but he had been "his guardian and majordomo, just like I am for you, Pasha!"

The first evening off the yacht, we made our way to a seaside motel. We settled in around the pool and veranda—we were the only guests in the place—gazing out over the placid sea. I ordered a gin martini. When the drink arrived, it had been mixed with three parts vermouth to one part gin. Mohammed, seeing my distaste, disappeared into the kitchen.

I heard sounds of a scuffle. Within minutes, out came the hapless waiter, a mouse under one eye, carrying the crispest, driest, most frigid gin martini I'd ever tasted.

The prime objective was to visit a fabulous archaeological site at Aphrodisias, where Professor Kenan Erim of New York University was digging. The way to the high hills of Aphrodisias is gorgeous, punctuated by the greenest fields I'd ever seen. The mountains begin

abruptly. The dusty road up to the site gets narrower and narrower. The region is logging country. Around the tight bends, out of a plume of dust, trucks piled with huge logs came careening at us. We stopped near the summit for coffee at a restaurant with mud floors and a couple of wooden tables tumbled against the streaked walls. Mohammed told us confidently, "This is the place where I have arranged a banquet this evening." We had been informed that one of Kenan Erim's rules was that no visitor could stay for meals or the night.

Aphrodisias is one of the true wonders of Hellenistic civilization. The grand amphitheater is constructed so that one comes upon it utterly by surprise. The elliptical stadium, capable of seating ten thousand, is dug entirely below grade. The marble sculptures Erim had found were amongst the most beautifully crafted I had ever seen. Erim took us on a brisk tour of the vast site, the storerooms, and the labs, explaining all the startling pieces and buildings in a singsong full of emotion. He was adamant that "they're *not* going to drag these pieces away and dump 'em in some museum or warehouse where thieves'll get 'em. I'm insisting that nothing leaves the site. Hell, if tourists want to crawl over these pieces like they do at Ephesos, let 'em come *up* here."

We were so hungry and parched by the time we reached the restaurant that we agreed we wouldn't complain about its sorry condition. When we stumbled out of the cars, we saw that the place had been transformed. There were clean carpets on the dirt floor. The walls had been whitewashed, inside and out. There were fresh linen tablecloths and candles. The proprietor and his wife had bathed. And the chicken was superior. Mohammed's magic.

The end of our tour was Istanbul, where I decided to remain an extra day before going on to fight the fresco battle in Rome and Florence. When I came to say farewell to Mohammed, he refused to leave me and rejected my offer of payment.

Instead he turned into something of a pasha himself. He donned a three-piece black suit, while I forced myself into my best "cruise" clothes and we sashayed around the city like millionaires. He knew everybody. Best of all, he had access to the closed cultural sites. We toured them all, in private, as well as the bazaar and several belly-dancing and striptease joints. Mohammed insisted that he accompany me to the airport. There, with him at my side, the notoriously rude customs officials became gentlemen. I swept through and was

taken to the first-class lounge. Mohammed must have been a government agent.

I flew off to Italy and assaulted the arts officials in Rome and Florence who were responsible for making decisions about the frescoes—Ugo Procacci, Baldini, and members of the Consiglio Superiore. Claus Virch and I compiled a list of the six frescoes we absolutely had to have. He had sneaked a look at the conservation reports and knew which pieces were sound enough to travel. But, I learned, fragile conditions had nothing to do with withholding the treasures. Ugo Procacci told me in confidence that two members of the Consiglio, Mario Salmi and Cesare Brandi, had opposed the list he had submitted for political and procedural reasons. *No* first list could possibly be passed. What would people think? That the Consiglio was a rubber stamp?

Hearing that, I dashed down to Rome to deal with Brandi and Salmi. I had met them both when I was a curator of medieval art and, thank heavens, had been highly respectful of them both, especially Salmi, whom I had consulted on a number of acquisitions. I found out which restaurant in Rome was Brandi's favorite.

I became evangelical. I said "Fresco" would be the most important exhibition ever held in the history of the United States. The entire art historical community of the country was waiting to see it. It was bound to receive massive press coverage. The conservation community, once against the show, had united in its favor.

He seemed impressed.

"I have some confidential information for you," I told him. "The corporation funding the entire cost of the show—more than six hundred thousand dollars—is Olivetti."

Aha! the scholar said as he leaned back in his chair and took a long sip of wine. "Dr. Hoving, you are persuasive. You have succeeded in persuading me that the Consiglio should reconsider your six frescoes. Yet there is one very significant problem. If only you had not planned to send these frescoes by airplanes."

In fact we had *not* planned to send them by air, knowing there might be objections. A ship had been selected weeks before. Why the most influential member of the Consiglio Superiore did not know that was a mystery. I presumed his ignorance meant that the other members were equally unaware of our travel arrangements. I pretended that I was wrestling with the terrible decision of changing all shipping plans. I sighed. I announced, "I shall guarantee a boat at once. I will send all the frescoes by boat."

"Ah, in that case, I shall recommend that your choices will go back onto the list."

"May I write Mario Salmi that you are so favorable?"

"I'll call him. Actually, my vote will swing the others. And I hope to see you in New York at the grand opening."

Soon after my return I received official word that eight top pieces had been added to the list.

"The Great Age of Fresco" opened to a gala dinner hosted by the Met and Olivetti in the last week of September, the beginning of New York's social season. Trescher had assembled the guest list, and it was glittering. The guests didn't hug the bar or just strut around showing off. They rushed to the galleries. I have never seen such astonished looks or such joy. Harry Parker had come up with a stunning educational device—young interns in his department recreated the process of the removal and reattachment of a fresco. We had trouble herding our guests to the tables downstairs. After dinner most returned to the galleries for a longer look.

The reviews were glowing—"Superlatives are dangerous, but this show calls them up by the dozen. . . . It is the most unexpected exhibition in many years." "There will not be a more spectacular show until Charles de Gaulle sends over the windows from Chartres."

I was at the apogee of my Met career, or so it seemed. My relationships with the curators were warm. The trustees adored me. And Kevin Roche and John Dinkeloo had come up with a series of brilliant solutions for the refurbishing and expansion of the museum.

I went up to Hamden, Connecticut, for a long weekend. There were no sketches, floor plans, or models. Just ream after ream of paper, spread out over thirty feet of running wall surface some four feet high, forming a time line of the contents of the museum.

The chronology began with Egyptian prehistory and ended with contemporary American painting. There, in one lucid graphic, was the roster of all the top masterworks from twenty curatorial departments plus "footnote" objects that showed what the museum could become, an all-encompassing encyclopedia of mankind's visual creativity. But the time line also showed how chaotic the Met's holdings were. It was easy to see what was missing—primitive and Oriental. The collections of the Met were lopsided—dense in European paintings and decorative arts of the eighteenth and nineteenth centuries. Suddenly, I was looking inside a Metropolitan Museum I had never known.

Roche and Dinkeloo had divided all the works into three broad categories—"God, Society, and Artistic Creativity." We discussed the overall priorities of the museum and how to make it conform architecturally to the time line. Their approach forced us to lay out the galleries in as near a chronological order as feasible. It goaded me to pursue the missing pieces—Oriental art and Nelson Rockefeller's superior collection of African, Oceanian, and ancient American works. I realized that the master plan was going to cost many millions of dollars—God knew how many. I was a little frightened at the size and the complexity of what I had to do.

We were embarking on the single most important architectural and philosophical undertaking in the history of art museums. We vowed to produce nothing less than a vast educational demonstration of man's visual genius housed in a series of structures twice the size of the existing seven-acre museum.

Reality, like water, always seeks its own level, and soon the masterful time line gave way to the urgencies of real life. Bobbie Lehman was looking more and more frail. Suddenly, he was whisked to the hospital. "It's just a routine check," his lawyer and executor Ed Weisl, Sr., assured me. "Bobbie's going to do the right thing, once he sees the building plans."

To my distress I learned that Bobbie was very sick and that he had definitely *not* made up his mind. I began to have nightmares. When it came to the whims of art collectors, I knew, *anything* could happen. Hurry, I told Kevin Roche. Get a Lehman solution done right away.

Arthur Rosenblatt made weekly excursions to Connecticut carrying photographs of the Lehman Collection and the interiors. We assembled a complete file of everything in the collection. One problem was that the collection kept changing. At one point Ted told me that several of the choicest Impressionist paintings that seemed to be on the original list had been removed. Lehman was said to be planning to give about a dozen paintings, mostly French Impressionists, to his wife and son. What was left in the nineteenth-century pictures seemed to me to be weak. For the first time I wondered aloud to Rousseau what the art press was going to think of a collection which had "a bunch of nothings" for a denouement. He tried to smooth over my concerns, emphasizing that the old masters and drawings were the best in America.

In early April, Roche called me. "It's okay to come up to Hamden

and see the Lehman solutions, but, Tom, keep calm." I'd never been more keyed up in my life about anything than to see what they had achieved for my most burning hope of making Lehman happy enough to commit. By this time I had gone far beyond my first glib description to Arthur Houghton; I had elevated winning or losing it to something of the dimension of Waterloo. Roche advised me to set aside a day.

Roche's staff had made green and beige drawings of the museum's ground plan and had produced gorgeous renderings of the fourteen-room Lehman townhouse designed in 1905 by John Duncan, the architect of Grant's Tomb. The very quality of the drawings—finished, confident, calm, rather like Kevin's speaking voice—created a climate of authority and inevitability.

"The first solution," Roche said, "intends to emphasize the house as a shrine, set off on its own though associated with the Met."

The slide showed the Lehman townhouse plunked down in the middle of the public parking lot on the south side of the museum. It looked ghastly, especially since the little building itself had been rendered so perfectly in all its details—French late-eighteenth-century facade, the scrolls, the mansard windows, the articulated cornice. The sides of the Lehman house were shown as they would be if the structure were cut out of 54th Street and airlifted up to 81st Street.

"Notice how the building is set *just* within the precinct of the Met, on the very edge of the property," Roche said very seriously. "To symbolize the association—*and* the independence."

"Kevin, this looks like hell! You can't be serious," I said.

"There's more."

The next solution had the surgically removed Lehman townhouse set up in the south parking lot opposite the original 1889 south, red-brick facade of the Met.

"This also looks like shit," I said.

He gazed at me coldly and said, "Now let us see how the Lehman problem can be solved *inside* the museum."

The next series of slides showed the facade of the townhouse inside the museum in an enormous courtyard enclosed with a skylight. It was as if one were looking at 54th Street with a glass roof, with all houses other than Lehman's having vanished. It was intriguing.

But Roche had another indoors solution. "The Lehman town-

157

house is, as you know, American copied after a nineteenth-century house in Paris, which was itself a copy of a structure destroyed in the Revolution," Roche said. "So, this time we put it in the American Wing, next to the nineteenth-century assay office facade."

I asked Roche which solution he favored. It was the one I thought was the horror, the townhouse placed alone in the south parking lot in its own garden. "If one is going to transplant a piece of street architecture, one might as well shove it in their faces," he said, and then added, "Wait. The presentation isn't complete. Here comes the fifth act in our drama."

By means of slides, Roche guided us into the museum, through the Great Hall, to the Grand Staircase. The stairs had gone! In their place was a broad boulevard stretching from the Great Hall straight to the back of the museum—to the Western arts section. Roche explained how the boulevard would be identical to the one that went to the left from the Great Hall to the Greek and Roman collections and to the restaurant. Later on it would be necessary to create another boulevard on the right cutting a swath through the Egyptian department. "The three boulevards will provide a commonsense traffic pattern for the place," Roche calmly explained.

Roche's slides made it seem as if we were on a magic carpet, flying down a majestic boulevard through the medieval sculpture court into the rectangular gallery with Michael Paul's French sculptures and to the threshold of a sensational new wing, octagonal in form, half-imbedded into the hill of Central Park—the Lehman Pavilion. It had an octagonal interior courtyard illuminated by a graceful glass skylight. On axis to its entrance was a magnificent gallery dominated by one of Lehman's finest paintings, the portrait of the Countess de Broglie by Jean-Auguste-Dominique Ingres.

The Pavilion had two floors. Below were galleries for Lehman's drawings. On the main floor—all constructed in golden granite—were Bobbie's period rooms, looking exactly as in the townhouse. Roche's assistants had painted in miniature all the key Lehman paintings and had placed them exactly as they were in the townhouse. The solution was splendid, simple, and sophisticated.

Roche's finale was a slide showing a view looking back from the octagonal central gallery. There to my surprise I saw the original red-brick facade of the museum, the one facing the park, dating to 1870, cleaned to its original state, preserved intact within the Lehman Pavilion.

Roche smiled. He knew his trap had worked. "At least, it's something, and a reflection of the true greatness of the Lehman 'thing,' " he said.

The comparison between the solutions of recreating the Lehman townhouse in the parking lot or in some courtyard and the Pavilion was shattering. The building was a jewel, virtually lighting up the part of the museum building that was forbidding and dishevelled.

Roche abruptly asked, "Tom, do you entirely trust Bobbie? Are you confident he—or his foundation trustees—will go through with the gift, even if the building is finished?"

I said I really didn't know.

"I guessed. So we designed this Pavilion for a dual purpose," Roche said. "The building will be built in granite—no steel. But the walls between the period rooms and the central court will be made of cinder blocks. *If* the Lehman deal falls through, then the Pavilion can be used as a special exhibition hall, one that will attract visitors, especially when we get rid of those stairs and open up the boulevard."

I congratulated the team for such a compelling "solution." How fast could we get some sexy models made?

"Mid-April."

"Do it."

Over the next three weeks, Lehman grew weaker. Even Ed Weisl admitted to me that he was "not well." When Roche-Dinkeloo produced the models, I pinned Lehman down to a presentation in the board room on the eleventh of April. Several days later his secretary phoned to say that he would have to reschedule since he had to go to the hospital. I felt as if the world had come to an end, but the same day the secretary telephoned to ask if April 18 would be acceptable.

Roche had made a model of the entire museum—measuring about five by three feet. Into it the Lehman Pavilion could slide as if it had existed for decades. He had made a larger model of the Pavilion itself, with sections that could be removed, like a dollhouse, to reveal Lehman's coveted period rooms with the paintings in miniature. It was like an architectural Fabergé Easter egg.

Bobbie came to my office precisely on time, but looking like hell. He was dressed in his usual dark-blue suit with a white shirt and a pearl-gray tie. He sat in the chairman's seat at the end of the table and said nothing throughout the entire presentation.

I said only one thing, which occurred to me at the last moment: "Bobbie, what we've tried to do is not only please you but also create a focal point for the entire architectural plan of the museum. The Met's future in physical terms rests on the Lehman Pavilion—forever." He gazed at me with soft, friendly eyes, and I had the horrible feeling that his mind had gone.

Kevin, for almost the first time since I had known him, spoke out distinctly and loudly. He praised Lehman's "excellent decision" to give his collection to the Met "because of the uncertainty of where the city of New York is going in the future—as far as neighborhoods are concerned."

Kevin was persuasive—dangerously so, I thought—in romancing the "sore-thumb" solutions. When Roche turned to the interior solutions for his private museum, Lehman's eye flickered with interest. I had thought he favored the one in the courtyard. Then Kevin embarked upon the most compelling sales pitch I've ever heard.

"The fifth way of providing a Lehman Pavilion within the museum is different. Mr. Lehman, for a professional museum your house is too small. There are no storerooms. Your collection of frames is housed outside the building. There's only one office. If there are to be assistants, even a secretary, certainly students, more office and study space will be mandatory. And what about the drawings? A mere fraction of the drawings can be shown on 54th Street, and there's inadequate space to store those that are not exhibited. I'd say that 54th Street is but *half* the size a public museum should be."

Lehman stirred. "When I open my place to a charity group, I must say, we have problems. I understand what you say. But how to have my house and twice the space, too? What do you do? Go underground?"

"In part . . ." Roche said.

Lehman seemed to back away.

"No, the most elegant solution," Roche said, "is to combine your desire to recreate your rooms with a building that's in keeping with the superb nature of the collection. It must perform two additional functions—be a professional museum space and draw the vast public who come to the Met to an area quite close to your heart that is now not visited."

The slides of the octagonal Pavilion were flashed on the screen and the model fitted into the museum plan. The large model with the removable sections was wheeled into the room. As Roche explained

the plans and the building, I studied Bobbie's face. He seemed pained. When Roche had finished, Lehman rose to his feet to study the octagonal structure and then the exterior and interior solutions of recreating his townhouse. Finally, he spoke.

"I cannot possibly see building these replicas. They look strange. But this Pavilion bothers me, too . . . It's beautiful . . . but don't you think it could be thought of as a bit pushy?"

I felt triumphant and horrified at the same time. I knew I had won. He'd give us the collection. He'd go for the gorgeous octagonal Pavilion. I was horrified because I knew that I had grievously miscalculated what Lehman was really after—something infinitely more modest than what Roche was proposing. For a second, I thought of saying, "You're right, it's too big. Why not give you back the galleries you had before you moved the collection to the townhouse?" Back then, there had been five large galleries within the European Paintings Department. I realized that we could *easily* have gotten away with six or so galleries that invoked the general feeling of the house and that they alone would have swayed Lehman.

Before I could say a word, Ted Rousseau broke the silence—and inadvertently committed us to the octagonal Pavilion, many millions of dollars worth of construction, and lots of agony.

"Bobbie, *no* one will think it's pushy. Why, it's the *only* way to present the collection. The public will *adore* it. I think it's discreet and elegant."

"Well, in that case," Lehman said. "I'll accept it."

Bobbie Lehman weakened at a distressing rate. As he grew more ill, I visited him as much as I could in the hospital-like room in his apartment. In the final months it was hard for him to speak. I would bring some small gem from one of the museum's collections or from The Cloisters. By then he was half-paralyzed, barely capable of moving, but I could see the pleasure in his eyes when he caught sight of a page from the renowned Belles Heures of the Duc de Berry or the portraits by Giacometto da Veneziano.

I talked to him about the final deal. He asked me haltingly whether the museum wanted to pay for the building or the annual costs of running the Pavilion. I quickly opted for the one-time cost of the building, which John Dinkeloo had calculated to a precise seven million eight hundred thousand dollars. Lehman agreed.

I took great pains to explain to him how Roche had designed the Pavilion so that in the future it could be transformed into special

exhibition galleries. I asked him to give permission to keep the Pavilion exclusive to the Lehman collection for only twenty-five years and then disperse his collections—with his name attached—to the other departments of the museum. He opened his eyes very wide and said, softly, but clearly, "I agree."

After the rush on the Lehman Pavilion, I meant to leave Roche-Dinkeloo alone and allow them to develop the entire master plan. But it was not to be.

The Temple of Dendur arrived on the freighter *Concordia* in 661 crates. It, too, had to be housed. For a moment after the 1967 Middle East war, Henry Fischer and I thought we would lose the edifice. But negotiations proceeded in good faith.

I had the stones stacked on the museum's south parking lot inside a huge, inflatable air structure with a number of plastic windows so visitors could peer in to see our workers counting and marking the stones. It was one of the most intriguing three-dimensional jigsaw puzzles of all time.

At the same time Rosenblatt discovered that the city's capital budget contained four hundred and seventy thousand dollars for facade changes to the museum. The amount, first included in 1963 on the urging of Jim Rorimer, was about to be taken out of the budget by Parks Commissioner August Heckscher unless we came up with a design immediately. So, once again, Roche-Dinkeloo's peaceful contemplations were set aside, and they hurried to complete the drawings for the cleaning up of the facade and the Great Hall.

The work was ready in less than two weeks, and again the presentation overwhelmed me. The facade of the museum looked as if it had been picked up and moved fifty feet back from Fifth Avenue into the park. Instead of a crabbed, narrow alley in front of the grandiose structure, an elegant plaza had been born, something that would be fitting for Rome or Paris. The doghouse entrance and the steep stairs were erased and in their place an inviting three-sided apron of stairs reached out toward Fifth Avenue. The dangerous automobile entrance was eliminated; wide turnarounds were set on each side of the stairway. Each turnaround had an elliptical fountain furnished with a line of jets. At the far ends of the long building were two small parks each planted with a grove of trees. In the parks, paved with hexagonal blocks, were a host of chairs.

There were to be new signs, new lighting to enhance the liberated look of the facade, and, of course, an air curtain at the main portal. The stairs themselves would be warmed from underneath and thus would seldom gather snow or ice for very long. The doors were made of polished golden brass as were the banisters.

The motifs of the central part of the building had been done in threes—three tiers for the stairs, three banks of stairs, three banisters—in harmony with the three great arches of the Hunt building. The rest was in twos, to harmonize with the double facade designed by McKim, Mead & White.

The changes Roche proposed in the Great Hall were even more impressive. The stone would be cleaned to its original ivory hue, and the arches and the three domes painted a lively terra-cotta. In the center of the Great Hall, Roche had stationed a shining brass information booth, the symbol of hospitality. Under the two other domes were attractive octagonal wooden benches with their centers planted. The fourth niche, removed in the thirties, had been restored. The lightness and warmth was breathtaking.

"We've got to do it!" I said. "If I see just *this* constructed, then my tenure will have been successful. How much will it cost?"

"The facade can come in for one point six million," Rosenblatt said. "We've calculated the Great Hall for four point five."

I winced.

"Hoving, you can get the money," Rosenblatt cried out. "You think the mighty Met can be face-lifted on the cheap?"

"Sure, I can raise it," I said, sounding invincible. In my heart, I wasn't so sure.

11

HARLEM ON MY MIND

For a publicity hound, there is nothing as exciting as the cover of the Sunday *New York Times Magazine*. I made it on December 8, 1968, wearing a conservative suit, a trendy tie, and a smug grin. I was on a raised platform between the Angel of the Annunciation and the Virgin Mary of Jacopo da Pontormo's fresco. "The Total Involvement of Thomas Hoving" was written by the art reporter Grace Glueck who, despite a few digs about my flamboyant style, called me a "multi-media extravaganza" with scholarly credentials, social connections, and a sure instinct for the box office, "eager to outwit the forces of fuddy-duddyism" with energy and "boyish candor." That candor and boyishness, the article hinted, might get me into a few scrapes, one being the exhibition due to open in the new year, the cultural-photographic extravaganza, "Harlem on My Mind."

I looked upon "Harlem on My Mind" as a turning point. It was going to justify my view of the museum as a moral, social, and educational force. Through "Harlem," the museum would pay its

true cultural dues. It would chronicle the creativity of the downtrodden blacks and, at the same time, encourage them to come to the museum. I expected the show to become a symbol of my fighting to persuade the museum world to get into the swim.

A few days before the official opening in the second week of January 1969, I walked into the show for the first time accompanied by its creator Allon Schoener and his research and design team. The exhibition was one of the largest the museum had ever mounted, thirteen galleries' worth. The ensemble was more grandiose than I had imagined. Some of the photos—all black and white—had been left small, others had been blown up to life size and measured over thirty feet long. There were dozens of slide machines plus recorded voices, music, and the ambient sounds of people calling out to each other. There were unforgettable tracks, from Mother Brown, a ninety-year-old resident who had been born a slave, to Billie Holiday and Aretha Franklin singing famous ballads, Father Divine, Marcus Garvey, Joe Louis, dancers at the Cotton Club, Bill Robinson, Malcolm X.

The first gallery contained floor-to-ceiling photographs of apartment buildings around 1900—the first wave of black residency. This was followed by a photo mural of Congressman Adam Clayton Powell's father standing in front of his Abyssinian Baptist Church surrounded by the children from Sunday school. Beyond that was a maze of galleries depicting the thirties. After that, the gallery spaces opened up again to a room filled with portraits of poets, writers, philosophers, musicians, artists, and ministers, many by the photographer James Van der Zee, whom I believed to be the single most important contributor to the show. Allon Schoener and his assistant, Reggie McGhee, had happened upon a run-down storefront with the sign, "Photographer, Van der Zee, Weddings, Family Gatherings, Children." They found a harried man in his seventies surrounded by dozens of cardboard boxes filled with thousands of photographs and negatives. Each was labelled by the year and identified every person in the shot. These photos—from the twenties up to 1968—chronicled almost every aspect of Harlem. Van der Zee specialized in portraits of jazz musicians, religious notables, and politicians. But he had also recorded hundreds of families and had invented a type of funerary photograph in which the "ghost" of the departed appeared to hover in the background. Schoener instantly recognized that he had stumbled across not only the backbone of the show but one of the coun-

try's most important photographic archives as well. All of Van der Zee's materials would be archived and preserved. When Schoener and McGhee had wandered in off the street, Van der Zee was about to be evicted. Without doubt, they saved him for the nation, for who knows what would have become of his possessions.

I found the exhibition powerful, somewhat shocking, beautiful in some images, disturbing in others—and unforgettable. "Harlem" was much more about culture than sociology, more about a struggle to maintain a cultural base than a racial history.

"Now, if *only* the critics and the public look at this as a show instead of a political act or a multimedia event that's going to destroy the museum, then it'll be a great success," I said. And I believed "Harlem" would be a success even if a bit controversial. Everything about it was dynamic, especially the catalogue published by Random House for $4.95 and in a blazing red- and yellow-covered paperback version for only $1.95. "From Black to White Harlem" was the first chapter with provocative, staccato headings; "Race Riot," "Fight Against Raised Rents," or "On Better Troops in the War." "An Urban Black Culture, 1920–1929" was part two: "Landlord Brings in Negroes to Get High Rents" and "Irving Berlin Borrowed Chants from South" or "James Weldon Johnson on Anglo-Saxon Superiority." Then there was "Depression and Hard Times." Then, "War, Hope, and Opportunity" followed by "Frustration and Ambivalence, 1950–1959." The final chapter, illustrated by a portrait of Malcolm X, was entitled "Militancy and Identity" with headings like "Malcolm X Likens Slaying to 'Chickens Coming Home to Roost,' " or "Three Violent Days."

Schoener had patterned "Harlem" after his much-acclaimed documentary history of Jewish immigrants, *The Lower East Side: Portal to America*.

But I was deceiving myself. A series of fires were burning. I had seen the smoke and foolishly had ignored the signs of conflagration. I had dismissed the growing trouble as simple "community fuss." As a member of the white, liberal establishment, one who had emerged from the optimistic and naive Lindsay administration, I was mesmerized by the idea of a photographic history of Harlem at the country's most distinguished art museum.

Schoener was a genius, but he was also protective of "his" show and reluctant to allow outsiders to participate. He got into a running argument with a community firebrand by the name of Ed Taylor who

became the head of the Harlem Cultural Council. Taylor demanded a job, was spurned by Schoener, insisted that his organization create the entire show, was spurned again, and after launching a host of unreasonable demands withdrew his group's support for "Harlem" vociferously. It was clear that Taylor and his cohorts wanted the show to fail. And the three community experts taken on to help in historical matters proved to be spoilers almost from the first meetings. One, the Harlem historian John Hendrick Clarke, had remarked to Schoener at their first encounter, "If you're another downtown Jew who's here to rip us off, good-bye."

In the midst of the growing fracas, Ed Taylor shouted to my community affairs officer, "The crux of the whole mess is Allon Schoener because he is a white man who knows nothing about Harlem. He is never available to the community; he is actively lying; he is playing off one element against another. He does not answer letters or return phone calls, has made this a New York Council show, and promotes the attitude that the community should come to see him. He should be ousted."

Even McGhee and Donald Harper, his chief researcher, who were black and well qualified, were looked upon as aliens and were dismissed as incapable of understanding the spirit of Harlem.

The black artist community rose up in fury against the show. The leaders—the painters Romare Beardon and Henri Ghent—were enraged that the first black exhibition in the history of the Met would contain no paintings. There were excellent reasons for not having any works of art, of course, and in fact they would have crippled the impact of "Harlem." But once the fierce criticism hit the press, the show was condemned as mere documentation and, as one critic cried out, "cultural cutesy-pie-ism."

Another fire burning the underpinnings of "Harlem" was the school strike that exploded in the fall of 1968. It was the most vicious strike that had ever taken place in the history of New York City. The issues were tangled, and racial. When it got down to the nub, the school strike involved the bitter conflict for control of the teachers' union between the entrenched whites and the community blacks who wanted power and who believed they had been excluded.

My true attitude was summed up in a trendy and defensive one-page foreword for the catalogue in which I confessed that as a privileged kid growing up in white Manhattan, Harlem was "a light-year away" and I was taught that "Negroes constituted a menace, a tribe

that must not be allowed to come down the Avenue." I went on to say that to me, as a kid, "Negroes were people but they were happy, foot-twitching, smiling and sunny." And I embellished the truth, creating a friendly family maid, Bessie, who laughed a lot, and Frank, our chauffeur, who was bitter and silent. I stated that in those days, any confrontation on a peer basis with a Negro was "almost ludicrous," and I justified "Harlem" at the Met as a means of opening up a benevolent confrontation.

When I read my embarrassing text in galleys, I asked Schoener if I could rewrite it, but he discouraged me, saying he liked the confessional tone and especially the part about the maid and the family chauffeur. So I let the foreword go unchanged. But the real sparks came from the principal essay, written by a young black woman, Candice Van Ellison, when she was a high school senior.

Van Ellison described the frictions between blacks and whites in stark terms.

To Van Ellison the most serious racial problems were caused by the conflicts between the Jewish landlord and the black tenant. She pointed out that a large portion of black women served as domestics in Jewish homes, which explained "the higher rate of anti-Semitism among black women than men." She added that even the middle-class Harlem black male who had worked up the ladder in government frequently came into contact with Jews who had already attained higher rungs on the ladder.

Her essay ended with the chilling statement, "One other important factor worth noting is that, psychologically, blacks may find that anti-Jewish sentiments place them, for once, within a majority. Thus, our contempt for the Jew makes us feel more completely American in sharing a national prejudice."

I exploded to Schoener. "We can't have that sort of sentiment in this catalogue! That one line about contempt for the Jew is *dynamite*. It's simply not true."

"But it *is* true, Tom. These are truths. You may not like them, but they are truths," Schoener argued. "Anyone who ever worked in the civil rights movement—and I ought to know—saw the deep prejudices against Jews on the part of blacks. You cannot expunge it. Would you leave out some nasty fact—a horrible truth—about some painting in an exhibition? 'Harlem' *has* to have truth. I know these statements are raw, but most sociologists recognize these ugly aspects."

"I'd say tone 'em down. Change 'em."

"I'm a Jew. I'm offended—sure!—but I have to recognize these feelings are facts. Publishing these statements apparently didn't bother [Jim] Silberman of Random House."

Reluctantly, I decided I had no right to edit or censor. Yet my political nerve ends were warning me that such inflammatory statements might cause a frightful row. I still didn't grasp the fierceness of what the reactions might be.

A week before the show opened to the trustees, the Harlem community, and the press, Schoener got a call from a friend, Julius Schatz, who had just attended an "emergency" meeting of the Manhattan chapter of the American Jewish Congress. The congress had obtained an advance copy of the Harlem catalogue and was planning to send a delegation to Mayor Lindsay and the City Council urging that all city funding be cut off from the museum until the catalogue was withdrawn.

Schoener was frightened by the intensity of his friends' remarks. "Here I am, a member of the Jewish community—and a fairly devout one—being called, in effect, a traitor to my race! Tom, you know city politics, *would* the city be able to cut off funding? How much is it?"

"Over three and a half million dollars," I said.

"Lindsay wouldn't just cancel the money, would he?" Schoener asked.

"He can't. The City Council could do it. Now, you tell me, what *will* the congress do? Allon, let me remind you that I wanted that crap to come out. *You* convinced me to leave it. 'Truth,' I believe was the reason."

"Tom, I hate to say this, but I have the distinct feeling that you're no longer in support of the show. Your staff hates it and perhaps this has spilled over on you. Ever since the school strike, you've seemed distant and cold. Are you still going to support it?"

"What choice do I have?" I barked.

Schoener tried to reason with the American Jewish Congress, and it seemed to do the job. A calm settled around "Harlem on My Mind." I waited with trepidation.

The gala black-tie opening, with trustees and socialites sitting next to members of the black community, went smoothly. I had the feeling that everyone was on their best behavior. The conversation was tense, serious, not the usual social chit-chat. I made a toast, trying

to bury every hatchet that had been brandished during the preparation of "Harlem." Even opponents made a point of coming over and congratulating me for my courage in mounting the show.

At the press opening I was nearly assaulted. Reporters accused me of racism or of violating the sanctity of the museum. A television correspondent asked me what I thought of the "raging controversy" over the statements by Van Ellison.

I was exhausted and angry and had lost control of myself. I made the most unfortunate statement I had ever made. I said directly to the camera, "Her statements are true. So be it."

From the moment I uttered that monumentally stupid statement, I was lost. The only thing that lifted my spirits that evening was the late arrival of the minister of information of the Black Panther Party who, alone and unaware of the museum gossip and ideological arguments, wandered through the galleries and emerged to say "This is brilliant, and I'm going to write it up as such." I smiled wanly.

I went home drained, a beaten man. Joe Noble called, his voice grim.

"Tom, something terrible happened—ten paintings have been slashed. On each, someone—an adult I think because of the height —etched into the varnish the letter *H*."

"Which paintings?"

"Ted's making an assessment—he's over there now. . . ."

"Shall I come over?"

"No need. We've got the situation under control. The only picture of major value according to him is the Rembrandt, *Christ with a Pilgrim's Staff.*"

"The guy carved an *H*?"

"All very superficially. Mostly into the varnish. Ted thinks they'll all be back on view in days."

I was stunned.

"What do you advise?" Noble asked.

"Let the *Times* know."

"Do you think that's wise?"

"If we don't tell 'em, the guy who did it will."

"Good point."

"Get Ted to call me."

Rousseau was on the phone within minutes and reassured me that the act was more symbolism than vandalism.

"What's *H*?" I asked, "*Harlem* or *Hoving*?"

170

"Don't take it personally. Be as strong as you've been throughout all of this."

Martin Arnold, the *New York Times* reporter from the city desk, called. His front-page story would characterize me as speaking in a voice "shaking with anger."

I telephoned Arthur Houghton to brief him. He was clearly distraught but as sympathetic as I'd ever heard him.

"We knew there would be some tough times, so try to maintain your balance. I empathize with you. I have a feeling things are going to get worse. We might have to hire special guards."

"Already thought of that, Arthur. I told Ted to close down half of the Paintings Department galleries and double up on the guards. I did the same with the American Paintings galleries."

"Glad to see you working well under stress. I want to say that I admire you and continue to support you."

Late that night, I sat down in the darkened dining room of my apartment and wrote a letter of resignation in longhand on a yellow pad.

Fortunately, I stuck the letter in the desk drawer overnight. The next morning I read it and put it into my personal file, never to be shown to anybody.

The members' opening started so well that I thought the chaos was over. The crowds streamed in in record numbers. Sales of the handsome catalogue were phenomenal. By the end of the day and evening, more than three thousand had been sold, more than double the sales on any day of the fresco book. But in the afternoon the blow came. Joe Feldstein, one of John Lindsay's chief political aides, called with venom in his voice.

The mayor was making a statement about the catalogue. Lindsay congratulated the museum for mounting the show but charged that the book accompanying the exhibition was inexcusably racist with a series of offensive statements about the Jewish community, the Irish community, and the Hispanic community. Lindsay called upon the trustees and me to withdraw it at once. Feldstein said, "My advice is to act now. Do what the Mayor wants or you're in deep shit!"

"That's swell, Joe," I said. "The 'crusading liberal' John Lindsay is now into book burning and censorship?"

"Come on, Tom. It's not that. This is a political thing. You were here, once. Try to understand."

"Tell him, no withdrawal," I said. "It's the truth, what's in that

introduction, and the truth, no matter how disgusting, cannot be covered up. Also, tell him, I'm saddened and shocked by his statement.''

When the *Times* called for my reaction to Lindsay's words, I said, ''I consider myself a human being of integrity, patience, and tolerance. I looked very carefully over the manuscript copy of the introduction. I am convinced these statements are not racist and not bigotry and not slander. What I condemn is the tenor of the times, which forces a young person who has lived in Harlem all her life to have these opinions.''

Allon Schoener was livid. ''There was *no* attempt on my part to provoke anti-Semitic feelings. As a member of the New York Jewish community, I believe we must face the realities of the world in which we live. Miss Van Ellison has merely drawn attention to the facts.''

As for Candy Van Ellison, when reached at Bridgeport College, she replied, ''I don't see what the Mayor is mad about. What I wrote was true.''

The next day Dore Schary, the eminent film producer and president of the Anti-Defamation League, condemned the catalogue as something akin to the worst hatred ever spewed out by the Nazis. Rabbis around the city began to denounce the show, the museum, and me. Two members of the City Council were calling for a hearing —at once!—to consider halting all funds for the museum until the offensive catalogue was removed from sale.

Houghton began to crack under the pressure. ''That's *serious,*'' Houghton growled at me. ''*Do* something. And do it fast. I have the feeling, Hoving, you're on the ropes.'' It was the first time he had called me by my last name.

''What if I can get a disclaimer from Candy Van Ellison, stating that she *never* intended to be racist—we can get her statement copied up and inserted into the books,'' I suggested.

I called Schoener and told him what I wanted. ''It's to buy us a little breathing spell,'' I said.

''It's bowing to lies, pressure. I'm totally against any sort of disclaimer. It won't work. It'll sound *guilty,* dammit! They'll *never* give up if you admit you're wrong even in this small way.''

''Allon, I'm going to do it. And as the head of the show and the editor of the catalogue, I want *you* to reach Candy and get the statement—by tomorrow.''

''This is terrible. I see our relationship has gone down the drain.''

''I'm not thinking about a relationship, I'm thinking about how to

save a brilliant show and a book catalogue, which happens to be selling like mad. I'm under fierce pressure from my board. . . ."

"Aha!"

"No, it's about the money from the city. The movement to take our funding away is *serious*. Please . . ."

Schoener reluctantly complied, and Van Ellison, a young woman of amazing good humor, said, "Sure." When the catalogues went on sale the next morning, they contained a mimeographed insert: "The facts were organized according to the socio-economic realities of Harlem at that time, and . . . any racist overtones which were inferred from the passages quoted out of context are regrettable."

What the devil did her statement mean, I wondered. I doubted it would work and held my breath.

Opening day attendance was ten thousand—about twice the average for the opening of any temporary exhibition in the museum's history. The catalogue sold forty-five hundred copies. I had posted young members of the staff at the exits to listen to the comments. The visitors were clearly intrigued. Few of them seemed offended by any part of the exhibition. I was heartened when I heard that blacks were streaming into the show—something that had never happened before in the history of the Metropolitan.

Still concerned with the city-funding issue, Arthur Houghton called an emergency meeting of his top trustees plus an outsider who he said would give "invaluable advice on what to do next." The outsider turned out to be the Hon. Arthur Goldberg, former Secretary of Labor under Lyndon Johnson, former justice of the Supreme Court, and at the time the ambassador to the United Nations and, of course, one of the most respected Jewish leaders in the nation.

"Arthur will figure a way out of this mess you got us in," Houghton said ominously.

What he did was almost the opposite. Goldberg intoned that in his view there was nothing to be gained by the "continuance of offering for sale [of] the offending catalogue." As for the issue of censorship, he smiled an Olympian smile and suggested "the catalogue could be stored somewhere and then reissued when passions had subsided at no cost, to the appropriate groups." Houghton and Gilpatric seemed eager to comply, while Dick Dilworth was unconvinced. I suggested a second disclaimer from me offering an apology for using the Introduction and confessing that it should never have been used at all. Goldberg agreed and Houghton and Gilpatric went along.

My apology was greeted with derision. There were increasing out-

cries from City Council members to "launch an economic boycott against the Metropolitan." When I had told Schoener of the apology, he had accused me of mishandling all the PR and the politics. "You were God in the Parks Department with the public, the politicians, and the press, so how could you have so messed up this situation?" he cried out. "You've lost courage. Think of me! I'm being called a traitor by my own race! I'm taking unbelievable shit because as a white person I'm accused of having stepped out of line in trying to do something significant about the blacks." His statement hurt because it was true.

By this time I was like a bloodied boxer, reeling around the ring, incapable of protecting myself against an opponent who was pounding me into a pulp. The Sunday reviews began to appear and they were critical. The *New York Times* published a bitter editorial condemning the show and its anti-Semitic statements.

I began cancelling my appointments and holing up in my office talking only to my closest advisors. Harry Parker, a strong supporter of "Harlem," was constantly at hand as were Ted Rousseau and George Trescher. Trescher went so far as to suggest the *New York Times* was in the middle of a deliberate campaign, shaped from the highest possible echelons, to discredit "Harlem" and especially me. He said that John Oakes, Mrs. Sulzberger and others were talking to the trustees about getting me removed and that the catalogue was only the *symbol* of what they wanted to get rid of. Trescher burst into tears. I was profoundly moved by his emotional concern.

Robert Bernstein, president of Random House, let me know that he thought my actions on the disclaimers and the apology were "strong and correct." Random House had no intention at that time of withdrawing the book from sale, he added. But, as it turned out, Random House was not saying the same thing to Allon Schoener.

Bennett Cerf, the celebrity chairman of Random House—he was a fixture on the popular television quiz show *What's My Line?*—and Bernstein, who had a distinguished record fighting for civil rights all over the world, had called Schoener to task, asking him to issue a personal apology for the catalogue. Schoener had refused. The publishing executives had informed Schoener that under the continuing and increasing pressure from the Jewish community, they might not be able to hold out much longer on withdrawing the book. Schoener said flatly, "But that would be book-burning." Cerf, incensed, shak-

ing all over, thrust his finger towards Schoener's face and shouted, "Do you know what you have done to Random House?"

The attacks increased. The Jewish Defense League, headed by the radical Zionist, Meir Kahane, picketed the museum. At times thousands of protesters brought Fifth Avenue traffic to a crawl. More rabbis and more politicians jumped into the fray.

Houghton called. "Some of the trustees are angry," he said. "Francis Plimpton is pressuring me to have a board discussion of how we got into this mess and why you didn't sufficiently brief us on what the Harlem debacle was going to be. I'll have the meeting of course. There may be a closed session at which you—and all ex-officios—will be asked to leave the room. If so, I'll leave with you. Hell, if need be, I'll walk out the front steps with you, hand in hand."

"That means a lot, Arthur," I told him.

Suddenly, the news broke that the new regime in Iraq, headed by Saddam Hussein, had hanged fourteen men—nine of them Jews—for spying. The pickets surged down Fifth Avenue to the Iraqi consulate, then located on 79th Street just off the avenue, pausing to vilify the Met on the way. On Thursday, January 30, twelve of the more prominent members of the City Council issued a resolution requesting the immediate withdrawal of the catalogue *and* the withholding of city funding until such time.

When that news hit, Arthur Houghton called me at home. When especially disturbed, he became exaggeratedly polite. When he asked me to join him for a "simple desk lunch" down at Steuben and I saw how magisterial he was acting, I knew something grave was about to happen.

We chit-chatted about details of the museum, in an elaborate and leisurely manner. Then, almost as an aside, Houghton said, "Tom, the catalogue's finished. We feel that unless we withdraw it, the museum will suffer financially to a degree that we might never recover. Think of the consequences of *no* city money. Somewhere we'll have to raise three and a half million additional funds a year. I think the museum's current state of affairs is not, ah, conducive for the raising of funds—the Jewish community being some of our more valiant monetary supporters."

I found it was difficult to speak calmly to the arch patrician who was, so airily, defending censorship and what amounted to book-burning. All I could manage was, "The resolution won't make it out of committee."

"That's not the point. The mayor's calling for the withdrawal more forcibly every day. They *mean* to take our moneys and they'll do it," Houghton said.

"Give me a little time . . . at least to explain this to the staff. . . ."

"No. Tom. This is a directive from the officers of the museum. It must be done. Now."

I walked back from Steuben at 56th Street and Fifth Avenue to the museum, feeling more depressed than at any time in my professional life. I cursed Lindsay as a political hack and cursed the bad luck of the show and the critics for having inflamed insignificant issues. But by the time I got to my office, I had caved. Perhaps I should have told Houghton to issue the order himself and then quit. But there was no place to go. I was too exhausted to fight back.

The next day, just after we had sent out a press release about the withdrawal of the catalogue, Mort Lawrence, the intense, dark-haired, gravel-voiced publisher of a local newspaper, *Park East*, telephoned to say that he'd made a major discovery about "Harlem." I told him to come right over.

"Tom, Candice Van Ellison's essay was almost totally changed by Schoener," he said. "All the inflammatory statements are *not* hers. They come from Patrick Moynihan and Nathan Glazer's book, *Beyond the Melting Pot*. Van Ellison *cited* these quotes in footnotes in her essay. They appear *in quotes*. Schoener removed those quotes, cut out the footnotes, and paraphrased the stuff to make it sound dramatic. To make it seem *she* had written it."

I stared at him dumbfounded.

"What I'm saying is that the original text from which the controversial stuff is derived gives full credit to the various research resources used by the student, but in editing it, Schoener took out the quotation marks and attributions, so that the introduction appears to contain only Van Ellison's *original* thoughts on race relations."

Lawrence laid out on my desk the Introduction, a copy of Van Ellison's original essay, and Glazer and Moynihan's *Beyond the Melting Pot*.

"I can't believe it, but it's true, isn't it?" I said dumbly.

"You know, to me the funny thing is that *we,* the tiny staff of *Park East,* found this. *Not* the mighty *New York Times*."

"Maybe they didn't want to," I said.

When I called Houghton, I said, "We can announce this and go on selling the catalogue." His response was, "My reaction is that a

completely flawed Introduction makes it even more proper that we withdraw.''

The confrontation I had with Allon Schoener the next day about the discrepancies started off with acrimony but ended with mutual expressions of frustration and anger, towards others, not each other.

''*Why,* as a professional editor, did you *do* it?'' I demanded.

''I didn't want the thing to sound like just a high school essay,'' he said.

''It's *your* fault. If you *had* let it alone, we'd be still selling those books.''

''I don't think so. You gave in too quickly. You succumbed to the museum board—the pols, the lawyers, the *real* racists. I have to tell you that your action in putting out that dumb disclaimer and that dumb apology and then going along with the book-burning and then locking those catalogues into the cellar here is disgraceful. I thought a lot more of you. I used to admire you.''

''Come off it, Allon. We've both screwed up. So, I caved. The events were too much for us. I still think the show's brilliant, and I think in some years I'll look back on this as a major breakthrough. We're going to make it.''

''You'll make it,'' he said. ''They'll have to keep you. It would be too embarrassing to throw you out so early. But I'm ruined. I don't know what to do. I'm called a terrorist and a traitor by my own people.''

Allon Schoener eventually moved to Grafton, Vermont, and established a consulting and free-lance writing career. Except for necessary meetings, he has never returned to live in New York City.

The executive committee of the board of trustees met in February. For the first time since I arrived, there was no rehearsal beforehand. Houghton raced through the normal agenda, spending a mere fifteen minutes on what normally would have taken an hour. When he was finished, he turned to me and said, ''Tom, a few trustees have some questions concerning the recent events and your conduct recently. I would like to ask the vice-directors and the treasurer to leave the chamber.''

I had expected a closed session but had assumed that it would remain parliamentary. I was wrong. The first cries of outrage came from Francis Plimpton.

His words came out in a flood, but I hastily wrote down memorable phrases: ''Never seen such an institutional disaster''; ''annihila-

tion"; "a museum wrecked by foolhardy actions"; "failure that will blot your record forever."

I was calm. In a curious way, I welcomed the attack. I made myself look unruffled and acted as if I were taking serious notes on Plimpton's diatribe. I glanced at Houghton whose face was very pale. A good sign. That meant he hadn't orchestrated Plimpton. Elderly, white-maned Devereux C. Josephs, the chairman of New York Life Insurance Company, and a close friend of my father-in-law, was next.

"I agree with my colleague, Francis Plimpton," Josephs said. "Mr. Hoving, you have done a great disservice to your institution. I have, Mr. President, a question, namely, how many so-called exhibitions of social progress, 'relevancy,' and 'practical life' is our impetuous director going to commit us to, without allowing us the courtesy of knowing *anything* about his secretive plans? Also, I want to know how much more trouble is this director going to get us into?"

I decided to ignore Plimpton. From my political experience, I had learned always to answer the last person. The point was to answer the enemies as if you were talking to your friends—softly, rationally, and insistently—and I saw that I still had *some* allies on that board.

"Mr. Josephs, I have brought, of course, a list of the times—there are six separate times—when I fully briefed either Arthur Houghton or an officer of the board or the executive committee officially of the progress *and* the problems of 'Harlem.'

"To answer your question, Mr. Josephs, about how much trouble I'm going to cause in the future. Probably a lot. You know why? This museum's still in a deep quagmire. Getting out isn't going to please a lot of you or the outside public or the art press. But you've got to allow this institution to extricate itself from the mire and get moving. A few steps have been taken. The women's issue is on the way to solution. The accounting system is starting to get straightened out. We have the beginnings of a career and salary plan in the works. A worthy management study. Even a fund-raising plan. The Centennial's going to be a landmark. The fresco show was a moment of history. We are creating a master architectural plan—the first in our history. The public is streaming in. The membership is up, despite the defections from 'Harlem'—and they'll be back. The unions are quiet. More money has been raised since I arrived than in the previous twenty years of this place. Kings . . . The Terrace . . . The

178

Musical Instruments. When I met your Search Committee I told them . . . what *did* I tell you, Frank?'' I said, turning to the chairman, Frank Rogers.

"That there'd be some turmoil,'' he said.

"Yes, turmoil. I spelled it all out. When I gave that speech to the AAM, which so many of you came up to praise me for, I spoke of 'relevancy' and activity and criticism, lawsuits and some bad press. It's going to happen. You cannot avoid it. I have gone out of my way to let you know *everything*—those of you who have intrinsic interest in the Met and who want to be a part of this revolution. I admit to blunders—lots—involving 'Harlem.' So what? It's *one* effort out of hundreds we'll do. Will the exhibition schedule include dozens of 'social shows'? Not if I can help it. Relax. This is a long pull. At times it's going to get rougher. Wait till we start expanding into the park. But I never failed to tell any of you, those who cared, what the hell was up or coming up. And I won't fail to do that in the future. Listen. I sat here—what?—a year and a half ago and watched as one of your distinguished body virtually tore apart my predecessor. I get some of that feeling now. And I don't need that. Do I make myself clear? I love this institution. I'll try my damnedest to make it greater. I shall make my share of mistakes. You must understand that. And, of course, so will you.''

Silence. For the first time since I'd met him, Arthur Houghton looked flustered. But in a few seconds he said, ''Well, are there any more questions or comments? Well, hearing none, I suggest that . . . and I hope you understand this, Tom . . . I suggest an executive session of the full board—ah, Tom, can you leave?''

"Good idea,'' I said breezily and shot Houghton a look of pure acrimony. This was the man who said we would walk out of the room and down the steps of the museum, ''hand in hand.'' He avoided my eyes.

I pondered whether to go home or to stay in my office until the executive session was over. I decided on the latter, figuring that after my performance, the board could not possibly fire me. I left slightly ajar the door of my office leading to the corridor through which the board members had to leave the museum, hoping that Houghton would stop in to tell me what had happened. He did.

"Tom . . . I suppose they've had meetings at the Met like that before. Now, your remarks defused a possibly ugly turn of events. There has been a board resolution. Brooke proposed it. We have

created a subcommittee, which makes it an advisory body only, through which you can inform the board and its official committees on forthcoming exhibitions. . . .''

"A sock in the face," I said angrily.

"Call it a slap on the wrist," Houghton said with a tight smile.

"No way, Arthur. *You* brief 'em. I'll tell you, as I always have, about the upcoming shows. But I will not submit to a bunch of amateurs. Okay? And, what about this talk of yours of walking out with me 'hand in hand'? Thanks. Look, I'll work with you. I'll deliver the Centennial. But from now on, it's different. No one sells me out. Just keep that exhibition subcommittee off my back."

That evening our relationship ended. Houghton was to continue on as chairman for another year and a half, throughout the Centennial he had so imaginatively and courageously championed. But from that evening until his abrupt retirement from the board, Houghton had given up. I suppose he saw that I was not to be dislodged. And what if he had engineered my ouster that evening (which he could have done)? I can only imagine that Arthur Houghton, faced with the prospect of another lengthy search for a director, had himself caved.

Wounded, occasionally hounded by the aftereffects of the disastrous "Harlem on My Mind," I needed weeks to recover from bouts of depression and self-doubt. What the hell had we achieved, I kept asking myself. After a while I saw that we had achieved a great deal. We had identified and possibly saved for posterity the works of a talented photographer, James Van der Zee. Blacks have never stopped coming to the Met. Eventually Arnold Johnson, one of the strongest Harlem supporters of the show, was voted a member of the board of trustees. I never heard another word from either Francis Plimpton or Devereux Josephs. The infamous catalogue went underground in a storage bin in the museum but was doled out—every single one of its fifteen thousand copies—to black school groups and individuals. Years later, the Schomburg Library accepted with thanks all the Harlem photo murals, which can be seen there today.

12

I NEED A COUP TO SURVIVE!

I managed to hide how deeply affected I was by the failure. Barely. It was the worst disappointment I had ever suffered in my life, and I had brought it on myself. At the least I had made it worse. I fell into a miasma of self-pity and felt I might almost be having a nervous breakdown. I railed at the press to my wife. I employed the classic excuses: they had built me up, just to tear me down, even destroy me. It was nonsense, of course. I had blundered. I had been inept and stupid. My confidence was shaken and I could not seem to regain it.

I have never had close friends, and in my agony I found I had no one to turn to for solace except Nancy. And I needed an outside friend. It was Ted Rousseau who took charge of me and saved me. One day, Ted came to my office and literally ordered me to have lunch with him. He came directly to the point.

Ted had spoken to ''key trustees'' and had found out that my survival was ''perilous.'' Of course I knew that the leaders of the

181

oust-Hoving movement were Plimpton, Josephs, Redmond, and Wrightsman. Rousseau told me now that several more were thinking of joining them—Brooke Astor, Joan Payson, and Dick Dilworth. He said Arthur Houghton was on the fence, watching which way to jump but leaning against me. Only a handful of the trustees were on my side—Danny Davison, Dick Paget, Dick Watson, and Ros Gilpatric, who had been calling the angry trustees to urge calm. He had managed to sway Harry Morgan and Mary Whitehouse to my side.

"You have to come up with a stunning coup not to be fired," Rousseau said. "What triumph do you have in your pocket that you can announce quickly?"

My pockets were empty. Lehman would not allow me to say a word of his decision. I knew of no remarkable acquisition possibilities. I told Rousseau about my letter of resignation. Perhaps I should submit it.

"If you submerge yourself in bathos, you aren't worth saving," he said acidly. "I told Joan Payson and several other board members that if they force you out, I plan to resign."

I was moved. Rousseau reached over and gripped my arm.

"Tom, all I see these days are your two worst failings: your craving for admiration and a tendency to lapse into self-pity. Snap out of it."

For a few seconds I was furious at him for unmasking me. Then I had to laugh. He had lanced the boil.

"I advise two immediate actions. One, get some favorable press the trustees will read," he said. "You must have *some* friends in the press. Use them. Two, land Nelson Rockefeller's collection. The way has already been paved. You said yourself that getting his primitive collection would round out the encyclopedia."

"I *did?*"

"Tom, your third failing is that sometimes you don't remember what you've said. I hope your vow to land Rockefeller was not simply another glib statement."

I blushed.

It might work. Nelson Rockefeller was not only a supporter, he owed me a favor. During his attempt to run for the presidential primaries, he had persuaded me to become a member of the draft-Rockefeller committee. Rocky had assured me and my colleagues that he would enter the race. To our embarrassment, he did not enter. And then he did when it was too late and, of course, failed.

My only concern was that Rockefeller's primitive collection was so enormous. Did we want it all? And what about his fine collection of modern paintings and sculptures? Rousseau said the modern pieces had all been pledged to the Museum of Modern Art and having *more* primitive pieces would tend to legitimize the collection. The moment to capture the primitive pieces could not be better. The governor was hoping to mount a series of art shows of his entire holdings in the spring and summer. Word was that since his political future had fizzled, he wanted to be known as a "Medici, a great art patron."

Rousseau also suggested that I talk to Houghton, who was a fan of primitive art, especially Eskimo.

"What if the trustees look upon primitive art as another 'Harlem'?" I said.

"The Rockefeller name will make it gilt-edged," Ted said. "By the way, the best therapy is to get away. Come with me to Europe. Far away from the board. Let's go to London, Paris, Vienna to get loans for the Centennial shows."

I told him to start arrangements.

The meeting with Houghton was somewhat emotional. At first we found it hard to look directly in each other's eyes. Soon we were admitting our recent faults and excesses. If the meeting had not taken place, I believe I would have been thrown out of the museum. Houghton accepted my apology for getting angry at his behavior about "Harlem" and apologized for his "insensitivity."

I quickly explained Rousseau's idea of wrapping up Rockefeller, and Houghton said he would talk to Dick Dilworth at once. Then, with his typical abruptness, he mentioned his passion for Eskimo art and said in that expressionless way of his, "Why don't I contribute a fund, say, a hundred thousand dollars, for you to acquire the best Eskimo art around. I'll introduce you to the one man who knows more about the works than anyone, Jim Huston." He punched up his phone and asked his secretary to send Huston up to the office.

Huston was his favorite artist at Steuben Glass and had created most of the hunting motifs in crystal—the fish leaping out of the water for the fly, the Eskimo waiting by the side of the hole in the ice to stab a seal below the surface. I thought the stuff was horrid. I said nothing, of course.

Huston gave me a crash course on Eskimo art. In a week we were on our way to Ottawa to buy, spending most of a day in a government warehouse where thousands of Eskimo sculptures in stone and

bone were stacked on shelves. They ranged from mawkish airport stuff to masterful depictions of the unforgiving Arctic environment. With Huston helping me, I picked out about seventy-five thousand dollars' worth of pieces, which would form the nucleus of the Eskimo collection. Houghton was delighted at my choices. "I see that your choices fit in perfectly with Jim's own collection," he said. I smiled at him. Years later Houghton donated the funds to buy Huston's superb private collection.

Dudley Easby and his wife, Elizabeth, put together a quick exhibition of Mayan art from the Guatemalan National Museum, the University of Pennsylvania, and several private collectors they were wooing. We published a brochure solely with Nelson Rockefeller in mind. The key sentence paraphrased a Rockefeller dogma: "The Mayans were the Greeks of the pre-Columbian world."

We spent almost as much money on the small Mayan show as we normally did on a major exhibition. It was a modest hit, though I didn't have to care what the critics or even the public thought: Rockefeller adored it. He sent me a letter of congratulations, signed, "Warmly, Nelson." I informed him "confidentially" that I was planning a major pre-Columbian exhibition for the Centennial. Houghton told Dick Dilworth about our "entrapment" plans and he advised us to make an architectural model showing how Rockefeller's "wing" might fit into the master plan.

I knew of the perfect location for the Rockefeller wing. I instructed Roche-Dinkeloo to design a building over the public parking lot on the south side of the museum. The building would be a twin to the structure on the north housing the Temple of Dendur and we could put the entire Western European Arts Department in it as well. The concept was attractive as well as being logical and I urged the architect to draw up some "quick, sexy sketches" so I could flash them to the governor when I found the right opportunity.

About that time I got a needed lift in the press from the *New York Post* columnist Murray Kempton. In a column entitled "The Long Knives" he wrote, "Thomas Hoving was reported yesterday to be telling his friends that he may have to resign. . . . If Tom Hoving has a fault, it is in being careless of warnings, necessary or otherwise; and, if he has come to feel a sense of alarm, then he must have a very good reason. We are as democratically careless about people of special value as we are about ordinary ones. It occurs to me that I joined the cry against 'Harlem' without bothering to say that this

mistake had been made by a man of great qualities. . . . We demand that he apologize to us; but might not one of us also beg his pardon for having spoken as though his whole life had been this one deviation from a career which otherwise has placed us all so much in his debt?''

The sun was beginning to shine again. Rousseau may have gotten me over my trembling before the board, but I kept on having a few pangs of fear. One occurred when I found out that my favorite curator, the brilliant, glib, and ambitious curator of the Islamic Department, Ernst Grube, one of my centurions, had allegedly been taking kickbacks from several art dealers to support a mistress. I confronted the hapless young man with my ''evidence''—only circumstantial—and he admitted everything. I handled it as if it were a routine resignation and was greatly relieved when no word surfaced in the press. I was very anxious about leaks since I had informed the publicity-hungry Attorney General Louis Lefkowitz about Grube's transgressions. The ''General'' did not pursue the case. Grube's misfortune was our fortune, for I was able to enlist the ablest man in the field, Professor Richard Ettinghausen of Princeton, as the new head of the department. The lanky, bird-like Ettinghausen conquered everyone with his charm, intelligence, and drive.

Another staff member resigned, but this one not to my sorrow, Philippe de Montebello, an associate curator of European Paintings. No one in the museum was more self-assured, but Ted Rousseau was convinced he had no eye.

De Montebello dropped into my office one evening to ask about his future in the European Paintings Department. I informed him that it wasn't promising. He had no degrees and Rousseau didn't favor him. I urged him to become a museum director, get a few years experience building programs in the real world of administration, fund-raising, and unions, and climb up the ladder. I sent out some letters to those museums with vacant directorships. Within several weeks Philippe told me that Houston was seriously pursuing him. He wasn't keen since, as he said, Houston was ''so provincial.''

I offered the opinion that Houston was exactly the place where he'd receive the best training. De Montebello took the job and I was glad to be rid of him. I knew he was conservative, but I hadn't quite realized that he was opposed to everything I was trying to do. Upon his appointment, the *Houston Post* quoted him, ''The permanent collections are the most important thing. They're what a museum is

all about. Exhibitions are a passing sensation." He wanted no razzmatazz but scholarly shows. "A museum is a temple where one escapes the hustle and bustle to reflect, to look at beautiful things in peace and quiet." A few years later I was to find myself recruiting him back to the Met as my second-in-command. Eventually he became director.

———————

In late March Ted and I flew to Europe. The first stop was Zurich for a three-day meeting of the international committee for "The Year 1200," a show of late Romanesque art I had dreamed up for the Centennial. The period some twenty years on either side of the year 1200 had been one of intense artistic creativity not unlike the high Renaissance. A new brand of realism had been spawned—human beings came to life and displayed real emotions. Draperies—the soul of medieval art—were transformed from something stiff into slippery cascades of cloth that caressed and revealed surprisingly sensuous bodies. For the first time since the fall of the Roman Empire, a large amount of purely secular art had been made. The period fascinated me and held a personal relevance, as it was during that time that the lovely English ivory cross from Bury Saint Edmunds was made. Florens Deuchler and I had formed a group of scholars to help pick the objects for the mammoth show and to help us in writing the series of catalogues.

The gathering of scholars was chaotic, like the tower of Babel. The scholars spoke French, German, Spanish, and Italian. The meetings, punctuated by gourmet lunches and dinners with the finest wines and champagnes, were productive. Every loan Florens Deuchler had asked for was granted. When it appeared that a particular piece might be in doubt, I would promise the curator free passage to the United States plus a week at our expense. The gentle bribery succeeded.

Deuchler, who had come ahead of us to organize the meeting, drew me aside and informed me of one of the "most amazing art discoveries," which he had made, of course. On a scouting trip to Oslo to look at a group of Romanesque wooden reliefs for the exhibition, he had been attracted to an eight-inch-long ivory figure of Christ in the Kunstindustriet Museum.

He had sensed immediately that the piece belonged to the Bury Saint Edmunds cross at The Cloisters. Years before, when I was

researching the cross, I too had at first been convinced that the Oslo Christ was part of the English cross. But the definitive catalogue of medieval ivories stated that the Oslo figure was fully carved on the back. That meant it would not have fit correctly on the cross. Gleefully, Deuchler told me that the cataloguer had made a mistake. He had persuaded the Oslo curator to remove the walrus ivory figure from its case, and the Christ had a flat, undecorated back. Moreover, all the measurements seemed positive. Deuchler said, "I have made all arrangements to have it for the show—but listen, we might even be able to *buy* it."

The six-inch lyrical figure had been found in a flea market in Copenhagen by a distinguished Danish medievalist in the twenties. In his will he had given it to the Copenhagen Museum with the proviso that if anyone ever established that the piece were Scandinavian, then it had to be deeded to the Oslo Museum. This transfer happened in the thirties because back then it was assumed, wrongly, that every piece of walrus ivory must have been carved in Norway. Deuchler believed that if we could prove the Christ belonged to the English cross, then Oslo might think of selling it at the right price. If the fragment was fitted to the cross in New York, we would have the proof and could try to negotiate. I was thrilled.

I dashed back and forth from New York to Europe with Ted Rousseau half a dozen times. Most of the trips were unnecessary. I was simply escaping from the ghost of "Harlem" and the day-to-day running of the museum, which was becoming increasingly dull. Travel was luxury class the whole way. I was chauffeured to the airport in a limo; I flew first class, stayed in grand suites at the best hotels, dined at great restaurants, drank a lot, and got entangled in a number of affairs with all sorts of women I met on the way—museum staff members and pricey call girls. It was, considering what I had done to poor Ernst Grube, naked hypocrisy, but it was glorious fun.

Most of the time Ted Rousseau came along. We'd get the urge to check out London, and in a day we'd be off making the rounds of the dealers and salesrooms. On one occasion we had been contacted by a dealer offering a six-foot-tall painting on a wood panel of the standing Madonna and Child by Jan van Eyck. The dealer had told us that "the painting may *not* be totally fifteenth century—you see, the picture was restored in the seventeenth century, but so historically that no one would think of cleaning it anyway." We flew over, studied the enigmatic picture for a half hour, and found it a muddle

with no traces of the Flemish master. We had known beforehand that it was a dud. The jaunt was just for fun.

Some trips were for "1200," and others were for the concluding exhibition for the forthcoming grandiose Centennial celebrations to last no less than eighteen months beginning in April 1970. Ted wanted to pin down loans for his show, "Masterpieces of Fifty Centuries," the chronological display of the finest work in all of the museum's departments supplemented by treasures sent to us by the greatest museums on earth in honor of our one hundred years. Ted and I would wine and dine colleagues who might lend a masterwork. The National Gallery in London promised a marvelous John Constable; the Victoria and Albert pledged an early medieval brass candlestick, one of the top five works in the institution; the Rijksmuseum "guaranteed" the *Jewish Bride* by Rembrandt. The Louvre called to say that Minister of Culture André Malraux had cleared his calendar and was prepared to grant us an audience. We flew over that evening.

Malraux had crafted himself into one of the most intriguing intellectual figures of the half century. His stories about himself had become legend, the best being his wartime escape from certain death. Colonel Malraux—his code name was Berger, or Shepherd— had been wounded by the Nazis in an ambush in the south of France and dragged to a hotel where he was interrogated by an SS man posing as a priest. Malraux had exposed the phony priest by engaging him in a discussion of the *Confessions* of St. Augustine. Infuriated, the SS interrogator called for a firing squad and ordered Malraux shot. He was thrust against the wall, face to, but had turned to look defiantly at his executioners. Because of his courage, they had let him go. (I didn't believe the tale.)

Malraux had been crowned as the ideal *homme engagé*—the committed man. He was exalted as a unique combination of genius: intellectual, man of action, philosopher, fighter, poet, and revolutionary. His books, most of which I had read, were somewhat stagey novels and jargonistic art books. I didn't much like them. But now Malraux was minister of culture. If he blessed our loan requests— no matter how outrageous they might be—we would get them.

Rousseau and I were commanded to meet the minister at the Palais Royal at four-thirty in the afternoon. I have never seen the Palais more beautiful than on that sunny spring day. We were like eager job applicants, impeccably turned out. As I marched nervously

across the open garden towards Malraux's wing, I couldn't help thinking that the eccentric minister might subject me, as my step-mother had done, to a fingernail inspection. Met by a blue-uniformed, be-ribboned, be-plumed majordomo who saluted us, we were led up two flights of stairs. We entered the august office and waited. And waited. One hour, an hour and a half. Rousseau became anxious that I was going to walk out. He was right; I was just about to take off. Then the door to the minister's office opened and another uniformed lackey motioned us in.

Malraux was slumped over an enormous Louis XVI desk, dripping with ormolu. He half rose, thrust out his left hand—in his right he clutched a Gauloise—and slumped back down.

"Who do we have here?" he asked his aide. Ted told Malraux who we were.

"The Met? I haven't been there in some time. Mr. Hoving, I have heard of you—a kind of revolutionary. Hard to be a revolutionary in the deadly museum business."

The minister lit a Gauloise off another and started to talk very rapidly in an indistinct mumble. He talked for the greater part of an hour. I understood maybe twenty percent—for the most part a dis-tillation of his book *Museums without Walls.* He never once let go of a cigarette. I passed the time watching each ash grow long and fall to the desk or the rug. Suddenly, in the middle of a sentence he stopped, looked at us in bewilderment, and asked, "What do you want?"

Ted Rousseau described his idea of the "Masterpieces" exhibition and asked for a "splendid loan" from the Louvre.

The minister started up another Gauloise, nodded, and seemed to become comatose. It was clear we had been dismissed. We left him hunched there at his desk. Later on Ted's request was granted— Georges de la Tour's *Nativity,* Watteau's *Gilles,* and Delacroix's *Liberty on the Barricades.*

Vienna was next for "Masterpieces." The city of art is also the city of sin. The official purpose of the junket was to meet the newly appointed director of the Kunsthistorisches Museum to beg for "Masterpieces" loans and one ivory carving for "1200." The direc-tor was a former curator, Fritzie Klauner. She had gotten the job purely because she was senior on the civil servant totem pole.

Since we arrived several days before our official appointment, we investigated sin city. After a grand dinner at one of the town's leg-

endary restaurants, we dallied at the Bar Rentz until three A.M. with the two most attractive performers, either at our front-row table or, occasionally, in the *Separaten,* the small rooms in the back of the nightclub outfitted with a bed, a bottle of champagne, and a tub of hot towels.

Ted had disappeared with another young lady around the time I left and had not returned to our hotel by the time I straggled into the lobby. We met for breakfast in my suite and with the history of the night before painted on our faces, staggered to the administrative offices of the Kunsthistorisches Museum to meet Fritzie Klauner. She was a stern woman in her sixties with a tight smile and hair on her legs who glared at us like a mother superior. I was suffering, not only from a glorious hangover, but from the strain of trying not to burst into laughter. I could see Ted was about to laugh, too, which only made the task of looking serious more difficult. We managed, just.

The discussions about a masterwork—we were asking for a Breughel—bogged down at once with a lecture from Fritzie on the perils of sending works of art abroad. She allowed us to hang around her office for over an hour, gazing disapprovingly at us as we begged, and only then told us what we had to do to secure a loan. All requests had to be personally approved by the minister of foreign affairs, a man by the name of Kurt Waldheim.

Somewhat to our surprise, we got an appointment with Waldheim right away. He reminded me of a shiny lizard. Everything about him had a sheen—his glistening black hair, his tanned face, his voice. He suggested lunch at one of Vienna's most luxurious restaurants to discuss the "highly delicate issue of loans." We got nowhere. Waldheim suggested that we meet for dinner the same evening at another of Vienna's most expensive restaurants to discuss the problem further. He brought his wife, who spoke three words the entire evening. We advanced no further. He suggested we join him the next night— at our expense—for another dinner at still another of Vienna's most expensive restaurants. Again no progress was being made until Ted invited him to come to New York to attend the gala dinner of the "Masterpieces" show, all expenses paid. Waldheim gave us his sly lizard's smile and asked, "What was the precise picture you wanted? Some Breughel? It is altogether possible the loan can be arranged."

Europe helped me to exorcise the demon of "Harlem," but it was the developing master architectural plan that made the hurts all but vanish. I haunted the Roche-Dinkeloo studios in Connecticut. To me, the most beautiful part of the complex master plan Roche was developing was the luminous Great Hall and the spacious plaza with its two tree-filled parklets, its fountains, and its inviting stairs. I had tried to raise the seven million dollars for the undertaking but had met nothing but stony faces from the board members I had approached.

No more than two weeks after Roche had completed his models, I received a phone call from someone whose name I recognized from my prep school days, Barnabas ("Barney") McHenry. He was a lawyer with only one client. This client was interested in the museum in a way I might "find deeply sympathetic." I told him to come the next morning.

Barney McHenry was a suave, soft-spoken man who had a way of looking at one slightly askance. He would punctuate his conversation with an occasional low chuckle that suggested he was telling one a profound secret. We started off chatting about school days, but I was too curious about his single client.

McHenry chuckled a really-secret-information chuckle. "She's Lila Acheson Wallace."

The name meant little to me. I seemed to recall Henry Fischer having spoken of a Mrs. Wallace. "She's interested in Egypt, right?"

"Yes. But I'm not here for Egypt," he explained. "You know she's the cofounder of the *Reader's Digest*."

"Of course," I lied.

"Lila has dedicated herself to making things beautiful in New York. She wants to spend all her money before she dies, making things look beautiful."

I had no idea where he was leading me. As McHenry spoke, he looked at me more and more sideways until I thought I'd have to get down on my knees to look into his eyes.

"Lila thinks the Metropolitan is . . . ah . . . grungy, though that's *my* word, not hers. She thinks the institution is too great to have such a shitty-looking facade—again, *my* word—and is convinced the entrance hall you've got here is filthy and sad."

"I agree," I said. "It just so happens that our architects have come up with an absolutely spectacular design for both the plaza in

front of the facade—and the Great Hall. I've never seen anything *more* beautiful. We have just finished models and a slide presentation.''

''When can Mrs. Wallace see them?''

We made a date for the week following for lunch across the street at the Stanhope Hotel and a presentation in an empty gallery off the Great Hall. On a sunny day in May, Lila Acheson Wallace came to ''have a glance,'' as Barney put it. She was a strikingly beautiful, petite woman in her seventies, all in blue—dress, hair, eye shadow. She was wearing a magnificent brooch in platinum and diamonds of the winged horse Pegasus—the *Digest* symbol—designed by the Tiffany jeweler Jean Schlumberger. Lunch was chatty and lighthearted. Lila talked about her affection for my father and his work at Tiffany and for Billy Graham.

Kevin Roche, John Dinkeloo, and Arthur Rosenblatt were waiting in the gallery. Before making our pitch, we toured the Great Hall and showed Mrs. Wallace a section of the stone which we had cleaned, transforming it from coal-brown to the ivory of its original color. Kevin gave his slide show and presented the dramatic models, explaining the philosophy of the project. Mrs. Wallace appeared unimpressed. She seemed to take note only of a detail—the chairs we planned to put in the two small parks. When the presentation was finished, I closed with a few words about the developing master plan —the Temple of Dendur, playing to her Egyptian interest, and the American Wing.

''What will the plaza and hall cost?'' she asked.

''Around seven million,'' I said.

''Do you mind if I suggest one change in your plans for the interior? Think of having two shops opposite the entrance, instead of coat rooms. I have a feeling that a pair of attractive shops might earn each year an income equivalent to that from a ten-million-dollar endowment. Anyway, I love the plans. Just send me the bills.''

Lila Acheson Wallace got up, thanked us for the lunch and our time, and apologized for staying so long. I escorted her down the steep old steps to her car, and I returned to the gallery.

''What the hell do you suppose *that* was all about?'' Kevin asked. ''What did that remark about the bills mean?''

''I've no idea.''

The next morning McHenry phoned. ''What a swell presentation. Roche-Dinkeloo are sure impressive. She's going to pay for it all. I'll

send you initially a million—in the form of *Reader's Digest* stock which I'll place with the New York Community Trust, which is how she usually does it. We don't want to hold you, by the way, to the seven million you mentioned yesterday. Looks to me like it's going to be a bit more. And Lila's going to be good for it.''

Good for it! And McHenry's assessment was modest. Over the years, just for the plaza and the Great Hall, Lila Wallace gave the seven and a half million for construction, plus an endowment of four million to pay for the perpetual maintenance of Hall and facade plus another four-million-dollars endowment for fresh flowers in the great four niches and the planters near the benches in the Hall, the single most gracious gift anyone has ever given to the Metropolitan.

Talk about a career-saving coup! But I was not allowed to announce it.

May 1969 was Nelson Rockefeller's month in New York City. Three shows of his varied collections opened simultaneously at the Museum of Modern Art, at the Met, and at his own Museum of Primitive Art. And the press did attend to him like the Lorenzo de' Medici he wanted to be.

The preparation for our show, singling out the finest pieces in his primitive collection, was straightforward. The staff of his private museum worked well with our curators and designers. Rockefeller's chief curator, Robert Goldwater, whose gloomy expression made you think his face had never seen a smile, turned out to be a genuinely funny man, a delightful intellectual. I had cornered Rockefeller at his crowded gala tea party at Pocantico and shown him the "quick, sexy sketches" of his wing. He had devoured them. His narrow eyes became tighter slits. "Hey, fellah, this *is* good. Makes one think."

Stuart Silver's installation was theatrical without being overly dramatic. The design made the arcane pieces popular, even sympathetic. The first gallery was devoted to the tall, multicolored ancestor poles, called Bi'sh poles, which the late Michael Rockefeller had collected. We set up the podium and the microphones for the governor to say a few words to the press.

"I am immensely proud to dedicate this fine-looking exhibition of the works I am truly in love with," Rockefeller said. "Not only are these my intimate friends, but some, the things from New Guinea, are emotionally powerful to me—because of my . . . dear . . . late son, Michael . . .''

It was the perfect thing to have said and the emotion in Rockefeller's voice and the look in his eyes moved all of us. Young Michael Rockefeller had disappeared in New Guinea while on a trip researching the island's famous tribes and buying works of art.

"I'd like to digress, if you don't mind," Rockefeller continued when he had gained control of himself. Now he was the seasoned campaigner, his square face wreathed with a smile, his arms outstretched.

"When I came on the board of the Met for the first time—so many years ago, when I was a kid—I expressed my zeal to an elderly trustee of assembling for the museum at *my* expense, mind you, the greatest single collection of the art of Oceania, Africa, and the Americas on earth, a collection equal to the holdings in England or Germany. The trustee, I won't embarrass his name or memory by telling you who he was," Rockefeller's eyes slitted in amusement and he gave that signature sideways nod of his head. "The old boy told me to forget all that 'native' stuff and spend my time and money on 'good things' like Greek art. Well, that statement drove me to collect the art we have here in these magnificent galleries, art which, to me anyway, is no less moving than the works of Phidias or Michelangelo or Leonardo. I forgive the old boy and the Met. And to prove it I want to let you know that arrangements have just been concluded— the 'treaties' are about to be signed—to transfer my Museum of Primitive Art, lock, stock, barrel, including works of art and curators and staff—*everything*—to the Metropolitan Museum of Art. The two great institutions will as of this moment be merged and become the greatest single encyclopedia of art in the world. I announce also that my young, creative friend, Tom Hoving, who's experienced from time to time a bit of frustration at my hands and has gotten himself into some trouble in recent months, has gotten the museum's architects to come up with a beautiful plan to house the Primitive Museum, and I announce that this Wing is to be built on the south just over there over the parking lot and will be known as the Michael C. Rockefeller Wing . . ." His voice broke. God, it was a heady moment, made headier because of the poignancy. The press actually clapped.

"Hey, Tom, are you surprised?" a reporter called out to me in the question period.

"Absolutely," I said.

"How do you feel?"

I paused. "Kind of saves my ass around here."

After the Rockefeller gala Rousseau told me, "You have won. I had dinner last evening with Joan Payson, and she gushed on and on about how brilliant you are. Not one word about 'Harlem.'"

"If I had to do it again," I said, "I'd have had Rocky's stuff and 'Harlem' running at the same time. What a fuss that would have made!"

The Rockefeller coup made it safe for me to preen again in the open and I did so. With the same zest with which I had manipulated image into reality in my Parks days, I engraved into the contemporary cultural mythology that I, Hoving, was one of the rare crusading forces in American museums. I managed to get across the point that most other directors—especially Sherman Lee of Cleveland—were holding back the entire profession from its leap into the modern era. I began to think once again about the possibility of a political career or, at least, *something* other than the backwater of a museum life, another manifestation of my almost desperate urge to be wanted.

———

By the early summer of 1969 it was evident that Bobbie Lehman was dying. I made appointments, but each time I was told at the last moment that he was too sick to see me. When I did manage to visit him, I saw a man wasted, but by no means somnolent or senile. When he was rested, he clearly understood what I was saying. He would nod with comprehension when I brought up what we had agreed about the Pavilion, that it would be built with museum money, that after a period of twenty-five years his collections would be dispersed throughout the departments of the museum and the building turned over to special exhibitions. There is no doubt that Lehman knew what I was saying and agreed with me. I also happen to know that his friend, counsellor and executor, Edwin Weisl, Sr., knew of his thoughts and our verbal agreement.

The last time I saw Lehman was in late June. On August 9, I received a call from Ed Weisl that he had died. Hurriedly, I organized a memorial service in the medieval sculpture court on the twelfth of August. Weisl was the only speaker, something I had decided upon.

On the day of the memorial service, the *Times* ran a story stating that the collection had been bequeathed largely to the family, Lehman's widow, and son. The Met, the article reported, was to receive

one hundred thousand dollars. Had the Met been cut out of Lehman's will? I pumped Weisl at the service, and all he would say was, "Tom, the affair is in good hands."

"But you remember," I said, "that in June Bobbie confirmed that we were going to get the bulk of the holdings and an endowment to pay for their upkeep. You remember confirming that over the phone in June after I had talked to Bobbie?"

"Please, Tom, this is not the moment."

Afraid that Weisl might be pulling a fast one, I thought of cancelling my forthcoming trip to Europe and the Soviet Union with the Wrightsmans. But after I had briefed him on my suspicions and written a letter for the files to be used by our legal counsel as part of the paper record I was building on the Lehman affair, Houghton urged me to go.

"Arthur, you can imagine my feeling on reading the *Times* that morning of the memorial service for Bobbie," I said. "First I thought some reportorial mistake of great magnitude had occurred. Then— Jesus! could it possibly be true? I was totally confused, since I had briefed Weisl on what Bobbie agreed every step of the way. Yet I have the funny feeling that Weisl is perhaps going to negotiate away from what Bobbie and I agreed on. We must be vigilant.

"George Trescher has a helpful suggestion—let's announce the Lehman benefaction at the dinner you want for September 25 in honor of all the benefactors, past and present. I spoke to Weisl and he *seemed* pleased and murmured something to the effect that he hoped and expected that all the agreements would be ready by then. But we *have* to be vigilant."

Houghton assured me that he'd keep his fingers on the pulse of the Lehman situation.

We met the Wrightsmans in London to go to the Soviet Union, my first visit. The surface was glossy and varnished, but if one looked around the corner or walked down a street that was not on the prescribed tour, one found horrible conditions. I was astounded by the poverty and the squalor of Leningrad. The Hermitage was crammed with stunning works of art, but it was also filthy.

It smelled of dust and rancid food from the makeshift restaurant. It consisted of five palaces built over several centuries with numerous nineteenth-century renovations. It took a half dozen visits to figure out how to get around.

Except for a dozen triumphant masterpieces—Leonardo's *Ma-*

donna, the *Prodigal Son* by Rembrandt, Poussin's *Tancred,* Giorgione's *Saint Catherine,* and a number of superb oil sketches by Peter Paul Rubens, the collections were admirable but not up to those in the Prado, the Louvre, the National Gallery in London or Vienna. The real treasures of the Hermitage were the art and cultural artifacts of the peoples of the Altai and Pasyryk mountains and the nomad Scythians from the Ukraine. From tombs in the Altai mountains, their contents frozen in perfect condition, came rugs and tapestries of flamboyant color and lively design, carved wooden and felt saddles, and marvelously intricate horse trappings and sculptures in brightly colored felt in the shape of elks or flying birds, all dating to the sixth and fifth centuries B.C.

The gold and silver of the Scythians, kept in a three-chamber vault with a foot-thick door at the entrance, were miracles. A gold cup three inches around showed Scythian warriors at an encampment, one pulling out the rotten tooth from the mouth of a companion. There was a solid gold comb, four inches tall, with a Greek warrior on a magnificent horse lancing a cringing enemy. The best Scythian material was in the classic Greek style, because the Scythians and the Greeks had been trading partners. One object grabbed my attention, a tattooed human upper arm with wild, interlaced blue, red, and yellow decorations beaded and lined into the thick human parchment. While the others spent most of the time in the picture galleries, I haunted these chambers, memorizing their contents.

Boris Pietrovsky, the director of the Hermitage, was an archaeologist of Scythian and Altai tombs and a member of the prestigious Soviet Academy. He was six foot six and carried himself like a soldier. He had striking, large limpid eyes which were slightly crossed, a huge brow, and a row of thick teeth with two gold ones in front. I recognized him from the photograph in Harrison Salisbury's *900 Days.* Pietrovsky had been cited in the book as one of the most stalwart of the besieged Leningraders. He had holed up in the cellars of the Hermitage with only a miner's lamp on his head and a long stick with rags soaked in water, which he used to extinguish the sparks set off by the German incendiary artillery. The works of art had long before been carted into the interior, but Boris Pietrovsky had helped to save the buildings.

I presented him with Harrison Salisbury's book, which was banned in the Soviet Union. He smiled, closed his eyes, and, in halting English, proceeded to quote from the book. Because of the

"scarcity of certain books from the West"—a delicate way of put-
ting it—people who could memorize entire books would then read
them back to others. Memory "geniuses" would foil state censor-
ship.

Of course, I brought up the subject of exhibition exchanges, spe-
cifically old masters from us in exchange for a spectacular Scythian
show. But, I was told, the political climate was not "quite ready."

In Moscow we were to meet the minister of culture, Yekaterina
Furtseva, a former mistress of Nikita Khrushchev, who had survived
under Leonid Brezhnev. She was a dedicated collector of an-inch-
off-the-ground natural sable coats and *the* say on any loan exchange.
The minister's chief assistant, Alla Butrova, was herself imposing.
Tall, plump, with a beautiful, sympathetic face and lively eyes, she
spoke English with a distinct American accent—she had been as-
signed to the embassy in D.C. for some fifteen years. Butrova never
kept notes, but never forgot the slightest detail of a conversation or
negotiation.

After a day or two Rousseau and I began to understand the innu-
endo of phrases from Butrova and her assistants, such as "people to
people" or "people are more important than governments." We
stressed that the Metropolitan was a private institution with *no* gov-
ernment ties. If a show could be worked out, we would never go
through our own embassy in Moscow, we said. Alla Butrova smiled.
"You learn quickly."

Madame Minister Yekaterina Furtseva granted us an audience in
her palatial offices, not unlike the luxury that surrounded André
Malraux. Through an Intourist interpreter, we chatted breezily about
the glories of the museums of the Soviet Union and flattered her
outrageously. Furtseva had a girth, her face was plain, but she ex-
uded power. She spoke with considerable wit. We uttered the stan-
dard words of praise about the beautiful way the Russian museums
and the works of art were being treated—"such displays!" "such
moving exhibitions!" After a while Furtseva raised her hand to stop
us. "Enough! I know our museums look pitiful compared to yours.
Perhaps at the right moment in the future we can talk substantively
about some liaison, some agreement. Quid pro quo."

"Come to America as our guest," I said.

"I shall not forget your gracious invitation."

I returned to the Met eager to let the curators know that I had made great strides in the Soviet Union and to say that I had landed the most important coup in the Met's history. Instead, I received a curt request to appear before the Curatorial Council. Barbara Goldsmith, a sort of muckracker in the cultural arena, had written an article in *New York* magazine revealing some of my choice observations about the "old-guard" curators. It quoted me: "I get things done with the aid of a new guard who see things my way—a young, energetic group who evince a disdain for the old regime, a group that's impatient and has little inclination to woo the old guard. I can't stand some of the stuffed-shirts. The ones who like the labels that contain the barest information. It's silly. It presumes you're fully trained before you come. What does Middle Kingdom mean to you? Doesn't mean much to me, and I'm a fully trained historian. What does *kylix* mean to you? We *have* to make communications simpler than this. I mean most of my nineteen departments look only at themselves. They have neither the understanding nor the desire to do something for the general public."

The meeting started off with Dietrich von Bothmer and Henry Fischer complaining about being singled out and pilloried in the national press. It was my turn to be furious. I hit them with what later was referred to as the Hoving Doctrine. There were eight points:

"You don't communicate and you're gonna start now.

"You don't write for the public and you'd better.

"You all complain too much and you'd better stop.

"You talk against me behind my back and you'd better stop.

"You're selfish. That has to stop, too.

"You're narrow-minded. Open up.

"You don't give a damn for the public, so start romancing your departments—now!

"Don't bitch at every little thing in the press.

"Finally, something you ought to know. The Lehman Collection is ours. Something else you'll want to know. I'm leaving. Oh, I'll stick around until after the Centennial. All I can do here will be done in five years. You are wearing me out. You think I want to have this place kill me—like Jim Rorimer? Five years. Good day."

My pronouncement had been premature, for I knew that Ed Weisl and the members of the Lehman Foundation and their lawyer, Paul Guth, had dedicated themselves to giving us a hard time. I met Weisl with Ashton Hawkins, our in-house lawyer, and Gilpatric, patiently

reading from detailed notes of all my conversations with Bobbie. Weisl was no longer the gregarious, political figure. He said the members of the foundation had problems and that Paul Guth had problems and that Robin Lehman had problems. Some of the problems were ego trips on the part of some Lehman Foundation board members. Guth drafted a document so dense, so lacking any sense of mutuality, that Ros Gilpatric commented that it was more like an "indenture for a trust."

Other board members of the Lehman Foundation showed up demanding to see the models of the Roche-Dinkeloo scheme and haggled over the architectural details. Lehman trustee Charles Zadok even suggested that we "go back to the drawing board on this one." Meanwhile, Weisl learned that Robin Lehman wanted the agreement to state that the Lehman townhouse would be opened to the public as an active museum. I threw myself into the counterattack with an intensity that startled both Zadok and Weisl. Charlie Zadok kept on bothering me so I finally lost my temper and struck back. "If we change one centimeter of that model and those preliminary plans—the very ones Bobbie himself approved, in the presence of witnesses, by the way—then the whole Pavilion will have to go back to the Landmarks Preservation Commission for a full review and after that the City Council and possibly the Board of Estimate."

It wasn't true, but I knew Zadok knew nothing about real New York City bureaucracy and thus was terrified of it. He quickly removed his objections. I used the same scenario with Weisl and Guth and was amused to see these two sophisticated legal warriors become nervous.

I also frustrated Robin Lehman's "populist" idea to throw open the Lehman house to the public. I had Joe Noble prepare a memo with "six immediate steps" needed to make the Lehman house secure. Again I scared them with a worst-case scenario. We would have to double-check the working of alarms, review the electrical, steam, air-conditioning, and other services in the building to ensure they were in safe and trouble-free condition, supply additional guards on a twenty-four-hour, seven-day-a-week basis, install a hot-line telephone, and alert the police captain of the proper precinct, and that was just the beginning of it.

Negotiations dragged on so slowly that I became convinced that we wouldn't be able to make the announcement at the Centennial Benefactors' Dinner. But on September 24, the day before the gala,

we got a preliminary agreement strong enough for the announcement.

The gala was to be held in the enormous gallery I had set aside for European paintings throughout the Centennial. Houghton and I stood at the entrance to be able to greet the trustees of the Lehman Foundation. I greeted Robin Lehman, who wore a white turtleneck shirt with his tuxedo, and escorted him along the mezzanine. He stopped suddenly and said, "I think I am not going to make the announcement. I think you and the foundation took advantage of my father."

I was burning.

"Mr. Lehman, your father and I developed a relationship of a kind I don't think you could even comprehend," I said. "We worked this thing out together, inch by inch. He was very happy. Okay? Now, I personally don't give a shit whether you announce or not. But that was the agreement. Either you make the announcement as planned," I said, "or I'm going to toss you over the railing of this mezzanine."

Startled, Lehman looked at me, his wandering eyes out of focus, and calmly walked on. Once at the stairs, where the place cards had been laid out for each one of the round tables, he paused and said, "I want my lawyer to examine the seating arrangements."

I laughed in his face. It was such an absurd thing to say. The lawyer inspected the cards and their placement and nodded his assent. Only then did Robin Lehman enter the chamber.

The mood of the evening was incandescent, like a family gathering attended by every great donor or descendant of every great donor in the history of the museum. Robin Lehman was stone-faced, scarcely acknowledging the friendly greeting of the many guests who came to greet him.

Houghton spoke first, praising the donors for their support and describing his beloved Centennial. He introduced Ed Weisl who introduced Robin Lehman. When Robin ambled up to the lectern, he looked disdainfully at the silent throng and then told how he had shared "since childhood" his father's interests in the arts. "We both went over the disposition of his art possessions and jointly decided that it would be in the best interests of the country and the world to give this collection to the Metropolitan Museum."

I almost choked.

Arthur Houghton leapt to his feet. We all felt that if he didn't immediately accept, the gift would be snatched away. "The an-

nouncement that you have just made is almost beyond the power of adequate acknowledgment. It will be the largest gift in the history of the museum. It will enrich the museum beyond measure. It will add a crown of glittering jewels to our collections. In one single moment, and by an act of unparalleled generosity, a miracle has been wrought that lifts the Metropolitan Museum at the opening of its second century from greatness to preeminence. Now, please let us all raise our glasses to the immortal memory of a man who loved art and who loved his fellow man. Robert Lehman.''

The day after the gala Ted and Nancy and I went out to dinner and got quite drunk.

''Tom, the 'coup of all coups,' '' Rousseau exulted. ''This could be the apex of your museum career . . .''

''And my life, for Christ's sake,'' I concluded.

In a way it turned out to be just that. Landing the Lehman Collection was a coup for Ted Rousseau too. He had kept Lehman on the leash when everyone else had given him up. And the coup was also the moment, as I interpreted it, when the old guard of the museum lost their final stranglehold on the Met. The ''great Jew,'' as Ted Rousseau called him, had truly beaten down their intolerance and their anti-Semitism.

The next morning, though, the Lehman struggle continued. I felt Robin was about to launch an offensive against us. He urged that the Lehman house be opened to the public. Weisl informed him that the Lehman house would definitely *not* be opened to the public and that the Met structure might take years to build, so Robin issued a statement to the press.

''Under the present arrangement, my father's collection will be kept from the public for some time to come, wholly inconsistent with what he had intended. . . . Based on the commitment that my father's intentions are not being carried out, and that his Collection of pictures is not being properly treated from the standpoint either of the family or the public, I have filed an objection to the proposed disposition of my father's estate.''

Ed Weisl knew that Robin was probably genuinely interested in the greater public but he was also interested in something for himself, and Weisl asked us to allow the foundation to give Robin more works of art from the estate. Why not, I said. As soon as he received more, we heard little from Robin Lehman.

Whatever Robin Lehman had done to complicate the affair was

insignificant compared to what Ed Weisl then proceeded to do. On November 14, he wrote a letter to Ros Gilpatric, stating that there was no commitment in the will or in any other document that any part of the income or principal of the foundation was to be used for the wing or the Lehman Collection "when, as and if it was given to the Museum."

I was angry at Weisl's letter. "Should we sue?" I asked Gilpatric. It was his turn to blow up. He ordered me to allow the lawyers to continue their work and recognize that much of the Weisl letter was "legal pawing of the air."

"I don't think you quite understand the deal I made with Bobbie," I retorted angrily.

Gilpatric was harsh. "I would suggest, Tom, that under the present circumstances, it might be better to settle for what we can get— the collection *in solido,* in perpetuity, in a building *we* have to pay for from endowment—and I think we'll have to change the constitution of the museum to do that and force the Lehman Foundation to set aside at least a third of its assets to pay all costs, excluding the utilities. For Pete's sake, do you want the collection?"

"Yes," I said weakly. I caved. I should not have.

In time a satisfactory arrangement was made—though I still bridled at it—whereby the Lehman Pavilion would be constructed with a number of the galleries designed to look like the rooms in Bobbie's house. Roche designed the Lehman Pavilion in such a way that it could be converted readily into special exhibition galleries in the event that the foundation reneged on the gift, something I feared up until the formal opening, years later. Someday, I am convinced, the collections *will* be dispersed, but that is another matter. From the moment the legal nit-picking began, that special aura that for me had always surrounded Bobbie's magnificent gift, was ruptured.

Despite my coup or coups, the corporation's annual meeting in 1969 was tense. The pall of "Harlem" still hung in the air, and I was not looking forward to questions from the floor. Houghton was nervous that someone—specifically Roland Redmond—would pop up and interrogate him about the incomplete Lehman negotiations. But Redmond kept quiet. The climate turned out to be surprisingly benign. I described "Harlem" as "difficult and controversial," fudged on Lehman, fudged again on the costs of the "master plan." I brought up the issue which would become the most corrosive in my administration—the disposal of works of art. In a recent Acquisi-

tions Committee meeting I had stressed the need to organize a weeding out of the bursting collections: *deaccessioning,* the standard museum word for getting rid of things. I urged deaccessioning to proceed step by step with the preparation of the architectural plan.

Houghton announced that Douglas Dillon would become the new president in December and that he would assume the vacant chairmanship. After the meeting Dillon asked to see me in my office. I was wary. Round-faced, laconic, with the smallest hands I had ever seen in a man of his size, he stuttered in a monotone, punctuated by long pauses. I warmed up to him when he said he admired what I was doing and fully approved of all my programs, even "Harlem," and said he would pursue the Centennial celebrations and the master plan with all the energy he could muster.

I had my doubts. He looked so lethargic.

13

HAPPY BIRTHDAY, HAPPY FIGHT

The Centennial celebration, which began at that tumultuous dinner and closed down eighteen months later, was a groaning smorgasbord. Life was exhausting. There were openings, seminars, lectures, receptions, galas, cocktail parties, movies, and political drop-ins. And, all the while I was struggling for the future of the museum, the controversial architectural master plan.

The first show, "New York, New York," dubbed "Henry's Show" opened October 16, 1969—and there has never been a racier affair in the history of the Met. We threw a glitzy reception and a "state" dinner, and the mod crowd partied until well after midnight. A few showed up in black tie, but most came as characters from movies—pirate flicks, *The Cabinet of Dr. Caligari,* Esther Williams splash epics. Arthur Houghton gripped my arm tightly after one stunning blond with a transparent blouse, no bra, and a micromini skirt passed by. Virtually every painter and sculptor represented in the show attended.

Geldzahler stationed himself in the principal gallery and held forth, fielding compliments on the exhibition and his catalogue. I caught George Trescher's eye, and we both broke into laughter. Most of the catalogue entries for the works of art—and they were slim—had been compiled by Trescher's staff. Henry had missed deadline after deadline, and his pallid essay offered graduate-school jargon about abstract styles that had waxed and waned in the vicinity of New York and Long Island in the past couple of decades. "As curator, my guiding principles in deciding which artists to include . . . have been the extent to which their work has commanded critical attention or significantly deflected the course of recent art. These 'deflectors,' as they may be called, are those artists who have been crucial in redirecting the history of painting and sculpture in the past three decades."

Though the New York art press was, as expected, vituperative about the show, its aesthetic impact was exceptional. In thirty-five prime galleries—the European Paintings galleries—taking up some twenty thousand square feet, four hundred and eight works by forty artists had been installed. In the luxurious space abstract-expressionist and pop pictures took on the feel of old masters. Our galleries made the cramped galleries of the Museum of Modern Art look wretched, something I was hoping would happen. Walking through the halls filled with enormous works by Pollock, Still, Kline, de Kooning, Motherwell, Helen Frankenthaler, Morris Louis, Avery, or Barnett Newman was akin to a series of "visual orgasms," as Henry had muttered to me one day before the grand opening.

The show boosted some artistic reputations and deflated a few. Franz Kline's works came off sadly one-dimensional, and Willem de Kooning's later canvases appeared bland.

More outraged about "New York, New York" than the critics who didn't like it were the artists who hadn't made it. Louise Nevelson ("She wasn't even on the list of those *not* to be included," Henry remarked) revealed that Henry had approached her dealer two years earlier "begging" for a major donation of her works to the Met (which was turned down). Richard Poussette-Dart, the painter, complained, "This exhibition . . . distorts a whole creative period historically by its false value system of selection where hucksterism and the fast buck are signs of artistic worth. . . ." The painter David Hare said, "Henry's interested in going out to dinner and meeting famous people and being in . . . the selections . . . have less to do with art than with [his] career."

Henry tried to seem unruffled, but he was stung. He tried to defend and explain what he had meant by "deflector." To one interviewer he explained that he had listed everyone he could think of and then cancelled out everyone except those who "looked interesting." The truth is he had made the list in consultation with critic Clement Greenberg, artist Frank Stella, art historian Michael Fried, and curator friend Walter Hopps.

The last word about "Henry's Show" was made by Tom Hess, the editor of *Art News* and an art critic, the man I had decided was the best candidate to replace Henry: "The Metropolitan's version of the New York School plunks you right down into the lush 1960's and leaves you there. The sunlight is filled with money; the applause is deafening; even the paintings are smiling on this glorious 4th of July. And the sense of history is lost beneath layers of charm; the gala nature of the festivity has drained its subject of meaning."

In the first two months of the Centennial, there seemed to be a gala every other night. I was becoming drained. It was difficult to keep the smile in place and the banter going—even harder when I contemplated the year and a half of exhibitions, and I had much more on my plate than those.

The second grand exhibition of the Centennial was "my" show, "The Year 1200." I wanted the show to be broad and historic, something on the scale of the exhibitions mounted by the Council of Europe. Naturally, I hoped the show might help us buy the original Christ Florens Deuchler had discovered in Oslo. Deuchler had been something of a Middle Eastern rug dealer in the way he bartered for objects. He persuaded several institutions to send manuscripts and precious pieces of enamel and jewelry that had never before been sent anywhere. Luck was on our side too. One evening in Paris, Ted Rousseau happened to overhear that the Abbey of Fontrevault was to be closed for several years by the Monuments Historiques of France. He recalled that the tomb effigies of Henry II and Eleanor of Aquitaine were there, and the next day he asked the chief of the department for the loan of the tomb figure of Queen Eleanor. We got her!

One piece I had wanted as much as any was a gorgeous enamel from the massive shrine made by Nicholas of Verdun in 1173 for the monastery of Klosterneuberg outside of Vienna. On the way into the abbey, Rousseau, Deuchler, and I noticed that the library was closed —the roof obviously needed repair. Deuchler suggested that the way to the abbot's heart might be for the museum to pay for those repairs.

The first question out of my mouth to the abbot was how much it would take to re-open the library. His excellency said that it would cost in the vicinity of thirty thousand dollars, and I responded that the Met would be delighted to make the full donation in exchange for three plaques from the Nicholas altar. The cleric beamed as he clasped my hand.

In order to be different I opened the exhibition with a life-sized color photo of an immense Byzantine fresco from a church in Yugoslavia, which was the perfect image of the 1200 style. The wide-eyed Madonna and stern Christ Child mesmerized those who entered. The swirling "wet" draperies clinging to the attenuated bodies of the Virgin and Child were as ferocious as anything one would find in contemporary art. When the visitors turned the corner and saw the staggering array of physical masterpieces of the twelfth and thirteenth centuries, they swooned.

The manuscripts we obtained were spectacular. My favorite was a book called the Devil's Bible, on loan from Stockholm, which measured two and a half by three feet and had been painted on the stomach skins of three hundred and fifty-two purebred donkeys. The style was rather crude, but the presentation was a smash.

The "treasury" had everyone talking. Stuart Silver designed floor-to-ceiling showcases to reflect the shape of Romanesque columns as one might find them in a cathedral in France or England. Each had a cylindrical section brilliantly lighted where the gold, silver, enamelled, and jewelled reliquaries and sacred ecclesiastical objects were displayed. Visitors gasped when they entered the gallery.

Another hall presented stained-glass windows surrounding two extraordinary objects—the silver-gilt and enamelled shrine of the Three Kings from the Cathedral of Tournai in Belgium and the Eleanor of Aquitaine. Many visitors were struck by how much the effigy looked like Katharine Hepburn as Eleanor in *The Lion in Winter*. I became obsessed with the idea of having the actress photographed looking into the face of the stone Eleanor and begged her through her assistant. I didn't think much of my chances. A week later, when I returned from lunch, a temporary secretary reported that "some woman, kind of looked familiar, asked for you, and I told her you were out and she said, 'Tell Mr. Hoving, I'd be delighted.' I didn't get her name."

I raced to call Ms. Hepburn, and we got her permission, but never managed to arrange the shoot.

I would go to the museum late at night and wander through "The Year 1200" just for the pleasure of seeing such a matchless array of beauty. At times I became quite emotional, wondering if I had done the right thing in abandoning The Cloisters for politics. Invariably, I would end up gazing at "my" Bury Saint Edmunds cross and the sinewy, twisted, fragmentary ivory figure of Christ from the Kunstindustriet Museum in Oslo. How I lusted for that Christ! From the moment Deuchler told me about it, I had been plotting how to get the piece. I had already instructed Deuchler to start softening up both the director of the Oslo museum, Lauritz Opstad, and the chairman of the board of trustees, Per Hannson, the head of an insurance company.

When Hannson came to New York on a business trip, I invited him to my office. With the cross on my desk, I laid out the evidence that the Oslo Christ had to be an integral part of our fabulous ivory. I took him through all my arguments, showing the photos of the Christ, which he remembered. I named all the scholars who agreed with Deuchler's theory. I proposed a direct purchase. But Hannson said there might be "political problems" because of the "citizen nature" of the board of directors. Then I suggested the Christ come to The Cloisters on indefinite, perpetual loan, like the unusual agreement James Rorimer had made with the Spanish government to exchange a series of Romanesque frescoes for the Fuentidueña apse.

I suggested that in exchange for the Christ, The Cloisters would deposit in Oslo one hundred and fifty thousand dollars. The Kunstindustriet Museum could use the income for acquisitions. Hannson smiled. His institution had almost no purchase funds, but he was curious: why only one hundred and fifty thousand dollars? I took him through some folderol about the relative measurements of the cross and the Christ. In 1963 the cross had cost six hundred thousand. The Christ was about one-twelfth the size, so even with inflation, the sum was generous. I reminded him that his director had insured the Christ for only ninety thousand dollars.

Hannson left me with the distinct impression that he would line up his board. But a week later, I was surprised to receive a letter from Hannson coolly rejecting my offer. When I next met Hannson in New York, like a fool, I told him that I would do *anything* to get my hands on the object. He suggested silkily that if I were to come up with a truly handsome amount—he left the figure up to me—he was "positive" an arrangement could be worked out. So inebriated was

I with the idea of actually possessing another fragment of "my" cross that I told him I'd get the board of trustees to set aside as much as three hundred thousand dollars for the deal. He whispered, "Mr. Hoving, I was thinking of more like half a million dollars."

I said, "You got it!"

Dillon and Houghton approved the figure to be extracted from The Cloisters funds. The Finance Committee rubber-stamped the deal, and Ashton Hawkins and Herb Brownell drafted a contract. Per Hannson wrote me that his board had agreed to the proposition. I was in ecstasy.

Then disaster came. At the first meeting at which the full board could consider the proposition, Houghton, Dillon, and I were overruled. The trustees refused to tie up such a large amount of Cloisters money. Nothing I could say had any effect. I sent Hannson a lame letter about a "new offer of some sort" but nothing happened. In a face-saving gesture, I arranged for the Christ to remain with the cross in New York for two years after the "1200" show had closed, with the understanding that Oslo would then have both cross and Christ for a year. We hoped to continue the two-year, one-year loan agreement for some years, but shortly after I retired the loan lapsed. I consider the loss of the Bury Saint Edmunds Christ one of the most severe blows in my museum life—and one of the most arbitrary actions on the part of the board, which should have let the director have his way about a work of art.

Although I was crushed, I didn't have the time to let the sad affair affect my state of mind. The Centennial juggernaut was racing on.

The plaza and Great Hall had been finished in time, barely, for the April 10 birthday. Several days before the official opening, Lila Wallace threw a party for the construction workers. She danced with almost every worker. DeWitt Wallace was overwhelmed by what had been accomplished and told me, "She has her own independent foundation, you know, and if I were you I'd be very friendly to her."

The friendlier we got, the more I was convinced that she would fund all the Egyptian galleries—a tremendous undertaking—and the building to house the Temple of Dendur as well.

When Roche showed me the models for the Egyptian galleries, I was elated. He had punched out a grand alley leading from the Great Hall straight north. The tomb of Peri-Nebi and the staff offices had been moved out of the way for his boulevard. When curator Henry Fischer and his staff had objected and Roche had redrawn the plans

so that the thoroughfare still existed but was placed to the right along Fifth Avenue, I thought the curators were placated.

All the works were displayed chronologically from prehistoric times through the pharaohs and into Roman times. The objects were so arranged that by the time the visitor got to the temple, the sculptures and other pieces in nearby galleries dated to the same period.

Roche had devoted much of his creative energies to the magnificent sculptures from Queen Hatshepsut's funerary temple at Deir-el-Bahari across the Nile from ancient Luxor—a pair of monumental sphinxes, column capitals, portraits of the queen including a superb seated statue. The sphinxes had lined the causeway leading up the terraced and porticoed temple and were all but identical. Roche got the clever idea of amplifying the pieces by placing them in a reconstructed portico made of plywood and plaster of the same dimensions as the remains in Egypt and placing a large mirror at right angles so that our stage portico seemed double in size. Though it was a dash of theater, we both felt the setting was historically accurate.

I invited Henry Fischer and his curators to Connecticut to see Roche's beautiful models. Fischer perplexed me by saying that he would not bring his staff—as chief curator, he wanted to be the sole judge. Fischer sat like a statue throughout an hour's briefing. When the presentation was done, I asked him for his comments and all he did was to glance at his watch and remark, "It's time to go to the airport."

As soon as he was gone, I blew up. Several days later he complained bitterly about the "theatrical" design of the Hatshepsut gallery and called the design for Dendur "inept." His gripe was that the sloping wall would be impossible to clean. He brought an amateurish sketch and insisted it had to be the basis for *the* plan for his galleries. I knew I had to get rid of him. With his attitude I knew the Egyptian galleries would never be renovated correctly. I phoned Barney McHenry and told him that I planned to kick Fischer up and out.

"There's going to be big trouble. Lila adores Henry," he said.

"I don't care. The guy's impossible. Does Lila *really* want the department to look like hell? Explain to her that I want to promote Henry to a high new post—research curator—where he can do anything he likes."

McHenry reluctantly agreed, principally because he too was in love with Roche-Dinkeloo's schemes. He convinced Mrs. Wallace

to pledge the funds for Fischer's new job, but she punished me for Fischer. When I begged for three and a half million dollars for Dendur, she put me off. After a time of penance, Lila did fund the renovation of the Egyptian galleries and gave over twenty million dollars to keep them.

The actual birthday was celebrated over two days. On the twelfth of April, 1970, the day before the anniversary, we threw a lavish buffet lunch for the press to open the show "19th-Century America," and in the evening we gave a dinner for museum members. President Nixon did not come, but the First Lady did and was gracious and indefatigable. At the stroke of six, Pat Nixon appeared at the new entrance where Arthur and Betty Houghton, Douglas and Phyllis Dillon, and Nancy and I were waiting to greet her. She surprised me with her knowledge of American Victorian.

A crowd of seventeen hundred guests in formal attire were all waiting for the receiving line to begin. Pat Nixon was a great trouper. Two and a half hours later when the last couple had gone through, the First Lady turned to me and whispered, "Whew!" That was all.

I wasn't very fond of "19th-Century America" but realized it was perfect for the Met. It was fresh and scholarly, too, bridging the gap between museum and universities. It encouraged a lot of hesitant donors to give works of art to the museum. The show was one of the first to take a detailed look at the complete range of nineteenth-century American painting, sculpture, and decorative arts, including interior design, a period which had been appreciated by only a handful of experts. The exhibition ran for nearly five months, was visited by a quarter of a million visitors, and helped focus attention on the increasing destruction of nineteenth-century sites and buildings.

Although there were many rare loans, including Thomas Eakins' *The Gross Clinic,* which I considered the most powerful painting ever produced by an American artist, most of the paintings were from the Met's own holdings. That was the way I wanted it. I saw the exhibition's real strength as a fund-raising and political tool to stress the need for a new American Wing and department.

On the day of the birth of the Met I walked up the stairs thinking the gods were smiling down. But then in the Great Hall I saw a monstrous, ugly cake looming over the information desk in the center of the brand new Great Hall and had a fit. George Trescher had spent fifteen hundred dollars for a huge confectionery blob, the kind of thing strippers bounce out of at smokers. I ordered Richard

Morsches, Joe Noble's chief assistant, to get the "thing the hell out of here!" Trescher was furious but I didn't care. We celebrated by throwing an all-day open house for the public. Radio and TV gave the event splendid advance coverage, and Macy's paid for a full-page ad in the *Times* urging everybody to come to the event. By nine-thirty, a huge crowd was waiting to get in. John Lindsay bounded up the new front stairs at a few minutes before ten, made a gracious speech, thanking Lila Wallace, and pushed a button which turned on the twin fountains in the plaza.

The first couple into the museum received an enamel and chrome *M* plaque—our handsome new logo—designed by the sculptor Frank Stella, and every hundredth visitor got a free family membership. Lindsay, Houghton, Dillon, and I stood on line shaking hands for the first couple of hundred visitors, but we had to give up. More than fifty thousand people came through our doors.

We ran back-to-back lectures in the auditorium, concerts on the front steps, which proved to be an ideal place just for sitting. The public was fascinated by a synoptic mirror on display in the Costume Institute, an imagery device where people could "don" costumes of all dates and historical styles. A specialist sat at a desk in the Egyptian galleries transcribing people's names into hieroglyphics. There was a master of chess in the Western European Arts Department who beat everybody all day long. "The Year 1200" and "19th-Century America" played to full capacity.

Nothing like the Birthday Ball had ever been thrown in the city before. We created four separate ballrooms in the museum, decorated by the four most fashionable interior decorators.

The arms and armor wing was decked out by "Sister" Parish and Albert Hadley to look like a ballroom of the Tenderloin epoch. Mirrors and spring flowers were everywhere, and the place was a knockout. A Meyer Davis orchestra belted out waltzes, polkas, and the cakewalk.

McMillen & Company turned the sixteenth-century Velez Blanco patio into Belle Epoque. The theme was Turkish delight, the music was the tango and the black bottom. The avant-garde and the show-offs took the room over. I couldn't believe some of the costumes. See-through blouses and even a few see-through pants punctuated the Valentinos, the Scaasis and the Bill Blasses. I spotted one young lady in a gown made out of an eighteenth-century Chinese silk tapestry. Another guest came in a dress made out of mail with nothing

underneath. Black vinyl jumpsuits were all over the place. People got drunk and stoned early on and remained that way.

Angelo Donghia's creation in the Egyptian sculpture court was by far the most inventive. He had taken the rectangular space stuffed with statues of Hatshepsut and transformed it into a 1930s roof-garden supper club in the style of an "Egyptian" movie theater. Immense faux columns in turquoise surrounded the hall and supported a translucent hung ceiling, lighted in Donghia "moonlight" and shimmers from the Nile. The food was thirties and the drink, the sidecar. The music was foxtrot—fast.

The fourth ballroom in the Fountain Restaurant opened at midnight and remained active until five in the morning. Billy Baldwin had fashioned a dark and sexy disco. The decor was decadent Viennese inspired by the designs of Gustav Klimt.

I cruised all night, never once sitting down for more than five or ten minutes. I didn't take a drink because I figured that if I started I'd get smashed. I staggered home around five.

After the ball, the very mention of the word *Centennial* made me shiver. I was realizing, too late, that it would have been better to celebrate the birthday with just one glorious event. The normal workings of the Met were suffering.

Still, I had to keep turning it on. "Before Cortés: The Sculpture of Middle America," the fourth show, turned out to be surprisingly popular. Nelson Rockefeller was so pleased that he confided he would increase his financial commitment to the Michael C. Rockefeller Wing.

The governor had much to thank me for. I had saved him from a major embarrassment. A few days after the exhibition had opened, I received word through the Guatemalan Consulate in New York that Rockefeller's grand Mayan stela, a key piece, had been stolen from a Mayan site and had been shipped illegally to the United States. The Guatemalan officials had a set of photographs of the tomb robbers lugging the stela out of its resting place. They were about to hold a press conference and demand the immediate return of the stone. When the governor was informed, he told his lawyer, "Hoving will know how to deal with this!"

I got Rockefeller to write the president of Guatemala a letter full of apologies, saying that he had no idea the piece had been removed illicitly from Guatemala and that the stone would be sent back at once, that is, if the president would grant one request: that the stela

remain on loan at the museum for the run of the Centennial show, labelled "Property of the Guatemalan People."

I figured that all the government wanted was a magnanimous gesture. I counted on the Guatemalan president thanking Rockefeller and leaving the stela at the museum. Guatemala had hundreds of stelas.

In a week President Mendez Montenegro did exactly that. To this day the stone rests in a prominent place in the Michael C. Rockefeller Wing, "on permanent loan" from the People of Guatemala.

The Centennial came to a fitting conclusion (at last) with Rousseau's show, "Masterpieces of Fifty Centuries." It wasn't anything like the host of incredible artistic treasures on loan from the dozen finest museums in the world in homage to the Metropolitan that it was planned to be. After our countless trips to Europe pleading our case, we were promised such treasures as a Leonardo, a Michelangelo, Rembrandts, statues from the treasure of King Tut, and Impressionist paintings that had never been loaned before. But just as the lists were being firmed, the months of hard work unravelled.

One evening Rousseau's assistant, Jim Pilgrim, a chubby, drawling, bright-eyed chap with an unquenchable desire to tell the truth, dropped into my office. "Do you have any idea what Ted has been doing with 'Masterpieces'?" he asked. He went on to say that Rousseau had accepted so many fancy loans that the insurance would come to three times the amount budgeted for the whole exhibition. "This is a juggernaut plunging out of control," he said. "If you don't stop it, it will be the biggest financial scandal in the museum's history. Ted knows all this; he's been concealing it." I challenged him to prove it, and he did with a sheaf of figures. With no hesitation, I told him to cancel the foreign loans. Pilgrim was aghast.

Coolly, I said, "Show only our works—the best from each department, all mixed together, a time line, from pre-Hittite through Egyptian, through Greek and Roman and medieval and all the way up to Jackson Pollock." Then I thanked Pilgrim for "saving my ass."

The amusing thing about the abrupt decision was that, except for Rousseau, no one seemed to mind in the slightest. Houghton and Dillon both thought it was a better idea anyway.

With the gala opening of the "Masterpieces" exhibition, the Centennial came to a close. For selfish reasons I was relieved. Except for "1200," what had been produced was in large measure the fruit of other people's creative energies. The Centennial is remembered

for the monumental exhibitions and the glitzy gala, the introduction of television and film, and the drumbeat of publicity. But the event was more complex. Its real contributions were in the host of community activities and innovative educational projects and in the sending of many of the Met's finest art treasures to institutions throughout the United States and the world. The Centennial made the Metropolitan a household word, the symbol of excellence and creative vigor. Afterwards the museum moved into an equal rank with the Smithsonian—at least in the public mind. The festivities cost a million dollars—for the ball alone we spent almost a quarter of a million—but the Centennial raised nearly four million and perhaps as much as ten million more indirectly: the shining image of the museum as a "winning" institution acted like an irresistible magnet.

The Centennial also marked the end of an epoch. Arthur Houghton virtually stepped aside as chairman, and Douglas Dillon became the powerhouse of the board. The Dillon-Hoving era began. And if Houghton's tenure had been noted for a storm or two, this one would be remembered for its hurricanes.

Sometimes I had to wonder if Doug Dillon had any emotional capacity. He could be firm. He could get enthusiastic about our "revolution" at the museum and poetic about the master plan—his favorite area—but he did everything with an Olympian calm. Despite his curious mannerisms, I had come to admire Doug Dillon more than anyone on the board. He was a welcome contrast to Houghton, who acted warm but was cold. Dillon was not as clever as Houghton, but his common sense and decisiveness more than made up for it. Dillon seemed, superficially, to be moody, at times lethargic. It gradually occurred to me that he may have assumed a slow manner to be a more effective negotiator.

President Dillon insisted upon a regular weekly meeting in my offices—on Tuesday. In times of stress we met every week and were on the phone several times a day. He wanted open discussion about *everything* that took place in the museum. I didn't want to do that, although I never told him so. There are certain things that happen in any large institution, things that bubble underground, in a sort of institutional River Styx, which the lay board should never know. And there are shady matters a president in particular should never learn about in the event that the law starts sniffing around. For example, I had never told Arthur Houghton that the Auvergne Madonna I recommended buying in honor of James Rorimer had been smuggled out of Belgium by Harry Sperling.

216

I'm glad I didn't tell my new president about the past smuggling episodes, for he turned out to be highly ethical about art and backed sweeping changes in the way the Met conducted its business of collecting and halting our acquiring works that had been smuggled.

I had attended hearings organized in Paris by UNESCO on the shocking increase in the traffic of smuggled archaeological works from third-world countries into Germany, Switzerland, England, and especially America. At the conference I was astonished to learn of the extent of the smuggling, especially from Africa, Turkey, and Italy. It was not that I suddenly got religion; it was that I recognized that with the UNESCO hearings, the age of piracy had ended. I decided to change the Metropolitan's free-wheeling methods of collecting. Just in time.

Not long after I began to draft the new guidelines, Ted Rousseau got a phone call from an official in the Consulate of Turkey in New York demanding the "full details" about the history of a sixth century B.C. hoard of silver and gold antiquities the official described as "a treasure which belonged to King Croesus stolen by you from Turkey." The material had been purchased by Dietrich von Bothmer over three years starting in 1966. It was called the East Greek treasure for purposes of obfuscation. The hoard had been found by tomb robbers in a village called Elmali near Sardis.

Rousseau insisted, falsely, that the Met had not been involved. The Turkish complaint was reported the next day in the *New York Times*. I called Rousseau, my new assistant John Buchanan, von Bothmer, and Ashton Hawkins together to plan what to do. No letter had arrived from the Turks (it never would) so I decided to lay low. When the Turkish authorities pressed their case in writing, we would respond.

Dietrich von Bothmer asked what we should do if any damaging evidence were found that our East Greek treasure had been excavated illegally and smuggled out of Turkey.

I was exasperated. "We all believe the stuff was illegally dug up," I told him. "Drew Oliver [a junior curator in the Greek and Roman Department] has strong evidence. He went to the tomb and says he identified the lower parts of the pair of sphinxes which are now hidden in your storeroom. For Christ's sake, if the Turks come up with the proof from their side, we'll give the East Greek treasure back. And that's policy. We took our chances when we bought the material." Dillon supported me.

Dillon could, at times, appear to leave me twisting in the wind, as

he did when certain trustees started to pressure me to institute a mandatory admissions charge. Dillon said nothing pro or con. Houghton was the head cheerleader. "Make it a dollar—for everybody—and it'll add up to around three million dollars a year." The man who saved the day was Henry Ittleson, an honorary trustee founder and chairman of the investment firm C.I.T.

Ittleson made an imaginative suggestion: have a purely voluntary admission. He called it "pay what you wish but you must pay something." He urged us to set up cash registers at the three entrances from the Great Hall and play to the "embarrassment factor." There was to be a sign suggesting a fee of a dollar. Each visitor would have to go through the official act of buying a ticket even if for only a nickel. Ittleson was convinced that we could expect perhaps two-thirds of the suggested fee. And any visitor who objected should be allowed in free.

When I described the unusual arrangement to Dillon, I expected him to go against it. But he warmly supported it. Herbert Brownell got approval from the Corporation Counsel of the city and Parks Commissioner August Heckscher went along with a six-month trial period. Predictions on how much each visitor would really pay ranged from my optimistic high of forty cents to "a damned nickel," as Charlie Wrightsman said.

I was surprised not to get much flak from the press, and in only a month the plan proved to be working. Visitors paid an average of forty-seven cents. Gradually, the suggested sum was increased, and by and large the percentage paid remained the same.

Dillon had promised that he would be the buffer between me and the individual members of the board, no matter who they were. And he turned out to be a man of his word. A group of radical artists planned to mount a demonstration at the Met against the Vietnam War, for equality for women artists, and for a democratically chosen Met board of trustees. The leader, Alex Gross, called for the takeover of the Metropolitan's Great Hall. Several trustees were in a fury, especially Wrightsman.

He demanded I close the museum on the day of the threatened takeover, call out the riot police, erect wooden barricades at the main doors, and set up chain-link fences at the three main corridors.

I told him I planned to invite the protesters into the Great Hall and encourage them to have their day-long teach-in. What the demonstrators wanted was to be shown on TV storming the gates and being

turned away, perhaps beaten by cops. The smart way to deal with the demonstrators was to let them drone on. The more they did, the less press they'd get. I had convinced Alex Gross that we both should "elect" peace marshalls and legal observers. I guaranteed that no uniformed police would be seen in or near the museum throughout the demonstrations.

Wrightsman told me that he would ask Dillon to invoke a special meeting of the trustees to override me.

"Do it, Charlie, and I'll resign," I said. "On the front page of the *New York Times*. And the story will say, 'Hoving Quits Because of Trustee's Meddling.' "

In the event, the demonstrators came quietly into the Great Hall. There were only a hundred of them. The TV crews soon disappeared when they saw no blood. The speeches were excruciatingly boring. Gross, who had promised fire and brimstone, sounded like a statesman.

The evening the demonstrations fizzled, Wrightsman called Dillon to say, "I sent a letter to you and think I stopped it, but if one comes from me tomorrow, *don't* read it." Dillon and I had quite a laugh at the image of Charlie desperately trying to extract his letter from a postbox.

Once the Centennial had ended, Dillon threw himself—and me— into the arduous task of shepherding the master plan through the city government and weeding out our bloated collections.

"Let's build as fast as we can," he said.

We began with a mortifying blunder. Arthur Rosenblatt, usually politically attuned, ordered the ragtag trees along the facade chopped down to make way for the new plaza and parks at each end. Over the weekend. In the dead of night.

The counterattack was instant. The East Side Conservation Committee, which had been watching us with growing suspicion, picketed one of our grandest post-Centennial openings. They carried signs bearing catchy slogans: "Stop the Butcher of the Trees"; "So Long Central Park." Mrs. John Heimann, the leader, and her band chatted politely with the arriving guests, many of whom they knew well, and enlisted a number into their ranks.

The protest had been coordinated with an inflammatory radio address on WNYC by the "critic-at-large for architecture and planning," Robert Weinberg. Weinberg suggested that the Rockefeller and Lehman collections and the Temple of Dendur could be built

elsewhere in the city—at the Fulton Fish Market or at the J. P. Morgan house on Madison and 57th Street. Lewis Mumford, the respected architectural historian, got considerable press with his remark, "The museum's expansion is another nail in the coffin of New York."

I hammered out a war strategy which listed over three hundred tasks, problems, and obstacles. I jotted down all the official and public agencies and groups that had the right and the desire to meddle—the City Planning Commission, Landmarks, the Art Commission, Parks, the City Council, the Board of Estimate, two community planning boards and citizens' groups like the Parks Council, the Municipal Arts Society, Heimann's East Side Conservation group, landscape architects, architects, the Victorian Society, Classical America, and the National Trust for Historic Preservation. I toted up enemies and friends. The enemies far outnumbered the friends.

When I finished, I was both aghast and thrilled. The job was immense. It was a hell of a challenge. The three other master plans drafted in the Met's history had all failed. I was determined mine would succeed.

Of course, I had concerns, but not about the plan itself or the abilities of my architects or Rosenblatt, whom I had forgiven for his clandestine tree slaughter, or even about finances.

At our regular Tuesday meeting I discussed with Dillon the need for action and my anxieties that the board of trustees might not be strong enough to withstand the pressures. There were going to be anger, grief, shouting, screaming, lies, accusations, perhaps lawsuits. I referred to Houghton's surrender to the forces of censorship during "Harlem." I reminded him of the "ever-traitorous" Roland Redmond. I complained about the flightiness of "those society women" on the board who were susceptible to bad press—especially when it came to Parks and Conservation. I asked him where he stood.

Casually, he asked two questions—what were the chances for success, and how much would the entire plan cost to build?

When I had on my arrival advocated a building program I had told the board that our chances for success were about sixty-forty. Now, the odds had flip-flopped. I had no idea about construction and maintenance costs. My rough guess was that the plaza, the Great Hall, the four new wings, and all the interior renovations would come in between sixty-five and eighty-five million dollars. To maintain the

new building, I figured we would need something like five to seven million dollars a year more income than we currently had.

Dillon looked subdued. He gazed at his hands. Then he glanced up and said, "Oh, let's go ahead. The next generation can pay for it."

He demanded that we be certain of our legal rights and obligations. A battery of lawyers investigated our original state charter, the original city lease of 1878, and all subsequent changes. The lawyers responded that if our lease was both for buildings and land, then we could build virtually anything we wished on our plot of land. This was a twenty-acre or so site bounded on the south by 80th Street, on the north by the transverse road at 85th Street, and east and west by Fifth Avenue and the drive in Central Park. Since the city owned our building and we were situated on city-owned land, we needed only two steps to obtain official permission to start construction. The Art Commission had to approve the design of any exterior addition or major renovation, and the Commissioner of Parks had to approve. No other city body had any say, not the City Council nor the Board of Estimate. The Landmarks Commission could examine the plans, but only in an advisory capacity. Community planning boards were purely advisory.

Parks Commissioner August Heckscher, whom I had once thought would be no more than a figurehead, pored over every detail of Roche and Dinkeloo's scheme. He demanded in-depth briefings. Heckscher had a way of standing hunched over, his head hanging forward. After my presentation, he hunched further and muttered, "Beautiful, Tom, but it's *bigger* than I would have expected—or hoped." That remark made me nervous. But then he whispered how much he admired the way the Roche-Dinkeloo scheme had captured the park's architectural design and that he adored the two entrances from the park side.

But the commissioner was being sneaky. To Mayor John Lindsay he harped on the opposition's arguments and complained about the "over-centralization represented by the Met collections" and our encroachment on park land. He also shaded the truth, claiming that the Lehman Wing was "substantially larger and more obtrusive than the earlier projections shown to me by Tom Hoving." He advised Lindsay to insist that the "great expansion be balanced by services rendered to the communities."

I got my hands on some internal Parks memoranda and learned

that Heckscher's aides had a hidden agenda! They were planning to force us to decentralize our collections. They were going to make us commit to keeping the garden courts in the American Wing and the south wing "forever green" and to maintain them with private moneys. They planned to make the Lehman Foundation pay all costs for the Lehman Wing. And they intended to extract a guarantee that the two entrances from the park would always be open to the public. Even more disturbing, they planned to make us amend our lease and pledge never to build after the master plan was completed.

Arthur Rosenblatt became frantic. He warned Dillon that the enemy had us cornered. I tended to agree. Two city councilmen, Robert Wagner, Jr., and Carter Burden, had already made critical statements to the press. Councilwoman Carol Greitzer, a left-wing firebrand, was opposed to building anything in the park.

To add to Rosenblatt's woes, one of the members of the Art Commission, Robert Zion, a talented landscape architect, had come out against our building into the park, no matter what the lease might allow. He announced he would vote against us. Public hearings might be called for.

I had developed an almost pathological fear of appearing before a public hearing on the master plan. In New York City, legalities have little to do with winning or losing a municipal battle. If our enemies could gain public favor and sway August Heckscher, we would be ruined. It was much easier to block construction than to win approval. We spent a great deal of time working to make public hearings an impossibility.

While we were trying discreetly to obtain the only official permissions we needed, our opponents, masterful guerrilla warriors, were inflicting wounds. Their charges were false but had a ring of truth. They claimed we had gotten our city permissions clandestinely, that the expansion would be three times the size of anything we would publicly admit, that the costs would be triple too, and that there was no lease at all.

By the early spring of 1970, I sensed we would lose the battle if we relied merely on our legal rights. I begged Dillon to let me start fighting back. He told me to "get going!" My first two tasks were to neutralize young Bob Wagner and Carter Burden and to line up Congressman Ed Koch as a supporter.

Councilman Wagner was respected, though I had found him indecisive in the past. If he were not the son of a former mayor, I

thought, he would never have become such an influential member of the City Council. He called one day for a full review of the master plan. Rosenblatt and I guided him for three painstaking hours through the deteriorating Met and laid out our plans.

The following day Wagner surprised me by calling to say, "You have convinced me that this is an excellent scheme, and I shall support it."

Next on the list was Councilman Carter Burden, the aristocratic son of Shirley Burden, nephew of the financier William A. M. Burden, and husband of Amanda, a stepdaughter of CBS chairman William Paley. At twenty-eight, he was the youngest councilman in the city's history. Blond, slim, energetic, always shirt-sleeved, smoking a pipe, he was a Robert Kennedy sound- and look-alike. He had worked for Kennedy in the Bedford-Stuyvesant rehabilitation project.

Burden was the premier example of a limousine liberal, set to question and attack every institution of the Establishment. He and his glamorous wife lived in the fashionable River House; their every move was chronicled in gossip columns.

To me, Burden was a little-league symbol of the glib social politics of the seventies, propelled by the Kennedy dictum that "ends justify means." I feared him. Against my better instincts, I decided to give him the dog and pony show. I was pleasantly surprised. The tour, if brisk, was cordial. His only alarming comment was that he was "much taken by the theory of decentralization." But as he left, he remarked, "I have no particular interest in the issue of park encroachment."

I was counting on the support of Ed Koch, congressman of the Upper East Side, the Silk Stocking district, where there were more grand cultural institutions and museums than on any like plot of land on earth, including Paris. He was a friend. I had supported him since his first campaign for public office. He came to be briefed but spent less than an hour and seemed distracted. We had lunch at the Stanhope across the street. As coffee was served, he said, "Tom, I'll probably have to go against the plan, but as a personal favor, I'll phone you before I do." I got up and walked out, leaving him with the check.

In those days I was not a fan of the *Village Voice,* finding its political stance hysterically leftist. When the *Voice* wanted to interview me for an article on the master plan, I thought of ducking it,

but when I heard the writer would be Jonathan Black, a fair reporter with a witty style, I agreed. We gave Black the full treatment—the walking tour, the photographic show-and-tell of a crowded and dismal Met, our measured, sonorous arguments against our enemies. Nothing but smiles and salesmanship. Black's article was long and boisterous and ended with a call to arms, "Park protectors are not confronting a nut millionaire like Huntington Hartford . . . they are taking on the institution of the Metropolitan Museum of Art . . . managed by the same incestuous interlocking Board of Directors and Trustees that controls every other monied monolith in the city, a crusty, patrician, elitist claque that looks at New York through the tinted glass of a Lincoln Continental. And the oppositionists are also taking on Thomas Hoving, darling wonder-boy of the art world, salesman extraordinaire, human dynamo, a man with influence, friends, and connections snaking through all the worlds of culture, finance, and politics, a man with the visions of the Louvre dancing in his head. Try and convince anyone that all that's just an encroachment."

At our next Tuesday meeting, Dillon was as disturbed as I had ever seen him. He showed me a series of letters—from John Bayley, president of Classical America, to trustee Judge Untermyer and from Untermyer to Dillon. Bayley asked for the immediate public disclosure of all our renovation and building plans. "It is widely rumored that plans call for the removal of the Grand Staircase," he wrote. "If there is any truth to this rumor, we urge you to appoint a panel of distinguished architectural historians to review all plans before demolition starts." Untermyer's angry letter stated that he was sympathetic with Bayley and suggested he was considering changing his will, which left his stupendous collection to the Met. Untermyer bewailed that he had voted in favor of removing the Grand Staircase as part of the Lehman scheme. He realized now that he had been misled.

"Perhaps we should reconsider the removal of the stairs," Dillon said.

"Stay firm, hunker down," I advised.

I knew I was in big trouble when Heckscher called me to say, "Tom, I've decided to hold public hearings on the master plan—to help me come to a decision on approving them. My staff is in accord. I know you would do the same if you were still the administrator of Parks. And Dore Schary agrees fully. Tom, it's all for the best. The public will decide."

For a few seconds I couldn't respond. Then I went wild. When Rosenblatt heard me—he knew who was on the phone—he grew alarmed. I told him to listen in. My voice had an edge of hatred. "Augie, this is the most irresponsible thing I've ever heard from a public official. You are a goddamned trustee of the museum. You are its landlord. You know that the charter gives you the sole right to approve any building program of any sort in any of the institutions under your stewardship. A public hearing will attract every park nut in town. Even thinking about one is a destructive act.

"A public hearing might frighten the Lehman Foundation right out of town," I went on. "Other donors waiting in the wings will leave us." I reminded him that just a month before he had praised "Kevin's ingenious solutions."

"I know that and I still admire the plan."

"You *do?*" I said. "Then why do you need some fucking public hearing to help you make up your mind? Who's gotten to you? Is it Schary? When Schary was the head of the Anti-Defamation League, he hated me because of 'Harlem.' "

"Tom, I have never been spoken to like this in my life!"

"You should have been!" I shouted. "How *can* you be so gutless? Augie, dammit, get this dumb public hearing out of your mind."

I slammed the phone down. Rosenblatt ran in from the next room. "You've just killed the master plan—and my job—but what the hell, I loved every second of it. That *idiot!*"

I appealed to Lindsay. He agreed to a meeting the next day at City Hall. But he warned me that Augie Heckscher would be there, and I had to scurry to get Doug Dillon to join us. I hoped that Dillon would be able to talk Lindsay into ordering Heckscher to play by the chartered rules: just examine our plans and give us the go-ahead. After Rosenblatt and I made our pitch, Lindsay turned to Augie. The commissioner said flatly that he would *not* approve the plans without a formal public presentation. Lindsay barely glanced at us and said, "Well, that's it, boys." We left without further discussion. Dillon raced off to his limo, and Rosenblatt and I wended our way uptown. Rosenblatt was nonplussed. "I thought this Dillon was King of the World, ex-Secretary of Everything, ex-Ambassador of Everything," he said bitterly. "He didn't say anything. Just stood there as if he didn't know what was going on. He should have opened his mouth and said something, *anything!*"

We resigned ourselves to a life of hell and we got it.

Over the next twelve months we had to appear at least twenty-five

times before various political and citizens' groups. I sensed that the key to victory was the proper attitude—a highly positive attitude. I knew we had to drum up platoons of witnesses. The rule of thumb was that as the Establishment, we had to have at least twice as many witnesses as our opponents. Our list had to include museum professionals and lay people from all five boroughs. All races and creeds would have to be marshalled, to contrast with the mostly white, well-educated, upper-middle-class Parks lovers and conservationists. I told Arthur Rosenblatt to contact everybody we ever did a favor for in Parks—every recipient of every boccie court, every swimming pool, every ball field. Our ace in the hole would be, I hoped, our Harlem contingent, especially our tough, resilient friends from "Harlem on My Mind."

We had to have one set of facts and stick to them. We prepared a paper, "Issues and Answers," and produced a glossy publication of the Roche-Dinkeloo plans, drawings, and photographs of models. I enlisted a "truth squad" of staff and friends who would take notes on what our enemies were claiming. I needed all quotes pro or con that had been reported in all the press and told Trescher's office and press officer Jack Frizelle to deal with this. I urged them to be especially alert to radio interviews—people tend to embroider facts on the air. Whatever our opponents said, we had to demolish. What we said had to be true, legal, ethical, and consistent. We had to give the impression that we were very proud of what we were doing and attack, attack, attack.

Our lawyer, Herbert Brownell, sometimes reminded me of the Dormouse. He moved in slow motion and looked down at the floor at crucial moments in a conversation. But he had a brilliant mind. Brownell's code of ethics was lofty. He had been the attorney general for President Eisenhower. Later, as general counsel for the *New York Times,* he had resigned in protest over the publication of the purloined Pentagon papers.

Brownell drafted a clever letter to Heckscher and asked for a meeting with the commissioner to explain it. The meeting was a deft move, for Brownell had shrewdly gauged Augie as someone impressed by celebrity. Brownell bowed to Heckscher's lesser demands but got stubborn when it came to changing the museum's lease to stop any building of any kind after the plan was completed.

He looked at me and Arthur Rosenblatt almost shyly and made a most surprising remark. "But, as you boys know, you have effec-

tively prohibited future generations from altering the shape of the buildings, anyway.''

I tried to look innocent.

''You are submitting the plan to the City Art Commission and to Landmarks as an architectural whole—a full silhouette.''

I laughed and confessed that it had been Rosenblatt's idea to ask the Art Commission and, later, the Landmarks Preservation Commission, to approve the plan as a silhouette so that *our* plan would never be changed.

''Apparently, Augie doesn't realize that you've already bowed to his demand,'' Brownell said quietly. ''Perhaps at the right moment, we, too, shall bow publicly on the lease. It might be a useful tool.''

We also addressed the issue of decentralization. We emphasized that the contemporary solution was to discover how the museum could best respond to local cultural needs while still maintaining its integrity as an encyclopedic resource. Our recommendations called for the museum to make a greater effort to lend fine works of art to community organizations, but the report also argued as to why a physical decentralization would be a sin. The Met was committed to the idea of making a comprehensive history of man's creative achievement, in one location. It would be impossible to duplicate the staff of expert curators and conservators elsewhere. And we had become persuaded that communities in New York were interested in controlling their own cultural facilities and would resent the imposition of the Met on their neighborhoods.

To get in shape for Heckscher's hearing, I lightened my work load, stayed home as much as possible, and slept eight hours a night. I memorized our brochure of questions and answers. I practiced a ''friendly and nonaggressive'' pitch in front of a mirror: ''It used to be the rage to call for the breakup of the Yankees. Why, I don't know. Let psychiatrists explain why anybody would want the destruction of a team that symbolized excellence, brought us some of the best baseball ever played and the best players in history. It sometimes seems to me that this call to break up the Met is as nutty. For the public and scholars alike it's vital that fifty centuries of visual beauty from all artistic cultures that ever lived, from a gold artifact an inch high to Rembrandt's masterwork, *Aristotle Contemplating the Bust of Homer,* are all in one place.''

As the day of Heckscher's hearing approached, I reviewed the list of our speakers for gaps. I would scream at Rosenblatt: ''Get me a

goddamned landscape architect!'' or ''Get me an Hispanic!'' Or ''Get me *women*, more women, dammit!'' He did. The list was a classic cross section of money, brains, talent, modesty, race, color, and creed—seventy-five speakers in all. We submitted our list to the commissioner but were told by one of his aides that we had ''too many witnesses.'' Schary and Heckscher had decided to limit both sides to twenty-five. I was flabbergasted—was this to be a fix?

Our final list ranged from Ken Donahue, director of the Los Angeles County Museum of Art, and Tom Buechner of the Brooklyn, architects Philip Johnson and Marcel Breuer, Roger Stevens of the Kennedy Center in Washington, a speaker from every borough, and a group of black and Hispanic community representatives. The other side was lopsided with conservationists, parks purists, and liberal politicians.

That evening, as I made my way up the front stairs of the American Museum of Natural History, I spotted a television crew filming some notable. It turned out to be the senatorial hopeful Ted Sorensen, John Kennedy's former speech writer. I paused to listen to him accuse the museum of destroying the beauty of the park by ''grabbing acres of irreplaceable land.'' I thought of butting in but decided to maintain my composure for the evening ahead. In any case, I had my doubts whether Sorensen knew which museum he was talking about.

The auditorium of the Natural History Museum, a graceless, dark-brown, and ill-lighted interior, was not, I thought, the happiest place for a hearing. Augie had originally wanted the meeting to be outdoors at the Delacorte Shakespeare Theater, but the chance of bad weather had convinced him to go elsewhere. I would have used the Delacorte as an argument, reminding the commissioner that some of the very same park lovers lined up against the Met had bitterly opposed *it* as an encroachment. Augie got things under way by welcoming the throng and stating the theme of the inquiry. He asked me to run through my slide show—''as quickly as feasible.''

I punched up my slides quickly and machine-gunned my words. I showed the original drawings for Central Park with the site of the museum actually labelled as such. Then I showed the three earlier master plans, calling them ''ugly, huge things designed with no consideration for what was going in these awful buildings or the visitors.'' I slipped in a few particularly depressing images of the garbage pickup areas, the dirt-streaked west facade, the half-

demolished playground on the north. I showed off some of the proposed new additions—Rockefeller, Dendur, American Wing, Lehman. At Lehman there was a smattering of boos and Chairman Dore Schary tapped his gavel just like a judge in a movie.

I pulled a paper out of my pocket and read what I said was an important new statement: "The Lehman Foundation has told us that the gift is conditioned on *this* wing being built. If it is not built by a specific date, the Foundation may cancel the agreement with the Met and send the collection to another institution. Any other city in the world would move heaven and earth to get this great treasure for their citizens; it would be a tragic mistake for New York to lose the greatest art collection ever assembled in this city."

There were boos and shouts. "Blackmail! Lies! Lies!"

That flustered me a bit, and when I returned to my presentation, I slowed down. Someone handed me a note from Los Angeles Museum director Ken Donahue, "Tom, it's running too long!" I wrapped up my presentation with our "math package" as Rosenblatt called it, the formula of how we would build into the park and still give back ninety-one thousand square feet of green space to the people of New York. I returned to my seat drenched in sweat, glad I didn't have to field questions.

Schary commanded all speakers to limit their remarks to five minutes and try not to repeat what others had already said. Edward Tuck of the Parks Association was first. I steeled myself, but he offered little new.

Our side got two in a row—Thomas Buechner of the Brooklyn and Marcel Breuer, the architect of the Whitney Museum, who would, in gratitude, be given a one-man show at the Met later on. Buechner challenged the idea that the Met was hoarding its treasures. The museum had "2,058 works of art on loan to other institutions in town, a perfect definition of decentralization." Breuer croaked, "I am for this master plan because I think that the park does not lose anything, especially if these awful parking lots are put underground."

Then the podium was taken back by the enemies: Arthur Brook, chairman of the New York County Liberal Party. Brook gave me a body blow by comparing my Lehman "threat" to the threat some years before by the donors of a fancy playground in Riverside Park to be designed by Isamu Noguchi. "Our opposition did not abate; the gift was withdrawn. Our children sledded in Riverside Park in

the winter; they played baseball there in the summer. Everyone knows Commissioner Hoving opposed that Noguchi playground.''

Then Richard Edes Harrison, the cartographer, had Heckscher nodding in agreement with his pungent remark: ''In Staten Island there are 39 people for each acre of park, in Queens, 95; in the Bronx, 268; in Brooklyn, 454; and in Manhattan, 750.'' He demanded that Heckscher test our lease in court. The suggestion frightened me. His voice rising, Harrison said, ''I have read the law of April 22, 1876, and some of the subsequent laws to enable the museum to have 'authorized occupancy' *but that is not the same thing as owning park land!''* There was a tremendous burst of applause, and I could see Ed Tuck and Herschel Post of the Parks Council talking to each other excitedly. My God, they are going to sue, I thought.

Our next witness, Philip Johnson, controlled some of the damage. The pixie architect whose thin, super-cultured voice was transfixing, came up with a classic: ''I am an architect, and I want to speak in favor of this plan, but I shouldn't. I should be jealous of Kevin Roche's magnificent plan. But I'm not. The Met, to me, is the Louvre of this country. In the Louvre there are many museums. In the new Metropolitan there will be, too. Heaven knows I am for parks —I was the architect for the garden at MOMA. I made a park at my glass house. I am for grass. I am for people. I am for parks. I agree with Marcel Breuer that this 'invasion' of the park is not of the magnitude to disturb the public. I think that six million people visiting the museum also have rights.''

The opposition was looking glum.

Schary announced that Carol Greitzer would be the next speaker, followed by Carter Burden.

I was perhaps the only person in the room who knew that Carter Burden was not going to testify. That morning, my staff had called all the elected officials we believed were going to testify to find out their positions. I had been briefed on Burden's position. ''The councilman will definitely be against the museum,'' his aide had said. On what grounds? ''Because of encroachment.'' When I had spotted Carter Burden in the auditorium, I had reminded him that after his tour of the Met, he had said that he wasn't concerned with encroachment. I warned him that if he testified against us on encroachment, I would expose his prior statement. He grew flustered and fled into the lobby to talk to a member of his staff. Though he hung around in the back of the theater, he never came forward to testify.

I gritted my teeth when Carol Greitzer moved to the speaker's rostrum.

She started off warm and friendly, one of her standard ploys. She said that her district included all of Central Park "including the museum, the animals and the two people that the census taker tells me reside there. I don't know where, probably in the zoo." She planned to discuss our plan as it affected people. "The City, of course, has an interest because the City owns the whole park, including the museum site, despite the habit of Museum officials referring to the land as 'our property.' "

I bristled. No one, not I, even in one of my more irresponsible moments, had ever made such a statement.

Greitzer dismissed our right to build anything on our site, even projects such as Lehman that were privately funded. She advocated the abrogation of any lease between the museum and the city or the state, saying simply, "Times have changed, particularly for preserving open space, particularly in Manhattan." She charged that the museum was going hell-bent against the process of change: "For whatever changes it makes seem to be in opposition to the desire of the public it theoretically is serving. For example, the great painting collection has been removed from its place of honor at the top of the great stairs to a remote gallery off to the north beyond the Chinese Gallery. One curator resigned in protest of this move, and an unusual number of resignations in the professional staff have taken place recently."

I nearly jumped out of my seat. She knew that the Paintings Galleries had deliberately been placed in the newly renovated, mammoth "Bowling Alley" and that many of our finer pictures were out on loan. The remark about staff resignations had me hopping. I could do nothing.

Greitzer ripped apart our argument that the strength of our collections was that they were centralized, saying if it were true, then "we wouldn't have had The Cloisters seven miles away." She called for the total decentralization of the Met. "Why won't the Met provide seed art for Brooklyn, for Queens and for Staten Island?"

Greitzer closed by claiming that the city had "a clear right to revoke its agreements of 1878 in the interest of the needs for open space and the needs for helping local neighborhoods in the decentralization of cultural facilities." She added that our lease allowed us to use the park area for our collections and the library, *not* cars. "In 1878, we didn't have cars—with Central Park in imminent danger by

231

being dug up for subway lines, water tunnels, by police and fire facilities, the museum should be especially concerned about making still another encroachment.''

The applause was tremendous. And Heckscher seemed pleased.

It was midway through the hearing. Several of our supporters had disappeared, and some members of the opposition had departed too. Now was the time for both sides to bring out their heaviest artillery. Our opponents began the barrage with the canny Robert Makla, who didn't disappoint.

Makla claimed there was a "secret agreement" between the Met and the Lehman Foundation and urged Heckscher to investigate it. Heckscher nodded. He referred to a little-known—and costly— plan, funded by the city government under Mayor Wagner, for ren- ovation and refurbishment, initiated by Jim Rorimer with the backing of the Parks Department and the City Planning Commission. He stated that this "excellent plan left no doubt that *all* the space needs of the museum could be dealt with *inside* the existing structure." Finally, he pilloried our idea of tacking whole museums like Rocke- feller's onto the Met.

By ten o'clock Dore Schary was calling off name after name of people who had signed up but had departed.

I was gloomy. Although we had demonstrated a far greater com- munity sophistication, I sensed that we had not been persuasive enough. My only hope was to convince Augie Heckscher by written testimony from personalities and big names. At best, I felt we would have to face at least two other hearings before the indecisive com- missioner of Parks made up his mind. At worst, Augie would make a statement that he couldn't "in all conscience" support the plan as drafted.

The more I thought about the future, the grimmer it seemed. Dore Schary had been pointedly interested in our opponents and singu- larly cool to our friends. I had resigned myself to his anti-Met stance. I was slumped in my chair when I heard Schary introduce "a speaker who, because of his position and background certainly ought to be heard, Karl Katz, director of the Jewish Museum."

Katz had given me a vibrant tour of Jerusalem, Bethlehem, and the National Museum of Israel when I visited Israel with the Wrightsmans, and we had met often at various museum functions. Dark-haired, intense, with eyes that could flash, he possessed a me- lodious voice and a keen intelligence.

Katz approached the podium and seized it. He looked out at the now meager audience, gazed benevolently at Dore Schary and Augie Heckscher, and, in a clear, confident voice, launched a most amazing speech.

"I also wear another hat besides being director of the Jewish Museum here in this city. I work in another city where you can't buy land, where land is sacred, and where every piece of that land is ancient, important, inestimable. And that is Jerusalem.

"I am the chief curator of the National Museum of Israel.

"When we were planning to build our national museum, the City Planners decided to give the museum the biggest piece of land, a part in the center of the city for the building and its expansion—a space three times the size of the room to house the Rockefeller Collection, the Lehman Collection, the temple from Egypt.

"Who could object to what the Met needs when in Jerusalem they have taken sacred lands and said, 'Build a museum'? I am for the Met's expansion plans."

Katz sat down. Both Heckscher and Schary looked thunderstruck. It was as if a prophet had come down from the hills and exposed the whole hearing—the petty controversy—as nonsense, something hardly worth the attention of aware and intelligent human beings. Karl Katz had moved both Schary and Heckscher. The evening dragged on for a little longer, but the affair was over. And we had won. I just knew it. A few minutes before midnight, Dore Schary closed up the shop, thanked all present for their "forbearance," stated that, for him, the hearing had been of great value in helping him make up his mind what to do. Heckscher nodded sleepily.

14

SWEET VICTORY

We waited for Heckscher to respond, a monumental mistake. All mine. I should have given him everything he wanted—provided park entrances, landscaped the covered courtyards, capitulated on changing the lease, given up forever any expansion. We intended to do all of it anyway.

But I had sunk into a lethargy. After the Centennial flurry I lost direction. And now, summer was approaching, and key trustees and lawyers were disappearing. The shocking thing about my failure to wrap it up was that Augie, somewhat plaintively, sent us a clear indication of how he felt in a radio interview on WNBC. He really liked the master plan, only qualifying his delight with the phrase "the museum is still under negotiation."

During my lassitude, the Landmarks Preservation Commission abruptly changed its position and decided to hold its own public hearing to help formulate its "advisory statement." The Landmarks hearing was a Roman circus on a sweltering August day when most of our defenders were out of town. I was in the Soviet Union. The

234

opposition chewed up Kevin Roche, who was speaking on our behalf. Its arguments were tediously similar, as was the cast of characters. Little of the "testimony" had to do with the subject at hand, how the new additions might affect the older buildings.

The Landmarks Commission tabled its opinion. Then City Council President Sanford D. Garelik called his own hearing. He was one of the most lackluster politicians in town and the most frustrated. He had been a hopeful in the first Lindsay administration and was supposed to have become the first Jewish police commissioner in the city's history. But his bid had failed. Eventually, Garelik was elected to the presidency of the City Council, a job with no real power. Someone on his staff must have convinced him that a public hearing on the Met's expansion plans would be political money in the bank.

When Herbert Brownell pointed out to Garelik that there were no legal grounds for the hearing and that the City Council had no chartered rights to alter the plan, Garelik shrugged. Thereupon began the most controversial hearing in the history of the City Council. It became the setting for Carter Burden's best theater.

The meeting in the fall of 1971 in the handsome Victorian City Council room at City Hall started in the morning and lasted until after eight. There were dozens of witnesses on both sides and a few new arguments. The interrogation was dominated by Carol Greitzer and Carter Burden. Once they saw what was going on, the more Establishment-minded members of the council disappeared. Many of those to whom I had delivered goods and services while in Parks came over to me to shake my hand as the session droned on— especially when Greitzer or Burden happened to be speaking. Greitzer's remarks were threadbare. Burden's were little more than insults.

As I toiled through the master plan presentation trying to sound upbeat and studious, there were a few hisses from the audience and some muffled boos. Nothing could have made me happier. I could see that my friends on the council, including Tom Cuite, the majority leader, were unhappy. Even Sandy Garelik frowned and rapped his gavel. When I finished, I was grilled by Burden.

He fastened on our mobile museum, called Eye-Opener, asserting that its success proved that underprivileged areas of the city needed culture. He challenged us to take parts of our collections—"the admittedly duplicates or inferior works"—and give them to other institutions either to sell or to become part of their collections.

"Sure," I said.

Carter became flustered. Not just loans, he said; he meant gifts.

I said that I meant gifts. "Good pieces, too, not the second-rate."

"They can *have* it?"

"Sure."

"Are you correctly stating trustee policy in this—in giving objects away?"

"The trustees are firm in their intent," I said. "You know, you really must get out of your mind this false notion of the Met as a vain, arrogant institution attempting to crush people."

Off balance, Burden asked me why, if I didn't know the exact costs of the expansion, had I come to the council for approval of this plan?

"*You* demanded we come, not me!" I snapped.

As Burden was saying something about how "elite" our board was, I got a brainstorm. I confessed that some of the trustees of the Metropolitan were less familiar with far-off places like Staten Island or Brooklyn. I thought borough trustees ought to be elected to serve on the regular board of trustees. Dillon's eyes grew wide. Gilpatric sat up. Garelik asked what I meant. I suggested that the Met trustees should elect as permanent, voting members of their distinguished body a trustee from each borough in order to learn firsthand the cultural needs of the rest of the city.

Garelik replied, "If that could happen, it would go a long way to ease my concerns. Mr. Dillon, as president, can you pledge your best efforts to do what Dr. Hoving just said?" Dillon, with the smile he had sculpted during years in front of hostile congressional committees, said calmly, "I think it's a very beneficial idea."

Burden collapsed slowly. The council members were beginning to drift away. Burden almost pleaded with the National Gallery's director, J. Carter Brown, to testify that an "encyclopedic" art museum was an endless, nonsense scheme. Brown waved a well-manicured hand and asked, "Is the visual encyclopedia an octopus? No. There's a positive dimension to understanding the open-ended nature of the variety of man's creations."

Burden inquired whether the Met had to expand indefinitely to become an encyclopedia.

Not at all, Brown replied smoothly. It was a little like trimming a Christmas tree. "The point is when you have the right dramatization of the richness of the past, anything that does not enhance should not be endorsed."

Called to the stand, Dillon almost inaudibly mentioned that the

museum would pledge never to build beyond the dimensions of the master plan. More council members were leaving the chamber for more pressing business.

Dillon was followed by Ros Gilpatric. When Burden tried to get him to agree that any promise by the museum could be broken by trustees in the future, Gilpatric was firm. "There is such a strong moral and ethical obligation we feel at the Met that I cannot conceive of a future body of trustees ever going against that promise."

The final blow to Burden came when Donald Elliott, the chairman of the Planning Commission, testified that the commission, responsible for the general growth of the city, had no objections to the Met's expansion plans. He and his fellow commissioners had studied the plans carefully, commenting "we like them."

The hearing flickered into darkness and nothing ever came of it. There were no restrictions, no local legislation, no orders. We never heard from Garelik again. The only elected official to pursue the case was Carter Burden. And his pursuit became ragged, though it caused us considerable work and agony.

The aftermath had its amusing moments. Thomas J. Kane, president of the American Society of Landscape Architects, a body that had taken a neutral stand on the plan, wrote to say that in a "rather theoretical and almost irresponsible view" the group had decided to take the position—non-unanimously—that the entire existing Metropolitan Museum of Art be moved wholly out of Central Park.

Ironically, I had huddled with Roche and Dinkeloo and Dillon and prepared a counterproposal to our expansion dreams. And it was serious, too. The Dillon estate in Far Hills, New Jersey, was massive and was only a forty-five-minute drive from the city. I had asked Dillon to turn over a portion of his land to the Metropolitan and allow a new Metropolitan Museum to be built on the site if our plans were shot down. He said yes.

The new Met was to be a radiant panoply of glass behind which the public could see astonishing examples of ancient architecture, the Temple of Dendur, Roman frescoes, the medieval screen from Valladolid, the sixteenth-century Blumenthal patio, all the way into modern times. The galleries in the new Met were laid out chronologically like the "Masterpieces" show, with all disciplines mixed and juxtaposed. We evaluated the scheme and learned that the entire cost would be *half* the amount needed to renovate and construct the new wings at the Met.

Legally, there was no way the city could stop us from leaving

town with all our treasures. Of course, my "new" museum in New Jersey was only an exercise in frustration, but it did come in handy in the final arguments with Heckscher.

As a last effort to quiet resentments that still stirred against us, we decided to give up another part of the master plan: the removal of the Great Stairs. Rosenblatt wrote me a cowardly memo on the subject: "The political climate makes it imperative that the removal of the Stairs be severed from our agreement with the Lehman Foundation. The quality of this new wing and its impact on the life of the museum and the City is in no way contingent on the removal of the Stair. Nor do I feel that the success of the master plan is contingent on this action."

I was furious but had to agree. Ed Weisl expressed his disappointment but sighed and told me that he guessed it wouldn't make any difference. I stalled until Ada Louise Huxtable wrote a piece on how perfectly the Lehman Collection would fit into the Villard Mansion across from St. Patrick's Cathedral on Madison Avenue. Then I announced the "postponement" of the stairs demolition.

At long last Augie Heckscher drafted his opinion, published in an attractive brochure: "I am today, the 20th of January, 1971 . . . prepared to approve a permit for the building of the first element of this plan, namely the Lehman Pavilion."

I had tricked Heckscher and the city government. It had been my strategy that if one presented the overall master plan in deliberately general terms and, at the same time, sought instant approval for specific parts such as Lehman and Dendur, no one would ever bother us again. I knew that Lehman and Dendur would be approved —Lehman had its own money; the city had already voted moneys for the Temple. I knew that, on the basis of these approvals, I could claim that the entire plan had been approved. It worked. No one figured it out.

Nothing could stop us now except that a week later the Municipal Arts Society slapped a suit on Augie Heckscher, arguing that the Board of Estimate had to approve our plans. The court enjoined Heckscher from issuing the permit for Lehman or any other construction. It was mere harassment, an attempt to force us to halt until the rise of building costs would make it impossible for us to build.

A year or so later the third of three courts in Albany came down with a unanimous decision stating that the museum had not only the right but the obligation to build, an obligation so strong that not

building might be grounds for dereliction of our chartered duties. The court delays had worked to our advantage. During 1972 and 1973 New York sunk into a recession, and the construction business was suffering. New bids for Lehman and the other sections of the master plan came in significantly lower than what we had budgeted back in late 1970. The savings amounted to some twelve million dollars. I sent a scroll "of honor" to Brendan Gill and Ed Tuck, heads of the Municipal Arts Society and the Parks Association, thanking them for helping us so much.

After the heady days of dreaming up architectural solutions and dueling with the political dragons, I expected to avoid all the foot-slogging supervision of actual building. But, early on, I found the building part to be fascinating—sometimes wild.

The basic trick to construction is maddeningly simple: get the work done as fast as possible to save money without letting the work become shabby. The catch is that few succeed. Contractors live to lengthen the time of every project.

Of all the projects in the master plan, the American Wing seemed to have Lady Luck protecting it, especially when it came to the financing. John Lindsay resisted all my entreaties to inch some construction money into the capital budget. "Get some of those old rich farts to put up the dough," he said. In fact, we had already raised a considerable amount from individuals and foundations. Joan Payson had paved the way with a pledge of five million dollars and the Kress Foundation had promised a sizable amount if the city put up money.

As soon as Abe Beame became mayor in 1974, I paid him a visit. He liked me and respected me. I had been the only Lindsay commissioner who consulted with his colleagues and friends just after he had lost the mayoralty election in 1967. I had also given him a private presentation of the master plan.

Mayor Beame greeted me warmly and asked what he could do. Rosenblatt figured that a ground-breaking ceremony with Beame officiating would virtually guarantee city money. "We'll give him a chrome-plated shovel, we'll have a fife and drum corps, a party with all the richies. I'll bet you anything that when you ask in the next budget five million for the wing to match the private moneys, you'll get it. Beame *cares* about culture and the mighty Met. He comes from Brooklyn—Cadman Plaza—and looks up to the Met. Lindsay, well, when you come from a wealthy family and go to Yale, you take culture for granted."

Beame not only came to the ceremony, but he stuck that chrome-

plated shovel on the wall of his office in City Hall. Rosenblatt saw to it that Mayor and Mrs. Beame received pleasant mementos every year—things like our replica of a silver seven-branch candlestick made in New York in the late eighteenth century. During the near-bankruptcy of the city when the state slashed the budget almost to nothing, Beame insisted that the city's three million remain for the American Wing.

John Dinkeloo was an engineering genius. The original design of the glass-enclosed courtyard for the American Wing, that vast vestibule in front of the neoclassic assay office facade, called for a series of lofty steel supports to hold up the roof sixty feet above ground level. The original bids had come slightly below our estimates—thanks again to the legal delays—but then the costs of steel skyrocketed after the oil crunch of 1973–74. Within weeks Dinkeloo recast the working drawings so that the steel supports were replaced by much cheaper but equally sturdy concrete piers. The savings were at least five million dollars, and the look of the American Wing court was not in the least affected.

John achieved his other small miracle during the worst of the construction recession. The stonecutters' union relaxed its stringent rules to allow fine stone cut and finished to be imported into the United States. Dinkeloo implored me to send Rosenblatt and him to Carrara, the ancient marble quarry in north Italy, to buy as much marble and choice green stone as possible. They bought a "mountain," which was used throughout the building for walls and pavings and, over the years, saved millions of dollars. There's still a good supply left today.

If the American Wing was under Lady Luck's wing, it sometimes seemed the Temple of Dendur had fallen under King Tut's curse. I failed time after time to raise money to rebuild the structure and the complex to house it. After Lila Wallace turned me down, I had no idea where to turn. Raising money in New York City for an Egyptian temple soon after the Six-Day War was a challenge. Then a saviour appeared.

One day, after the most recent rejection for Dendur funding, I remembered that Arthur Sackler, the eccentric inventor of Beta-dyne, had mentioned his dream of uniting Egypt and Israel. He had donated large sums to Israel and Egypt—a hospital in Cairo and a hospital in Tel Aviv.

I phoned him and asked for an appointment right away. He sur-

prised me by saying he would come to me, and he arrived less than a half hour later, his eyes burning, perhaps fearing I was about to ask him to remove his collection. I told him about Dendur and blurted out that he was the only patron with the guts and the foresight to pay for the glass around the temple. I told him I needed three and a half million bucks.

Sackler stared at me without a word. My last card had failed. Clearly, the man was embarrassed and was trying to figure out how to say no without making me feel like a fool. Suddenly, I heard him say, "I'll do it." Then it was my turn to stare.

"Tom, you must know why I sat there silent—around twenty seconds." He smiled. "I wanted to dine out on the story that it took the great Hoving as long as twenty seconds to hit me for three and a half."

Sackler made good on his pledge, and his name was placed on the wing that surrounds the temple. The big curse vanished, but we felt the effects of a dozen small ones. Sackler's lawyer drafted a complex legal document, almost as ponderous as the one Paul Guth had created for the Lehman gift. The dollars would come in over a long period of time, which wasn't very helpful since we had to borrow a few times from the endowment to pay the contractors. Three and a half million dollars was not enough to pay for the entire building, which included an underground parking garage for employees and a loading dock—a complex so sexless that I doubted I would ever raise a penny for it. A saviour came along instantly for the unseen part—it was Douglas Dillon. "What else should a president *do*," he asked, "if not pay for the places where you'll never find a plaque on the wall?"

Still, the most difficult curse to break was Christine Lilyquist, whom Ted Rousseau and I had impulsively promoted to head of the Egyptian Department after Henry Fischer. She was unable to delegate. She insisted that all six hundred eighty-two stones be sent out to the laboratory at Brookhaven, Long Island, to be X-rayed for flaws. The examination of the first stone took six weeks. At this rate, the temple would be rebuilt sometime in the year 2100. I tried patience, pleasantries, and guile. Lilyquist challenged me with the standard curator's warning that unless modern science examined each stone, the temple might collapse, resulting in the loss of a unique monument of ancient times. I called in Rosenblatt.

In a few weeks he found a solution. When the museum had last re-

erected an ancient building at The Cloisters—the twelfth-century apse from Fuentiduena—the architect had been Geoffrey Lawford of Brown, Lawford & Forbes and the stone masons had been elderly Italians from Ottovino & Sons.

I hired Lawford at once, and Ottovino managed to bring out of retirement some of the key craftsmen who had worked on the Apse. Although Lilyquist objected, she had been out-maneuvered. At her every complaint, I pointed out that the Italian masons had re-erected a more complex work of ancient architecture without mishap. The rebuilding was completed without any damage—and without all those X-rays. The Ottovino men even deciphered and used a number of hieroglyphic markings on the stones. The ancient stones were set up, in a series of dry runs, according to the "mysterious" markings, and then set permanently.

The dedication of the Temple of Dendur by Arthur Sackler was the day after the historic Camp David peace initiatives of Anwar Sadat, Menachem Begin, and President Carter.

After Dendur the planning began for the installation of the permanent Egyptian galleries. By 1975, Lila Wallace was growing frail. Her lawyer, Barney McHenry, had agreed to put up the funds necessary to execute Roche's splendid scheme for the Egyptian galleries, the ones that had triggered Henry Fischer's departure. The plan had been altered slightly from Fischer's time: the clever reflecting treatment of the Hatshepsut materials had been eliminated. Still, the basic time line of Egyptian civilization was intact. We were all eager to proceed. Except Christine Lilyquist.

Faced with the task of examining, cataloguing, and preparing for display the staggering number of objects in the Egyptian collections from neolithic and pre-Dynastic times to the late Roman period, she grew more and more indecisive. McHenry indulged her with almost unlimited sums of money, even spending a small fortune fixing up a garden court outside her office. Contractors found it almost impossible to get permission to make measurements or carry out work. There were endless delays.

We intended to show every work the Egyptian Department possessed—over ten thousand—the finer pieces in large central galleries, the lesser things in accessible study-storage rooms and cubbyholes. The only real decisions were about what belonged in the main galleries and what in the side chambers. Lilyquist insisted upon making a dry run for every vitrine. The work became a night-

mare. At one point she demanded that every work of art in the collection be fully restored before anything was installed, which would have taken a decade. McHenry, by now the only person able to reason with Lilyquist, worked out a practical arrangement, whereby pieces could be installed and then taken away to be restored or worked on after the cases had been finished.

Not long after the first phase of galleries opened, they were shut down. Apparently, the sophisticated systems intended to balance the humidity and dust were not sophisticated enough. But Steve Weintraub in the Conservation Department devised a method so that objects in cases needing differing humidity levels could get them—simply and virtually forever—by the use of different doses of silica gel.

The Egyptian Galleries, sixty-seven thousand square feet, cost the Wallace Foundation twenty million dollars. The work started in 1972 and was not completed until 1983. The bill should have been fifteen million at most. But Barney McHenry wanted everything to be "right." And I didn't take adequate steps to force Lilyquist to proceed. As they stand today, the permanent Egyptian galleries are no doubt the most thrilling of any on the globe—and the most costly.

I was delighted when Nelson Rockefeller's term as vice-president was over. I was looking forward to the moment when he would start helping us to plan and raise money for the Michael C. Rockefeller Wing. Nelson liked to be known as a man of action and a "builder." His public works in the state of New York rival those of a minor pharaoh—hospitals, colleges and universities, and the gargantuan Mall in Albany. He used to tell me at dinner parties that he was proud to have cut his teeth in building projects such as Rockefeller Center and that nothing pleased him more than to watch one of his edifices surge upward to the heavens.

He returned as a trustee and immediately began to do all the wrong things. He meddled with the design and neglected his pledge to give four million dollars. Instead, he pressured Brooke Astor to have her foundation put up four million dollars on his behalf and never gave a penny more.

Matters became poisonous one day when he showed up with his family architect, Wally Harrison, in tow. Harrison was an elderly grouch who kept complaining about everything Roche-Dinkeloo had done. Rockefeller insisted on a huge reflecting pool underneath the

installation of a Sepik River canoe, even though he was told that such an amount of water would generate dangerous humidity. We gave in. Later, the empty pool had to be covered. He ordered an ugly wall to be built on the parapet to prevent visitors in the European Paintings galleries from looking down into the Rockefeller Wing. When Rockefeller retired and the nominating committee elected his daughter Mary Morgan, Michael's twin, to succeed him, she assumed oversight of the Wing and the meddling continued.

We had a number of tense moments trying to finish the Lehman Pavilion. The entire building was made out of the finest limestone without any interior steel supports and cost only 7.8 million dollars. During the final stages of the work I had to force the curator, George Szabo, away from the installation, because he too was unable to make up his mind. The building was opened on schedule to the pleasure of the Lehman board of trustees.

What they never knew was that less than six months before the Lehman Pavilion was ready to open, the general contractor had discovered a "design error." He claimed he had bid on a set of erroneous drawings, and he demanded an additional hundred and fifty thousand dollars or he would walk off the job.

Ashton Hawkins, secretary and in-house lawyer, was uncertain what to do, and so was his assistant, Penny Bardel, who was normally a keen counsellor. Our very distinguished Wall Street gray-flannel-suited firm of Lord, Day & Lord was similarly confused. All they did was to give me the advice that they thought the contractor might be "holding us up to get a payment."

Rosenblatt went to John Dinkeloo, who was wrapping up some construction litigation in Indiana. The law firm that had handled the case effectively was based in New York—Max Greenberg & Associates. They handled only construction litigation.

Max Greenberg turned out to be a tiny, rumpled chap, who listened to the story and agreed to take the case. He called for his associate Jerry Reiss, a Harvard man who had been turned down by the WASP firm of Lord, Day & Lord. Greenberg said the simple job would cost ten thousand dollars. Hawkins and Bardel could hardly believe the low fee. They were so unimpressed that they urged Gilpatric and Dillon *not* to hire Greenberg & Associates.

Arthur Rosenblatt howled and Dillon gave his go-ahead. When the contractor's lawyer heard the next day that Greenberg & Associates had been retained by the museum, the complaint was dropped and

the work on the Lehman began again with less than a week's interruption.

The most exciting construction project I had to deal with at the Met was the underground parking garage. Because of my concern about public access to the new Met and partly because Nelson Rockefeller welshed, the idea was born for an underground garage with seven hundred and seventy parking spaces. Without Rockefeller's money, we had to pay for his wing somehow.

The first person I spoke to about the garage was Robert Moses. The cunning octogenarian, builder of more garages than anyone in history, gave me a vital piece of information: "Design it in such a way that no school buses or campers can enter. Buses drive away revenues and, besides, all bus drivers pocket the money they got for parking. Let them drop off the kids and go away and park and come back." Campers had to be banned, according to Moses, because "the squatters will stay for life." How to stop buses and campers? Just lower the entrance to the garage to a height that would "tear the roofs off them." It worked.

Andre Meyer, who turned out to be a stellar trustee, fought petulantly against the garage. We would lose money; people would be mugged. To bring him around, I had to arrange a private get-together for tea at his apartment. I explained that I wanted to guarantee a massive income for the museum. But he didn't understand. Finally, I appealed to him personally. At length, Meyer said he would drop his objections. Still, he said, he thought I had "become irrational in this silly pursuit for such a mundane facility."

Meyer had caused some damage. In an attempt to appease him, the trustees had forced me to cut back the number of parking slots from nine hundred to seven hundred and seventy. To make a profit, I had to create a virtual monopoly. And so I did.

I appealed to the IRS to allow us to have at least one hundred and fifty overnight and monthly customers. Normally, a tax-deductible organization would have to restrict all parking to business hours, say seven A.M. until ten P.M. At first the IRS resisted. But I knew that Lincoln Center had obtained permission for daily and monthly customers. I met a top official of the IRS and told him that unless the Met received a comparable deal, we would file suit in the tax court to overthrow Lincoln Center's privilege. Within three months we received our permission.

Then I learned that the city was planning to force the luxury apart-

ment houses about to be constructed across from the Met to build parking garages, and so I hired real estate lawyer Sandy Lindenbaum, who petitioned the Board of Standards and Appeals to waive the facilities. The tenants with cars became our monthly clientele.

In order to encourage daily parkers, I asked the traffic commissioner to increase the parking meter fees from 72nd Street to 86th Street on Fifth Avenue and to extend the dreaded tow-away program to 86th Street. Then I got the new parks commissioner, Martin Lang, to allow me to establish a parking fee significantly lower than those in the commercial garages on the East Side.

The smartest thing I did was to make sure that the city, especially Parks, *never* paid a cent towards the construction of the garage. If the city put up a dollar of capital funds, it would ask for the lion's share of my parking profits.

Before Lang was appointed, the acting parks commissioner had been Herschel Post, the executive director of the Parks Association, a man who was suspicious of the museum and who disliked me personally. Rosenblatt and I had asked for a special meeting with him to put on a show of demanding a large chunk of money to build the garage. Post was furious. Why should the strapped Parks Department pay for a project which would only contribute to the destruction of Central Park? I went into an act of pounding the corner of the desk, demanding at least fifty percent of the five million dollars we needed to build the garage, as our "right" under the city-museum lease, which I reminded him had been so strongly upheld by the courts.

Post growled that as long as he held a position in the Parks Department, he would guarantee that we would never get a penny for the garage. Finally, he called in his secretary and dictated a letter stating that the museum's garage would never be funded in any way by Parks. I dared him to sign the letter and hand it over to me. Post did so gladly, and Rosenblatt and I departed, looking angry. When we were out on the street, we howled with joy.

The work on the garage ended on schedule and under budget—at 4.7 million dollars. We hired a professional parking company to run the enterprise, and in two years all costs had been paid back. The garage still constitutes one of the most significant sources of revenue for the Metropolitan. Without it we couldn't have had either the Rockefeller Wing or the Paintings galleries above the wing named for Andre Meyer, who also turned out to be far less generous than

he had led us to believe. Such is life among the rich and the famous in the world of art museums.

Who in the end was right about the master plan—our opponents or us? Is the expanded Metropolitan an ugly, vast encroachment, a white elephant, an ever-expanding behemoth? Or a rational series of much-needed structures? It has been condemned by certain architectural critics—both Ada Louise Huxtable and Paul Goldberger, the current *Times* architectural critic, hate it. If the master plan possesses one failing, it is not, as these critics suggest, that it is too big, but that it is too little and too cowardly. We, the planners and the achievers, lost our nerve and on occasion sank to the level of politicians in compromising the design.

The Grand Staircase should have been demolished; many more escalators and elevators should have been installed; the entrances to the park should have been left open to the public; the garage should have been far larger; the linear boulevard ought to have pushed out the Egyptian Department offices. The original Lehman agreement to disperse his holdings throughout the museum after twenty-five years should have been fought for in the courts with the result that the Pavilion would eventually have become a special exhibition hall. The southwest wing should not have been turned over to Modern Painting and instead should have been devoted to the Metropolitan's greatest strength, Decorative Arts. Roche had made plans to reinvigorate The Cloisters, all of which I backed away from when I detected trustee apathy, feeling at the time that I couldn't fight another architectural war with all the other skirmishes. We should have proceeded with the construction of the protective glass structure to surround the Fuentiduena apse at The Cloisters, which is still deteriorating in alarming fashion.

Perhaps I was wrong and weak to have compromised, but still, the massive, complex series of renovations did change the Met forever, changes which no one else can easily disturb. The master plan also transformed how millions of visitors use the museum. What we accomplished—on or sometimes under budget—remains unique among museums in the world. The master plan has even inspired others—I. M. Pei referred to some of its features as inspirations for his monumental work at the Louvre museum. I might have accomplished more with the plan. But there was always so little time and so many battles to fight.

15

TRUTH, NOT ART

Other than winning a good, dirty fight, there was nothing I liked better than chasing a spectacular work, especially when the chase was more like a spy novel than an academic textbook.

One morning, soon after our victories in the courts I was startled to see Ted Rousseau come into my office—he was not one known for his early arrivals.

Rousseau's eyes were aglow as he placed an auction catalogue from Christie's on my desk. On the cover was a yellow-greenish portrait of a young black man, I guessed in his early thirties. I thought the painting might be Spanish, or an Impressionist, a Manet. But it was more vibrant than Manet. Was it Italian seventeenth century? Post-Caravaggio? But it was more sensitive. It was almost a colored snapshot.

"It's the single finest painting available in the world," he said, pulling up a chair.

The picture, life-sized, was by Diego Velázquez. The subject was

his assistant, a Moor. He had painted it in Rome in 1650 on his second long visit to Italy on behalf of Philip IV. It had been in the Radnor family in England for nearly a century and was, unexpectedly, coming up for sale on November 27.

"We have to make a great effort," Rousseau said urgently. "This is better—a good deal better—than Rembrandt's *Aristotle*."

I had never heard him talk with such enthusiasm, not even when he had urged me to chase Leonardo's *Ginevra dei Benci*.

Ted had first seen the painting in 1953. He had been visiting castle Longford, the country seat of the Earl of Radnor near Salisbury, and had spent several hours looking at the rich collection. He had been overwhelmed by the Velázquez.

"Tom, I recognized it as one of the most beautiful, most *living* portraits ever painted. You know I consider Velázquez to be the greatest painter in history, and *this* is one of his prime works. Yes, *prime!*"

I played devil's advocate. I reeled off some of the Velázquezes I knew best—*The Surrender of Breda;* the portraits of the King and the Infanta in Vienna; the divine *Las Meninas;* the poignant studies of the dwarfs in the Prado; and *my* favorite, the cryptic, unforgettable portrait of Pope Innocent X in the Doria Pamphily Palace in Rome, which I thought was the most successful portrait in Western art.

"Ah, you have mentioned exactly the right one!" Rousseau said. "*Juan de Pareja* was painted *as a sort of practice session a day or two before he painted Innocent.*"

Velázquez's biographer, Antonio Palomino, had written about the painting. After Velázquez had received the commission to paint the pope, he painted Juan, Ted told me, "less to limber up his fingers, which I doubt Velázquez needed to do, than to prepare himself for the difficult task of painting a person with a slightly florid, pale visage dressed in brilliant crimson robes." After the painting of Juan was completed, Velázquez instructed his assistant to carry his portrait to the studios of several of his peers, knock on the door, and assume exactly the same pose as in the picture. This had a sensational effect. Palomino wrote that those who saw the man and the painting reacted with a mixture of "admiration and amazement."

Palomino wrote, "They didn't know as they looked at the model whom to address or where the answer would come from." The painting had soon gone on display in the great portico of the Pantheon,

where the general public had the rare opportunity to view the masterpiece. There, according again to Palomino, it was "universally applauded by all painters from different countries who said that the other pictures in the show were art but this alone was 'truth.' "

By this time I was clutching the catalogue. The painting had disappeared when Velázquez returned to Spain in 1652. In the eighteenth century it had turned up in the collection of Cardinal Trajano d'Acquaviva, a consul for Spain. After that the picture was listed in the Baranello collection in Naples sometime at the end of the eighteenth century when it surfaced somewhat mysteriously in the hands of Sir William Hamilton, the British envoy in Naples from 1764 to 1798. Hamilton's inventory calls it "a portrait of a Moresco slave by Velázquez." Christie's catalogue tartly noted that Juan could never have been a slave but became a distinguished painter in his own right after his apprenticeship with Velázquez.

The portrait reappeared in the collection of Jacob Pleydell-Bouverie, second Earl of Radnor at Longford Castle, Salisbury, in the early nineteenth century. According to Helen Matilda, the Countess of Radnor, who published a catalogue of the family possessions in 1909, the painting was thought to have been purchased in 1811.

I asked Ted why the Radnor family would sell it at auction instead of trying to make some sort of tax deal with the authorities, a practice that was beginning to occur in isolated cases in England. He had no idea. Perhaps the current earl was "dotty."

"The best people have been after this picture for years, especially Georges and Daniel Wildenstein," he said. "Every year, old Georges Wildenstein would send his English agent, a splendid grande dame by the name of Mrs. Georgiana Blois, a kind of *Arsenic and Old Lace* character, and the bosom pal of all the mothers of the English and Scottish nobility, with an offer. The earl would reject it. Finally, Wildenstein sent her with a blank check. Even that was refused."

"How much would it take to buy it?"

"Three to four million dollars."

I choked. The price was almost unheard of. I knew we had few purchasing funds in our coffers and that the struggle to raise the funds would be monumental. I was on the verge of discouraging Ted when my own passion for acquiring simply exploded. The painting was world-class. The most basic duty of the Metropolitan was to

seize such treasures. Not making a major effort would be tantamount to dereliction of duty. Besides, because of the rush of the Centennial and the turmoil over the master plan, the museum had not acquired a truly grand masterpiece in a long time.

"What the hell else is the Met for, anyway?"

"Great!" Ted said. "What's first in the battle plan?"

"Wildenstein," I said.

That morning I called the firm's American president, Louis Goldenberg, and asked if Wildenstein would act as our representative in the possible purchase of the Velázquez. I wanted to get to Wildenstein before any other museum or collector in the United States did and, if possible, before he decided to buy it for himself. Of all the old master dealers in the world, only Wildenstein could afford something that expensive. Goldenberg, who was primarily an accountant and by no means an art expert, was guarded. He said he'd have to talk with Daniel and would get back to me.

I set up a meeting with Rousseau, Everett Fahy, the curator in charge of European Paintings, and our chief conservator of paintings, Hubert von Sonnenberg, to plan our campaign. I ticked off the information we would need: facts on the condition of the picture; how many copies existed and what they looked like (the Christie's catalogue mentioned five copies, one of which was hanging in New York's Hispanic Society); how the painting compared to *all* other Velázquezes; the full history of the piece; how much it would take; and who our competitors would be. I told them all to get ready to go immediately to London to examine the painting and, after that, on to the Prado and to Rome to study the comparable Velázquez works.

I briefed Dillon at our Tuesday meeting, and he was intrigued though leery. He asked Dan Herrick how much acquisitions money we actually had. Herrick told us that we had scarcely one hundred thousand dollars. Dillon wasn't fazed by our poverty.

"Depending on how much Goldenberg finds out about the general price area," he said, "and assuming that Wildenstein is willing to become our agent, I'll figure something out—probably a combination of dipping into one or both of the endowment funds plus a payback schedule plus, of course, passing the tambourine to friends."

Hubert von Sonnenberg gave himself a crash course on the painter. Within a week he had made a most remarkable journey into the core of our three Velázquez pictures, using every tool available,

from the magnifying glass to the X-ray and infrared and ultraviolet lamp. He came to my office and gave a spellbinding description of what he had learned,

"In his later works Velázquez seems to have changed his technique from rather heavy laying-in of paint surfaces to a 'watercolor' technique of thin washes beneath sudden, stunning blobs of almost raw paint which he floated over a brown ground with a reddish tinge applied to the raw canvas. His canvases in the late period—and the *Juan* is late—are almost invariably nubby. Velázquez wanted the rough surface of the canvas to act as the highlighting. He also allowed the reddish, thin ground to be seen so as to give a sort of red glow from deep within the painting. All our pictures have been relined. This flattens out the tiny mountains and valleys of paint and thus they have lost considerable luster and sparkle. We must determine if this *Juan de Pareja* has been relined. We must determine whether its varnish is old or modern. If the picture is pristine, then we must go for it. If not, I'd say, forget it. Only a good long look in London will tell us what we have to know. It is imperative that we be allowed to scrutinize the painting—under laboratory circumstances. I'd recommend we clean small parts of it."

A few days later Goldenberg called to say that he had just returned from a meeting in Paris with Daniel Wildenstein and wanted to talk to me "after hours—alone." I set it up in my office for five-thirty the same afternoon.

Goldenberg, a tall, pale man of calm demeanor, looked so grave as he entered my office that I was sure he was going to tell me that Wildenstein had made arrangements with another client.

"For Georges Wildenstein, Diego Velázquez was the greatest painter of all history, of all countries," he said. "And for Georges—who you know, Tom, had *the* finest eye in the world—*this* Velázquez was the best painting the master ever produced. Daniel agrees with his late father. You see, since his father's death, Daniel has been seeking a work of art that might become the perfect memorial. Since Georges' passing, each year Daniel asked the Radnor family to sell this painting to him—at *any* price. Why hasn't the Radnor family sold it? Well, the picture *is* the finest in the collection. Daniel is even keener to buy it."

Goldenberg seemed about to confirm the bad news, when he veered off. I found his dramatics somewhat amusing. Why, he wondered aloud, after spurning so many advances had the earl so sud-

denly placed the painting on the auction block? There had been a
theft of five paintings from the castle, he told me, a theft that had
been set up by someone who knew the collection well. But the
professional thief commissioned to steal the Velázquez was not an
art historian and had mistakenly taken a portrait by the Flemish
painter Frans Hals, which was roughly the same size as the *Juan de
Pareja*. The earl, frightened that another thief would steal the Veláz-
quez, had suddenly offered the painting to the head of Christie's, Sir
Peter Chance.

I sat there tensely.

"To Daniel, the *Juan de Pareja* is, in a sense, a twentieth-century
painting," Goldenberg said. "He feels that the firm *must* buy it. Our
business, he admits, will be jeopardized for several years, but we
cannot afford *not* to buy it. After all, two generations of the Wilden-
stein firm have been pursuing it."

I sighed.

"You are fortunate that you called me as soon as you did. Daniel
wants you to know how much he admires not only the Met but you.
His father and he had some problems with the earlier administration,
as you know. But he feels good about what you have done—Lehman
—and what you are doing. He is impressed that you think the same
way about his cherished painting. Although he wants the *Juan* for
the firm, he recognizes that the single most important public place in
the world for the painting to reside would be the Metropolitan.
Therefore, Daniel has instructed me to tell you that Wildenstein will
act as the agent of the museum—with absolutely no compensation
—under one proviso. That is you must be willing to guarantee that
you will pay a price over what he is considering."

"What's that?" I asked quickly.

"Four million dollars."

It was time to be bold.

"Ah, Doug Dillon and I have already discussed the price, and we
plan to go far above four million," I said. No such discussion had
ever taken place, of course.

Goldenberg stared out the window for a few seconds. "In that
case, I am instructed to tell you that we will be your representative
at the sale. But it must be clearly understood that if you—after your
official trustees vote or whatever—meet or surpass this price, then
we will work for you. But if you decide to try at a price lower than
four million, we will decline. Moreover, if the museum's final bid is

unsuccessful, Wildenstein has the right to enter the bidding at a level *clearly* higher than the sum you authorized us to bid and try to win the picture for ourselves.''

Without pausing over the disadvantages of such an arrangement— I knew there were many—I promised to play it Wildenstein's way.

Having secured the best agent on earth for free, I asked him to establish the identities of the top two or three bidders and, if possible, the exact amount the underbidder was willing to pay. People are most indiscreet in the world of museums. If we kept careful track of all rumors, hints, and stray bits of conversation, we might be able to figure out who wanted the painting most.

Our strategy from the beginning was dissimulation and misleading rumors. We decided to capitalize upon my flamboyant, somewhat erratic, image to befuddle our competition. The scheme was for me to act wildly enthusiastic at first, then seem more and more discouraged, complain about the difficulties with the city government and the board's lack of interest—then become frantic, and finally bored with the whole idea. We discussed how to manipulate the art press and how to crank up the rumor mill. I had lunch with Ashton Hawkins and confided to him *in strictest confidence* my dream of landing the most important painting in world history. After lunch, the word spread that we were players.

Part of our disinformation campaign was to show interest in the copy in the Hispanic Society, said to be the best of the five known copies. My campaign aside, I couldn't help but be distressed when I saw the picture. It was flat, lifeless, with paint tentatively applied in details of the lace collar around Juan's neck and his hair. His hand was ugly and wooden! *If* this was an accurate replica of the *Juan,* why bother? But Sonnenberg bucked me up. ''For God's sake, Hoving, wait till we look at the original.''

On the twelfth of October, 1971, Rousseau, Sonnenberg, and I flew to London. We met Everett Fahy early the morning of our arrival. Our excitement was intense. Ted had made arrangements for a VIP view of the painting at noon. I napped for an hour.

Sir Peter Chance, chairman of Christie's, was an impeccably dressed, florid Britisher, the very symbol of upper-class culture neatly folded around commerce. He was clearly impressed that we had come with such a show of strength. Ted dashed his expectations by explaining that we were on our way to a conference in Germany when the news broke about the *Juan de Pareja* and that he had bullied us into passing through London.

I had never seen Ted so brisk. He lit into the flustered Sir Peter as if he couldn't care less about either his answers or the painting.

"So, what's the latest on the price, Peter?"

"I should say—truly—a figure approaching the two-million-guinea mark."

"Come now! It's not *that* good," Ted scoffed.

A guinea—no longer in use these days—amounted to a pound plus a shilling. While Sotheby's always conducted their sales in pounds, Christie's favored the more pretentious guinea. Two million guineas was around 5.2 million dollars.

"The condition's *perfect*," Peter Chance said. "The picture will not be cleaned up for the sale. Lord Radnor forbids it. He also is somewhat against anyone . . . examining it . . . scientifically. But no matter, we all matriculated into connoisseurs without all these fashionable instruments, if I may say so, Dr. von Sonnenberg."

"That sounds as if something *is* wrong," Ted said. "Who else has been around?"

"Just *everybody*. Baron von Thyssen. The National Gallery here . . ."

"What about Carter Brown?"

"Not so far. But he *will*. And the Spaniards. And Laclotte from the Louvre. You know, the Louvre has not one example of the master's work. Amazing. I would have thought Napoleon would have purloined at least one. As you know London is *rich* in Velázquez . . . But only, of course, from the early periods."

It was time to cease the banter and have a look. Sir Peter introduced us to a young "guide," but it was obvious that the thin, bright-eyed youth was a security man who would never let us out of his sight. That was bad, for Sonnenberg planned to subject the painting to intense scrutiny to be sure about its true condition and compare it with other Velázquezes, a kind of scrutiny any security man would want to prevent.

The first impression of a work of art is the whole pedigree, the rush that comes to the experienced art watcher in the first thousandth of a second. The fleeter, the better. The speed wipes away false hopes and inflated dreams, the insidious way one's mind can cheat one into thinking the work is more profound, more authentic, more desirable than what is really there.

I entered the chamber where Christie's had chosen to display the masterwork. It was different from the room where I had seen the Monet, but equally humble. The room measured only fifteen by ten

feet, with one dirty window, a shade hanging halfway down. There were only two lights, one hanging from the ceiling and the other, a spotlight. There were several chairs. *This* was the hall of honor for something worth *two million guineas* or more. I motioned Fahy to place a seat in front of the *Juan,* which had been set on an easel. Hubert set up the spotlight as close as our security man would allow.

"Hit me!" I said. The light clicked on, and I glanced directly at the picture and then looked quickly away.

The split-second impression was vivid. I thought I had seen a human being, alive and about to open his mouth to say something, coyly yet proudly gazing back at me. I believed I had seen a film of sweat on his brow. The impression was shocking.

Another glance. This time I was struck by how *colorless* the painting was. No florid flesh tones, no cerulean eyes, no glaring backdrop, no smart hues on the jacket. Plain, simple flesh, dark-brown flesh of a real creature, not a baroque baby or angel or saint or grand seigneur. I was thrilled to find no embellishments, none of the whiz-bang so tiresome in seventeenth-century artwork. I was reminded of the pictures in the Prado of those dwarfs—the elegant and poignant little men seated reading huge tomes or standing on stunted legs looking out impassively. Those pictures had the same muted, human colors. And an equally raw intimacy. I brought to mind all the other Velázquezes I could—the history pieces, *Las Hilanderas, Bacchus Appearing to the Peasants,* Philip on horse or standing around stiffly, the Infantas in Vienna, even the two tiny landscapes in the Prado painted sometime in Rome, though no one knew whether on the first or second trip. Nothing—actually not even the dwarfs— possessed the same almost matter-of-fact *actual* humanity. All I could think of was that Velázquez must have loved this young man.

My colleagues were rapt. Now I gave the painting my full attention and, to my dismay, I found that it diminished in strength the longer I scrutinized it. The face of the young black wandered out of focus. The non-colors began to turn greenish-yellow ever so slightly. I was seeing what I had avoided on the first glance. The condition of the picture intruded.

We went over every centimeter of the painting with Hubert guiding us. The security guard never left our side. God knows what his reaction would have been had one of us gotten really close or touched it. Hubert talked mostly about the defects he could see. The varnish had sadly browned out, and its consistency had turned thick, giving an unpleasant yellow cast to the painting.

The guard sat down. What would the picture look like with the varnish removed? We whispered the question. Hubert grumbled that without getting his fingers on the painting's surface, he could *not* be sure, yet it seemed that the varnish was *not* the original and he surmised that the gunk had been applied in the late 1930s, just before the *Juan* had been displayed publicly for the first and last time since its debut at the Pantheon hundreds of years before. He thought the varnish would come off easily. Could he see beneath it? Was there any apparent damage to the surface of the canvas? Finally, Hubert told us to be quiet and allow him to scan the painting in peace.

The examination took about a half hour. When he was finished, Hubert shot us a quick smile and a wink and then set his face into a scowl and breathed one word just loudly enough for the guard to hear, "Trouble!"

We left, passing by Sir Peter's office to let him know that we might be back. We were not sure when. We'd call. Sir Peter tried to look pleased.

We went to one of London's best restaurants and chattered like magpies. I grilled Sonnenberg. Though guarded, he told us that he was "almost positive" the painting was virtually pristine.

"But I *have* to get my hands on it," he said. "We *must* come back and get rid of that guard. Without handling it, I wouldn't want to recommend it at the price you've been talking about."

After lunch we made a tour of every Velázquez in London from the great early *Water Seller* in Apsley House to the three works in the National Gallery. We were all convinced that the *Juan de Pareja* was far more impressive. I began to dream up scenarios in which the British government would *have* to acquire the painting or block the export and take years to raise the funds.

"We have to go back tomorrow," I decided. "And be sure Hubert inspects the damned thing the way he wants. If we wait, we lose the opportunity to compare what we find in the *Juan* with the paintings in the Prado where the director will *surely* let us look at the pictures in a scientific way. Here's the plan. Call Sir Peter at home tonight. Say anything, but get us in tomorrow as early as possible. Don't drink anything at breakfast, nothing at all—all morning. We'll wait the little bastard out. Then we'll dig away."

Ted secured the appointment for nine o'clock, and we were at the door of Christie's waiting. The guard recognized us immediately and seemed to relax, which I'd counted on. He asked if we wanted coffee. Ted said he'd be delighted, but only if the security man joined

us—a clever move. Ted pretended to sip his coffee. Once again we went up the creaking elevator. We set up the chairs in a row several feet from the painting, turned on the spotlight, and gazed.

The gaze lasted more than two and a half hours. I spent the time passing my eyes bit by bit from the upper left across an inch, down then to the left an inch, down and then to the right, until I had scanned the picture and followed by working my eyes all the way up in the same manner. Just short of three hours. We engaged the guard in bantering conversation, taking care, also, to tell him everything we knew about the picture and Velázquez and Juan. He listened avidly, seeing that we could make him seem an expert in the eyes of all those who would follow us. Hubert then made what might have been the coup of the escapade. He leaned back in his chair after filling the ears of the guard with the subtleties of cleaning off varnish and said, "Perhaps you should take notes on all this precious information."

The guard said brightly, "Right! I'll be back in a few minutes. Ah, don't say you've been left alone, understand?"

Oh, no! we chorused.

As soon as he started the elevator, we moved into action. Ted placed a chair against the door under the knob, and Hubert seized the painting and was about to take it off its easel when I cried out, "What if it's wired?"

"Then we go to a British jail," he laughed.

He carried it over to the window and held it up before the light and exclaimed, "Marvelous! See! No relining. Fabulous."

He handed the canvas to Ted.

"Got to get it out of the frame," Hubert said.

"Do we have time?" I asked. I was becoming very nervous. "Don't we have enough information?"

"Out of the frame!" Hubert muttered.

"Do you hear anything," I whispered to Fahy, who had his ear to the door and looked exceedingly uncomfortable.

"Not yet."

"Okay. Go ahead," I told Hubert, but the order was unnecessary. He took it over to the window and once again allowed the sparkles of light from the sun to come through the canvas.

"Hey, something interesting," he called out. "The canvas is thicker on the top and on the right side. Could it have been folded?"

"He's coming," Fahy said in a strangled voice. "I can hear the elevator. Hurry. *Please!*"

"Get that damned chair out of there!" I cried. Everett removed it. By the time the young attendant opened the door, the picture was back in its frame, on the easel, the spotlight placidly bathing it with light. Our hearts were pounding, but we looked impassive, almost bored. We remained another half hour, gazing at our prey, chatting with the guard. When we left, he stayed behind. And as the four of us walked to the elevator, I turned to Hubert and, in a bold stage whisper so that the guard could hear, said, "Funny about a work of art. Sometimes they grow and grow. Sometimes they die. I would *never* have thought this picture would have died. Shit!"

We stopped by Sir Peter's office. He asked whether we wanted to reserve seats for the sale.

"No thanks, Peter, I don't think that will be necessary," Ted said.

We barely got to the airport for the flight to Madrid. I was exultant. At dinner Hubert spelled it out. The canvas was pristine; no one had ever flattened it by heat or relining. Thus the paint structure was in the finest possible condition, perhaps *the* best condition of *any* painting by the master. The varnish was not old but it was a benevolent kind. Beneath the varnish, Hubert believed he had seen pure, undamaged paint of an intensity that he had not seen in any seventeenth-century picture. He was convinced that the flesh tones would be rosy, the doublet gray, the background a delicate shade of gray-green. But what made him most excited was the suspicion that someone, perhaps someone in the Radnor family, had folded under an amount of canvas on the top and right side to fit a neoclassic frame. If the canvas had not been sliced to make the picture fit what we all saw was an early nineteenth-century frame, then the paint might be still preserved. What a prospect! It was the only thing we had found wrong—or, more accurately, puzzling—that Juan was placed directly in the center of a square format. That dead-center placement of the sitter was not the common seventeenth-century mode but was quite common to neoclassic pictures of the early nineteenth century.

The director of the Prado, Xavier de Salas, was well-read in his field and could quote footnotes from arcane texts impressively. He had a dazzling eye, a warm sense of humor, and not an atom of envy in his body. When we asked to have a special look at his immense inventory of Velázquezes, he allowed us to go anywhere we pleased —outside of normal visiting hours—from the storerooms and conservation labs to the public galleries. He also confided to us a state secret. In the twenties and thirties, the chief paintings conservator

of the Prado had cleaned all the Velázquezes and many other trea-
sures with his two thumbs and pieces of stale bread, which he'd
balled up to roll in tiny circles across the surfaces of the canvases,
even the huge ones. The man had not destroyed the Velázquezes,
but he had done the worst possible thing to them: He had slightly
flattened the paint. When we saw the Prado's pictures close at hand,
it was apparent that the condition of the *Juan de Pareja* was superior
to them all.

Xavier de Salas knew exactly why we had descended on the Prado
just a month before the sale. He guided us into a gallery temporarily
closed off so that we would stumble on a large and ugly canvas by
Juan de Pareja himself, one depicting *The Flight into Egypt,* painted
ten years after Velázquez's portrait, in which he had made himself
younger, more svelte, and decidedly less a "Moor." De Salas asked
us if we would be bidding but was too much a gentleman to press us
on how much. Ted was open about our intentions though he did not
reveal what we had learned about the *Juan*'s state of health. De Salas
informed us proudly that the Spanish government, at his request,
had voted a sum of one million dollars for a "symbolic bid." For
Spain, then a relatively poor country that already possessed the
mother lode of Velázquezes, a million dollars was a startling amount
of money. That news alone would be a powerful argument with the
Acquisitions Committee.

We remained in the Prado for a day and a half, seldom coming up
for air, studying the Velázquezes "scientifically," and then we took
off for Rome to see the *Pope Innocent X,* which hung in splendor in
the Doria Pamphily Palace.

The Doria Pamphily Palace and art collection, owned by an an-
cient Italian aristocratic family, still wealthy and influential today—
papabile, "capable of electing popes," as the Romans say—is open
to the general public two days a week from ten until one o'clock. In
order not to be conspicuous, the four of us entered the building
separately within a ten-minute period after the doors had opened.
Hubert and I strolled through the gilded galleries ogling the baroque
treasures. Caravaggio's sweetest work is there, as are vast, moody,
and romantic landscapes by Domenichino and the Frenchman
Claude Lorrain. Among the finest pictures the Carracci clan pro-
duced hang on the damask walls. But the most lustrous jewel is by
Diego Velázquez. The *Innocent* was in the company of illustrious
portraits such as Rembrandt's *Jan Six,* Raphael's *Pope Urban,* and

Albrecht Dürer's gripping Christ-like *Self-Portrait in Munich*—and, we hoped, *Juan de Pareja*.

The papal painting, which is life-sized and full length, depicts the pontiff sitting on a throne used, one suspects, during business hours, not ceremonies. The chair matches his cool eye. The pope appears as if he were granting the onlooker an audience—somewhat grudgingly. The painting is reflected in the mirrored doors of the room in which it is hanging. Walking up the corridor, one can see the pope at a distance and the impression is so lifelike and magnetic that, instinctively, one walks straighter. The illumination of the chamber is subtle. In the half dome of the large niche where the painting hangs is a glass aperture which allows the sky to bathe the picture in a glow. As Hubert and I strolled, oh so casually, into the *Pope*'s lair, I felt my skin tingle.

Hubert and I knew our plan. Everett and Ted were our lookouts. We climbed over the balustrade. Hubert drew out his close-up glass and examined the picture, saying something I couldn't hear. I suddenly heard Everett clear his throat in a signal, and seconds later Ted coughed. I was instantly on the other side of the railing. Hubert followed. Seconds later a guard poked a bored face into the room and then continued on. Soon Everett and Ted joined us in the *Pope*'s chamber, and we laughed quietly at our luck and our prowess.

Dinner was a raucous victory celebration. To Sonnenberg, the *Pope Innocent X* and *Juan de Pareja* were virtually identical in condition and quality—surely Velázquez's two finest surviving works. The puzzle was, Why were these portraits so different from all of his other works? Velázquez is well known for the intensity of his realism, yet compared to even his most naturalistic pictures, these two stood out dramatically. We had no idea. But we were inclined to believe that Velázquez had emphasized "truth" over "art" in both *Juan* and *Innocent* to appear as radically different as he could from his Italian colleagues. Although the canvases he created on his return to the Spanish court display a high degree of realism, he never again attempted anything like the blazing reality of *Juan* or *Innocent*.

For a brief moment I worried that we'd be accused of succumbing to a fluke, something Velázquez had made deliberately bizarre. But we were convinced that Velázquez had been spiritually transformed by his Italian experience and had outperformed even his own genius.

Back in New York on Monday, we met with Dillon. He was amused about our espionage and riveted by our findings. We planned

how we were going to land the masterpiece. Dillon had the last word: "Meet with Goldenberg; tell him we're going to pursue the picture with all our financial powers—we're not going to let this go!"

Goldenberg and Wildenstein confirmed what I expected. "The person or institution who goes over two million guineas, or around five million two hundred thousand dollars, will get it."

Today, five million two hundred thousand, in the aftermath of the go-go eighties art market, sounds flat, no more than someone's opening bid for a mediocre Impressionist. But in 1970 the amount was beyond comprehension. It took us days to get used to the idea. Where, in God's name, would all that money come from? Even borrowing from *both* restricted purchase funds would be insufficient. Now, to find out who would be bidding and for how much were the burning questions. Goldenberg had not come up with that information.

The solution came to me in the middle of the night, and when I described it to Dillon and Rousseau, they were instantly taken. "I'm going to get on the phone and call Sherman Lee in Cleveland, Perry Rathbone in Boston, and Carter Brown in Washington and ask them —in total confidence—if they want to buy Velázquez in partnership with us—fifty-fifty, to be shared, say, in a four-year exchange, in perpetuity."

"What if somebody *agrees!*" Ted asked.

"Better yet! Maybe it's time to throw aside the concept of total ownership of art in museums. For pure publicity, it'd be best if we shared with San Francisco, so I'll call Ian White, too. Sharing will benefit the people and our purse. Each four years there'll be a spate of fresh news stories: 'The masterpiece is coming back.' I'm serious about this. The beauty is, it'll help us no matter what happens. If it works, we'll save money. If it doesn't, we'll know who's in and who's not. And, if it doesn't work, we can leak to the press that we tried to share the masterpiece to cushion the financial blow. We're going to catch hell for buying the most expensive painting in auction history just when the city and state are going to be laying off thousands of workers and the budgets are being slashed."

Dillon endorsed the idea but suggested he ask his friend Paul Mellon, the patron of Washington's National Gallery. Dillon subsequently had a "serious discussion" with the philanthropist who admitted that there was a "certain amount of sense in the idea." Yet, he felt that the time was not right for such an arrangement.

Then he added that the National Gallery was not "especially interested" in the *Juan de Pareja*.

I, too, was surprised by the response to my inquiries. Rathbone told me that his cupboard was bare, though he liked the idea—"Call me on another one, Tom." Ian White, fascinated, discussed the issue with some members of his board. They were not against sharing; it was only that the De Young Museum was "broke." Sherman Lee ruminated and phoned me back to say that it wasn't yet the time for sharing art, especially a "delicate canvas" like *Juan de Pareja*. Besides, he said, Cleveland had decided that since it had acquired a fine earlier Velázquez some years previously, *The Drinker* (which was, in our opinion, merely a workshop effort), his museum was going to bid on its own.

When Dillon and I met two days later, he asked, "Have you discovered the identity of our nemesis?"

"Sure, haven't you?"

I was a bit sharp. I thought he might have figured it out for himself. The serious American competition was obviously the National Gallery in Washington. Dillon was disbelieving. I quoted back to him what Mellon had said—that the Gallery wasn't "especially interested." Any other reason might have been plausible—lack of funds, anything, but not lack of interest. You couldn't be uninterested in the single finest Velázquez ever to come up for sale. They were in, I insisted, and Dillon eventually agreed with me. Cleveland had, frankly, surprised me. Lee, in using the word "delicate" to describe *Juan de Pareja*'s condition, clearly did not know the picture's true shape. He hadn't really looked at it or compared it to other Velázquezes all that carefully, I concluded. Would Lee be a dangerous competitor? Dillon asked. Hell no, I said. "He hasn't studied it."

What about Europe? Dillon asked. Ted had learned that the French were talking about bidding, but he discounted the possibility, dismissing the Louvre as a hopeless bureaucracy and Malraux as "addled." Rousseau and Daniel Wildenstein had gleaned from separate, highly reliable sources that London's National Gallery had set aside one million six hundred thousand guineas, a tremendous sum for them.

We spread rumors around like the disinformation section of the KGB. That the painting was not the original, just one of the five copies. That we were haggling to buy the picture in the Hispanic Society—for around one million dollars. That the city had specifi-

cally forbidden us from making a bid (a rumor that would return to haunt me). That we were trying "desperately" to buy the *Juan* with other museums around the country, which proved we were broke.

On November 10, Dillon convened a special session of the Acquisitions Committee. He called the meeting to order and named me acting secretary. Rousseau briefed the members of the committee on the place of Diego Velázquez in history and emphasized the greatness of the *Juan de Pareja,* and Fahy and Sonnenberg spoke about its provenance, history, and condition.

The committee then exercised its executive-session privilege and excused Ted, Hubert, and Everett. Only I remained representing the professionals. I didn't waste time raving about the picture. I assessed our competition and described my efforts to buy the work with Cleveland, Boston, and San Francisco.

Joan Payson cried out, "Fine! So, we all want it. It's *so* beautiful! But how much is it going to cost? Do we have *any* idea? Auctions are so horrid, you just *never* know."

I reported the latest price estimate Lou Goldenberg had given me —*definitely* over two million guineas, or five and a quarter million or more. Joan Payson and Minnie Fosburgh gasped.

"Douglas, won't this be politically and financially dangerous?" Minnie asked.

"Yes and no," he said. "But it's solely up to you. This committee has the authority—with the approval after the fact by the Executive Committee—to purchase this picture for any sum you wish." He continued soberly, "I have been studying the financial situation carefully, and there is a way—a logical way."

I had never appreciated Dillon's style quite so much. Had he been enthusiastic, had he allowed his voice to rise, had he permitted his face to show any emotion, he might have lost. If anything, he became more pedantic, more studied in his explanation of the financial details, and thus more convincing.

"It is my suggestion," Dillon said, making "suggestion" sound rather more like "command," "that if you are inclined to make a bold try for this masterpiece, the bulk of the funds be taken from the principal of the Isaac D. Fletcher Fund with the understanding that at least two million dollars be paid back—over time—from the income from Rogers, Fletcher, and any other funds restricted to buying art."

The Rogers Fund, he explained, had been given by Jacob S. Rog-

ers, a New Jersey manufacturer of locomotives, and amounted to some ten million. Dillon then launched into a mind-numbing précis about the long-term budgetary effects of juggling funds. If the Rogers Fund were to be used to replenish the Fletcher Fund, it would mean cutting into the annual acquisitions fund exactly $368,576 a year. That would leave only something like $400,000 per annum for all departments to acquire works of art.

"I would also add that any donations to land this picture would be most earnestly hoped for," he said in conclusion.

There was an ominous silence. I glanced at the committee members, and for a second they seemed like one of those old tableaux vivants—maybe Rembrandt's *Anatomy Lesson of Dr. Tulp*. Everyone had inched back slightly from the table and away from the president.

Dillon and I had tried to guess beforehand who would place the first gift on the table. I had picked Andre Meyer, because he was among the most recent arrivals on the board, more than slightly pushy, and always eager to flaunt his financial position. Dillon had thought Wrightsman would plunge in first: "He's the only one on the committee now that Bobbie's gone who adores and understands paintings and is rich enough to do something about it."

It *was* Charlie who spoke first in a near whisper: "If there's anything in history this group must do, it is to buy this Velázquez. I have some highly confidential information." He paused for the desired effect. "When I learned from the director that we were interested in the painting, I called my good friend, Lord Clark of Saltwood . . ."

I groaned inwardly. Clark would be spreading the word all over England about our going for the *Juan de Pareja!*

Charlie ignored the stricken look on my face. "Kay knows this field and he said—confidentially—that this is *the* greatest Velázquez there is. And, more important . . ."—Charlie's voice grew husky— "this will be the last great picture that will be allowed to leave England. I stand firmly behind getting it. I like Doug's financial solution. I pledge two hundred grand of my own funds—to get us excited." He laughed softly as he turned to stare directly at Meyer, who seemed to redden slightly, I thought.

Arthur Houghton took the floor. "I second Charles' sentiments. My only qualm is the fire storm of criticism that is bound to come from the press. We should be prepared for an awful beating. Many

rank and file museum members may resign. Our government 'friends' will be harsh. But to me, the quality and character of this world masterpiece far outshine such difficulties. I suggest, Doug, that you establish an ad hoc committee to consider the public relations aspects if we do win the picture. Anyway, I want to stress that the purchase of *Aristotle* by Rembrandt—in my view a great act on the part of the museum—makes it almost mandatory that we add the *Juan de Pareja* to our collections. To increase that 'excitement,' Charlie, I'll pledge a hundred thousand of my personal funds.''

Andre Meyer circled the air with his hands. ''Nothing is more correct for us than to vote—unanimously—for the acquisition of this treasure. Quality is supreme and *this* is supreme quality. You know my constant refrain—it is always better to have a few great pictures than to throw away our moneys on a host of lesser things. I, too, will pledge . . . ah . . . what Arthur Houghton has graciously pledged.''

Joan Payson added that *she* would give a hundred thousand—''at the minimum.'' (Later she pledged another hundred thousand.)

Then Brooke Astor complained. ''But five million dollars is an incredible, almost unseemly sum. My God! I hate to say this, but, with the turmoil in the city, I wonder if this is the best time. Surely there will be other pictures.''

My heart was racing. Was she going against it? I knew how effective Brooke could be. Her influence in the museum was great because she had promised the Astor Foundation's massive support of the museum's building program.

Brooke stopped herself and smiled. ''I suppose I have painted myself into a corner on this—having so many times in these meetings urged fewer things of better stature. But, I am a poor little girl, so forgive me if I pledge only fifty thousand dollars.''

''I suppose I vote yes, too,'' Minnie Fosburgh said in a weak voice.

And that was it.

Doug Dillon expressed his warm thanks at the ''gratifying spontaneity'' of everyone's generosity. ''Put me down for a hundred thousand. Now, ladies and gentlemen, just *how* deep are we going to dig into the Fletcher Fund? What is your wish?''

Wrightsman sniffed and said, ''Why, we've got to go above the two million guineas. No one's crazy enough to go to that level— except us. I want my two hundred grand to be used specifically in the area over the even bid of two million guineas.''

Brooke Astor asked why wasn't I going to attend the auction and do the bidding. I told her I was too green. Why Wildenstein? I said they were the best.

"What if they cheat?" Joan Payson cried out, hitting the nail on the head, as usual.

"Then, we've had it!" I said nervously.

"Let me suggest a plan of action," Dillon said. "Allow Tom and me to carry out all that's necessary from now on. Tom will communicate what we've done here to Lou Goldenberg, keeping me informed of any last-minute price changes, the appearance of new possible bidders, et cetera. Secrecy is vital. Any broader discussion of this vote with anyone—even trustees—other than the members present will jeopardize our chances of success."

"Is that legal?" Brooke asked.

"Brooke, nothing in our constitution or bylaws requires that a purchase using restricted acquisitions funds be reported to the board prior to its acquisition. It is imperative that if we're successful, no word about our purchase gets out—either to the rest of the board or to anyone—family members included. If we win, there's the probability of a long process to get an export permit. We must also have time—under total secrecy—to prepare our public relations stance."

"And we need silence," I cut in, "to have the time to clean it—if we win. That will have to be done at Wildenstein's. I say we don't 'pay' Wildenstein until just before exhibiting it. That way we don't have to say a word to the full board."

Arthur Houghton raised his hand and, his face expressionless, asked for the floor. "Let's, for God's sake, give our president the power to do what he sees is right to land this treasure. If the president and the director feel at the last moment a bit more money is needed, let us now authorize them to use more money. We are, after all, prepared to go to something like five million and a quarter dollars. It would be a shame to lose it for another half a million—that's less than ten percent. Call it president's discretion."

His motion passed quickly. On the way to the dinner in the Louis XIV room, Houghton held me back in the corridor and muttered, "How cheap Andre Meyer turned out to be! I wonder if Lazard is broke. I'm shocked by his cheapness."

In the days before the auction I was a bundle of nerves and indecision. It seemed that once having made up my mind to go for the painting, my thoughts became more erratic. I badgered Ted con-

stantly to reassure me that *Juan* was a masterwork. A week before the sale I almost made up my mind to call off the deal. Then my resolve stiffened. I awoke with the realization that our strategy of one bid over two million guineas was doomed. Early one morning I telephoned Dillon and asked to see him.

"You know I'm convinced that Carter Brown and Paul Mellon are our competition," I said tensely. "If I'm right, I'll bet you anything that Carter will do what Charlie hinted we ought not do—stop bidding at the even two million guineas mark. Last night, in the middle of the night, I remembered something. When I had been at the museum less than six months, someone told me—I can't remember who—that it was bad luck to stop on an even number in an auction. Here's what we should do—instruct Wildenstein to enter late, at an even number. And, instead of one bid over the two million, let's make our scheme two million guineas plus one additional bid back to us."

Dillon sounded flustered. "You mean if a bidder comes in *after* our bid of two million one hundred thousand guineas, and there's a second bidder at two, two, and another comes in at two, three, we have the option of coming back into the bidding at two million four hundred thousand guineas? Do you realize what this might mean financially?"

"Precisely!"

"That's upwards of five million seven hundred thousand dollars!"

"Yes. That's the only way we'll win it—the only way. I'm positive that Carter's agent will go to two, one and collapse, and *we* will capture *Juan* at two, two."

"All right," Dillon said, almost casually. "You can call Goldenberg but be sure to call him at the very last minute. I will not have leaks."

I phoned Goldenberg on the twenty-fifth of November, two days before the midday sale. He informed me that Alex Wildenstein would be doing the bidding and that Daniel had learned that the National Gallery might be going higher than one million six hundred thousand guineas.

"That doesn't bother me in the least," I said. I told him our plan. It took him a few minutes to get the ploy straight in his mind. I repeated our strategy several times to be certain he understood. It was amusing to hear the normally cool-headed accountant sound so uncertain.

"At last, I understand," he said. "Say, this is an excellent stratagem. And I see *why*. This makes you believe it would be impossible for . . . *us* . . . to . . . ah . . . pull a fast one at the end."

"Of course," I said smoothly, astounded by his incriminating remark.

I took the long Thanksgiving weekend off, and I spent it worrying.

Once I had transmitted the final word on our strategy, Daniel Wildenstein had become commander-in-chief. He decided it was wise not to appear in the sale room himself and assigned his top staff to carry out the work. Max Harrari would watch over the first half of the bidding—up to the level where London's National Gallery would go and, one hoped, falter. Wildenstein wanted his man to be able to elevate the bidding if it stalled. The key to the second half of the game was Daniel's son, Alex. He had been chosen despite his youth because he was accustomed to attending racehorse sales on behalf of the family, where the pace of bidding was even more frenetic.

No art auction had ever been so swift or helter-skelter. Within sixty seconds of the announcement of the lot number for the *Juan de Pareja,* the bids accelerated through the danger zone of one and a half million guineas. Alex called out in a loud, confident voice, "One, six!" stepping right on top of the National Gallery of London's final bid. There was a murmur of astonishment. The auctioneer became flustered and squinted at Alex. He didn't seem to recognize him.

Then the auctioneer started up again, too quickly, Alex thought. It was almost as if the man were frightened. Alex was troubled about why the man was not "fishing," lowering the bid increments and slowing down the pace. For one moment Alex, too, became flustered but quickly regained control of himself.

By one million seven hundred thousand guineas, only Alex and Geoffrey Agnew, the man who had bought Monet's *Terrasse* for us and was probably now working for Carter Brown, remained. Alex kept darting his eyes around the crowded chamber watching for a late contender.

"One, eight!" Alex said.

Agnew hesitated. "One, nine."

"*Two!*" Alex's voice sounded firmer as the bids increased.

There was an even longer pause, and Agnew said, "Two, one."

Before the words were out of his mouth, Alex called out, "Two, two."

A pause. It seemed like a minute; it was seconds.

The auctioneer looked around the room and rapped the ivory hammer to the podium. The audience rose up and cheered. Alex walked to the stage and laughed when he saw that the auctioneer finally recognized him. He realized then that the poor man had been worried that he was a fraud.

The press careened down the narrow aisle and assaulted Alex.

Alex maintained his cool. He told the journalists, "We bought the painting for inventory. My grandfather and father—all of the family —have always considered this picture to be one of the three most desirable in the world. I dare say it's not all *that* expensive—not when you consider what a fine racehorse brings these days."

Because of his easy manner and the reference to horses, the press believed him. We got not one phone call asking if we had been the purchaser.

Across the street in a fashionable restaurant, Daniel knew exactly what had happened when someone rushed in to proclaim that "Wildenstein bought it—for *stock!*"

In the rush of events, no one called me. As it was the Friday after Thanksgiving, there was no one at Wildenstein's in the city. Goldenberg called, talked to my wife, but said nothing. When I called him back at his country home, the phone kept ringing. Finally, I reached Fahy. "I presume we did all right," he said idly, and I had to work hard not to start shrieking at him. "Do you want me to find out?" he then asked amiably. That would be nice, I said in as soft and unconcerned a voice as I could muster. In an hour he phoned to say that we had won.

At the beginning of the New Year the picture was sneaked into the Wildenstein Gallery on 64th Street between Madison and Fifth. Although we had thought of bringing it to our conservation laboratory, we felt that it would be safer if Sonnenberg restored the canvas in an attic room at Wildenstein's. Elaborate precautions were employed to keep our secret. Dillon was determined not to tell the board until shortly before the picture was to be placed on display. No member of the staff was informed with the exception of Stuart Silver who had to start designing where and how to show off our prize.

Sonnenberg worked fast and smoothly. The first hour he had the

canvas off its stretcher and found that sections of the picture had really been folded under. When he did, I got a call from Rousseau to rush to Wildenstein's to view the new expanses of canvas—with most of the original paint preserved, though a bit mashed and crackled. I was overcome by the new scale the painting gained. After all, we had found a mere one hundred and four square inches—one and three-eighths inches on the top and two and a quarter on the right side. But the canvas suddenly possessed a startling sense of freedom and spontaneity.

Once the painting had been unfolded and cleaned and the minor cracks in-painted, the work was that veritable "mirror of truth" described by Palomino. When the painting was set in a Spanish seventeenth-century frame we had bought and hung on the red velvet wall of one of Wildenstein's presentation rooms, Juan de Pareja seemed capable of speaking. Hubert had been right; the most astounding feature of the work was that there was hardly any color in the picture. Grays, creams, and black. That was it. The spare clay of human life.

Dillon and I agonized about how long to keep the picture under wraps. It was the most awkward time to make a splash about lavish expenditures. The city had cut back our expense budget allotment so that we were forced to close down the museum every Monday. We had announced the closing as a benefit to the public, that we needed a full day each week to clean the place. But we hadn't fooled anybody. We talked seriously about keeping the *Juan* under wraps for years. But that was not to be.

Geoffrey Agnew strolled into Wildenstein's gallery in Paris in April and breezily told Daniel that the "purchase is a fraud"—he was certain a museum had bought the portrait, and he was about to find out which one. So Dillon and I decided that we had to reveal what we had done. We chose the twelfth of May, the day after the meeting of the full board of trustees and the day of a regularly scheduled staff meeting.

Dillon wanted to know if there would be any embarrassments—complaints from curators that the purchase funds of the museum had been so stringently restricted. I didn't think so. My concern was from the volatile educators, who had become somewhat radicalized. I told Dillon that Harry Parker and his group would want to be reassured that the priorities of the museum were not changing with such an expenditure.

"One would think that the acquisition of such a world masterpiece is in itself the nucleus of the educational process," Dillon observed.

But when I told Harry Parker, he flew into a rage. "I cannot believe this!" he cried. "You have in one stupid stroke lost millions for this institution! I find this purchase inexplicable and outrageous and indelibly damaging to the museum."

I chewed him out. "People don't give a damn what the Rembrandt cost," I said, "or what the Canova cost, what the Raphael cost, what the Unicorn Tapestries cost—all they care about is that these beautiful, powerful things enhance their lives. They are proud that the museum owns them. Someday you'll learn that, sure, education, outreach programs, liaison with colleges and universities, publishing books and articles is important—but they all pale in comparison to collecting treasures. Collecting is still what it's all about. Collecting is why people come in the doors. The *Juan de Pareja* will be the biggest piece of education material you've got going for you. The point is—and someday you'll experience it yourself—you have to have the guts to reach out and grab for the very best!"

The meeting ended. Harry Parker left, his face black with anger.

The trustees were not in the least angered. Even Roland Redmond went along—at least at first. (Later, he would object to how we paid for the picture and the fact that the board had not been told earlier, calling Dillon's move to use Fletcher principal "illegal.")

Ted and I worked long hours with Stuart Silver to come up with a presentation that would allow the public to see the work properly and still protect it. Joe Noble had devised a clever metal shield which, at the touch of any one of several concealed buttons, rolled down faster than anyone could throw a grenade or a vial of acid at the picture. A guard would be stationed at all times at the side of the painting with his foot almost touching the activator.

I was feverish with concern about what the reaction would be to the extraordinary price. Nancy and I took Harlem businessman Arnold Johnson and his wife, Etienne, to dinner, in part to explain why his election to the board of trustees was taking so long—Johnson had been a pillar of strength during "Harlem on My Mind" and in the recent architectural hearings. I said that it took almost half a year for "your standard blue-blooded WASP to get in to the most exclusive club in America, and *you* are a black Cuban!" He was amused.

The Johnsons brought up the *Juan de Pareja*. "When it sold for so much we talked about it. Such a fine picture of that proud, young

black. It would have been something of pride for the black community—you know, the most expensive painting in history, a black." Casually, I told them we had bought it. "Nothing could be more beneficial to this community," Johnson exulted. "In your press releases, be sure to say right at the top that Juan de Pareja was black. Cover the black magazines and newspapers and radio."

The next day I saw to it that everything he said was put into motion, and we began to feel that maybe we would not get totally hammered.

The day before the big show-and-tell Lou Goldenberg called excitedly. Daniel Wildenstein objected violently to the press release. Wildenstein, perhaps stung that he had not purchased the painting for himself, was accusing Goldenberg of "mismanagement and blunders" in not presenting the Wildenstein's story in the release. I gave in to Daniel's every wish—it would include that Wildenstein had made "no profit" and that Hubert von Sonnenberg had cleaned the painting "in association" with Wildenstein. I even invited the senior art critic of the *New York Times* to Wildenstein's—not the Met—to view it.

As the moment of public exposure came closer, I retreated into a shell, fearful of the dire effects of the blast I was sure would come against the museum and me. I felt that if we received the expected criticism, my museum career would be pretty well at its end.

To our astonishment the press, the art critics, and the public reacted highly favorably. Although *Time* magazine's critic roasted us for "gross inversion of values" in spending such a fortune, John Canaday praised our acquisition in a *Times* editorial. Most people gave little heed to the money involved.

I experienced a spiritual and mental uplift of the kind that I had never felt in my life followed immediately by a sharp feeling of depression. As I noted in my diaries, the *Juan de Pareja* had put me on top of the art world yet was also, in a sense, a harbinger of doom. "I've gotten to the point," I mused to myself, "where I've just about had it—in the museum and in city government circles. I've run pretty fast in these four years and have gotten the place going in a certain direction. Maybe life *is* only a series of valiant attacks followed by discreet pullbacks. I feel I've done my job and it's a question of running out or not running out. Either way I'm satisfied."

Of course, the truth was far more complicated. In the years of intense, exhausting work, I had constructed feelings of ambivalence

towards the Metropolitan. I was satisfied with what I had done, also dissatisfied. I wanted to quit in full glory, but I wanted to hang on for glories and triumphs untold. From the moment of the Velázquez triumph, that ambivalence began to eat away at me.

16

THE
BIG
"KERFUFFLE"

I had raised a rumpus in the press early on by stating that running the Met was no different from running General Motors. I had meant it. If you took the glamour away, the museum was just a business with all its excitement—and drudgery. I had started off my directorship wanting to make the Met into a crusading force, but I was coming around to the opinion that the institution had to be molded into an efficient business enterprise blessed with economic equilibrium.

I was convinced that I had eased the Met into the twentieth century with the establishment of the career and salary plan, the educational and outreach programs, and especially with the building plans. But there was far more to do to make the institution a finely tuned mechanism.

The revenue-producing opportunities were paying off handsomely by the end of my fourth year. Under the guidance of Brad Kelleher a new postcard shop had been constructed in the broad alley adja-

cent to the Grand Staircase. The earnings in the first months of operation outperformed our most ambitious projections. Franchising of sheets and other soft-goods items was gaining hearty revenues. I had even initiated reproductions of choice clothing from the Costume Institute—attractive dusters of the early twentieth century or evening dresses from the twenties—and printed a mail-order catalogue with lovely Marisa Berenson modelling the outfits. The initial orders were brisk, as were those of the burgeoning mail-order business in general. For the first time in years our budgets began to look favorable.

To me, a vital part of transforming the Met into a business was to make changes in the makeup of the board of trustees. After a quiet struggle I was able to accelerate the election to the board of the borough trustees I had suggested in the City Council hearing. Some of the interviews were madcap. At one plush luncheon in the director's dining room, trustee Dick Perkins asked Arnold Johnson, the proposed representative from Harlem, how he would solve the poverty and violence in the black districts of Brooklyn and Queens. Arnold, a Harlem businessman, sat stiffly and tried to explain that just because he was black didn't give him insights into every black weakness. Hell, he said, I'm not poor or violent. That observation probably elected him.

The proposed trustee from Staten Island, Muriel Silberstein, an art educator, dazzled Dillon and Dick Dilworth, and her performance made it easier for the rest of the borough trustees to enter the privileged fold. Swiftly, the board elected Sol Shaviro from the Bronx, Henry Saltzman from Brooklyn, and the former borough president of Queens, Judge Frank O'Connor, as the people's representatives. When they showed up at their first meeting and asked penetrating questions about the true goals of the institution and how the trustees supervised the running of the place, it became evident that we had gathered up the right crowd.

Joan Payson embraced the new board members, making a point of sitting near them and urging them to ask "dumb questions." It was typical for her. After Dillon and Houghton and Gilpatric, she was perhaps the finest trustee the Met ever had. The tiring old guard slowly passed into oblivion. A new structure was instituted so that the older members could not hang in for virtually unlimited terms.

Not that the troublemakers entirely disappeared. Roland Redmond, Francis Plimpton, and Mac Aldrich continued to chip away at the museum and at Dillon. Redmond dispatched one of his classic

diatribes against Dillon and Dilworth, claiming they had acted "illegally" in the funding of *Juan de Pareja*. Dilworth lost his temper, most unusually, and told Dillon that he thought Redmond was "crazy" and that unless the ex-president was put on "emeritus status" he would resign. "He's evil," Dilworth said. Redmond insisted that his motion to put a halt to future use of the principal of any Rogers funds for acquisitions be voted on by the full board. The measure was roundly defeated, and the only members in favor were Plimpton, Aldrich, Mary Whitehouse, and Redmond. We expected never to hear from them again. We were mistaken.

In a business nothing, clearly, is more important than a young, vigorous staff, and as luck would have it, a number of curators retired. I got rid of the deadwood in the Oriental Department and hired a vain and brilliant professor at Princeton University, Wen Fong. He had his supporters, one of whom was Dick Dilworth, and his severe detractors, most of whom were other Orientalists who did not favor his so-called wheeler-dealer image, his arrogance, and his technique of connoisseurship, which applied Western criteria to Chinese paintings; but that's precisely why I wanted him.

Initially, I suggested he dump Princeton and become the full-time chairman of the Oriental Department with power to restructure the staff and embark upon a crash program to attract donors and land great works of art. The wily scholar told me that he had made the "solemn pledge" to Princeton's president to create the finest Oriental center in American universities. With that I suddenly knew what he was angling for—he wanted to be the Oriental Man of the Nation. I offered him a dual role, keeping his Princeton post and becoming the consultative chairman of Oriental art. He seized the opportunity.

Within three weeks Wen Fong began to attract donors and treated the trustees as if they were assistants in his department. He subtly encouraged Douglas Dillon to collect in the field and scouted the world for acquisitions, not merely individual pieces, entire collections.

His derring-do with trustees was amazing. I had a hilarious lunch with Brooke Astor and Wen. Brooke began waving gaily to friends at nearby tables, until Wen admonished, "Brooke, it's time for business. Why don't you drop all those extraneous social projects your foundation is funding and throw all your money at the Met?" She gave a peal of laughter. With that, Brooke Astor's far-reaching financial support of the Oriental Department was born.

When some staff members departed for other posts, I actually felt

proud. What else was the museum for than the training ground for directors for the whole country? When Harry Parker left to run Dallas, I was elated for him. When Florens Deuchler told me he had to return to Switzerland to the life of a professor, I congratulated him. But I was even more pleased when I found talent inside the Met whom I could elevate, like Berry Tracy in the American Wing and Jock Howat for the department of American Paintings, Sculpture, and Watercolors. On the resignation of the registrar I appointed my former assistant and archivist John Buchanan to the post. Few people on the staff were as bright and quick.

When Jack Phillips, the rumpled chairman of the department of Western European Arts, retired, I was in Europe with Olga Raggio on a buying trip. I told her gravely that we were about to start a worldwide search for Phillips' replacement. Her face froze. I quickly added that the search had just ended and she was it. She became the first woman chairperson in the history of the Met. Within a couple of months she had pointed out a number of spectacular purchases and had given me a sensitive paper, outlining what should be done to still the burgeoning staff complaints in her department. Her recommendations on how to appease the dissidents had merit. Except in one case. This was a curator named Jessie McNab Dennis, who had vowed to create a curators' union. Jessie's tactics could try one's soul. At one Acquisitions Committee meeting we had just sat down for dinner after the curators had made their presentations, when half a dozen men and women burst through the *boiserie* doors of the de Tesse room chanting slogans: "Trustee power to the people!" "The Elite must go!" "We want *elected* trustees!" and "Trustees are pigs!"

The leader opened a jelly jar over the table and scattered a herd of cockroaches onto the surface.

Charlie Wrightsman plucked a solid crystal ashtray from the table —it must have weighed half a pound and had sharp corners—and wrapped it in a napkin, ready to split open the head of any protester who dared shout at him. I clamped my hand firmly over his.

The guards swooped in and the radicals were ejected. Charlie was furious. "I'd have been perfectly within my rights to crown one of those bastards!" The invasion accomplished its mission. The next day the newspapers reported on the affair.

I decided not to initiate an investigation. That would have played into the protesters' hands. Though privately I called Jessie the Joan

of Arc of the Met and was continually irked by her, I came to bless the day she had taken on the task of labor organizing. Our labor lawyer, Carl Schwartz, agreed. "Without Jessie, the union might win. If you didn't have her, you'd have to invent her."

And in one respect Dennis was right. There was labor discontent in some areas of the museum. My personnel director, John Conger, outlined an alarming picture of employee problems. It was not that a majority of curatorial employees were dissatisfied, just that the right number of dedicated "union lovers" had gathered together and might have the strength to force a union on a majority. He urged me to make reforms with the help of Schwartz, and we did, from electing representatives to attend trustees meetings, to sessions in which Dillon, myself, and the top staff would explain our decision making. The reforms gave birth to an entity called the Staff Federation. The federation compelled sweeping changes in the powers of the staff in art museums across the country and became the standard by which the profession now conducts its affairs and works with trustees.

The federation was, of course, a house union, but it had the advantage of giving the curators a greater degree of representation and independence than any governmentally sanctioned entity. The powerful chieftain of the city's municipal workers' union, Victor Gotbaum, objected to the Staff Federation and sought a secret election whereby I would permit him, without balloting, to form a curators' bargaining unit. I was in a quandary. But Schwartz took a daring risk. For the first time, or so he surmised, he had management petition the National Labor Relations Board for a union election. The votes came in seventy percent against a union, and Gottbaum told me that the Met would never have a curators' bargaining unit of any kind.

The union affair was not bloodless. I had beseeched the trustees to allow me to lay off about ten percent of the staff in order to make our financial footings stronger, and I did so before the NLRB "umbrella" came into play, moments before the election. I fired sixty-three staff members, a few of whom were union sympathizers. The NLRB sued, but Schwartz was relaxed about the action, saying, "Don't worry, in a year it'll end up with having to take back two or three—a gesture." He was right. Our union moves turned out to be excellent business.

It was also good business, I figured, to weed out the management staff as well. The first one on my list was second-in-command Joseph

Noble. He was convinced that he had an excellent chance of suc-
ceeding me.

He had always believed that I wouldn't last much longer: I might
be ousted or go off to re-enter politics. We tolerated each other wari-
ly. When did I begin to sense that Noble and Arthur Houghton were
conspiring? I sensed it in small things. They always had their heads
together in the moments before and after board meetings. When I
ambled over, they would dart away from each other. I decided to
test out my suspicion by telling Noble some highly confidential and
phony stories and then watch Arthur Houghton. Within a week or
two I recognized that Houghton had to have been told. I asked for a
meeting with Houghton at Steuben and without preamble accused
him and Noble of "going behind my back." Houghton gazed at me
dolefully for a long time, sucking heavily on his cigarette, and finally
gave a shrug and said, "Yes, I did. I was wrong. I'm to blame. I
suppose Joe has to go."

I nodded.

Joseph Noble left and was soon elected the director of the Mu-
seum of the City of New York. He turned into a dynamo, shook up
the staff, obtained new trustees, initiated some effective fund-raising
campaigns, and demonstrated a creativity in areas where he had
been less than supportive at the Met.

The second ax to fall on a high level was on George Trescher.
George had seemed lost when the Centennial festivities came to a
close. Elevated to the new post of vice-director for public affairs—a
large suzerainty—George was still frustrated. Never a team player,
George found it hard to fit in with the overall administration.

He acquired the habit of making end runs around me, on projects
he suspected I might question. He would keep quiet about what he
was doing until it was virtually too late for me to change anything.
When I asked him to give me a memo on what we could do in the
area of fund-raising and development, he told me he wasn't sure he
was interested in development. He got into a petty feud with Dan
Herrick, the financial officer, about office space and seized a part of
Herrick's area. When I was thinking of starting a summer restaurant
at The Cloisters, I was surprised and irked to find that an acquain-
tance of George's might bid on the franchise.

The last straw was a fracas that almost had Charlie Wrightsman
pull out of the museum. George had told me that Charlie wanted to
honor the American premiere of two films on Impressionism made

by Kenneth Clark. George suggested a Tuesday, when the museum was open to the public, so Charlie could save some money on guards. The plan was to have a gala dinner for around fifty of Charlie and Jayne's intimate friends at seven o'clock in the Medieval Hall and then premiere the films in the Grace Rainey Rogers Auditorium at nine o'clock. I told George Tuesday was out: I didn't like the idea of a private dinner party going on behind screens while the public was in the museum. I could see another cockroach protest, this time far bigger.

To my astonishment, when I returned from a trip to the Soviet Union, I learned that the dinner party was all set for Tuesday at seven. George had dashed off a letter to Wrightsman saying that I enthusiastically endorsed the party. Trescher was away, so I ordered one of his aides to let Charlie know at once that the dinner had to be given on another night. Wrightsman soon called me, livid, threatening that he would remove all the works of art he had on loan and would sever all relationships with the museum. The collection was worth around fifty million dollars, and more importantly every piece had been acquired with a thought to filling our gaps.

I informed Wrightsman that I could not allow a private takeover of the public museum. As he yelled at me, I thought of an obvious solution. Why not show the films at seven o'clock—and hold the dinner later on after the public had left the museum, at nine? Jayne Wrightsman, listening in on the other phone, cut in to suggest that the guests would prefer to dine fashionably late. And so Charlie calmed down and said that his objects on loan would stay—"for now."

By luck, just as I had made up my mind to let George Trescher go, the perfect replacement walked into my office: It was Edward Warburg, wealthy scion of a distinguished family, a superbly educated, urbane, witty man, and a social thoroughbred. He had been one of the founders of the Museum of Modern Art and had been active in a host of worthy causes ranging from the United Jewish Appeal to the City Ballet. I rather astonished him by suggesting that he become the vice-director for public affairs.

I spoke to Dillon, Dilworth, and Houghton—Trescher's main protector in the museum—about my decision to oust George. They had misgivings, especially Houghton, who said, "George's talented. He's dangerous, too. You'll be working with him in the future sometime, so whatever you do, make the exit happy—public relations-

wise.'' When I mentioned the name Eddie Warburg, they were delighted. Dilworth remarked, ''Eddie may be worth as much as fifty million dollars in fund-raising from the Jewish community and the Warburg Foundation.''

I patiently outlined my gripes to Trescher. I reminded him of his words when I had offered him the post of vice-director, that he would accept the job but wanted the time to assess if it would work for him. I said I guessed that allowed me to assess him and, as gently as I could, told him that I no longer needed him. He was dumbstruck and said, ''Are you really telling me I'm fired?''

''You bet,'' I said.

Another serious management problem was my closest friend Ted Rousseau. The curators were furious at his organizational gaffes. He seemed to be oblivious to dampening the familial feuds that sputtered like Chinese firecrackers throughout the museum.

I was in a quandary. Any other employee I would have dismissed. But there were the complications, subtleties, and the contradictions of cronyism. There was our deep friendship, the gulf in our ages, and the perceptible slackening of his vitality. There was also my need for a strong chief curator, his never-ending playboy high jinks, his ability to flatter and cajole potential donors, his allies on the board, my almost desperate need for an understanding companion.

But then the Nathan Cummings affair exploded, and I came close to firing my dearest friend. Nate was affectionately called Mr. Diamond-in-the-Rough by his friends and a ''vulgar bastard'' by those who had been bested or shafted by him in business. Cummings was, with Norton Simon, the symbol of the seventies tycoon—a brash, social-climbing character, blessed with the Midas touch. His companies included General Foods and General Dynamics. He collected art, of course. In the sixties and seventies it was de rigueur. He also had a beautiful younger wife, Joanne.

Cummings yearned to have his collection shown at the Metropolitan. When he approached me, I told him bluntly that he had some fine Impressionist paintings, but not enough for a show at the Met. I told him that Ted and I would choose a dozen pieces and that those pictures would be most prominently displayed in the galleries of the upcoming Summer Loan show and singled out for praise in the catalogue.

Nate nodded his head at me and said in his machine-gun way of talking, "Sure, sure, yeah. I want a reception, of course, you know, a few of our absolutely closest friends."

I told him I'd think about the reception and threw the ball into Rousseau's court. Two weeks before the opening of the Summer Loan Show I received an invitation to attend an opening night party for the Nathan Cummings show at the Met.

I was livid. I had specifically told Rousseau before he left for vacation to tell Nat I did not want a splash. I phoned Cummings to tell him he could not have the party. He asked coyly, "How are we going to stop all the reporters from writing about it?" I advised him to contact his friends and the gossip columnists and say that he had called the bash off in deference to the economic climate. He said he'd try, but I expected further flak about the party.

A week before the opening Nate's curator complained about the presence of the works from other lenders, claiming to Rousseau's assistant that they had not been told about this. Nate roared that he was going to pull his paintings and dispatch "nine hundred telegrams to the people I have invited" not to come to the show—or the Metropolitan—again.

"Tom, my friend, what's gone wrong? Usually the museum's run so well. But we appear to have a terrible breakdown in communications. I swear I was never told about these other collectors. Ted never said a word. I paid for this show. How would you like it if you paid for a show and suddenly found out that a whole bunch of other collectors were going to come in for a free ride? I swear I heard nothing."

I reminded him that I had told him, but he claimed Ted had "changed all that." He had me there. I called Doug Dillon and briefed him about the disaster, and he ordered, "Work out some sort of compromise with the other collectors. I don't much like Nate's bullying, but the word of the museum is at stake."

I tried to reach Rousseau, but he was incommunicado, and ordered a flustered Ashton Hawkins and Rousseau's assistant, Michael Botwinick, to call the other collectors and get them to delay their participation. The solution to the mess was easier than we thought. Lender Henry Pearlman's beautiful paintings were not scheduled to arrive until a week after the proposed opening anyway, and the other lenders told us they understood about Cummings' prima donna behavior. I was on the phone a dozen times with Nate in the final days,

inching an agreement along. In the end he agreed to a complex series of openings in which he would be alone the first week and then share the second week *only* with John Powers, followed by the rest—Pearlman, Hillman, Bernard, and Levitt.

Dillon gloomily predicted that we would probably lose the support of Cummings and all the others as well. At last Rousseau sent a memo to Botwinick, accusing him of selling out to me and Dillon. Rousseau was adamant that he had told Cummings the precise arrangement of the show several times and that Nate was a "bastard and a cheapskate who will do nothing for the museum." He would not talk to the other collectors about bowing to Cummings' wishes but would urge them to pull out of the show if Cummings were granted "his special week."

I went wild at Rousseau's insubordination and instructed Ashton Hawkins to tell Ted that if he wanted to resign, then Dillon and I were ready to accept. And if he refused, Dillon and I would urge his early retirement. Rousseau, the canny diplomat, once again became unreachable.

One of the conditions I had imposed on Cummings was that all news announcements about his show would be issued through the museum. The day of the reception I was surprised by calls from a number of newspapers asking me to comment on the stupendous discovery of a Georges Rouault painting on the back of another owned by Nate Cummings in his "great Metropolitan exhibition" and was it true that the new Rouault was worth half a million dollars?

I called Nate and told him that I considered him a duplicitous son of a bitch and that I believed Ted Rousseau. I accused him of using the museum to increase the value of his "lousy" collection and condemned his Rouault ploy. I never heard from him again. The museum received none of his paintings, nor Henry Pearlman's either.

The only thing good about the disgraceful affair was that Ted and I became warm friends again. I told him to stay away from administrative activities and to stick to questions of art and exhibitions. He soon gave proof that he had not lost his touch. His newest mistress —one of three current favorites—had confided that the chairman of the Lehman Foundation, the octogenarian Ed Weisl, Sr., was in love with her and had suggested that I appoint her to the Met board. In exchange Weisl claimed he would guarantee that while he lived, he would steer the entire Lehman income to the museum, over a million

dollars instead of the three hundred and fifty thousand we were already receiving. I was tempted. I saw the advantage of having a board member under my chief curator's thumb, and I needed every penny I could raise. But, in time, thinking of the disadvantages, I turned the idea down. Soon Weisl passed away. And he struck back from the grave. Owing to his Democratic Party links, his son Ed Weisl, Jr., became Abe Beame's Parks commissioner, and, of course, trustee and landlord of the Met. One of his first announcements was that he was unhappy with my performance at the museum. He did not turn out to be dangerous.

Rousseau kept on arranging trips to Europe for the two of us and rounding up collectors and collections. One was Colonel Michael Paul. Louis Goldenberg of Wildenstein called Ted to say that Paul was eager to make another gift of sculpture from Wildenstein's, this time a fruity *Nymph* drying her hair on a large basin, a work of the late eighteenth century by the Frenchman Louis-Claude Vassé, hardly a household word and unknown to me. There was a slight catch. Paul, who had given the Met almost a dozen sculptures in the past five or six years, was insisting the museum share the costs. The price was a million dollars. Paul wanted the museum to commit to a quarter. He also wanted me to write to his foundation board members that the value of the pieces given over the years had more than doubled.

I was in a fix. The pieces weren't worth the ten million Paul's foundations had paid, much less twice that. We had always suspected that Paul somehow augmented his income with an arrangement with Wildenstein, one, of course, of a legitimate nature. There was nothing wrong in the Colonel receiving a finder's fee from the gallery. Still I had a sour taste in my mouth. Ted and Dillon both felt, what the hell, didn't we want Paul to put up the four and a half million dollars it would take to build a gallery Ted called the Paul Mall? So, don't irk the man—especially at his advanced age.

I drafted an oily letter praising the gifts and stating that the collection was easily worth twenty-two million dollars—perhaps more, since the whole was so much more valuable than the sum of its parts. I assured Paul separately that Dillon would urge the Acquisitions Committee to share in the great Vassé *Nymph*. Kevin Roche rushed to complete drawings and models for the "Paul Mall."

The Colonel was euphoric at the models of the garden court, so I smoothly told him that I wanted his foundation to pay for the garden

—only something like four million dollars and the payments could be given over time, after his death. I pointed out that four million was less than twenty percent of the twenty-two million the Paul collection was worth. He took the hint. He asked, "Would you be able to emboss—in large gold letters—on the cover the words 'The Josephine Bay Paul Memorial Gardens'?"

Of course!

Over the next few years we received a few more interesting sculptures from Colonel Michael Paul, including a fine marble by Jean-Antoine Houdon. On his death we were informed by his puzzled foundation officials that no one had ever heard of his instructions for three or four million dollars to fund a memorial garden.

One morning Rousseau told me exultantly that we had to go to Moscow one more time. Our earlier trips to coddle the officials in the Ministry of Culture had paid off. There was a thaw in the air between the United States and the Soviet Union triggered by Richard Nixon's initiatives in China. We were informed by a member of the Soviet consulate in New York that we ought to go at once to Moscow to press our case. I wanted Karl Katz, director of special exhibitions, to join us. Soon after the public hearing he had been hired.

Katz was shivering with anxiety as the hours before his flight with me to Moscow ticked down without the arrival of his visa. "They hate Jews in Russia," he muttered darkly. "You go and I'll wait here."

I told him I'd go with him or not at all and pooh-poohed his fears. He was not a target of discrimination, I lied; the Soviets were hopelessly inefficient. At the last moment the visa arrived—the Soviets said it had been sent to the wrong place. I didn't believe the explanation for a moment and took care to keep a special watch out for Karl.

The only way to visit the Soviet Union was with a smile pasted on your face and a relaxed attitude. Nothing worked. The bureaucracy was surreal. The first words out of anybody's mouth were either "no" or "not possible." You had to ease in, stay loose, keep your sense of humor, and only when absolutely necessary lose your temper. When you chose to do so—and the tantrum should always be contrived—then the explosion had to be volcanic. It was important never to be worn down by the constant barrage of petty slights and mess-ups.

The way you were treated upon arrival at Sheremetyev Airport in Moscow was like a refugee or a criminal. As you left the plane and climbed into the dilapidated bus spewing out raw diesel smoke into your lungs, you became fearful that you'd lost one of your documents—the visa, health certificate, passport, or currency declaration —and would be sent God knows where.

As we bumped along in the bus on the way to the terminal, I joked to Katz that one of three things would happen when we got inside— our luggage would be lost, our documents would not be in order so that we'd have to return to London without the luggage, or we'd be allowed in but Intourist would have lost our rooms and we'd have to sleep on the cold marble floor of the horrid Rossia Hotel.

The Intourist chap had a clipboard with a sheaf of papers tallying up the tourists coming that day with the names of the hotels. Although you could *suggest* the one you wanted, they assigned you one. I always preferred the National, the faded art nouveau pile on Manezh Square across from Lenin's tomb, which had a *gemütlich* hard-currency dining room and a congenial bar and rooms with huge ceilings and outrageous faux-Victorian furniture. The Intourist chap searched for our names. We were not on the list.

We sat around for two hours when I told the clerk I suddenly remembered I had gotten a Telex assuring me that we *did* have accommodations in the National. I was banking on the fact that Ted Rousseau had already arrived and had talked his way in. Luckily, he had and his room was huge with a sitting room spacious enough for two cots. I got our luggage out of the waiting limo—we were travelling deluxe of course—and told the lady in charge of rooms that we'd bunk in with our companion. *"No!"* she screamed. "Not possible!" The room was not luxurious enough, and we had paid in advance for luxury accommodations.

It was time for a tantrum. I shouted and shoved a bunch of documents in the woman's face. We were official guests of the Ministry of Culture. We had an appointment to meet Khrushchev, I shouted. We would complain to the Politburo. Alternatingly, Ted played Mr. Nice Guy, plying her with compliments. When he pulled out a Chanel lipstick—Ted's Russian gifts ran to cosmetics while mine ran to things like windshield wipers—she began to melt. She said she'd accompany us to Ted's room to see if it were "luxurious" enough. Out of the car came the bags, up again five flights. Madame "Rooms" gave in, by this time reduced to giggles from Ted's honeyed compliments. •

In a week we conducted a flurry of meetings with ministry func-
tionaries—Baturov, Maturin, Masurov, and Butrova—and the in-
domitable Furtseva. Ted and I were astonished at how smoothly the
discussions went. It was obvious that the Politburo itself had blessed
the exchange. I had experienced a stroke of luck just before depart-
ing. Governor Rockefeller had invited me to fly up in his plane to
Rochester and hear an address by Nixon on revenue sharing which,
in fact, turned into a discussion of foreign policy including his opti-
mistic prognostication on relations with the Soviet Union. I had
talked briefly with the president after the speech and told him about
my forthcoming visit. His comment was, "A loan exchange might be
more important than any one of us thinks now." He urged me to
brief the head of the Council for the Arts, Nancy Hanks, on my
return. With my Soviet colleagues I, of course, harped continually
on my conversation with Nixon. That struck home. Over the days I
evoked Nixon's name whenever the negotiations slowed down.

They seldom did. In fact we had to endure only two three-hour-
long meetings to arrive at a concordat—in principle. My dream was
an exchange of some of our best European old masters for the gold
and artifacts of the Scythian tribes from the Hermitage. My Russian
colleagues wanted the complete Metropolitan—a variety show from
every department—in exchange for a selection of some 250 items
from all sections of the Hermitage. Ted Rousseau soon figured
out why. He had happened to see on a pile of books on a desk
in the ministry a catalogue of an exhibition sent by the Russians to
Czechoslovakia which contained precisely 250 pieces, the very
ones Baturov or Maturin or Butrova was describing.

"Say yes," Rousseau advised. "Take anything, I am positive we
can turn it around in the next stage."

In time we did and wrote out a letter of intent spelling out details
of transportation—mostly by air—insurance, conservation exami-
nations, guardianship, temperature and humidity readings of each
one of our galleries, and descriptions of our catalogues. (We had
brought "The Year 1200" and "19th-Century America" and they
were impressed.) Karl Katz suggested a grand television film made
by one of our networks.

"I agree!" said an ebullient Maturin, who expected to star in the
production.

Several years later—on the fourth of July—all Ted's labors came
to fruition. I went to Moscow to iron out the final details of the first

exchange of works of art between the United States and the USSR, officially sanctioned by Nixon and Brezhnev, and signalling détente. Henry Kissinger had become excited about our loan negotiations, remarking that if the two nations put culture on the agenda with the rest of the touchy items, when talks failed on the truly difficult issues, both sides could at least say to the world that they could agree on one vital subject.

Ted Rousseau became something of a dynamo after his chastisement and pressured me to go to East Germany to see the treasures of East Berlin and Dresden and begin to warm up the East German cultural officials for the prospect of stunning loans exhibitions. In December 1973 off we went to Munich and East Germany.

We hired a pair of Mercedes town cars with chauffeurs for the trip to Dresden. Despite the magnificent collections of the paintings galleries, the treasures of the Green Vaults and the restored architecture of the rococo Zwinger, I hated the city. It had the smell of death still hanging over it.

On the long drive from Dresden to West Berlin, I folded myself tightly into the front seat and dictated moody reminiscences of the trip and gloomy observations about my future. I mumbled on about the burdens of being director and about my "loss of creativity." My final words were about having "done the job at the Met and it's time to move on maybe to politics—and I await the call—or in something I have no idea what, which would be marvelous, the mystery and fear of the unknown."

The chance came from a most unexpected area—Philadelphia—where I was asked to become the chief executive officer of the 1976 World's Fair. I was assured I could form the themes, hire the architects, and run the extravaganza. I was flattered and intrigued and had many a chat with Robert Moses to learn his financial arrangement with the New York fair. The job offer floundered, partly because the Nixon administration was cool to the idea of a centralized bicentennial celebration where the "hippies" and anti-Vietnam War protesters could congregate. I also began to think that the Philadelphia fair would never become a truly grand event. I turned the job down but, like a good businessman, made sure that the Met, in order to keep me, was forced to negotiate my first contract. It was to be for three years, seventy-five thousand dollars a year, a raise of twenty-five thousand, plus a guaranteed rise to one hundred thousand plus a generous expense account. I was pleased with the new

arrangement, and for the first time in its history a director was not serving at the pleasure of the board, but like an executive in any American company. Newly armed and protected, I embarked upon what I had felt for several years was the next logical task for the Met to do—weed out the bulging collections, sell unneeded works of art, and use the money to acquire better, far more needed works of art.

It was called deaccessioning, standard museum jargon meaning the removal of a work of art from the general catalogue. Getting rid of excess works by public or private sales or exchanges wasn't a fresh idea. In 1885, five thousand "duplicates" from the heaping, mixed bag of Cypriot antiquities that the Met's first director, Luigi Palma di Cesnola, brought with him were dumped on California's famed Leland Stanford for the spectacular price of ninety-two hundred dollars. Another couple of hundred Cypriot seconds were sold to Princeton University. The moneys earned went for the acquisition of some Egyptian materials, which, in turn, had been deaccessioned from a museum in Egypt. From 1885 to 1970 roughly thirty thousand works of art had been disposed of. The political fallout was minimal, except for one isolated instance, a fire sale in 1929 of fifty years of accumulated junk.

The president at the time was the patrician Robert W. deForest, who was denounced by the New York press for getting rid of one hundred and fifty-nine paintings and six hundred and seventy-five objects. DeForest tried to explain that the Met had been lending for years to other museums and educational institutions but that the volume of stuff had piled up "too much to deal with in such a friendly manner." When it was suggested the museum might give the objects away, deForest testily pointed out that the museum was legally forbidden to do so. Besides, he said, "we need the money to buy things we don't have."

Editorials picked away at deForest about the "sorry" manner in which the Met had dealt with its surpluses. When someone suggested that all surplus material be burned, deForest retorted, "Instead of burning them, why not store them in a non-fireproof building, insure them at full value and leave the rest to Providence?"

I was amused by deForest's ripostes and laughingly told Hawkins and Rousseau that I'd model our forthcoming responses to the press "after crusty old Bob deForest."

"There won't be much flak this time," Hawkins told me. "These are modern times. Everybody disposes. How would MOMA collect if it didn't exchange?"

Nonetheless, I expected a few brickbats, especially from the *Times*, which seemed to have it in for me. My goal was far more ambitious than deForest's. I wanted to raise a twenty-million-dollar war chest. Over the years we had been dipping into the Fletcher and Rogers funds to pay for restorations, frames, publications, and sometimes even expenses for the curators to travel to and from Europe to look at possible purchases. Strictly speaking, the funds were intended to be used *only* for acquisitions, not the extras. Rousseau counselled me it wouldn't be difficult to winnow out twenty million dollars of excess works of art. After all, the Met had three million pieces.

In a couple of weeks Ted was back with the guidelines. The curators were to call the shots. There would be a rigid system of checks and double checks to define which works really contributed to the collections and which were superfluous. I urged the curators to look on the proposed sales as a once-only opportunity. In rare cases valuable works could be considered for disposal *if* clearly superior works—even just one work—by the artist, school, or workshop already existed in the collection or was soon to be added.

Rousseau had singled out one mother lode of paintings that could easily be exchanged or sold—the 1967 bequest of Adelaide Milton de Groot. The quality of the pictures ranged from a small number of world-class masterworks to sundry mediocrities by big names. When I saw the actual wording of the de Groot will, I had to admire the solution arrived at by her lawyers who had clearly been between a rock and a hard place trying to please her and the Met at the same time. She "requested" that the museum not sell anything but give the unwanted works to local museums. The determining factor was a phrase in her will, "without limiting in any way the absolute nature of this bequest," which meant legally that despite her request, we could do anything we liked with her pictures. Nothing would force us to give them away. Our outside counsel, Lord, Day & Lord, confirmed Hawkins' opinion.

I was delighted and quipped that we'd go ahead just the way Bob deForest had—by not sticking any museum with de Groot castoffs. My chief worry was that few art dealers or bidders at auction would be all that entranced by the de Groot sludge and that the return would be low. I recommended to Rousseau and Dillon that we'd do better if we exchanged her things with dealers who always can use some big-name, albeit lesser inventory.

After lengthy discussions with Rousseau and our lawyers, we

spelled out for ourselves the specific steps in the disposal process, steps that were more strict than those recommended by the American Association of Museums. I insisted upon two appraisals, one by a dealer and another by one of the auction houses. The checks and balances were tough, and there would be one full set for deaccessioning and another for actual disposal. I wanted time for all parties who had a vital role—curators, the administration, and the three committees of the board of trustees—to slow down the process, stop it, have another look, and change any decision.

The procedures were ponderous. The curator showed the piece to me and Ted. We would discuss it. The lawyers would search for legal restrictions. The piece would then be presented at a meeting of all curators for approval. If Rousseau and I concurred, the curator would then present the piece to the Acquisitions Committee. After that the trustees heard Ted's or my recommendation. The committee then voted on whether or not to remove the object from the museum's general catalogue. This was followed by a cooling-off period. If the appraised value was under twenty-five thousand, the Acquisitions Committee vote to get rid of the piece would be final. If more, the piece would have to be taken to the next meeting of either the Executive Committee or the full board, whichever came first.

After all that bureaucratic movement, there was a second cooling-off period. Then further steps were taken to decide how to dispose of the object.

Dillon examined the complicated structure, showed it to our lawyers at Lord, Day & Lord, and told me, "This is iron-bound. I can't imagine anyone not approving this. It will become the professional standard."

Rousseau and I met with each curator to find out what there was to get rid of. We didn't waste much time on those departments where what we could dispose of wouldn't bring much on the market. European Paintings was clearly where the surpluses were—and where the money would come from.

Our first plan of action came from Sir John Pope-Hennessy, the director of the Victoria and Albert Museum. I had stopped in to see him on my way to the Soviet Union, and I brought up the touchy subject of deaccessioning.

"*We* should do it here, too!" he cried. "The place is so cluttered! I should take the lesser things and call Sotheby's to come right in to our front gallery and conduct a fire sale. There'd be so much squeaking and yelling that I can't even suggest it. But, what a concept! A

fire sale would benefit the art market and would put decent pieces back into the private collecting arena, and the pieces could be retained in private collections or go on to other museums as gifts."

That gave me the idea to have our own fire sale in the medieval sculpture court. I met with Peter Wilson, the manipulative genius who had raised Sotheby's to the pinnacle of the art auction business. I admired his business acumen and sense of showmanship. Wilson had an inexhaustible anthology of tales about the art market and its odd denizens. He was somewhat indiscreet, telling how the feverishly eager industrialist-collector Norton Simon had kept bidding against *himself* in his determination to buy Rembrandt's portrait of his son, "Titus" (which later was exposed as a twentieth-century fake). Wilson had, several times, called out to Simon, "The bid to you, Sir, is *you!*" but Simon had ignored him, leading Wilson to believe that Simon had *wanted* to bid against himself so that his Rembrandt would surpass what the Metropolitan had paid for the *Aristotle,* at $2.3 million. Simon failed, since the "Titus" fetched only $2.25 million. Wilson would describe the art auction business as "launching an enchanted hot-air balloon, dear Tom, you know, just inflating a work gently, gently and when it stalls, adding a little bit of heat—finding a bid in the balcony, you know—and urging the balloon to fly, oh, so very high."

When I told him my auction idea in general terms, he looked like he might faint with joy. "Ah, brilliant! Ah!" He went on to embellish the "dream sale." It would take place in the early evening—"black tie, of course!"—the truly historical pieces must, he said, be separated from the "dogs." He was insistent that all decorative arts had to be set aside for their own special sale, too.

What specific paintings did I have in mind? It was the right moment to add a little heat to his balloon. I mentioned the de Groot pictures plus individual pieces Rousseau and I had discussed, Picasso's *Woman in White,* which had come from the Museum of Modern Art in the days both museums had a roll-out purchase arrangement, Renoir's *The Meadow,* Edouard Manet's *Woman with a Parrot* (which I knew had been skinned by an incompetent restorer at the museum in the early sixties), and Cézanne's *La Colline des Pauvres*.

Wilson's eyes bugged. "Tom, what I am going to tell you is preliminary, but, with paintings of this stature, I am confident that—if *I* were to handle the sale—you may expect fifteen to twenty million dollars. Will you let me handle it?"

"I'd think of no one else," I said.

"When?"

"The spring of 1972, if we get our act in order, or perhaps the fall."

The two most enthusiastic proponents of deaccessioning and disposal were Everett Fahy, acting curator of European Paintings, and Henry Geldzahler. Henry was eager to increase his acquisitions war chest and raced through the de Groot collection like a famished locust. He immediately pounced upon three paintings by the German Expressionist Max Beckmann and soon presented them to the Acquisitions Committee for deaccessioning. Andre Meyer dashed ice water on the request by asking how much the Beckmanns were worth. Geldzahler had evaluated them at less than twenty-five thousand dollars each. How did he know? Meyer wanted to know. Geldzahler assured Meyer and the committee that he had made a careful assessment. Meyer responded he felt uneasy with "a curator's evaluation." Wouldn't it be more prudent to ask for an outside evaluation? he asked. Dillon promised Meyer that "painstaking appraisals" would be made when we were actually about to dispose of anything and all appraisals would be reported back to the committee. The Beckmanns were promptly deaccessioned.

The first step in selling them was to find out the most recent auction prices. They were discouraging. Comparable Beckmanns had fetched a mere sixteen to nineteen thousand. Thus we decided to hold a "silent auction" among four dealers. One dealer bid sixty thousand for the three; another told us he'd take them on consignment; a third laughed at us; and the fourth, the Serge Sabarsky Gallery, known for its Expressionists, offered ninety-five thousand but only after Rousseau applied pressure.

Geldzahler scratched away at the de Groot lode again for no fewer than thirty-two pictures. This time he demanded a greater share of the "profits" for his department. He wanted to buy a handsome painting by the German contemporary, Hans Hartung. Ted and I agreed to let him purchase it if the de Groot sale did well.

The new lot was offered to seven dealers, but the results were dismal. Harold Diamond, who had first bid forty-eight thousand for five paintings, went up to eighty thousand for all thirty-two. Since the pieces were so modest, we decided to let the deal go through. Henry Geldzahler got his Hartung, and a few more dollars went to replenish the Fletcher fund. At the rate we were going, it was obvious that we'd never pay back the funds depleted for the Velázquez

or raise our war chest. Rousseau and I pleaded with both Geldzahler and Everett Fahy to dig deeper into their collections and select—at least for deaccessioning—some truly valuable items. Both curators complied with apparent zeal.

Geldzahler worked with a frenzy because he had found another star work he cherished—by David Smith. The sculptor enjoys an almost Olympian reputation among contemporary artists. His metal pieces, some in steel vividly polished in loops and whorls, were to be found in the most distinguished museums and private collections in America and Europe. The work Geldzahler had fallen in love with, *Becca,* had been created in 1965 in the last year of Smith's life. It was a burnished steel "painting" made up of broad and dynamic strokes and had been in "Henry's Show." Geldzahler had presented it twice to the Acquisitions Committee at one hundred thousand dollars and had been turned down—lack of funds. Afterwards, he had begged the owner of the Marlborough Gallery, Frank Lloyd, to give the work to the museum. Lloyd rebuffed him. Since then, the price had gone up to two hundred and fifty thousand dollars—high, but not out of line with other stellar works by Smith.

We suggested that if Henry chose a group of objects to deaccession, we would give him a lion's share of the revenues. Geldzahler went back a third time to the de Groot collection, selected five pictures, and, after the full disposal process, made a trade with Lloyd. He was so pleased that he showed up in my office one morning early to tell me what a "great director" I was.

Fahy had also plunged into the preparation of lists and hunted down exchange deals. One exchange was with dealer Julius Weitzner, a master manipulator, who had a reputation for applying exalted authors to modest works. He had also been suspected of fixing up paintings a bit more than strict conservation rules would have condoned. Yet, Weitzner never set out to cheat anyone. He lived by the motto "Let the Buyer Beware" and would emphasize to a potential client that he was as wary as anybody in the art business. In Weitzner's gallery there were dozens of so-so paintings of the sixteenth through eighteenth centuries—plus an abundance of nineteenth-century replicas. Yet occasionally, one could find a gem that Weitzner had overlooked.

Fahy found a spectacular one, a tiny painting in oil on copper by the early seventeenth-century Roman master Carlo Saraceni depicting an arcane religious subject—the Community of the Blessed

Adoring the Holy Trinity. Weitzner knew the picture was a Saraceni. He had bought it at an English country auction for less than fifteen hundred. But what he didn't know was that in the rarified circles of Italian seicento scholarship, Saraceni was considered a seminal creative force, a sort of historical bridge between late-sixteenth-century artists toiling in Rome and the members of the extravagant schools of Caravaggio and the Carracci. Weitzner was asking fifteen thousand dollars.

Fahy assured me that the Saraceni was worth at least three times that. It seemed to be in matchless condition, especially for a painting on bendable copper. Fahy had chosen a picture for exchange, *A Street in Delft* by Jan van der Heyden, which had been given to the museum in 1915 as an unrestricted gift. It happened that Weitzner adored it. On the surface the pleasant, banal street scene looked appealing. In reality, it was a wreck. As Fahy said, "its condition is so deteriorated that it would never be worth trying to restore. . . . The museum already owns three fine pictures by van der Heyden which more than adequately represent the artist. . . ." Sonnenberg backed up Fahy's opinion.

We took the van der Heyden to three paintings dealers for their appraisal and possible interest. One, William Acquavella, dismissed it as worthless. Another offered ten thousand. A third refused to quote any price at all. None of this was imparted to Weitzner. Yet, since he pined for it, he got it. He picked it up, delivered the Saraceni, and proclaimed himself "highly satisfied."

Fahy also supported my demand that a number of Impressionist paintings, exceptional on their own but lesser compared with other works by the same artists in our possession, be removed from the museum's collections. We would tour the Paintings galleries and the storerooms about what could and could not be dispensed with. Rousseau made the point that our choices be compared not only with comparable pictures in our collections but with those we knew were coming as gifts or bequests. Some of the pictures we discussed parting with were lofty in quality. Picasso's *Woman in White* was "reaching the summit," as Rousseau put it, but disposable because we had a far better Picasso, the *Portrait of Gertrude Stein*. We also realized that several more Picassos would be coming to us in bequests. We hoped that the *Woman in White* would fetch an enormous sum—perhaps a million and a half dollars.

Rousseau and I had singled out a number of fine Impressionists

that included Manet's *Woman with a Parrot* and Cézanne's *La Col-
line des Pauvres.* We wanted to deaccession two Camille Pissarros,
including the handsome *Steamboats in the Port of Rouen,* another
Manet, the *George Moore,* the unfinished version of a stunning pas-
tel we intended to keep, several routine Corots, a weak Brittany
Gauguin, a so-so Seurat, a Signac, a Daumier, a Vuillard still life,
and a second Picasso, *La Coiffure.* Ted, Fahy, and I had also argued
over a few others including Courbet's *Robert Le Diable* and Manet's
Torero, both of which he eventually vetoed.

All of these were to be presented by Everett Fahy to the Acquisi-
tions Committee in late November 1971. Our dream of the gala auc-
tion conducted by Peter Wilson in the medieval sculpture court was
starting to take shape. As usual, I couldn't keep my mouth shut. In
a "backgrounder" to *New York Times* art reporter Grace Glueck, I
blurted out my plans for the sales and swore her to secrecy. "This is
going to be the art story of the decade!" she exulted. I was pleased.
If she were right, the publicity would make prices soar.

In the sixties and seventies the tax laws for the donations of works
of art were far more liberal than they are today. Back then it was
possible for a collector to give a work to the Metropolitan—or a
college or university museum, or even a local hospital—bought for,
say, five thousand dollars, claim the value had grown to half a million
fifteen years later, and obtain a full deduction on the half million
without paying gains tax on the difference between the purchase
price and the most recent value. Works of art could also be given
over years with the owner retaining the piece until the last slice had
been taken as a deduction. This benevolent system supplanted an
even more generous arrangement, which came to an end in the early
sixties, whereby you could give a painting or a collection of works
to an institution, receive the full tax deduction, and keep the pieces
until you died.

Works could also be shared between several owners, and each
owner could get a tax deduction when his or her share was donated.
It was even possible to own a work with the dealer, get a partial
deduction, and then let the dealer come to tax terms with his share
—which had increased in value, naturally—in whatever way the
dealer wanted. Such was the case with a stunning painting by the
French eighteenth-century master Jean-Baptiste Greuze. The Met
owned seventy percent and Wildenstein owned thirty percent. The
Met's share of the picture had been given in the will of the late art-

book publisher Harry Abrams. But since Abrams apparently had not fully purchased the painting the "remainder" still belonged to Wildenstein. How to make a deal?

The Met owned a significant number of paintings and drawings by the French nineteenth-century classicist, Jean-Auguste-Dominique Ingres. The one in the Lehman Collection was one of the best in existence, the tour-de-force portrait of La Comtesse de Broglie. We also had other Ingres masterworks such as the twin portraits of M. and Mme. Jacques Louis Leblanc and the portrait of Joseph Antoine Moltedo, and an uninspired portrait of the Maréchal Count Gérard, which, to me, summed up the pomposity of Bonaparte's court. The painting had been acquired in an exchange with Wildenstein & Company for a number of lesser paintings. Rousseau had swung the deal and had never regretted it. It was Rousseau who suggested "turning the tables on Wildenstein" and trading another of our Ingreses, a gray version of Ingres's famous over-life-sized *Odalisque*, for the remaining third of the Greuze. The gray lady, or *grisaille*, the French word used by art historians for studies or paintings in grays only, had always been something of a problem. The museum's scholarly paintings catalogue had called the picture in all probability a study by Ingres himself for his magnificent *Odalisque* in the Louvre, a portrait of Bonaparte's sister.

Ted Rousseau thought otherwise. To him the painting could only be a study made by one of many Ingres students after the *Odalisque*. Ingres was, as Rousseau insisted, "perhaps cool and correct— maybe punctilious—but never gray—especially when he painted the sister of Napoleon."

Everett Fahy agreed with Ted wholeheartedly and urged me to convince Wildenstein to take the "Ingres" on trade. Ted handled the negotiations and had to use all his diplomatic skills, for Daniel Wildenstein felt our painting had to be by Ingres himself—with some admittedly slightly sloppy passages. But I had demanded that in any future sale, our belief that the painting was a school piece had to be clearly stated.

We sent the picture to France so Daniel could have a good look and think about my demand, and the picture was deaccessioned late in 1970. In France it lay in limbo. In the rush of the Centennial, the Velázquez, the fracases over the building program, budgetary turmoil, and staff agitations, the painting was totally forgotten. It would soon reappear at the most awkward moment and cause intense embarrassment to both us and Wildenstein.

Our systems of deaccessioning proceeded on schedule. At last, I was going to see a profound policy change, a striking modernization, something equal in scale to the master plan and the changes in the board of trustees and the staff. Some curators became so eager to deaccession that Ted and I had to cool them off. Dietrich von Bothmer suggested that we sell all the approximately thirteen thousand ancient coins, spread over six departments. I argued that we had to set up especially tough procedures to be sure we weren't wiping out a precious asset. Over six months the departments in question placed their numismatic holdings into three categories: pieces that were interesting for purely historical and educational purposes, those wanted by the American Numismatic Society, which was where most of the Met's coins had been on loan since 1909, and those coins that could be sold. The departments kept around two thousand. The Numismatic Society wanted about fifteen hundred (although the officials stated several times that they'd "like the whole lot") and about ninety-nine hundred were deaccessioned.

The next step was to find out which coin auction house would give us the best deal. We had first talked about letting coin dealers make silent bids but then concluded that, since our collections were so wide-ranging in time and in geography and because we had so many, haggling with individual dealers would prove too complicated. Instead we invited the world's leading ancient coin auction house, Münzen und Medaillen of Basel, to make an offer on the collection. We were assured a yield of as much as a million dollars. The offer would have been accepted had I not stumbled upon some insider information and, overnight, made a new deal, more than doubling our take, a deal that would also make me suffer.

Along with deaccessioning, part of the new businesslike posture of the museum, according to Dillon, was going to be a "professional fund-raising operation" like those run by colleges and universities. He demanded we hire an outside team and assign "our best" people inside to lay the groundwork for a campaign that would net a sum of about sixty-five million dollars. Compared to what Harvard might seek, this, of course, was peanuts, but it would be the first fund-drive in the history of the Met.

The firm of Kersting/Brown was brought in to work under George Trescher's former aide, an exceptionally able young woman by the name of Inge Heckel. At once our consultants told us that the worst move we could make would be to hold a flashy art auction that might earn fifteen to twenty million dollars. As wry Wiley Critz, our rep-

resentative from Kersting/Brown, said to me, "*If* you hold *that* auction, then forget about the foundations, the corporations, the members, or *anyone* giving you a cent for years after."

To Critz, art sales and trades and exchanges were something that should remain out of sight at the Met. He was in favor of our deaccessioning but only if we conducted our business secretly. He wanted to mount his fund-raising campaign in the full light of our general financial need—the city's economic plight, our deficit, our having to shut down a day a week, the staff layoffs, the need for building funds, our desire to have superior education programs.

I was impressed by Critz's arguments. I discussed the issues with Dillon, and we both came to the conclusion that our dream of a great public sale was *out*. The consequences of our decision turned out to be disastrous.

Still Rousseau, Douglas Dillon, and I were determined to salvage something for our war chest. Our goal was no longer to earn anything like twenty million. Our expectations had fallen to a modest five to ten million from individual sales or trades.

At the same time, Fahy was suddenly having "fainting spells," as Rousseau put it, when it came to making up his mind or sticking to a decision. Curators can be fragile souls prone to changing their minds, and Fahy, who had effortlessly sent several valuable paintings through our complex deaccessioning machinery, began to backtrack. He would propose a group of Impressionists one month and call for their withdrawal the next. I haunted his office, continually persuading him to stand pat.

Despite Fahy's waffling, Ted and I insisted that he agree to sell two "big money" pictures to repay the debt on the Velázquez. These were van Gogh's *Olive Pickers,* purchased through funds donated by Mr. and Mrs. Richard J. Bernhard, and yet another de Groot painting, *Tropics* by the Douanier Rousseau.

The *Tropics* was to be presented to the Acquisitions Committee on November 3. When it came time, Fahy did a volte-face. He argued that since the museum had but one other Rousseau, he was concerned about its departure, even though he knew another, finer Rousseau had been pledged as a gift. The committee prudently cancelled the sale of the *Tropics* and postponed a decision on a number of other de Groot paintings.

Patiently and gently, Ted brought Fahy back around. The man was a most charming individual, much given to smiles. What I didn't

appreciate at the time was that Fahy would smile and say anything to duck an awkward confrontation. At any rate, a month after the November meeting, Rousseau and I reconvinced Fahy to part with both the van Gogh and the Rousseau. He stated in writing that the *Tropics* is "surely inferior to the other large Rousseau in the museum, the 'Repast of the Lion,' and could be sold without weakening the strength of the museum's collection of nineteenth century paintings. . . ." Based upon that, in January the Acquisitions Committee recommended to the full board the deaccessioning of both paintings, and the full board approved.

On Ted's advice we decided not to sell the pictures at auction. Six months before, a Rousseau of far finer quality and comparable size had fetched the then world-record price of seven hundred and seventy-five thousand dollars. With the standard expenses and the minimum commission, the price for ours would have been less than seven hundred thousand. Parke-Bernet gave us a hard estimate on the *Olive Pickers* of between seven hundred and nine hundred thousand. The amounts were tempting, we thought, but not enough.

Ted found an avid suitor for the two paintings: Frank Lloyd of Marlborough Gallery. Ted and Lloyd settled on a price for the van Gogh and the Rousseau of $1.45 million and a contract was prepared.

Whereupon Everett Fahy changed his mind again. On February 8, 1972, he deposited on my desk a memo formally objecting to the deaccessioning of Rousseau's *Tropics,* Picasso's *Woman in White,* his *La Coiffure,* a Gauguin, a Pissarro, and several other pictures.

Even after I wrote Dillon a sizzling letter about Fahy's indecisiveness, he decided to back away from selling any important Impressionists or Post-Impressionists. So I dutifully reaccessioned everything on the sacrifice list, except one, the *Tropics* by Rousseau. I reminded Fahy that *he* had urged its sale, then had objected, then had approved, and once again had said no. I vigorously defended its disposal to Dillon and the board committees. The trustees listened to all sides and went along with me.

Two weeks later, on Sunday, February 27, 1972, John Canaday of the *New York Times* hit us with a hard punch to the jaw.

The art critic's column was entitled "Very Quiet and Very Dangerous" and had obviously been initiated by his colleague Grace Glueck. She had conducted an inquiry, talking to dealers, Sotheby's, and some of our own employees, finding out whom we had approached and which paintings had been deaccessioned or were about

to be. She had phoned me with a host of specific questions and, though I told her the board had not made up its mind, she kept hammering me with questions about specific paintings. She brought up certain pictures that Ted and I had discussed only with Fahy and he with a very close circle of staff. Her information was out of date. I told her it was inaccurate.

When John Canaday produced his Sunday piece, based on her investigation, I was livid. Canaday had claimed that, according to usually reliable sources, the Metropolitan would offer for sale the very paintings I had repeatedly told Grace Glueck were no longer under consideration.

Canaday came out against any sale of anything by any American art museum. Museums, he explained, were neither merchandise marts nor aesthetic stock exchanges; they were repositories of precious records. "Nothing worth buying or accepting as a gift in the first place ever becomes less than part of the record of a phase of our culture, even if it also represents a curatorial idiocy. In spite of every exception, the rule is that selling from the collections is hazardous policy."

I phoned Canaday—I had been enjoying a kind of détente with him—and tried to reason with him. I assured him that the pictures he listed were *not* going to be deaccessioned. I said we would be selling in the future, as we always had, in a variety of ways. I said that our reasons for disposing of things had been published a number of times. I reminded him that he had supported the Guggenheim Museum when it had sold ninety-seven Kandinskys. He said he was "older and much wiser."

I should have left it at that. But, of course, it just wasn't in my arrogant and combative nature. I felt I had Canaday on the ropes, so why not strike back in an article? I could point to his exaggerations, while at the same time spelling out the museum's philosophy in print. I got approval from Doug Dillon. I had barely two days to write my article to make the next Sunday *Times* Arts and Leisure section.

Some wiser person should have told me to hold my tongue.

My piece was called "Very Inaccurate and Very Dangerous" and was neither deft, nor polite, nor intelligent. I made a frontal assault, charging that Canaday's information had been "ninety-nine per cent inaccurate."

"What are the facts?" I wrote. "The pictures mentioned by Mr. Canaday did come under preliminary discussion, but were placed

out of consideration either by the Board, the Curator of Paintings [by this time we had promoted Everett Fahy to help keep him in line], the Curator-in-Chief, myself or other colleagues. These included every single one of the pictures mentioned by Canaday except for the Gauguin, about which, incidentally, no final decision has been made." The *Tropics* and the *Olive Pickers* had not been mentioned.

I explained how many times in its past history the museum had disposed of works and why, describing too our "stringent process of review." I described what we did with the money—only using it for other, more needed pieces. I related how the Met collected in the belief "that the business of a great art museum is quality, not numbers." I cited illustrious exchanges of the past, the Ingres *Maréchal Count Gérard* and the Carlo Saraceni.

There were risks in disposing of things, but nothing was more irrevocable than missing a great work of art—the prime hazard of the profession—something far more likely to occur than an error in disposal.

I ended my piece in something of a rage, hoping to humiliate Canaday, but instead only fanned his flame.

Next Sunday, Canaday struck back with another column. Like my blast to him, Canaday's counterattack would have been better off stuck in a drawer for a while—or never published. He tried to claim "victory" in that he alone had stopped us from selling the works he had mentioned. We decided to clam up and go on with our plans. The next day Ted met with Frank Lloyd of Marlborough and signed the contract to sell him the *Tropics* and the *Olive Pickers*.

Four months later, when I figured the deaccessioning controversy had faded, it exploded. I got a phone call from Canaday who casually asked me if we had anything "major" up for sale. At the time we didn't and I said so. But I had forgotten about the *Tropics* and the *Olive Pickers* and the group of paintings we had disposed of in several silent auctions.

Two days later I got another call.

"Is it not true, Mr. Hoving," Canaday said, "that at least two of the Metropolitan's masterpieces are at this moment for sale on the London art market? I refer specifically to Henri Rousseau's *Tropics* and Vincent van Gogh's *Olive Pickers*."

For an instant I could hardly think. I felt like I was about to be arrested for some crime. I tried to sound casual, as if I had been

thrown a routine question. "Wherever did you get that idea?" I said. As far as I knew the pictures were not on the London market but in the Torino home of Fiat chairman Gianni Agnelli, whom Ted Rousseau had approached about buying the paintings. So I told Canaday firmly that the pictures were "not now in London for sale." Was I positive? Yes! He slammed down the phone. I yelled for Rousseau and Hawkins to come into the office at once. I knew I didn't have much time before he called back again. His editor would no doubt urge him to ask the obvious question any seasoned reporter would have asked from the start: were these pictures or any other from the Met up for sale anywhere in the world to anybody or at any gallery or auction house?

The call came less than ten minutes later. My heart was still pounding furiously. But Rousseau was by my side, so I answered the critic calmly, trying with my tone of voice to indicate that the matter of the *Tropics* and the *Olive Pickers* was everyday stuff.

"John, you know our position," I tried to explain. "We have stated over and over that we are going to sell. No, I did not lie the other day. At present there are no plans to sell or exchange anything other than dribs and drabs. Yes, right now, some paintings are being offered for sale. They happen to have been deaccessioned months ago. No, none of them are any of the ones you published back then —erroneously, I have to say. To my knowledge *no* London gallery is right now displaying the *Tropics* or the *Olive Pickers*. Is a private collector interested? Yes, one private collector has been examining them for months. Who? I'm not at liberty to say. Am I being clandestine? No. You must understand this is the way works of art are sold—most private collectors don't like having their names bandied about. No, I don't think these two paintings are 'masterpieces' when you take into account what else the museum owns. How else would I describe a 'rare' van Gogh? Or a 'choice' Rousseau? Those are *your* words. I'd call them good pictures, but not good enough for the Met with so much in Post-Impressionism. How many van Goghs do we have? Ted says 'around a dozen.' How many Rousseaus . . . ?"

I was trapped. Canaday angrily asked the question again. We only had one more!

"John, we have one other and it's . . . ," I said but he wouldn't let me finish.

He screamed—was it prudent to sell "half the Metropolitan's total inventory of the works of one of modern history's greatest masters?"

"In this case, yes," I said lamely.

Canaday's article was front-page. It had a huge illustration of the *Tropics*. It was entitled "Metropolitan Museum Sells Two Modern Masterpieces in an Unusual Move." It was a broadside rather than reportage. And it caused a series of explosions. I was hit with more artillery than during "Harlem on My Mind." The press, professional organizations, the city government, and finally the attorney general of the state of New York bombarded me. The *Times*, in a stunningly good piece of investigative reporting, rooted out the half-forgotten Ingres *Odalisque* in Paris and cast our on-and-off deal with Wildenstein as a classic case of clandestine art shenanigans. The painting was rushed back to the museum—to dead storage. Dillon lost his resolve momentarily and appointed a special committee of the board to examine the deaccessioning practices.

The Art Dealers Association accused me of a "breach of public trust" despite the fact that a number of members had delightedly participated in the trades and sales. *Time* and *Newsweek* roasted me as did *New York* magazine. Words like *sinister, warped, a war criminal of art* burst forth. I told Dillon I was physically, mentally, and spiritually worn down and could not sustain another "kerfuffle," as *Newsweek* termed the fracas. Trustee Dick Dilworth had hinted to me coldly that my chances of survival were once again "not good."

I tried to explain to my wavering board that all the deaccessioning was part of the ongoing streamlining of the institution, part of putting it on a truly businesslike basis. I admitted my errors—having fought back in the press too viciously, being insensitive to the charge that in getting rid of works of art, I had in some way broken secret treaties, damaged traditions, and forced the museum to become something it could never become—a business. But even my admissions of failure generated more criticisms. The truth was that deaccessioning was responsible, even innocuous, and had been blown out of proportion by my increasing number of enemies. More and more I was finding that my policies and moves, intended to make the Met more efficient and modern, were being contested in the press. Increasingly, I was discovering that if I fought the criticism I was perceived as a whiner and if I kept quiet I got slammed. I was a loser either way.

When Attorney General Louis Lefkowitz announced that he would open a full investigation with complete subpoena powers, I was relieved. I knew Lefkowitz as a publicity hound but was convinced at the same time that he respected due process and would not

take rumor as fact or misstatement as gospel. The inquiry lasted seven months. Dozens of art dealers, trustees, and curators were interviewed under oath. Thousands of documents were studied. In the end Lefkowitz announced he had found no cause for either litigation or legislation. No wrongdoing. No cheating or bilking of Adelaide Milton de Groot or anybody else. No harmful collusion with art dealers. No instances when we had sold cheap with the result that someone else had received a windfall. No evidence of mismanagement or hanky-panky. The only criticism—and it was harsh—was that I had handled the public relations atrociously. I had. I had acted deplorably in trying to weasel out of telling Canaday, and others, the full facts about the deaccessioning and auction plans until it was too late, with the result that the impression that I had been lying had become indelible.

Buoyed by being cleared of wrongdoing, I was nonetheless weakened by Lefkowitz's attack on my conduct. I was furious with the attorney general for pressuring Dillon and Gilpatric to surrender to his demands that henceforth all works to be disposed had to be at public auction. "Let Lefkowitz take us to court or pass a law in Albany," I urged. "He's forcing us into a restraint of trade." Lefkowitz would have and should have been defeated. But the board was shutting its ears to my voice.

One of my most appalling lapses of good behavior—and common sense—with the press during the "kerfuffle" had been a stormy interview with the art critic of *Newsweek*, a gentle artist by the name of Douglas Davis. I had threatened to punch him in the face after he breezily remarked that I wasn't capable of deaccessioning since I wasn't much of a collector. I had shouted at him, "I began as a collector and my instincts are still there. When I see something I want, I do everything I can to get it. I've gotten three hundred million dollars worth of stuff since I've been here and I've never made a mistake. What other museum, what other city in the world, has gotten these things? I'm proud that I've gotten the greatest objects in the world, in my time here. . . . I'm a breed that won't happen again, not out of genius, but because of treaties and other obligations. In the last waning hours of collecting, I will go through 'kerfuffle' to get the great objects."

17

THE
"HOT POT"

I have fallen in love more often with works of art than with women, which is, I suppose, more a professional quirk than a psychological flaw. I have admired thousands of works, loved a hundred or so. Only one was an object of total adoration—a Greek vase dating to around 510 B.C.

The vase, officially called a calyx krater, was designed by Euxitheos, the potter, and decorated by Euphronios, the painter. Though it is only eighteen inches tall and twenty-one in diameter, it is heavy: one has difficulty lifting it. It was made for mixing as much as seven gallons of wine and water. To call it an artifact is like referring to the Sistine Ceiling as a painting. The Euphronios krater is everything I revere in a work of art. It is flawless in technique, is a grand work of architecture, has several levels of heroic subject matter, and keeps on revealing something new at every glance. To love it, you only have to look once. To adore it, you must read Homer and know that the drawing is perhaps the summit of fine art. Truly, the calyx krater

is one of those rare pieces that is legitimately the perfect object of adoration for both the neophyte and the art snob.

I first heard about the vase in late September 1971. Elizabeth Hecht, the wife of an American antiquities dealer living in Rome, phoned with a confusing message. Her husband wanted me to know that he'd just been consigned a "startling piece," something he might offer me in several months. Hecht was one of the top numismatists in the world and had, at one point, charted a course to become a classics scholar. Along the way he became a principal purveyor of antiquities and was rumored to have contacts with the Mafia boss of the Italian antiquities market. Hecht even had a record with the authorities in Italy and Turkey for his involvement in questionable exports of antiquities.

We had met when I was studying in Rome in 1956 and 1957 and, again more recently, at the Met when he had once sauntered in with a gold Byzantine bracelet for me. Hecht was a diffident, moon-faced man who talked in semi-code—sometimes calling the objects he was pushing by fanciful historical names. Whatever role he was playing —scholar, *marchand-amateur,* finagler—Bob Hecht was very intelligent, and he had an almost infallible eye for spotting forgeries.

In early February 1972, Hecht sent Dietrich von Bothmer a handwritten letter that von Bothmer brought me in my office at nine o'clock the next morning with a lapful of books and photographs. Hecht's letter was written in his "espionage-style" language:

> It seems you misunderstood a question of mine in a previous letter, namely why Beazley omitted the "see the swallow" inscription on A of the Hermitage "pelike" from his text in ARV(2) (as well as in earlier editions). From its absence I thought he might have considered it spurious. If something like p. 14, no. 2 were in *perfect* condition & complete, would it merit a gigantic effort, a really gigantic effort? I am quite disposed to be *entgegenkommend* with Thor if you like him.

I knew that the late John Beazley had been the most revered English specialist in Greek vases and that he had been Bothmer's mentor. The illustration in Beazley's volume was of a vase I happened to admire greatly, the fragmentary calyx krater by Euphronios in the Louvre, showing Hercules in the death struggle with Antaeus. The German word *entgegenkommen,* Dietrich told me, means a willingness "to meet someone halfway."

I was startled and so was Bothmer. Did Hecht have a Euphronios? He told me that there were no more than twenty-seven Euphronios vases—and was about to launch into a lecture on the history of Greek vase painting. I cut him off and told him to find out more about this one—the price, where it came from. He should get some photos, too.

Actually, I thought I knew where it must have come from. An intact red-figured Greek vase of the early sixth century B.C. could only have been found in Etruscan territory in Italy, by illegal excavators. But when I said that to Bothmer, he replied that it was unlikely. "Cerveteri and the Etruscan sites near Rome are carefully guarded nowadays against the *tombaroli* and, besides, they've been plundered dry years ago."

We didn't hear from Hecht for a month—he was at a tennis camp in Spain and was not to be disturbed. His second letter was more carefully written, which meant he intended it for me. Of course, it was in code—a cute code:

Regarding p. 14 of Jackie Dear's red I once made a hint asking if you and your trusted associates would make a super gigantic effort. Now please imagine this broken, but *complete* and in *perfect state* —by complete I mean 99 44/100 % and by "perfect state" I mean brilliant, not weathered. It would hardly be incorrect to say that such a thing could be considered the best of its kind—I don't say that necessarily it is, but . . . it is hard to find competitors.

Assuming the first part of above paragraph to be the case, would it be able to be considered in terms of a specific painting (as, i.e. more or less the flags at that beach resort in France by Monet or someone, rather than a pot.) The equivalent might be available and I would then discuss it with you. But if a priori the trusted ones would think in terms of pots, it would be best not to begin.

"Jackie Dear" was Beazley; "red" was the red-figured krater; "beach resort" was our Monet, *Terrasse à Sainte-Adresse,* purchased for 1.4 million dollars.

Bothmer replied, asking for specifics. Hecht wrote back in code: "Gessler (the frohnvogt in *Wilhelm Tell*) not yet mature, but his salary in neighborhood of that beach resort with flags which made impression on Arthur and Tom." Bothmer explained that [frohn]vogt was a play on Eu[phron]ios; Gessler was the arrogant bailiff (vogt) who had decreed that all citizens had to bow down before his hat

and who had forced William Tell to shoot the apple from his son's head. "Gessler" meant the vase was safely in Switzerland.

I was hooked.

It took another month for Hecht to send a set of black-and-white prints which showed the vase put together, but with a spider's web of cracks. It was not intact. The pot was broken into several dozen pieces of varying sizes—hardly intact. Yet it was "complete," for it seemed that not even a grain of the original material was missing. To me, its completeness meant that the robbers had come across one of those rare Etruscan tombs which had not been sacked in ancient times and had not caved in. Even in its repaired state, the Euphronios was finer than any other surviving work by the artist. Since I was planning to go to Europe at the end of June, I asked Bothmer to call a meeting to see "Gessler," "Thor," Euphronios, and of course Bob Hecht. In a few days the object had been deposited at the Zurich home of its restorer Fritz Buerki. I flew over with Dietrich. Rousseau was to meet us there.

Dietrich never stopped talking all the way over—about his passion for Greek vases, what was currently making the museum rumor mill, and Bob Hecht. To Bothmer, Hecht was an honorable fellow, a genuine scholar, and an invaluable art dealer. He considered it important that someone with such good family connections and such exceptional credentials had entered the antiquities trade. Although the Met had not been all that steady a customer, Hecht had never failed to show Bothmer all his new wares. The only time Bothmer fell silent was when I asked him guardedly what he thought the origin of the vase might be.

I understood immediately. He didn't want to know anything. If he knew anything, he didn't want me to know what he knew. We established an unspoken understanding. We would consciously avoid knowledge of the history of the vase. All Dietrich would say was, "We may be surprised by what Bob tells us, for he did hint that he was selling the krater as an agent for the owner."

Bothmer's knowledge about the history of vase painting was compelling. He explained the process of how the Euphronios had been made—almost blindly, as it turned out. The potter Euxitheos would deliver an intact, damp vase, the color of terra-cotta, to the painter, Euphronios. Then Euphronios would have "painted" all ten of the massive figures, all the complex palmettes, the hundreds of tiny, delicate lines in the armor, the wings, the hair, the outlines of the

anatomical parts of the male bodies without ever seeing clearly what he had just drawn. The artist worked with an instrument that was something like a pastry bag with a bone or wood nozzle with a hole the size of one in a hypodermic needle. The solution used to make the relief lines and the colors ranging from light ochre to deep brown to opaque red for the blood could only be seen after the vase was fired.

The vase painter stuck the huge, heavy wet clay vase on his knees, hunched over, took the syringe and worked as fast as he could—totally from memory—never failing to stop a line at the right place so that, later, all overlaps would turn out to be in precise juxtaposition. The artist had to draw faster and faster, because the wet clay would begin to dry out. All kraters, Bothmer told me, had two rectangular spaces, between the upward-curving handles and the space on the back, where the painting was always less careful than on the front, because by the time the painter got to the back the vase was almost dry. The difference was a feature that only the most learned vase experts knew. The dangers in potting and painting an important commission were considerable. Countless times even the most gifted artist saw his work emerge from the kiln with a crack and had to throw it away.

We disembarked in bright, sunny, warm weather at Zurich and took a cab to restorer Fritz Buerki's place in a modest suburb of Zurich. As we got out, Ted drove up. Buerki and Bob Hecht were waiting. Out of the corner of my eye I saw the vase standing on a table in the corner of the living room that was cluttered with other vases. Without looking at it, I walked right through the room and out into a small garden. I wanted my first penetrating examination in broad daylight.

Hecht handed me a cold beer as Buerki hauled out a table, a pedestal, and finally the immense vase. I turned my eyes to the thing and felt as if I had been punched in the stomach. The first thought that came to mind was that I was gazing not at a vase, but at a painting. I was awed by the scale of the two armored, winged men, flanked by warriors standing at attention. These ''angels'' were lifting the body of a huge naked man off the ground, his blood flowing from several wounds. The warrior had delicate locks of reddish hair, his eyes were closed, his teeth gritted in the agony of his death. I walked around the vase marvelling at its size and its bulk. The shape of the upturned handles was electrifying; the curves of the sides of

the object, exuberant. The colors—ochres, browns, reds, a few pinks for the inscriptions—were like enamel on a black ground, a blue-black of such intensity that it seemed like a vein of coal. I sat down on one of the folding garden chairs, looked at Hecht, and said simply, "Sublime!" There was no sense in trying to act like a haggler. Dietrich was dumbstruck. Together we circled the great vase, darting in to examine a detail, moving back for the long view, darting in again to discover another wonder.

When we had calmed down, Dietrich described what Euphronios had depicted. The scene was from Homer. The body of the dead warrior Sarpedon was being lifted by the twins Sleep and Death. The figure behind Sarpedon was Hermes, and the warriors flanking the body were Laodames and Hippolytos. On the reverse a group of young soldiers, all identified by inscriptions, were putting on their armor. Bothmer translated the Greek inscriptions, some painted backwards. One said, "Leagros is beautiful." Leagros, it seemed, was the handsomest young man in Greece at the time and that helped to date the vase to the decade 520–510 B.C.

I didn't listen to all of Bothmer's comments. I was already thinking how to get the money to get this treasure. At the split second I first looked at it, I had vowed to myself to get it. I stood there in the warm sun in my shirt sleeves, beer in hand, crusty with lack of sleep, but my mind and eyes were as alive as they had ever been in my life. This was the single most perfect work of art I had ever encountered.

The body of Sarpedon was majestic, huge, lavishly muscled, yet slim as a dancer's. It was as anatomically sophisticated as a drawing by Leonardo. The hands were rendered with uncanny observation. I was struck by the two startlingly different moods. Sarpedon's scene was formal theater, possessing all the dignity of a Greek tragedy. The other side, with the warriors donning their armor, had all the bustle of a locker room. Two of the handsome youths waited impatiently as three others dressed. One youth was leaning over to pick up his large shield, another, a slim kid who was slipping a short sword over his shoulder, was looking down and seemed to be thinking, perhaps fearfully, of the battle. These youngsters were about to walk out the door into a struggle that would kill some, maybe all of them. Some would end up like Sarpedon.

I found the drawing the finest I had virtually ever observed. One long, unhesitating line that sped from the wing of Sleep through his arm in a pure stroke was genius. I marvelled at how Euphronios had

gotten every tangent, every overlap, every junction, every loop and whorl of the hundreds of different lines just right.

I tried to think of something comparable, from any time or any master. I could only think of the so-called Alexander sarcophagus in Istanbul, the precious drawings in the illuminated Book of Hours created for the Duke of Berry by the Limbourg brothers around 1410, and the watercolor of the bird's wing by Albrecht Dürer in the Albertina in Vienna. They were all unique masterworks, yet none had the same sense of soul.

After an hour, it was time to come down to earth. The tough work was about to begin, how to get the piece and for how much. At lunch we got down to business. Hecht had generously decided to come down from his price of one and a half million and rest at what he called the bargain level of one point three. As he spoke, he averted his gaze from mine. His voice was soft and he had a mocking smile on his face. He sounded as if he were giving the pot away free. "Bob, do we get green stamps?" I asked and he grinned. It was to be "one point three, eight hundred and fifty thousand in cash." He'd take some of our cast-off objects in trade for the rest—but *no* vases; pottery wasn't his line. He wanted sculptures in trade. Hecht demanded a firm commitment by September at the latest. If I wanted to make the deal then and there, a registered check, well, that was okay too.

I said I wanted the vase. I said it was "positively the finest work of art I've ever seen." But I said I couldn't pay a million three. It wasn't worth it. I suggested eight hundred fifty thousand in cash, in a month. "Just calculate the loss of interest in waiting," I said. "Yes, I can pretty well say I can get you that eight fifty in a month."

Ted's face was clouding over. He had been unusually quiet when Dietrich and I were circling the vase. On the way to the restaurant Rousseau had remarked, "Interesting experience." I thought he was under the impression that I was going to have lunch, thank Hecht, and leave for Paris.

"Tom, if I were the only person involved in this deal, I would accept the eight fifty," Hecht said. "But I am on commission—ten percent—and the owner insists on something over a million."

I didn't believe him. I asked Dietrich if he thought there were sufficient numbers of disposable sculptures that might satisfy Hecht. He nodded, looking alarmed to be asked the question so directly in front of the man we were negotiating with. Then I went into an act,

spelling out how poor we were, telling Hecht about the debts left over from the Velázquez. Suddenly, seemingly offhandedly, Hecht leaned forward and solved my money problems. And, amusingly enough, neither he, nor Rousseau, nor Bothmer realized what had occurred.

"My numismatic friends tell me," Hecht said, "that you are thinking of selling at auction here in Zurich the Durkee and Ward collections of coins. Why not swap? I'll give you the vase plus three hundred and fifty thousand for the Durkee coins alone."

I smiled and waved my hand dismissively, but I was so excited I was yelling inside. I excused myself to go to the toilet. It was just after three o'clock, mid-morning in New York. I put in a call to Ashton Hawkins who was close to wrapping up the sale of the Durkee and Ward coin collection to the Swiss coin auction firm, Münzen und Medaillen. Their latest estimate had been between three-quarters of a million and a million dollars and possibly as high as a million and a quarter, less the standard commission. I hardly gave Hawkins a chance to say a word.

"Do not make any deal with Münzen und Medaillen. I'm positive I can get—a much higher offer. Stall them, but do not make any arrangement with them." I clicked off.

My next call was to Peter Wilson at Sotheby's in London. I described the Ward and Durkee coin collections to him and told him exactly what estimates the officials at Münzen und Medaillen had given.

"What can you give me? I have to know fast. Peter, I shall call you back in a half hour for your offer. It's key."

He didn't hesitate. "A half hour will be fine, Tom."

I returned to the table and we started in on the next problem facing us—the provenance.

"What about the recent history of the Euphronios?" I asked.

Hecht looked me in the face for the first time. "My Finnish grandfather has owned it for seventy-five years." He chuckled as if he had just told a dirty joke. "Really. The owner has had it—in pieces—since before the First World War, I suppose around 1914."

"Name?"

"Dikran Sarrafian." He spelled it and Dietrich raised an eyebrow. "Dikran is an antiquities dealer in Beirut and handles everything from ancient Near East to Greek and Roman," Hecht added.

Bothmer shrugged.

"You mean to say that the krater came from Lebanon?"

"No," Hecht said. "Dikran inherited it from his father. He got it in . . . ah . . . exchange for a number of gold coins in London, back around 1914 or so."

I tried not to laugh. The gold coin story was Hecht's witty way of referring to our gold coins. Beirut was the cliché provenance for any smuggled antiquity out of Italy or Turkey. Lebanon was as shopworn an origin as "from an old Swiss private collection." Beirut was such an obvious laundry that I wondered why Hecht had not chosen the "Gessler collection" from Switzerland. That would have sounded more authentic.

I said I had to see documents and Hecht nodded. To pass the time until I could call Peter Wilson, I urged Hecht to tell me more about Sarrafian. I assumed the vase had been illegally dug up in Italy. I had no idea when. Hecht told an elaborate tale of how his friend Sarrafian had kept the fragments in a shoe box in his closet. Disturbed by the deteriorating political situation in Lebanon, Sarrafian hoped to raise enough money to settle in Australia. He knew the market for Greek vases, and depending on how much of a complete krater he had, he was asking anywhere from one and a half million dollars to two million, leaving it to Hecht to obtain the best price.

It was transparent.

"He knew he had something grand," Hecht said. "He didn't know the precise size—or the market value. I was the one who told him to hold out for a high price, the equivalent of an important painting. And, of course, when I saw what we had, then . . ."

What crap, I thought. I excused myself again to call Wilson back. In his usual breezy way, Wilson said he was prepared to offer a cash advance of $1.5 million—plus eighty-four percent of all gross receipts in excess of two million dollars. "I want us to put our feet firmly into the coin territory," he said. "Think about it and do come to London soon . . ."

"I'll come tomorrow," I said. "I'm sure Dillon and the board will approve." I was dancing a jig in the narrow corridor. I returned to the table for a few minutes more.

"Bob, my offer is not a penny over a million bucks," I said. "Eight hundred fifty in cash. Payment to be made in early October. The rest in trade. Sculptures. Which Dietrich can work out."

"Well I'll consult with Dikran," Hecht said with a smirk. "I don't believe he'll want to move below one million three."

"About this Sarrafian," I said. "We've been getting some flak from UNESCO on smuggled art, and I've introduced a new procedure. The curators must verify in writing the provenance of any ancient piece. If nothing is known, then we send photos and detailed information about the piece to all the countries where it could have been found. We ask the appropriate officials if it's okay. If the provenance is clear and unquestioned, we don't send out photos. I need anything Sarrafian can come up with to prove that he's really the owner, clear title, and for how long. Of course, it would be helpful if I had proof that Sarrafian will receive his share of the money if we buy the Euphronios. But, we're gonna buy it, I'm sure."

Hecht smiled back. It was an almost unforgivable thing for me to have said in a negotiating session. But I was passionate about the vase, and my reason had become clouded. Was the Euphronios really worth a million? I had just "earned" more than I needed to make the acquisition because of Hecht's offhand comment about the coins.

After talking with Doug Dillon, I went immediately to London. We engaged in an informal auction between Sotheby's and Münzen und Medaillen, and Sotheby's offer won hands down. The Met eventually collected nearly 2.3 million dollars from the sales.

After my unwise enthusiasm with Hecht I chose a different tack. I ignored him completely. He began to waver.

He wrote me on June 29: "If you appreciated the garden piece as much as you seemed to, there is no reason why we should not come to terms somewhere in between your price and my 1.3. Because of the dollar situation, I would rather make a sacrifice on the price for quick settlement. . . . This problem might possibly be solved by a bank's discounting the bill and charging me interest." He added a P.S.: "My wife was happy to hear that you finally saw and liked what she had told you about last September." I had no idea why he emphasized the point.

I didn't respond. I slipped the word to Dietrich that I was having serious second thoughts. In order to keep the pressure on Bothmer I forced him to scour his holdings for sculptures Hecht might want to take in trade although I had no intention of a swap. I only wanted to wear Hecht down. I let a month go by before I answered Hecht—coolly: "I do sincerely hope we can come to terms." Again I fell silent. Hearing nothing, Hecht dispatched a frantic letter to Bothmer offering an alternative: "1/4 on delivery (soon), 3/8 in October, 3/8

in March." I was wondering when Hecht was going to hear the facts about the Sotheby's coin deal. One sentence in his letter indicated that he had some inkling: "latest rumors are 1) earliest coin sale in January; 2) contract not yet certain." I concluded Hecht must have gotten inside information from Münzen und Medaillen.

Rousseau also put the squeeze on. He insisted on going back to Zurich "to look at the breaks in the vase again." Dismayed at the request, Hecht wrote Dietrich an anguished letter: "I heard a lament that the Southern Boys were taking over the Durkee-Ward action. . . ." He knew about Sotheby's!

But Ted Rousseau had genuinely come to suspect that the krater was not all original. I didn't care if he denounced the piece and the astronomical price. I indulged him. I wanted the vase; I would have it. His second visit to Zurich played into my hands. Hecht was interpreting Rousseau's opinion as a mirror of my feelings. Rousseau reported to me that he was satisfied that nothing was modern. Meanwhile, I allowed Dietrich to suffer the agony of trying to assemble a second list of classical sculpture to deaccession and trade with Hecht. What I really wanted was to call Hecht, agree to a million and a quarter, and *get* the vase. It was all I could do to continue to play the ever more dangerous bluffing game. Some other museum was going to start stalking my vase.

Hecht sent us a list of eighteen sculptures he wanted. His evaluation was $362,000, which meant the Euphronios would cost us one point two. Dietrich rejected Hecht's demand. I pressured him to assemble yet another list. This time he picked objects that were not on exhibition, complaining, "I see no reason why we have to sell to *Hecht*. Couldn't we pay off Hecht now in cash and sell these pieces later to someone else?"

He was right. It was time to bludgeon Hecht. I instructed Dietrich to let him know that I would not think of anything higher than eight hundred and fifty thousand in cash—to be paid in a month. That was it. I received a sharp letter from Hecht suggesting we break off negotiations and in the next sentence opening up some new negotiating possibilities, including a lower price. His "final" proposal was "1) One point one million C.O.D. in a week or so. or 2) .85 cash, Zeus head, and a .25 credit for the coin sales (i.e. I would be able to purchase up to that amount at the auctions without paying)."

I interpreted Hecht's response as saying between the lines that he would take one million. I felt the price was acceptable since Hecht

had started at one point three million. I let the game play out another few days by suggesting he ponder Dietrich's list again. A response was not long in coming.

It was on Monday, August 28. I was vacationing in Martha's Vineyard. Hecht's wife, Elizabeth, called Dietrich who reached me late in the evening. He was agitated. Hecht was only interested in a trade-in if he could obtain "class-one" objects, *not* castoffs. He would take $850,000 in cash and a credit of a quarter of a million (with six percent interest) for the coin auction in Zurich in November —the interest coming to $2,917.80. We would also have to pay insurance amounting to $3,375. If we paid in full now, Hecht would deliver the vase in twenty-four hours. Elizabeth Hecht told Dietrich, "My husband wants to have an answer by Wednesday, for after that date he would feel free to withdraw his offer to us and sell the vase as he pleases."

Mrs. Hecht emphasized that her husband preferred that we telephone her in Connecticut, for he didn't want to be reached in Rome. Ah, he figured his phone was bugged. Well, the hell with him. I wanted to speak directly to the man and make my final offer. I tried to get on a plane from the Vineyard to New York on Monday—no seats. It didn't matter; I was having fun letting Bob Hecht sweat. I flew in on Tuesday, checked in with Dillon about spending a million dollars from the proceeds of the coin sale, and briefed him on all the negotiations over the months. "Buy it," he said. I phoned an annoyed Bob Hecht in Rome but soon had him at ease by using code.

"Garden-man here. Relax. I want Gessler, as you know. For appearances' sake don't want to walk all the kilometers you mention. Can only go one kilometer. So, let's cut through the shit and agree on the one kilometer, okay?"

"Agreed," he said.

"I'll talk to your wife on details."

I sat back at my desk shuffling the black-and-white photos of my passion and felt a near-sexual pleasure. We had landed a work that would force the history of Greek art to be rewritten, perhaps the last monumental piece ever to come out of Italy, slipping in just underneath the crack in the door of the pending UNESCO treaty which would drastically limit the trade in antiquities. We had gained a triumphant work, one of surpassing power and infinite mystery, one, I knew, that would someday reveal a few surprises.

Dietrich told me emotionally that he had become resigned to the

sad fact that I had decided to let the vase pass. He complimented me on my ''coolness'' and blessed me for not having forced him to sell any of his treasures.

Two days later Hecht's bill arrived, on a cheap Swiss restaurant tab: ''1 Attic red figure crater signed by artist Euphronios and potter Euxitheos U.S. $1,000,000. Please pay by cable transfer to Union Bank of Switzerland, Bahnhofstr. 45, Zurich for Robert E. Hecht Jr.'' I chuckled at the misspelling of *krater* as *crater*.

At a special session of the Acquisitions Committee the pot was purchased for the record sum of one million dollars. No one seemed taken aback by the price, especially when I mentioned Sotheby's advance. But I had to swallow hard as I described the vase's provenance and ''our right to purchase it under the UNESCO regulations.'' The treaty, I added, had not yet been signed. I described the steps we had taken to assure ourselves that there was no impediment. I was very pedantic; I wanted to sound like a lawyer. I was walking on thin ice.

In the first place, I began, the dealer was not anonymous. It was Robert Hecht. So, too, was the owner, Dikran A. Sarrafian of Beirut a ''well-known art dealer.'' I explained that Sarrafian had stated to Hecht, and had submitted in writing, the fact that the Euphronios vase had been in his family's collection at least since World War I. Copies of the letter were in the acquisitions packet. More written documentation on its way had been read to me by Hecht, and I described that information.

The first letter from Sarrafian, of July 10, 1971, referred to the Attic ''crater'' that Hecht had seen with Sarrafian's friends in Switzerland and informed him that the vase to be delivered to Hecht alone would cost a million dollars. The second letter, dated September 9, 1972, declared that ''the origin is unknown and that my father got it in exchange with an amateur against a collection of Greek and Roman gold and silver coins in February and March of 1920 in London.'' He went on to say that the vase was in fragments and that he had authorized its restoration ''some three years ago.''

I also emphasized to the trustees that we had a bill from Hecht that also referred to the fact that the pot had been in the Sarrafian collection since World War I. We had, in fact, gotten two bills.

I did not voice my suspicions that both letters were concocted by Hecht. My reasons for believing so, admittedly, were based upon details—both Hecht and Sarrafian misspelled *krater* as *crater;* Sar-

rafian had authorized the restoration of the krater "three years ago" while I knew Buerki had just restored it; and finally, Hecht's first bill, dated August 31, mentioned nothing about Sarrafian, and the second, also dated August 31, did, and the second bill said that Hecht had the piece "from Dikran Sarrafian, Beirut, whose family has possessed it since before 1914," not World War I.

I excused my lack of communication by rationalizing that perhaps my suspicions were unjust. In many cases people who own works of art for a long time forget the precise details of when the piece first came into the family. It seemed logical that Sarrafian, considering the deteriorating political situation in Beirut, had gotten rid of most of his things and had sent the fragmentary krater to Zurich for safe-keeping years before.

There were no questions from the committee, simply delight that such a magnificent treasure had been landed and that the money had fallen into our laps. The vote was unanimous. Brooke Astor and Punch Sulzberger had written their approval earlier. Sulzberger, seeing it in my office, had been immensely impressed by the sheer beauty and flawlessness of the vase. His eye had picked out the places where the object had been repaired in antiquity by several lead clamps, and he had lightly asked if we had subjected the vase to the same tests we had given the Greek horse. I assured him that if we bought the vase, we would send a sample of the clay to a labora-tory at Oxford in England and subject it to a thermoluminescence test. As he was leaving, he ran his fingers over the glistening rim of the piece.

"I don't usually get involved in editorial matters, but *this* is so unusual; it's such an opportunity. Well, I can see this vase on the cover of the magazine."

"What a great idea!" I said.

Soon after the Acquisitions Committee had approved the Eu-phronios krater, I learned that James Mellow, a talented free-lance writer, had been assigned the cover story for the Sunday magazine and would be interviewing Dietrich and me. The story was to appear in November, I was told. The Euphronios was a perfect example of the merits of using moneys from the sale of deaccessioned objects, and a major story would help deflect some of the growing flak about our sales. I wondered why the writer was not John Canaday.

The Euphronios hit the news in classic style. There was a short lead-in on the front page of the Sunday *Times* of November 12, 1972,

and the vase appeared on the cover of the magazine. Mellow's piece was studious yet sprightly. He got a few things wrong—the price and the "official" story that it had been in a "European private collection since before World War II." The article also referred to the deaccessioning storm, but at least Mellow stated that the purchase of the vase was what the selling campaign was all about. Bothmer was the man of the hour, and the article described his bravery in the war. He had been wounded in both legs while on a mission in Dutch New Guinea but had carried a buddy back to safety. He had received a Bronze Star. His company commander had put him in for the Silver Star, but as Dietrich lay in the hospital recuperating, he told him that for the Silver he had to have two witnesses and he had only one—the man whom he had saved.

The article ended with an anecdote about John Beazley. The scholar had been convinced that a cup in the British Museum depicting the death of Sarpedon painted by a second-rate painter had to have been after a model by a grand master. As Mellow wrote, "Bothmer is convinced that he has now found the model conjectured by his old professor. With a magnificent stroke of luck, it has turned out to be a masterpiece by Euphronios."

Mellow was puzzled about the provenance. How could it be that in all the volumes and catalogues of Greek vases lining the shelves in Bothmer's extensive library, the krater had never been mentioned? "Bothmer shakes his head," he wrote. "The interviewer is left with the mild suspicion that the Metropolitan's new masterpiece might have materialized out of thin air."

Five weeks later a second front-page story on the vase appeared in the *New York Times,* entitled "How the Metropolitan Acquired 'The Best Greek Vase There Is.' " The "thin air" theory was shelved. The biting article stated that the object had been illegally dug up near Rome in late November or early December 1971. This initial charge was followed by nine more front-page stories in the next ten days. In the next three weeks there would be nineteen stories. The coverage was more extensive than the Christmas bombing of Hanoi.

The first story, written by the *Times* "New York Mafia reporter," Nicholas Gage, filing from Rome, described the vase and stated that Bothmer and I had refused to discuss details on its acquisition. But the *New York Times* had conducted an investigation which led to five European cities and included interviews with art scholars,

dealers, museum officials, and government authorities, none of whom were identified.

Gage asserted that we had purchased the vase without ever seeing the man who owned it and that Hecht's story had been disputed by "several European scholars and dealers" who agreed that the vase was genuine, but was found north of Rome in 1971 by bootleg excavators, who sold it to Mr. Hecht, who then smuggled it out of Italy. The diggers who found the krater were "veterans who knew they had a prize when they saw the paintings on it and its excellent condition."

Gage reported Dietrich saying that Hecht was "a reputable dealer," then wryly observed, "Mr. Hecht has been arrested in Italy and in Turkey on charges of buying antiquities illegally excavated, but the charges were ultimately set aside. The Turkish Government, however, has declared him 'persona non grata.' " Gage stated that the *tombaroli* had gotten one hundred thousand dollars.

There was a second story, written by David Shirey, a writer who had delivered a highly complimentary front-page article on me for *Newsweek* in 1967. Shirey's piece was an interview with Bothmer, who came off sounding imperious, saying such things as "it doesn't matter if our vase has been the 3,198th or the 3,199th found in Italy" or "I knew Hecht was involved in smuggling charges . . . many dealers are charged with smuggling." Shirey's article ended with a rap: "Mr. Bothmer's attitude throughout the interview was that of a scholar and curator to whom other considerations were incidental."

I put in an angry call to Hecht in Rome "to get over here right away for some explaining!" Hecht told me to "relax." I was stunned and a bit frightened, too, because I was convinced that the *Times* team had rooted out the straight story. But I didn't convey my feelings to my colleagues, especially Dietrich, because of our understanding about avoiding knowledge. Dietrich played the loyal game. He focussed in on one curious statement of Gage's that seemed to him "impossible"—the comment the diggers were veterans and knew they had a prize. Dietrich stated flatly that no vase was ever found intact. "If the so-called diggers saw it in pieces, how were they to know that its condition was so fine?" he asked. It was customary, he said, to set up fragments of what was found in the field in a box filled with sand so that the diggers could get a general idea of what they had. It was virtually impossible to obtain an accurate view of the whole vase.

I sternly told Bothmer either not to speak to the press or, if he had

to, to be careful about seeming so offhand. I then dashed off to hold a television interview beside the vase, which we had placed in a vitrine in its own grand gallery illuminated by a dozen spotlights. I defended buying it, emphasized that no United States laws had been violated, and made one of my patented gaffes—I jokingly referred to the krater as the "hot pot." The name, of course, stuck.

Gage's front-page story on the second day of the siege reported that the Italian *carabinieri* were conducting two separate investigations. He quoted sources as saying the Italian police were convinced the vase had been found in an Etruscan tomb within the last two years and that a second vase, also by Euphronios, had been found in the same tomb and was about to be seized by the Italian police. Hecht was under official investigation. He had been grilled by the police and claimed the owner of the vase was a "friend whom I can not name because revelations might cause tax problems in his own country." David Shirey wrote a backup piece in which it was revealed that Dietrich had told him that Hecht had acted on behalf "of an Armenian," adding blithely "the fragments might have been in a shoe box" and had been temporarily glued together when he had seen them in Zurich. Bothmer had identified Fritz Buerki as the restorer and had told Shirey that *he,* Bothmer, had gotten in touch with Fritz Buerki to repair the vase, saying, "Mr. Buerki is no minion of Mr. Hecht. He is a freelance restorer." I knew the statement to be untrue. When I mentioned it, Bothmer shrugged. When I demanded why he had mentioned a shoe box and pointed out that our huge vase couldn't possibly fit into a shoe box, he said testily, "Tom, I, of all people, ought to know in what space the complete fragments of a calyx krater would fit into."

The front-page story the third day in a row—Wednesday, the twenty-first—was titled "Seller of the Greek Vase Is Named by Met Curator." Dikran Sarrafian was identified by Dietrich and on the same day by Hecht's lawyer in Rome. That had been my doing. I had told Hecht coldly that if he didn't name Sarrafian, we would. Hecht had protested that "Dikran will get into terrible trouble in Beirut! I'll bet he never declared the vase when he took it out. He'll hate me!"

In the *Times* piece in which we revealed the two letters to Hecht that I had shown to the Acquisitions Committee, Dietrich told what we had paid—something the museum had almost never done before. The story at least gave the impression that we wanted to be open and cooperative. The next day there was another *Times* front-page

story by Gage, and this one had us on the ropes. "Never Saw Vase Intact, Beirut Dealer Says." The reporter quoted a host of statements by Sarrafian that were in stark conflict with his letters to Hecht and Hecht's statements to us. Gage had dashed to Beirut and had caught the sixty-eight-year-old art dealer in a rambling interview.

"Dikran A. Sarrafian, the Lebanese art dealer who was named by the Metropolitan Museum of Art as the person who sold it an ancient Greek vase for about one million dollars last September, said today that he had never seen the vase as a whole until he looked at a picture of it in a newspaper this morning." Sarrafian told Gage that he had handed over to Hecht "a hatbox full of pieces," mumbling "if anyone looks closely at the museum's vase, he should see a lot of painting over."

I was fuming. Why the hell did he say that? In other equally damaging statements, Sarrafian also claimed that it had been Hecht who had received the bulk of the money, commenting "I have no complaints about Bob Hecht. Good luck to him. Only the U.S. Treasury may be the loser, and it lost a lot more in Vietnam." Gage also reported Sarrafian as saying "I never expected the pieces in the hatbox to realize a great deal of money."

The *New York Times* obviously thought Sarrafian had never owned a Euphronios. And so did I. In one sense I was eager to hear what possible explanations Hecht would have—and at the same time, fearful of hearing them. He had called to say he was rushing to New York and would be staying at the Stanhope Hotel across the street from the museum and would meet me and my advisors at nine o'clock at my home. I had asked Ted Rousseau, Ashton Hawkins, Dietrich, and John Buchanan, the registrar, to join us. The gathering was tense. Hecht arrived, looking far more jaunty than I had ever seen him.

I asked Hecht whether he had seen that morning's *Times,* which reported that a certain Colonel Felice Mambour of the *carabinieri* had identified a grave robber "who had delivered to Robert E. Hecht Jr. the million-dollar Greek vase." Colonel Mambour was quoted as saying that Hecht had lied to him three weeks earlier when he said that he "knew nothing about the vase."

"What about that, Bob?" I asked.

"Mambour's man asked if I knew about a vase that had been dug up illegally last year near Cerveteri and I told him I hadn't, which I hadn't." Hecht was cool and unflustered, which surprised me.

The *Times* story dwelled on Hecht's "sudden and unexpected departure" from Zurich and his suspicious trip to Beirut. According to Colonel Mambour, Hecht had gone to Lebanon to "gather evidence for a retrospective reconstruction of the history of the vase."

"What about that, Bob?" I asked.

"If that were true, then I would imagine Dikran would have had a pat story for Gage."

The point was well taken.

The *Times* story hammered away on the inconsistencies implying that we, Hecht, and Sarrafian were all lying. We had claimed that the pot was in a European collection since before the war; Sarrafian had said he got it in 1920. The vase was not intact as we had said, but was in sixty or more fragments. We had insisted the owner had a valuable collection, but Sarrafian had said he owned nothing of interest. Sarrafian had said that the bulk of the money had gone to Hecht, not him.

"I am to blame for most of these inaccuracies," Hecht said. "I was the one who said European collection before 1914 because when Dikran said his father found the thing in Europe, I assumed that to be the case. I have brought with me a signed affidavit by Dikran in the presence of witnesses who attest to his signature."

The document read: "This is to confirm that the Attic red figure vase signed by Euphronios and consigned by me for sale in Zurich to Mr. Robert E. Hecht, Jr., in 1971 formed part of my father's collection and was acquired by him in the winter of 1920 in London in exchange for a collection of gold coins from the Near East. Moreover the above mentioned crater was in fragments and Mr. Robert Hecht was warned that I was not responsible for any missing pieces." It was signed February 19.

"That's why I went to Beirut—to have Dikran write this," Hecht said with a smile.

"Exactly what does this last sentence mean?" I asked.

"Dikran has always felt that despite the large number of fragments he's had, they could not have comprised a full vase. You cannot look at a bunch of fragments and tell. You simply have to put them together totally and to do that you have to know what you're doing. Right, Dietrich?"

He nodded.

"It was I who learned that the vase was complete. And I then advised him to put a large price on it."

"But," I said, "doesn't his July letter already *ask* for a million?"

"Easy to explain," Hecht said. "I had seen the pieces before that letter—the thing had been in Switzerland for a while—and, you see, already suspected it was terrific. The higher the price he got, the better I would do, and you know, I'm still interested in making a living."

"Why does Sarrafian dodge the issue of having made lots of money?" I asked.

"My mistake again. I erred in saying 'income taxes.' What I meant was that in Lebanon it's dangerous if it becomes known that you have just earned a large amount. Kidnappings are frequent there. In Beirut these days with the political and religious factions shooting at each other, it's *very* risky to be known as a successful man. Dikran prefers not to talk to anybody straight or to let on he's rich or to say that he owns *anything* other than some coins because he's afraid— as is his European wife—that something will happen. Besides, he likes to pull one's leg."

"Pulling legs didn't help with Nick Gage," I observed.

The day's *Times* blast also had a colorful "Man-in-the-News" article about Sarrafian, which further eroded our case. Sarrafian had told Gage, "All I remember is that the pieces contained paintings of old Greeks and a lot of inscriptions," and that some parts were missing. Gage reported that Mr. Sarrafian "does not live like a millionaire." "He and his wife, who is Danish, occupy a fourth-floor walk-up apartment in an old building."

According to Gage, Sarrafian made the rounds of several bars every evening and was in bed by eight-thirty. Gage observed, "This modest, almost apologetic self-portrait does not match the picture some acquaintances paint of Mr. Sarrafian. He was, they say, a highly sophisticated British intelligence agent in World War II, a man who parachuted behind German lines to act as a liaison with Tito's forces." Gage ended his article by quoting Sarrafian as saying he attended Oxford University and admitting, "But I was not very successful there and left without a degree."

"Dikran is, by nature, a highly secretive and almost paranoid man," Hecht explained. "Being Armenian he has seen or experienced much intolerance and has feared several times for his life. He's not the man who would want to talk to a Western journalist and might easily try to seem to be something he is not."

"But *did* he have this vase? And *did* he get payment?" I asked.

"He did. And I have a receipt for payment dated in October, and I'll get it for you." Hecht paused and looked over at our hostile

faces. Then he said something which came as a complete surprise and suddenly had me thinking that I might have been wrong in believing that the Sarrafian story was a phony.

"If you want to give the vase *back* to me, I'll take it . . . and will give you a million one hundred thousand dollars for it, too."

"No, no, no!" Dietrich said quickly. "Tom, there's nothing we did against the law. The piece entered legally. It came from Switzerland."

"Yeah," I said. "But what about Gage's report that Mambour has identified the *tombaroli?*"

The story, as reported by Gage, stated that three members of a gang of six *tombaroli* had been infuriated to learn that Hecht had received a million for "their" vase, since they had been given only about eighty-five hundred dollars. Gage affirmed that in the autumn of 1971, a haul of art objects was found in an Etruscan tomb near St. Angelo and Cerveteri, including our krater and "a Greek cup, smaller but perhaps more precious, and these were said to have been sold to an unidentified merchant for $200,000." Colonel Mambour "knew the name of the *tombarolo* who first handed the vase to Mr. Hecht."

At that, Bob Hecht asked jovially, "How could it be that the Euphronios, which was in Zurich already in the summer of 1971 and specifically mentioned by my wife to you in early September, could have been found in November or December?"

"She didn't mention a *vase,*" I reminded him. "Of course it *did* turn out to be the vase."

"If you look carefully into the facts," Hecht said calmly, "and the chronology, you'll see that this *tombarolo* story has to be false." He seemed to be enjoying himself and that impressed me.

Dietrich suddenly spoke up. Several months earlier Hecht had shown him that "smaller" cup, a fragmentary *kylix,* or wine cup, also decorated by Euphronios, *also* with the depiction of Sarpedon (one the master must have done quite early in his career, for Sleep and Death were hauling the Lycian prince off like a chunk of wood). To my horror, Hecht plucked a photo out of his briefcase and said quietly, "Here it is. Want to buy it?"

"Christ, Bob," I complained. "In the middle of this fire storm, you have the gall to offer me *this? * Where did *this* come from anyway? And . . . how much is it?"

He smiled. It was a mere seventy thousand and was currently in "a Norwegian collection." I groaned.

Dietrich explained that he had talked to various scholars about the fragment and had even showed a slide of it in a lecture to a scholarly symposium. I groaned again.

"I wouldn't believe the word of a *tombarolo* very much," Hecht said. "They tend to lie, usually to get out of another investigation or to try and get a reward. The standard story—I've read them dozens of times in the Italian press—is the man steps forward annoyed that he didn't receive enough. It never or seldom turns out that he had anything to do with that dig. Unless there is hard evidence—photos of the *tombaroli* holding pieces of this Euphronios vase—I wouldn't take the tale very seriously."

It was time to break for lunch. Hecht asked me if he could use a "secure phone" to talk to his lawyer to find out more about the *tombaroli*. First he called his wife in Rome. She advised him to stay out of Italy for the time being since the newspapers had judged him guilty. Hecht then reached his lawyer. I sneaked up to the door of the room where he was phoning and listened. I had to know if he had been lying. I believed he had been. Hecht spoke Italian, which I understood. What Hecht said to his lawyer surprised me. He asked about the *tombaroli*—how many, their names. Over and over Hecht asked *when* the supposed illicit dig had taken place. November? December? He laughed. Then I heard him ask in a loud voice, "*Hanno le fotografie? No? Bene.*" He was laughing. What he had said was "Have they photographs? No? Good!"

Hecht emerged looking highly amused. He looked at his watch and suddenly blurted out that he had to get to the airport quickly, he was about to miss his plane to Zurich.

After Hecht and everyone else had left, I stayed at home for a while and took the pages out of my diary in which I had speculated about the true provenance of the krater and put them in a safe place. I had no doubt that the trial by press might at some point turn into a real trial, and I did not want my idle speculations and fancies made available to the prosecution.

The next afternoon when I met *Times* correspondent David Shirey, I was feeling optimistic. If Bob Hecht, who had so much to lose, was not upset, why should I be? The Italian authorities did not have photos of the illicit diggers mugging with bits and pieces of their —*our*—prize, so why should I worry? I told Shirey that the *Times* stories were "crazy" and that the Italian authorities were being "suckered." When he tried to probe, I turned him aside.

The *Times* kept printing stories on the front page, accompanied, at times, by follow-ups on the inside. There was an unmistakable feeling of celebration in a few of them that made me suspicious about the reporter's true motives. The *Times* reported half-joyously that many of our colleagues thought the price ridiculously high. John Cooney, the curator of Greek and Roman at Cleveland, was quoted: "I would appraise the vase at $150,000 and be willing to go up to $250,000, but no more." One of the museum's irrepressibly dissident curators, Oscar White Muscarella, commented, "I wish I knew the Armenian word for *deus ex machina*."

The *Times* added that "Another unnamed curator said that the Sarrafian letters 'smelled awfully fishy.' " I still felt the same, though I kept analyzing the meaning of Hecht's casual attitude and the discrepancies between the Italian story of when the krater was found and when we learned about the vase. By the end of September, the *Times* backed off from its dogma that the krater had to have been smuggled: "Although some experts believe that the Metropolitan vase came from a recently plundered Etruscan tomb in Italy, there is yet no evidence to support this belief."

Yet, the next day, Sunday, the twenty-fifth of February, the *Times* hit us with three long stories, dredging up every allegation published thus far. It was getting to be a case of "guilt by allegation." The front page belonged to Nicholas Gage, who identified the *tombarolo* who had found the vase. He was Armando Cenere, a thirty-seven-year-old "bootleg" archaeologist, who swore the Euphronios had been discovered with a magnificent second Euphronios—the very fragmentary cup Hecht had shown me.

Cenere was alarmingly precise about the circumstances. The date was late November, 1971. The tomb was at Santangelo, twenty-five miles north of Rome. It had taken eight days to clear the bursting tomb of its many pieces of pottery, which included the two Euphronioses and a statue of a winged sphinx. Cenere had been shown pieces as they were dug up—he was a lookout—and had seen one so striking he couldn't forget it, one decorated with "a figure of a man bleeding." Cenere described the piece to Gage as "bigger than a man's hand," adding that it contained "almost the entire figure from the head to midway above the knees." Cenere had been shown a photo of our vase, presumably by Gage, though the story didn't say, and had "picked out the dead figure of Sarpedon."

I issued a statement to the *Times* saying that I was dubious about

329

Cenere. By this time, Hecht had obtained a sworn statement from Fritz Buerki that he had been delivered the object in August, 1971—and obviously, there's a great difference in climate in Italy between August and late November. Besides, photographs of the krater had appeared dozens of times in the Italian press, and Cenere could easily have seen them. I found it odd that of the dozens of fragments the *tombaroli* had found, the only one Cenere had been shown and identified was the central figure of the principal side of the krater—a bull's-eye. Another point that made me suspicious of Cenere was that his description of the actual Sarpedon fragment was at odds with the dimensions of the real shard.

Later we were told by a man with many contacts in Cerveteri that the *Times* reporters had dashed throughout Etruria with photographs of the krater asking whether anybody had seen the piece or excavated it. The only person to respond was Cenere, an itinerant worker, who had his memory refreshed by a photograph showing the detail of Sarpedon.

By this time all the newspapers, magazines, and radio and television stations in the world had mentioned something about the hot pot. Some had not played by the rules. A correspondent of the *London Observer,* Richard Walter, interviewed me and made a show of taking elaborate notes and ostentatiously halting when I said I wanted to go off the record. Later it was clear he had been "wired." As the *New York Times* reported the story: "On Saturday, Mr. Hoving first denied, then affirmed that he had seen a photograph of the cup. . . . Richard Walter of the *Observer* said Mr. Hoving himself had mentioned the cup in a tape-recorded interview. . . . Mr. Hoving said, 'Funnily enough, only today I was offered a kylix by Euphronios, and the subject on it is Sleep and Death bearing the body of Sarpedon.' " Walter had also gotten Sarrafian to say that he had given Hecht an invoice showing a fantastic price for his vase, at Hecht's request, so that he could "avoid paying United States income tax on his full profit." Curiously enough, the IRS never brought charges against Hecht.

The *Times* battering ram kept smashing into the Met right through February before it began to slow. Shirey wrote that Hecht had come to my apartment. I was reported as saying, "We spent Friday morning together and had a breakfast of bacon and eggs and later a spaghetti lunch. Mr. Hecht said to me that he has never been arrested, shackled, or fettered. I asked him if it was a hot pot. Mr. Hecht said that the krater was definitely not a hot pot."

I was becoming convinced that whatever our piece was, it could not be connected with anything out of the illicit dig of November–December 1971, if that event had ever occurred.

Douglas Dillon gave an interview to the *Times* in which he stated that few objects bought by the museum had provenance documents as extensive as the vase. "We had the vase legally declared in Customs and our purchase was done in good faith," he said. Dillon also stressed that even if it turned out that the vase had been smuggled out of Italy, we would give it up only if the Italians paid us back in full.

The FBI and the New York police entered the investigation on behalf of the Italian government and interrogated Dietrich. We issued a statement that we'd be willing to cooperate with any legitimate inquiry, but when the *Times* asked to be supplied a second time with the photos showing all the breaks, we turned them down. The *Times* was far from an official investigative body.

The hot-pot affair bubbled along until April of 1976, sometimes boiling furiously, sometimes simmering so gently that one might have thought the heat had waned. The *Times* coverage tailed off in May, and by the end of the affair the newspaper seemed so uninterested in the story that not a line appeared in the paper.

The Italian authorities, especially Colonel Mambour, kept issuing inflammatory statements about "positive proof" that our Euphronios had been "stolen" from Cerveteri. Four large pieces said to have come from the illegal dig were found by the *carabinieri*. The police turned them over to a highly respected professor by the name of Massimo Pallotino for his opinion, and he affirmed that they "belonged to a vase painted by Euphronios." We told the Italians that we would remove the krater from exhibition, place it in a storeroom, and allow the Italian experts—or *carabinieri*—to have all the time they wanted to fit the errant shards in. We knew that whatever the pieces were, they could not possibly belong to our vase. They had been described by unidentified sources as showing a "flowered pattern closely resembling that on the vase's rim." Not a speck of the rim was missing on our vase.

I had also been able to determine to my own satisfaction that the "bootleg" digger Armando Cenere was all wet. I allowed Nicholas Gage another look at our pre-restoration photos of the vase in order to discover precisely what fragment "as large as a man's hand" Cenere had outlined for him. The fragment Cenere described was far smaller than the trapezoid-shaped actual piece.

In July, I was vacationing again in Martha's Vineyard, far more fascinated with the slow death of the Nixon presidency than with Greek vases. I'd drop in to the museum a few days a week. Things were extremely quiet. When I arrived at the museum one sweltering morning, Wednesday, July 25, John Buchanan had some startling information. I had received a letter on singular stationery—brown, the color of a common paper bag—handwritten in purplish ink in a round, bold hand. The writer was Muriel Silberstein, a Chicagoan, unknown to me.

Mr. Hoving, I feel you should be sent this copy of a letter I sent to Dikran Sarrafian. . . .

Yours truly, Muriel Silberstein.

Dear Dikran Sarrafian,
Many years have passed since my husband and I visited you in Beirut (1964, I think). I hope you will remember us. Roberta Ellis introduced us. After having read and reread most of the publicity on the Euphronios calyx krater which the Metropolitan Museum in New York purchased, I feel it is my responsibility to tell you that I recall your showing me, when my husband and I were in your apartment in 1964, a large box containing, as you stated then, the shards of a Euphronios krater, which, as you said, your father purchased in 1920. If this bit of remembered information can be of any use to you now you may make use of it. I know you to be a man of integrity and hope that your good reputation is intact and will remain so. I saw Roberta Ellis recently, but have not been back to Beirut in these many years. Best regards to your family.

Sincerely,
Muriel Silberstein.

The name Roberta Ellis was quite familiar to me. She was the widow of Corson Ellis, who had lived next door from my father and mother in Lake Forest in the late twenties and early thirties and had thrown an almost unending series of parties with my parents. How Roberta Ellis figured in this was another one of the bizarre mysteries surrounding the vase, but for now I let out a howl of delight.

I called Silberstein at once and asked if I could come out with my lawyers and obtain a statement in writing. She hesitated and told me she would be away for a while and suggested a time in late October or November. I desperately wanted to hear her full story and get her

to sign an affidavit, but she resisted, saying only that she was "positive" she had seen the fragments of the vase years before. It was no use pressuring the woman, and I cheerily told her we'd meet in the fall.

Dillon had called for an in-depth, in-house investigation of the whole hot-pot affair by Ashton Hawkins and the Lord, Day & Lord lawyer John Loflin. Their first stop was Beirut. The goals were to get Sarrafian to swear in writing to his tale, identify some Lebanese who had seen the krater, find out when and how and by whom the pieces got out of Beirut, discover where Sarrafian had kept the vase in Switzerland, obtain proof that Sarrafian actually got paid, and obtain from Fritz Buerki or anyone else in Switzerland statements about when the fragments had arrived in the country.

Hawkins and Loflin went in October and had a typically Mideastern time. Sarrafian, as Loflin remarked to Hawkins, had to be "peeled like an onion," although he turned out, as Hawkins put it, to be a man "with style, charm and a certain presence"—definitely not the broken-down alcoholic described by Nicholas Gage. He was difficult and found the vase affair irritating and vexatious and let us know that he felt that the Met was somehow to blame for his name getting into the mess. Loflin and Hawkins met Sarrafian and Hecht, whom we had invited to participate, and Philippe Dargham, Sarrafian's lawyer, who was the former secretary-general of the Beirut bar association.

After considerable persuasion, Hawkins and Loflin at last got the papers. Some of the ambiguities and contradictions were never clarified. The date when Sarrafian was paid his money, early or late in October 1972, was never certain. The amount was either eight hundred thousand or nine hundred thousand. One receipt showed payment dated October 19, 1972, for 3,411,000 Swiss francs (roughly $909,000) given to Sarrafian by Hecht. Just who brought the fragment to Switzerland in 1966 always remained a mystery. One witness, Mounir Reza Bey, was at first eager to sign an affidavit that Sarrafian had shown him the Euphronios fragments then turned coy and backed out. While all this was going on, the United States Embassy was frantically trying to evacuate five thousand American nationals from the city.

But powerful evidence was assembled. We had Sarrafian's sworn account about his ownership, we had Hecht's report of how he had first learned of the vase, we had testimony from Dargham, the law-

yer, that Sarrafian had asked him about legal steps on taking his Euphronios vase out of the country, and we had testimony from a certain Mr. Hanna Azzi, a legal administrative clerk, asserting that Sarrafian had shown him the vase fragments in the early sixties.

Moreover, Buerki swore in an affidavit that he had received the fragments in the beginning of August 1971, and even better, we got an affidavit from the Swiss photographer in Basel, Dieter Widmer, to the effect that he had received "fragments in an unrestored state" in early September. He gave us the document proving he got paid on October 25, 1971. My wife had come up with the idea to approach the photographer.

The accumulation of "evidence" was impressive. Whatever the Euphronios krater *was,* clearly it had nothing to do with Armando Cenere's piece found in late November, early December 1971. We got our findings in the *Times* in a story by David Shirey, but the paper wasn't very eager to point the details.

Still, our research did have a dramatic effect in Italy. Once the courts received our packet of material from Hecht's lawyer, the warrant for his arrest was quashed. The judge revealed that all the data the *carabinieri* had gathered had been "raw," taken without oath and without cross-examination.

My security and certainty were short-lived. I had gotten my hands on confidential *carabinieri* reports of the interrogation of the "bootleg" digger and Bob Hecht. There was no doubt that a tomb had been clandestinely excavated in December 1971 near San Antonio di Cerveteri by six persons, all of whom were named and identified including Cenere. Hecht had been identified by the tomb robbers as the purchaser of a number of the stolen pieces, including a stone sphinx and a lion which Hecht had allegedly shipped to America.

One report stated that no one intended to sign written declarations, for fear of reprisals, since Hecht was considered a mafioso. I didn't show this information to anybody and was left to wonder why the *New York Times* hadn't gotten hold of the reports.

In late November, the Italian prosecutor signed up an archaeologist and a professor of nuclear geology to study the fragments that they believed to have come from our vase. We supplied the court with a sharp set of black and white pictures showing each crack and fissure. The experts ruled that the fragments did *not* seem to belong. The prosecutor threw out the finding and enlisted another pair of experts. Their conclusion was the same—the four pieces did not fit.

We wrote up a detailed, seven-page analysis and sent it to all the members of the museum corporation and, of course, the *New York Times*. Nicholas Gage reported on our findings, though he stubbornly defended the point that what Cenere had described to him as the shard with the "bleeding man" was not all that different from the actual piece.

It was too late to publish in our findings the astonishing information Muriel Silberstein relayed to us in late fall. As it turned out, the omission was a very lucky break. Hawkins, Loflin, and I met Mrs. Silberstein at the Drake Hotel in Chicago, and the three of us grilled her for hours. Muriel Silberstein was an attractive widow in her fifties who had assembled an excellent collection of abstract expressionist paintings. She had gilt-edged credentials, being an active member of the 20th Century Acquisitions Committee at the Art Institute of Chicago. She told me that Roberta Ellis, who had just passed away, had cured herself of alcoholism and had won a Ph.D. in Near Eastern studies. She had conducted intimate tours for friends to places like Turkey, Jordan, and Lebanon. In Beirut Roberta Ellis had suggested to the Silbersteins that they meet art dealer Dikran Sarrafian who, she said, owned an impressive collection of cylinder seals.

In the fall of 1964 the Silbersteins visited Sarrafian, who showed them a large number of cylinder seals, some of which were superior. When Silberstein told Sarrafian that she really wanted seals for a decorative necklace, he had laughed and said his were far too good for that and turned to some lesser decorative examples. She had purchased them and had had a necklace made, which she still cherished.

The Silbersteins had visited Dikran and his wife a second time. They were seated on the terrace when Sarrafian suddenly said he had something he wanted to show her. As her affidavit stated: "I followed Mr. Sarrafian into a small room where he opened a large box containing sherds. He told me they were pieces of something called a krater—an ancient Greek vase—signed by a great artist named Euphronios, which his father, an art dealer, had acquired in the early twenties. The sherds were large—very—and thick and extremely dirty. I have no recollection of any particular designs on them. Mr. Sarrafian explained that the painter of the vase was one of the important names in history and I always remembered the name, Euphronios. He wanted to know if I might be interested in purchasing them. I told him I wasn't."

Years later when the hot-pot fracas was raging, Silberstein had im-

mediately recalled meeting with Sarrafian. One evening at dinner Newman told her spellbound guests that she knew something about the vase that no one on earth knew, something that would help indicate that the Met was right and the *Times* wrong.

Her guests were entranced. She asked them what she should do. One, James Speyer, the assistant curator of twentieth-century art at the Institute, advised her to keep quiet about the matter—the Mafia might be involved. Another guest, Michael Arlen, the *New Yorker* writer, asked her how she would act if she knew a crime had been committed. Why, she'd tell the authorities what she knew, of course. Then, Arlen said, what would she do if she knew a crime had not been committed, but that somebody had been accused of committing one? Again Newman replied that she would reveal what she knew. Then she had to do the same, Arlen insisted, in the case of Sarrafian. Arlen made a point that he, like Sarrafian, was Armenian and was sensitive to the persecutions Armenians had suffered over the centuries. Arlen's arguments had led to Newman's letters to Sarrafian and me.

We dispatched Newman's testimony to Hecht's lawyers in Rome and to the Italian authorities. To me, what she had sworn to was crucial. It was one thing to speculate that Hecht and Sarrafian had conspired to concoct a phony provenance for the krater and another to suspect Muriel Newman, an upstanding member of the Chicago art community, had been a part of the conspiracy. She had nothing to gain. She swore she had never met Hecht or any members of his family. She was able to prove that she had been in Beirut at the time she claimed from stamps in her passport.

Despite all our "evidence," the hot pot wouldn't go away. Dikran Sarrafian and his wife were killed in a mysterious car crash. Despite the Italian magistrate's all but giving up the case, in 1977, almost six years after I had first learned about the Euphronios, District Attorney Robert Morgenthau began a Rackets Bureau investigation into the "conspiracy" lurking behind it. The assistant in charge of the bureau, Kenneth Conboy, subpoenaed the museum for all records on the vase. Though we were told a grand jury was probing the incident because of the recent deaths of the Sarrafians, my instincts told me that Morgenthau was after *me*. I contacted Arthur Liman, who took my case. From the first words out of his mouth, I knew I had come to the right man. Just weeks before, he had heard Morgenthau "railing somewhat irrationally," he thought, against me, about

how I had "almost destroyed the museum" by my "popularization programs." "This may be part of this investigation," he said. I believed Liman. I prepared a dossier on every possible link I had had with Hecht, even going back to my days in Rome when I had met him casually.

What Morgenthau's people didn't find out, until the last moment, was the existence of Muriel Silberstein. They were set to call Dietrich and me to the stand when they learned about her and frantically got her to New York. For two days she was interrogated by the pair of assistant district attorneys, Frank Brown and Kenneth Conboy. She described the experience as a "terrible ordeal," the point of which was to pressure her to change her story. Conboy asked her rudely if she weren't "looking for notoriety" in sending me her letters. She told him about her conversation with Michael Arlen. Conboy asked a barrage of questions: How big was the box? What did you see? Were the shards grimy or clean? What kind of light was there? She repeated her story a number of times. Both prosecutors asked repeatedly about her affidavit for us, suggesting that, somehow, she had been forced to give it. Silberstein smiled her calm little smile and said she might be "petite" but was not easily pressured. At that she noticed that some of the members of the jury began to look away from her and fix an annoyed gaze at Conboy and Brown.

Towards the end of the six-hour ordeal, the grim subject of the death of Dikran Sarrafian and his wife came up, with one of the detectives on the case saying "Well, it's strange, nine hundred thousand dollars unaccounted for and this Sarrafian and his wife die two months later."

Repeatedly, the assistant district attorneys pressed Muriel Silberstein to "change [your] testimony, it'll be all right." She looked at them benignly and said, "No, I can't. Not even if I wanted to. I can't change the truth."

At that, the members of the grand jury asked to go *in camera*. When they emerged shortly thereafter, they asked the case to be dismissed. It was.

At times I had wondered whether Dikran Sarrafian's krater was not the object of the cleverest con game in modern art history. Now, I am convinced it was not. But I am persuaded that, totally unknown to Dikran Sarrafian and to me at the time, it is the key to the most intriguing—and for Bob Hecht the luckiest—case of deliberately mistaken identity in the annals of art.

My latest theory is that there were two kraters and one cup, all by Euphronios, all owned by or consigned to Hecht. This two-krater theory revolves around a fine fragmentary calyx krater, also indisputably by Euphronios, depicting the struggle between Hercules and Kyknos (now in the collection of Leon Levy and Shelby White in New York).

This krater is about fifty percent complete. Enough of the fragments have been pieced together to be able to determine the diameter and height. The back side represents an athletic scene. It was sold in June 1990 in the Bunker Hunt sale of Greek and Roman antiquities . . . and fetched $1.65 million. In that sale was also the splendid cup by Euphronios with Sarpedon, the very one that Hecht had shown me and Bothmer in a photo in February 1973.

It is known that both the *kylix* and the Hercules krater came to Hunt from Bruce McNall, the proprietor of the Summa Art Gallery and Numismatic Fine Arts, a coin auction house, both in Los Angeles and, more recently, the owner of the L.A. Kings hockey team. In the mid-seventies, Bruce McNall was Robert Hecht's secret United States partner. Together in my office at the Met they both boasted to me of their partnership. Significantly, the pieces of this Hercules and Kyknos fragmentary krater are such that they would easily fit into a shoe box or hatbox and could readily be stuck together with tape for a photograph. The great Met krater would be too heavy—even in pieces.

Even though Hecht told me in Zurich he wasn't interested in vases, the fact is, he was. In the late sixties and early seventies he was conducting a bustling business almost exclusively in vases. The fragmentary Euphronios krater sold to Munich's Antikensammlung in 1970 for a quarter million and set a new high-price level. It seems likely that around the time he sold that Euphronios to Munich, Hecht recalled Sarrafian's fragmentary krater and persuaded Sarrafian to let him sell it. Sarrafian probably shipped off the shards to Hecht in July 1971. Hecht recognized that it was even more important than the Munich piece. Sarrafian's was the fragmentary krater received by the photographer Widmer in September 1971 that was photographed after the pieces had been stuck together temporarily with tape—not something one could have done with a complete, far heavier, krater. Knowing that Bothmer had yearned for a Euphronios, Hecht had his wife, Elizabeth, alert me about Sarrafian's in the most general terms, never mentioning that the object was a fragmentary

vase and not mentioning a price range. Until the discovery of a more complete Euphronios, Sarrafian's would be one of the finest on earth.

Then a miracle took place.

The Etruscan tomb near San Antonio di Cerveteri filled with Greek treasures, including the Euphronios *kylix,* the complete Euphronios krater, the sphinx, and the lion, was discovered in December 1971 and the contents bought by Hecht. The krater was restored by Buerki starting around January 1972. Hecht's jubilant letter to Bothmer in February 1972 was actually about *this* miraculously complete vase, *not* the handsome, valuable fragmentary Sarrafian Euphronios that prompted Elizabeth Hecht's call. When, in Zurich, I insisted that Hecht back up his vase with a clean provenance and title, he adroitly substituted Sarrafian's fine fragments—after all, it *was* a bona fide krater. That is, of course, why Hecht added that odd P.S. to his upbeat letter to me on June 29, days after I had been in Zurich, that he was happy I had seen and liked what his wife had described to me on the phone in September 1971.

This two-krater theory explains all the confusion, the ambiguities, the contradictions. It clarifies why Sarrafian kept insisting that his vase was not complete and that he had not gotten as much money as Bob Hecht. Hecht no doubt only later told him about the switch—when the question of money arose. The theory also leaves intact the testimony of all the people—Dargham, Azzi, and Silberstein—who swore Sarrafian had talked about a vase inscribed with the name Euphronios. He had. It explains why the Italians were convinced that a tomb had been broken into. It had. The theory explains why *we* kept sticking to our story that we had clear provenance and title and why we got rather paranoid about the *New York Times* and why, in its turn, the *Times* got furious at us because of our "lies and deceptions." And, finally, the theory explains why I had started off thinking that the old Beirut ploy was nonsense and ended up by being convinced that Sarrafian had to have owned the Euphronios—or, more accurately, *a* Euphronios.

Yet, what about those four Euphronios fragments of a rim the Italians received anonymously? How do they fit in? Certainly not to the Met's vase, of which nothing is missing. And they do not seem to fit into the "Sarrafian" vase, either. In all probability they are stray fragments left inadvertently behind by the nineteenth-century archaeologist, the Marchese Campana, the man who discovered the

great Louvre Euphronios krater depicting Hercules and Antaeus. Today, the pieces are locked in some secret storeroom in Rome's Etruscan museum, the Villa Giulia.

As for proof of this two-krater theory, it may still exist. It is probable that we never saw the record photos taken by Widmer of Sarrafian's fragments, although we were led to believe we had. What if the number of pieces in the Widmer photos were the same as for the "Sarrafian-Hecht-McNall-Hunt-Levy-White" krater? The photographer's invoice happens to mention that there were thirty-two prints, one for approximately each fragment. The Levy-White krater seems from counting the cracks evident in the photos to be made up of around thirty-five to forty pieces. The Met's krater has many, many more.

18

HIGH ROLLER

Why I wasn't fired in the wake of the deaccessioning and hot-pot scandals I'll never know. Other museum directors were falling like autumn leaves—John Hightower at MOMA, ousted by an imperious David Rockefeller, and Perry Rathbone at Boston, who got snared in a web of suspicion when it turned out the prime acquisition of his centennial, a Raphael, had been smuggled from Italy and was not even a Raphael.

There were continuing problems. Charlie Wrightsman attempted to have me thrown out and replaced by John Pope-Hennessy of the Victoria and Albert Museum. Wrightsman's putsch attempt—he was also calling for the retirement of Douglas Dillon—was foiled by Andre Meyer who told him coldly, "If Hoving goes, I go." Wrightsman backed off, but our relationship was over. Dillon made it clear that he considered himself *particeps criminis* in every tumultuous scandal. Other friends, including Ros Gilpatric and Daniel Davison, were unswerving in their support.

But perhaps the most compelling agent in my defense was Richard Dougherty, the incoming vice-director for public affairs. Ros Gilpatric stopped off at my office one evening after an arduous session drafting a pair of White Papers on deaccessioning and the vase Dillon had ordered to be prepared, and tossed a book on my desk. "Use it as a résumé for the guy we might hire to replace Eddie Warburg." It was the jaunty reminiscences of its author, Richard Dougherty, who had served as press secretary for George McGovern. It was the most unusual curriculum vitae I had ever read. I read it that night, and when Gilpatric called the next day, I said, "We *have* to hire this guy."

Dick Dougherty, a cigarette-smoking, gravelly-voiced bantam Irishman, was as opposite to the genteel, airily noble Edward Warburg as one can imagine. Witty and outspoken, Dougherty was incapable of toadying to anybody—museum trustee or presidential candidate. When we met, he looked me in the eye and laughed at the very idea of working in such a refined place. I signed him up immediately. When asked what he would do first, Dick Dougherty barked his throaty laugh and said, "Stop the fucking war between you and the *New York Times!* Now, Hoving, will you promise to shut up?"

I did, perhaps for the first time since I had come to the museum. Whenever I opened my mouth, it was not until I had been coached by Dick. Soon there was a truce between the *Times* and the Met and peace, too, with all the rest of the press. Within a short time I was no longer the leper. A series of stories began to appear "proving" that the museum was *the* leading tourist attraction in the city, outdrawing the Statue of Liberty and the Mets. The Met had probably been close to being the top tourist draw for years. Dick Dougherty simply etched the fact into the public mind. When he made a statement, people believed it.

When the dust began to settle, I came out of my bunker and tried to keep the revolution moving forward. There had been some talk among the trustees about entering into a period of "consolidation." To me the word signified nothing less than surrender. I nodded a few times when the word came up in board meetings and launched into a passionate description of the grand art exhibitions I planned to mount. I talked about covering the entirety of art history, from ancient Egyptian times, through Greek and Roman to the Renaissance into modern times. My thinking was to track the Met chapter by chapter with stupendous shows from all over the world, creating a

variety of publications and, of course, films and television programs. Few members of the board even reacted. Could they be getting too old, too battle-worn? My shows would, I swore to myself, eclipse the efforts of the Centennial and would outshine the performance of the Council of Europe.

Although the deaccessioning battle had sapped my fervor to get rid of things—even Dillon became gun shy—that did not prevent us from keeping the program inching along, to show our lack of guilt more than anything else. I scrutinized the world art market for acquisitions, finding that it was getting more and more difficult to find works of art that the Met really needed. One of the most intriguing acquisitions the museum ever made turned up under our feet and turned out to be very good business, indeed. It was engineered by Morrison Heckscher, the associate curator of the American Wing, who from time to time reassured me that he was *not* timid like his cousin Augie Heckscher.

He grabbed my attention by telling me that he wanted Arthur Rosenblatt and the New York architect Edgar Tafel to participate in a grand acquisition. Tafel, Rosenblatt, and Heckscher came toting a pile of books and a slide projector. "We have the chance to buy an entire house by Frank Lloyd Wright—the marvelous Northome on Lake Minnetonka in Wayzata, Minnesota." Heckscher turned on the slide machine and put up a series of color photographs of a gorgeous "prairie-style" Wright house with serene interior spaces and striking furniture and decorations. I had visited the house during a museum conference in Minneapolis. Unlike all other Wright private homes, this one had not been messed up. All the original furniture, down to the light fixtures, looked like the day the house was opened in 1915.

The house had been commissioned in 1913 by the Little family, about the time Wright was finishing the Imperial Hotel in Tokyo. Mr. Little's daughter and her husband, Ray Stevenson, still lived in it. They were seeking to build a more comfortable—and warmer— house on their property (the Wright house had originally been a summer cottage) and had asked permission to keep the Wright house and build nearby. Local building ordinances, however, forbade two abodes on the plot and all attempts to sell it had failed. The authorities had allowed them to start building a new Georgian-revival brick home with the mandate that those parts of the Wright house closest to the new house had to be amputated, namely the spectacular living

room, so vast it was almost a freestanding structure. A local Wright historian, Don Loveness, had alerted Tafel to the impending destruction of the treasure, and Tafel had gotten in touch with Rosenblatt.

Before coming to me, Heckscher, Tafel, and Berry Tracy, the chairman of the American Wing, had visited the house. As Heckscher said in a subsequent publication, "I won't readily forget that first overwhelming impression . . . a sublime space, exquisitely detailed. . . . The wood trim still had its original wax finish, the plaster its original earth-tone washes; even the original furniture was still in place. And it was flooded with autumnal light. Berry and I agreed that if the house must come down, we must have the room and all its furnishings . . . for the new Wing with a view to Central Park."

Heckscher was insistent that we get out to Minneapolis at once and buy not just the two rooms that had to be demolished, but the entire Little house and everything in it—its library, the three bedrooms, its furniture, the lamps on the walls, and some two hundred windows of ornamental leaded glass all designed by Wright. He suggested that what we couldn't install in the new wing we could sell to other museums. "The purchase of the whole contents will help blunt the inevitable outcry of our being party to the demolition of a landmark Wright house," he said. He suggested—albeit tentatively—that what we might make in the sale of unneeded parts might make up for some of the costs.

I asked what the costs were going to be. No one knew. There was only one way to find out—get to Wayzata quick and ask the Stevensons. So, two days later Rosenblatt, Heckscher, and I flew out, met the charming Stevensons in the few rooms they kept heated, and, after a tour of the magical house, started to barter.

Ray Stevenson could have played the typical Midwesterner in a television commercial. Bluff, with a glimmer of mischief in his eye, he told me, "I could beat my gums here about this house for a while, but the point is, we love it, but want to move into our new place, so I don't have the luxury of time. What about one hundred and fifty thousand dollars, which includes *everything*—all the furniture, the fittings, the stuff in the basement, including a couple of golf bags, some trunks of drawings or whatever, even the lightbulbs, hell, some of them are original."

"Agreed!" I said. We spent the rest of our time inspecting the new prize and having an amusing time with the delighted Stevensons. Approval by chit from the Acquisitions Committee came days later. And the loving demolition of the house proceeded smoothly.

The purchase turned out to be more of a bonanza than anybody realized. We found all of the original architectural drawings by Wright and a host of love letters from Wright to Mrs. Little carefully stored in trunks. That explained why the master had lavished such attention on the house, visiting it personally at every opportunity to see that the construction was going well. The acquisition and dismantlement cost something in the vicinity of a quarter of a million dollars, a fair portion of which was earned back by the sale of casement windows, furniture, and two small rooms. Today, the Salon is one of the glories of the American Wing.

In the spring just before the house would be taken down, the Stevensons held a last great party and invited everyone from the museum who had been involved plus a couple of hundred of their friends. I came in my blue felt Sicilian cape in honor of Wright, whose spirit I felt roaming around the rooms. The party was beautiful and poignant—and, at times, amusing. Morry Heckscher told me that several of the Stevensons' friends had quietly asked him what *was* there about the old house that could possibly interest the Met.

Once charged up again over acquisitions, I never let anything—even the most hopeless object—alone without at least a cursory examination. Had I become an addict? It sometimes seemed so to me. Writer Sophie Burnham thought so, and thus described me in her exposé of the art world, *The Art Crowd.* "The museum had a hold on Hoving. It was driving him in his own direction which was greed. . . . His sense of competition made him grab everything around, looking over his shoulder at the nearest runner-up. . . . The winning was what he loved. The prize was inconsequential."

Acquiring was, perhaps, my addiction, but it often seemed that all my time was taken up planning for exhibitions and travelling the world to arrange them. My dream was to have a fully balanced schedule of outside shows, of all sizes and subjects, of all moments of art history. More than anything, I wanted to display temporarily works of art the average visitor could hardly expect to see and that the museum could never hope to acquire. Scholarly shows were not discouraged, but I was more interested in reaching the nonspecialist. I had set my sights on three super shows—"King Tut," anything from mainland China, and that Scythian material from the Soviet Union. At the same time I pressured the curators to mount small exhibitions of high quality and maximum popularity. One, conceived by Charles Moffitt, the associate curator of European Paintings, was two dozen or so paintings that had been owned by Vincent van

Gogh. We mounted the show in a modest pair of galleries in the Paintings Department and had to move it to larger quarters when the public mobbed it.

In our campaign to entice the Chinese, Karl Katz came up with a clever idea—mount a show of all the important photos taken by Western travellers in China since the 1870s, with work by Robert Capa, Cartier-Bresson, and Rene Burri. The exhibition, some two hundred photos plus a fifty-minute documentary film, was hurried into place to coincide with Nixon's trip to Beijing.

The Chinese announced that a show would come to America consisting of the contents of a Han Dynasty tomb. Dillon and I churned out letters to Nixon, Kissinger, Chou En-lai, and Huang Hua, the UN ambassador. Huang had come to the Met with forty members of his staff shortly before the startling news had broken. The Chinese delegation had snickered at the Jackson Pollock and oohed over the most saccharine painting in the collections, by the French nineteenth-century academician, Paul Delmas-Chabas—his *Joan of Arc,* with the saint depicted as a cow herder having a vision of herself clad in silver armor. Dillon and I poured it on, and Nixon promised to hand-deliver our letter to Mao, but we heard nothing. Dillon had offered to reciprocate with anything the Chairman wanted from the Met, an incentive the National Gallery in Washington could not match since its policy was never to loan. Yet we were cut out of the historic China show.

From then on I was determined never to lose another blockbuster, especially to the National Gallery, and its director J. Carter Brown, who was a dedicated and effective opponent.

Almost as difficult as winning blockbusters was figuring out how to pay for them. The insurance—even if you could persuade a bunch of insurance companies to get together into a syndicate—was astronomical. The solution we happened upon came from the most unusual quarter—chicken farming.

I was grumbling to Daniel Herrick, the vice-director for financial affairs, about why the United States didn't have an indemnity program like the one in England, where Parliament guaranteed to reimburse any loss or damage to a work of art on loan from a foreign country to an official exposition. If we had something like the English indemnity, no premiums would have to be paid at all. Most art museums in the United States, though, were private, so it would be unlikely for Congress to indemnify them.

At this, a smile came to Herrick's face. He said the government did indemnify private businesses overseas. When he had worked for W. R. Grace & Co., he had been involved in a plan to insure private American businesses like agriculture and chicken farming against loss from expropriation. The federal government had an indemnity insuring offshore businesses up to ninety percent of their value. Why shouldn't the Met seek the same kind of deal from Treasury and State? We went to Washington to present the idea to Under Secretary of the Treasury Charls Walker. Walker curtly told us that there was no precedent for the government insuring any private affair. When Herrick reminded him, Walker sighed and said in his broad Texas accent, "I didn't figure you boys had heard of that."

It took more than a year to cut through the federal bureaucracy and to interest the head of the National Endowment for the Arts, Nancy Hanks, in the plan. It took two years more for the draft legislation to crawl its way through the machinery. By the time it got to the House, the bill called for an indemnity umbrella on all works of art coming to a bona fide exhibition from overseas—up to fifty million dollars per show with an aggregate in any given year of one hundred fifty million for the whole country (in 1992 something over $150 million per show with an aggregate of $400 million).

The testimony—much of it in the form of written statements— emphasized that smaller museums across the country would benefit more than the giant institutions in the Northeast or in California.

The bill passed both houses before the American insurance companies lobby woke up to what was going on and attempted a crash program to pressure Gerald Ford to veto the bill. In the turmoil the bill sat there, unattended, on the president's desk. Carter Brown of the National Gallery stepped in and virtually single-handedly rescued the situation. The president signed the bill. With his signature, the age of the blockbuster art exhibition began. For the first time, huge, comprehensive shows were financially possible.

Smelling victory long before the bill passed, I thrust the museum into a full schedule of grand European-type shows. I wanted the world—from London and Paris to Teheran and Cairo and from Taipei to Moscow and Leningrad and Dresden. "We've got to get going before Carter Brown grabs it all!" Since the regulations of the National Gallery forbade loans of their priceless materials, Brown and Paul Mellon, the chairman of the board and principal patron of the gallery, had come up with a solution. They visited the ministers

of culture of foreign countries asking shows to come to the nation's capital and promising they would be opened by the president and the secretary of state. The power of the White House seemed to be behind every exhibition request. And whenever we would talk about mounting a cooperative show with several American partners including the National Gallery, Brown and Mellon would insist that the show had to open first in Washington. Their tactics were brilliant and, over the years, I watched, grinding my teeth, as Carter Brown plucked show after show away from me. I screamed about his behavior in private with my staff but had to admire his talent for deal making. That's what the game is all about.

I have frequently been accused of inventing the blockbuster and, worse, of engineering the huge, popular shows for profit. The fact is that a blockbuster rarely made money, though usually the various product sales came close to paying for the expenses. In the early stages of creating blockbusters, I didn't think of revenues. We were doing so well in our own merchandising operations.

By 1974, Brad Kelleher was trying to acquire a glass factory in Massachusetts and had landed a contract with the Spring Mills sheet company to use museum patterns for their bedclothes. The sheet business proved to be a bonanza—with royalties approaching a generous six figures per annum. Almost everything I thought of or looked at, I tried to bend into a business. When Richard Ettinghausen of the Islamic Department told me that the empress of Iran wanted some advice on how to develop a nationwide network of art museums, I suggested that the Metropolitan Museum hire itself out as a consultant to Iran.

Richard Ettinghausen made the arrangements and guided me, my wife, Rousseau, and a friend of ours from Paris who had lived for years in Iran. The flight took over fifteen hours and I was exhausted. On our arrival just after midnight, a government representative told us brightly that we would have plenty of time to recuperate before we left at five for Isfahan. It turned out the "five" was in the morning! Ettinghausen asked my wife for a sleeping potion, and she, thinking that everyone in the world knew about the French suppository sleeping pills, handed him one that looked like a wax torpedo. When we assembled later to drive to the airport, Richard said, "No sooner had I swallowed that pill of yours than I began to feel strange." He pulled through.

We enjoyed a dream trip—Persepolis at full moon, Shiraz, mosques, tombs, the span of Iranian history from the earliest times

to the Sassanian monuments to the beauties of Islamic architecture
to the ludicrous "designer" tents built at incredible expense for the
celebration of the twenty-five-hundred-year "unbroken Empire of
the Persians" hustled by the egocentric Shah. I had to admit that the
beautiful land itself seemed capable of breeding inflated monuments
—from the Persepolis carvings, in which the muscles of beast and
human alike were blown up like balloons, to the garish mosques.
Everything was full of hot air.

I was supposed to have an audience with Empress Farah Diba,
but it was cancelled and I left the country frustrated. I made a second
visit, accompanied by Stuart Silver and Dick Morsches, vice-direc-
tor for administrative affairs, to inspect a variety of museums in
varying stages of construction. We arrived, guests of the govern-
ment, and cooled our heels for two days in our hotel. I called our
contacts in the Ministry of Culture and the secretaries would ask
who I was and what I wanted and why I was there.

At last I was granted an audience with the empress and was taken
to a small palace in town guarded by the most unmilitary-looking
bunch of soldiers I'd ever seen. The place was elegant European in
decor—rather "Wrightsman"—though worn down. I was ushered
into a salon that combined European and Islamic decorative ele-
ments. There was a triple layer of carpets. I was seated on a couch
between two *fauteuils* covered in white silk. A long coffee table
stood in the middle. The empress appeared so suddenly I was taken
aback, but she smiled when I "highnessed" her. She was young and
beautiful with glistening black hair and soft, vulnerable brown eyes.
She immediately launched into a sad litany of the difficulty of build-
ing museums and educational facilities in "such a backward, poor
country."

What to do? How to raise the money, she asked. "Your Highness,
I have the solution to your money difficulties," I said. "In my city,
there's legislation that allows one tenth of one percent of the cost of
a government building to be used for 'embellishment.' What you
ought to do is, just before the final signatures go on the contracts for
offshore oil companies to drill, tell them about the one tenth of one
percent for 'educational and cultural charge.' You'll make more than
enough for all the museums you'll ever want." She sat there for a
few seconds perfectly still and then shot her head back quickly in a
tiny laugh. Then came a dozen rapid-fire questions about virtually
every museum or historical site I had seen on my trips.

During our conversation, I perceived something moving very

slowly towards the door of the audience chamber. A man appeared slithering along on his belly. When he got close, he handed Farah Diba a note and started to crawl out of view backwards. She ripped open the envelope, looked at me, gave me a smile of dismissal, got up, and after a rapid good-bye, marched out of the room through the side door she had entered. The Met never became a consultant to the government of Iran or the empress.

Ted Rousseau did not come on the second Iranian trip. He had just been told that he was suffering from the deadliest type of cancer, pancreatic. I watched horrified as the valiant man slowly crumpled, at times stiffening in front of me as waves of pain went through his body, but acting as if nothing were wrong. Frequently, thinking about him, I would break down. Despite his illness, Ted kept on working, almost miraculously. He had been able to set up an agreement between the Musées de France and the Met to cooperate on a series of exhibitions and even purchases, a concordat vigorously supported by the new minister of culture, Jacques Duhamel. The first venture was to reunite the head (from the Met) and body (from the Louvre) of a glorious Sumerian statuette, from around 2100 B.C. The lovely alabaster, depicting Ur-Ningirsu, son of the ruler of Lagash, Gudea, would move from one museum to the other every three years.

Throughout the Louvre there were nothing but old friends and supporters who cherished the same dream of modernization, high-profile activities, and shows "of grandeur." It was Ted who thought up the first two in the historic exchange—"Medieval and Renaissance Tapestries" and "The Centenary of Impressionism."

Two sublime treasures of the Middle Ages are the Unicorn Tapestries in the Cluny Museum, created in the late fifteenth century, and the Unicorn set at The Cloisters of around the same time.

Still, the unicorn is the symbol of Christ, and the hunt, the Passion. But on another level the hunt is also a ribald "poem" of the consummation of marriage in which the obvious phallic imagery of the unicorn was well understood in late medieval times. Today, it might seem blasphemy for the Passion and the Virgin Mary to coexist with the tale of an earthy seduction in the same tapestries, but it was not peculiar in the late fifteenth century.

When Rousseau suggested that we ought to get the two Unicorn sets together and show them in New York and Paris, the cultural minister agreed. And when Ted followed that with the idea that all

our finest Impressionists join up to celebrate the one-hundredth anniversary of the movement, there wasn't a word of dissent from the professional staffs of either institution. Only James Rorimer's widow, Kay, and Roland Redmond tried to block tapestries.

But nothing could stop the tapestry show and indeed few exhibitions have been welcomed with such universal warmth as was "Masterpieces of Tapestry from the Fourteenth to the Sixteenth Century."

We assembled ninety-seven of the most beautiful tapestries that had survived from the end of the fourteenth century to the early sixteenth combining the clout of the Louvre, the Cluny Museum, and the Met. No institution asked failed to send a loan, even the Hermitage, which trundled off four pieces. The stars of the exhibition were almost too many to count. There was a sixty-by-twenty-foot radiant pink-and-blue tapestry circa 1383 from the flamboyant series depicting the Apocalypse from Angers. There was the loom-fresh fragment from the Cathedral of Sens depicting the Virgin Mary. And, of course, the two sets of Unicorns displayed in back-to-back galleries, which were breathtaking. The climax of the exhibition was four monumental tapestries from the Cluny depicting the story of David, part of a series of ten. Because of the popularity of the show, many of the rest were sent over later to be shown together for the first time in decades. Three hundred and seventy-seven thousand visitors came to the exhibit, making the show one of the biggest hits of the Met's history.

Stuart Silver and I worked on the layout together with Lamar Terry, the lighting designer. Terry came up with a deft innovation which added immeasurably to the success of the show. Because of the danger of light, the tapestries could not be subjected to more than the most minimal number of footcandles. In a dry run using one of our own pieces, we saw how dark the gallery had to be to satisfy the textile conservators, and we thought the show was doomed.

But Terry was more optimistic. True to his nickname, Prince of Darkness, Terry explained that light seemed bright or not only in comparison with the light that last surrounded a person. And *if* the lighting in the galleries and halls leading to the dark tapestry halls were lowered significantly, yet imperceptibly, by the time the visitors arrived at the portals of the show everyone's eyes would be acclimated to the low light. He stressed that it would be vital to show

no tapestries in the first two galleries, so that the light there could be drastically reduced to a level even lower than the light in the gallery displaying the first tapestry. Terry recommended the use of filters of a straw color to achieve an overall golden hue and atmosphere. Except in a number of secret areas, no white light would be allowed. Terry wanted us to illuminate with slightly higher intensity lights— all well under the mandatory candle power—a splendid animal's head or the gorgeous wing of some creature or the flash of silver in a mirror of one of the Cluny Unicorns or the face of the Virgin or Bathsheba—so that the eyes of our onlookers would, almost subliminally, be guided to the most attractive parts of the tapestries.

It was not until a day before opening night that we knew the Terry system of "decompression" and the subtle highlighting was going to work magnificently.

Frustrated in his attempt to quash the tapestry exhibition, Redmond continued his attacks on my policies by questioning the ways we were handling The Cloisters' endowment, especially a "curious transaction" in which we had bought from Sotheby's inventory a Carolingian ivory book cover for $117,600 and then, without explanation, sold half of it to the Louvre for $58,800—yet never asked the Louvre for the money. Roland Redmond pestered Dillon and Dilworth for months about this and other "possibly unethical" financial arrangements and followed up with a handwritten letter to trustee Mary Morgan, Nelson Rockefeller's daughter. She persuaded Dillon to form a special board committee to look into Redmond's accusations. The trustee committee of three probed the complaints and proved to Mary Morgan's satisfaction that the financial activities at The Cloisters were being conducted properly, even if the ivory transaction had been bizarre.

For years the ivory "sold" to the Louvre was thought to be a forgery. It was a book cover owned by the Paris dealer Nicolaus Landau and it represented the Crucifixion and the Three Marys at the Tomb. I had wanted to acquire it when I had been a junior curator at The Cloisters. But my Princeton professor, Kurt Weitzmann, convinced me it was a fake. Still, I had seldom gone to Paris without taking a glance at it in Landau's shop and once even slipped it in my coat pocket and sneaked it into the Bibliothèque Nationale where its mate, an almost identical Carolingian ivory, formed the cover of a book made in Metz around 820 A.D. I had set the two ivories side by side in the Bibliothèque and had found almost nothing

different. Weitzmann postulated that *no* medieval work of art had ever been exactly copied in its time; thus any replica had to be a fake. Landau had been asking around a hundred thousand and had not wavered even after the piece had been sent to New York and condemned by Weitzmann. Someday it would be exonerated, Landau had insisted.

It was. By an intense, troubled young man who had come to The Cloisters to replace Florens Deuchler, Jack Schrader. He had spent months peering at Landau's book cover and months more comparing other near-copies of other Carolingian ivories of the Metz school. He stunned me one day by arguing convincingly that of the fine Carolingian workshops, the one in Metz had deliberately and masterfully replicated numbers of book covers. I sent Schrader at once down to Princeton where he swayed Professor Weitzmann.

Landau was impressed by Schrader's scholarly revelations and graciously didn't raise the price—with the softening of the dollar the price was now $117,000. How to get the piece out of France? Landau arranged for it to show up in London for us to purchase it there. The Acquisitions Committee voted for it, and the rare piece—one of, say, a dozen on earth with few in as good condition—found a home at The Cloisters.

The night of the afternoon Acquisitions Committee meeting, Jack Schrader jetted to Europe on an art-hunting trip. The next day—at around four in the morning—I was awaked by a phone call from my friend Hubert Landais, recently appointed the director of the Louvre and all government museums in France. He was harsh. "How *dare* you smuggle the Landau ivory out of France! Tom, do you take me for an idiot? We both know that Landau's owned that piece for years. Just minutes ago my curator of medieval art tells me about having dinner last night with your Schrader and he shows her a photograph of the ivory and boasts how you just bought it. How did you sneak it out of Paris? I will move to have Landau arrested, and I shall expose you and Schrader in this criminal farce!"

I was mortified.

I burbled a while and then thought of a solution. "As of now you own half of it. Okay?" I said. "And you don't have to pay a cent. We'll share it—every three years—and I'll send it over next week and we'll pay all expenses."

"I understand," Landais said happily.

"But, Hubert, you have to drop all this 'criminal' stuff."

"I shall. But if asked by the press, I must say that I caught you and you suggested this arrangement to avoid embarrassment."

The matter was resolved. Luckily, no reporter ever asked Landais.

Before Ted's health deteriorated, he had been working hard on our colleagues in the Soviet Union to prepare for a multiple exchange of exhibitions to commemorate détente. The Scythian show was the key one, followed closely by the Russian costume extravaganza.

We were successful in getting both, primarily because of the new political climate and because a new player had turned up in the Ministry of Culture, a trim, six-foot-six-inch, tennis-playing, smooth-talking under secretary, Vladimir Popov.

Popov, formerly the head of the party youth league, was an exuberantly corrupt member of the elite, who adored flattery, gifts, and privileges. What persuaded him was a specially arranged tennis game on the White House court. I was in the habit of bringing him bottles of the cheap Popov brand of vodka, telling him that it had been bottled for him. It worked for six months until he found out that I had pawned off "the really cheap stuff" on him.

Once Vladimir Popov took over, I knew our project had been blessed, though he could be vexatious. At one three-hour lunch he roasted us for the sin of Vietnam. Then he went on to say, his voice dropping into a conspiratorial whisper, "The Soviet Union has a number of enemies. Some are outside our borders. And some are inside . . ."—he paused for dramatic effect—"and the enemies of the Soviet Union *inside* the country are all . . . in *Intourist!*" At which he burst into laughter. Though it was Popov who rammed through the grandiose "Russian Costume Show," it would never have had the magnitude it did without the astounding Diana Vreeland and Jacqueline Onassis.

No curator in the history of the Met ever had a more successful run than Diana Vreeland, the chief of the Costume Institute. We would meet once a year for five or ten minutes to settle on the next year's show.

"What do you want next, Boss?" she would say in that startling deep voice and look down on me from her magnificent nose.

"Who's the best recent designer?" I asked one year.

"Balenciaga!" drawing out the final *aaaah*.

"Should we do him?"

"Consider it done."

The next year, I said, "I have an idea—why not call a show the 'Tens, Twenties, Thirties' and . . ."

"*Great* idea, Boss, consider it done."

The year after that she uttered one word, "Hollywood." It was my turn to shout, "Consider it done!"

That was followed by the fabulous "Women of Style." Then by "Russian Costumes," which may have been one of the finest exhibitions ever held at the Met.

If there is one symbol of the revolution that took place at the Met in the seventies, it may well be Diana Vreeland. Her shows added a much-needed allure to the place and captured the imaginations of the younger visitors. More people attended her shows than all others, and the press adored her. When she left the Met, her health slipping away, the Met lost several heartbeats. Vreeland did not, of course, do all the work, nor was she responsible for the scholarly aspects of the Costume Institute. She had a brilliant second-in-command, Stella Blum, a sharp-witted woman who felt at ease playing first violin to the grande dame of fashion.

Everybody in the world of high fashion, publishing, and ultra-chic has a story about Diana. Mine is set in the Soviet Union. We had gone with her friend Fred Hughes, now the chairman of the Andy Warhol Foundation and then a vital cog in the Factory. The flight to Moscow is mind-numbing, and many travellers need four days to come to. Not Diana. Dressed like a lacquered black-and-red Japanese doll, her skin glistening with Vaseline, she strode through the airport like an exiled aristocrat returning to regain her rightful property. She didn't stop for a week. Morning was not her preferred time. So, with a crucial meeting set for nine in the morning with the officials at the Ministry of Culture, Diana told me to go "talk about all those 'museumy' details and I'll be there—on the dot of . . . eleven."

I went and talked and wasted time over the details of indemnity and shipping and the like as I watched the clock approaching eleven.

My Russian colleagues—there were six of them across the table—were getting more and more nervous. Finally, the question came, "What is she really like and will she come?" "Of course" I said smoothly, doubting she would.

A minute before eleven the door to the conference room opened and in she swept, radiant in crimson and shiny black, her hair pulled back so tightly it looked like a painted surface, neck arched. She

walked in slowly and gazed studiously over the heads of the flustered Soviet officials. I knew that look came from the fact that she could barely see without her glasses. She was damned if she'd wear glasses for an "entrance."

Diana sat, placed one arm on the table, and pushed herself back. She cast her gaze imperiously over the tops of the heads of the now-seated Soviet team. Her stupendously chic head turned majestically.

The Russians blinked first. "Ah, Mrs. Vreeland, what do you think of the Soviet Union?" It was a kind of Last Judgment moment.

Diana breathed deeply.

"Ah, *marvelous! God! marvelous!*" she said. "I have been up walking since dawn, ab-so-lute-ly *revelling* in the vast beauty of this city. God, the women are so beautiful. I mean these *complexions!* The land is so *vast*. So . . . *awe–in-spir-ing!* So grand. The women are so *gorgeous!*"

And she meant every word, too, except, perhaps, for what I always kidded her as her "dawn patrol." The Soviet colleagues all started talking at once and stood to shake her hand.

From that moment on, there was nothing Diana asked that was not done. She wanted to see an ethnic costume she was convinced had been the archetype for Coco Chanel's great classic suit—for Chanel had spent some time in Moscow with a Russian lover. The item was triumphantly displayed for her. Diana had been right. There was the garment Chanel had clearly adapted for "her" classic design. Diana announced to the group of Russians, who were now clinging to her every pronouncement as if it were a revelation from Lenin himself, "Let us all keep this our own little secret."

She had the culture people so wrapped up that I was discarded as she spent hour after hour patiently going through the hundreds of drawers in huge cabinets jammed with costumes, each costume lovingly folded away and preserved with specially treated, acid-free paper made for the occasion. She would praise lavishly—and, in time, would criticize, very gently but with needle-like effect. By the time Diana Vreeland left the Soviet Union, she had become legend there, too.

My eagerness to have exhibitions became an obsession. Although some of the curators complained that their normal work habits were being disrupted, I never heard one who did not reminisce fondly about the "amusing time doing that show." Someone got the idea of mounting an exhibition of *gold*—treasures mostly taken from our

own holdings with a soupçon or two from the outside, such as a couple of ingots from the Federal Reserve, and an astronaut's helmet, the visor of which was flecked with gold to filter ultraviolet light.

Then there was the "Allen Funt" show, a disreputable affair that hastened Everett Fahy's inevitable departure from the museum. Funt, the creator of *Candid Camera* on film and television, had gathered thirty-five paintings by the pre-Raphaelite Sir Lawrence Alma-Tadema, dubbed by the critic John Ruskin "the worst painter of the time." Somehow, Funt conned Fahy into showing the collection without telling me.

The first thing I heard about the fait accompli was a nasty news story in the *New York Post* to the effect that Fahy had sent over a number of paintings from the museum's collections—the likes of El Greco, Rosa Bonheur, Gauguin, and Alexandre Cabanel—to fill the holes in the walls of Funt's apartment while his Alma-Tademas were at the museum in a show called "Victorians in Togas." I was angry, but Fahy only shrugged. I asked the curator if he didn't think a one-collector show of a relatively unknown Victorian artist wasn't a bit dangerous—once at the mighty Met the pictures would soar in value. Wouldn't Allen Funt seize the opportunity to sell them? Funt had not given the impression of being a connoisseur in his statements about Alma-Tadema: "I'd never heard of the guy. But gradually I realized I not only liked his painting but that he was one of the very few painters available at less than a fortune. And gradually word began to get around the galleries that there's this nut who collects these paintings. I had more of this guy's work than anyone in the world."

Several months after the spurious show, Allen Funt put the entire lot up for auction and the prices set new records for the artist.

A month later Everett Fahy came to tell me that he had decided to leave the museum. I had not hidden my bitterness about the deaccessioning affair—and I also expressed to him my lack of enthusiasm about his eye, vexed that he was continually bringing forward "footnote" artists for purchase. He had been offered the directorship of the Frick Museum, a somnolent institution which, because of its outstanding existing collections, acquired very rarely. To his credit Fahy kept up the most cordial relationships with the Met and, in time, returned, once again as curator of European Paintings.

I knew exactly whom I wanted to succeed him—Anthony M.

Clark, the former director of the Minneapolis Institute of Fine Arts. Tony was a tall, heavy-set man with a mobile, mustached face. He appeared to be a practical man as well as a scholar—his specialty was eighteenth-century Roman painting. And he had an earthy sense of humor. He had become curator of paintings and sculpture at Minneapolis in 1961 and director in 1963. He had left the Institute under a cloud of rumors—something about his less-than-acute administrative abilities.

I discounted the stories. I wanted Clark for his eye, which *was* reputed to be acute. The fact that he had run a fairly complex museum intrigued me. I interviewed him twice and found him a charming and articulate salesman, convincing in his fervent expression of a sound collecting policy: "Don't mess around with the little-knowns; go for masterpieces!" I questioned him about what he thought of administrative duties, and he told me that he preferred the creative work but could easily handle management tasks.

The only word against him came from Ted Rousseau, who raised the question of how easily Clark might adjust to being a curator again after having been a director on his own, and to working under me, a person notorious for hands-on management and outright meddling. I told Ted that I wasn't concerned. I should have been.

It was horrible to see Ted Rousseau wither away, in terrible pain which no drug could ease. And Ted didn't want painkillers, anyway; they might have blunted his mind. I called upon Dillon and begged to have Rousseau elected a full trustee, the first staff member to be so honored in the museum's history. Dillon was enthusiastic, and Ted was voted into the position, to take office on January 1, 1974. In the fall Ted could no longer move around, and he went to the apartment of his lover and remained there to die. I saw him as much as I could and once, after a frantic phone call in the middle of the night, rushed over to help hold him. He died on New Year's Eve, twenty minutes before he would have become a trustee.

When Ted Rousseau died, my interest in the Met began to fade away swiftly. Without his élan and humor and sense of quality, the place became just another bureaucracy.

Sorrowfully, I began to think about whom I would bring in to be Ted's replacement, knowing that it would be an impossible task. I compiled a list of young men and women in museums throughout the world. In weeks I came to the conclusion that I did not want someone from the outside, principally because the curatorial and educa-

tional staffs had become very large—there were 18 curatorial departments with 125 staffers—and with the chairmen and consultative chairmen, the operation had increased in complexity with almost geometric power.

The man I chose to fill his shoes I bumped into by chance, and within minutes I had asked him to return to the museum as vice-director for curatorial affairs. Another impulse.

I ran into Philippe de Montebello, then the director of the Houston Museum, at one of those tedious museum conferences. We chatted somewhat wickedly about the dull proceedings. He talked frankly about his initial resentment of my pushing him out and said he had come to agree with me that it had been a blessing in disguise. He had accomplished much at Houston—the endowment had almost tripled in size, and he had collected well. He had pleased potential donors and had generated a busy publications program. But what impressed me most was that he had established no fewer than five curatorial departments and, best of all, the morale of the staff was high. He was young—thirty-seven years old—handsome, and intelligent, and he spoke four languages.

I said simply, "Don't you think it's time to come back to New York and be Ted's successor?" Philippe did not seem surprised. He replied that he believed he had done all he could do for Houston and was very intrigued. Within a month he signed on and in February 1974 took up the new post.

Our working relationship was intense, although it never became the highly intimate relationship that I had enjoyed with Ted. From the moment Philippe returned, I told him that I wasn't thinking of sticking on for too many more years and that if he performed well, he might be one of the top candidates on my list to succeed me.

Philippe soon got accommodated to his new position. He knew most of the players and handled himself with dexterity, assuring the curators that he was virtually their elected representative who would always be guided by their wishes, not the other way around. Perhaps it was because of that attitude that Philippe was never to play a significant role in acquisitions, at least, never to the degree that Rousseau had. Acquisitions and shows became my gourmet tidbits, and I became ravenous for the truly rare object or whole collection of objects.

One morning I was surprised to see Wen Fong sitting in my office charming my chief assistant, Cecilia Mescall. "Wen has to see you,"

she said. I was preoccupied and had no desire to see him but ushered him into my office. He coyly said, "I may have the greatest acquisition in the history of the museum."

The story fell out of Wen Fong's mouth in a rush. Basically, it involved snatching away from our strongest competitors the finest group of early Chinese paintings in private hands. He had been patiently tracking the Sung and Yuan paintings in the collection of C.C. Wang (or Wang Chi-ch'ien) and had reached an agreement to buy twenty-five for only two and a half million dollars. The purchase, Fong explained, would rocket the Met to the level of Boston, Cleveland, and Kansas City. Overnight we would be on a par with them, at least when it came to these vital early periods. Wen told me that Larry Sickman of Kansas and Sherman Lee of Cleveland had been pursuing C.C. for years and would be flattened by our coup.

Wen gave me a spirited description of old C.C. He was a frail man in his sixties, one of the great connoisseurs in the world, the last of the literati, a latter-day artist-scholar-expert-poet-philosopher type. C.C.'s position as an "eye" was singular, for he had spent half his life in China and half in the West and had come to terms with a highly traditional field using Western criteria—exactly what Wen Fong himself had attempted.

C.C.'s life belonged in a novel. Born in 1907, he had grown up in the intellectual hothouse of Souchou and studied the classics and calligraphy. At fourteen he started learning how to paint landscapes in the studio of a man who owned an exceptional collection of ancient paintings. He moved to Shanghai in 1932 to study law and painting. He began to collect porcelains. C.C. seized every opportunity to view a fine collection and around 1936 was appointed an advisor to a committee preparing a huge show of Chinese paintings to be sent to London's Royal Academy. For that he gained entry to the Imperial Palace and grazed through scrolls that few private scholars had ever been permitted to see.

C.C. then came up with one of the cleverest ploys in the history of connoisseurship—he would examine and photograph all the chops, or seals, customarily planted on Chinese paintings indicating their ownership. Even collectors who did not want him to see their paintings all wanted to know about the earlier seals. He travelled throughout China recording the seals in private collections and the Imperial collection. Thus Wang was able to scrutinize thousands of the best Chinese paintings in existence. In time, Wang published a grand catalogue of some nine thousand seals.

Wen Fong told me that Wang first came to America in 1947 and has since studied almost every Chinese painting in the states. He had dismissed the Met's A. W. Bahr collection of paintings, which had been purchased in the thirties for the astounding sum of three hundred thousand dollars and which were proclaimed the finest group in the country by the curator Alan Priest. Wang had pronounced that, of the Bahr Collection's 149 works, only 15 or so were of "museum quality." He had been right. The Bahr Collection was a blot on the Met's collecting history.

Wen Fong described the group of twenty-five pictures in detail and picked out one for elaborate praise, a fragmentary landscape called *Summer Mountains,* which Wen believed was by the legendary North Sung painter Ch'u Ting, not, as Wang thought, by Yen Wen-kuei. The difference was massive. The former (1023–56) was a more gifted follower of the latter (988–1010). One seal on the painting was that of the connoisseur-emperor Hui-tsung and may well have been a work he cherished. The point, Fong explained, was that most scholars perceived *Summer Mountains* to be South Sung, or some two hundred years later than North Sung.

I questioned Wen Fong on how we could really be sure that the C.C. Wang material would not become another Bahr Collection. Trust me, Wen Fong advised. I did trust him, but trust was not enough. Dillon pledged a considerable sum from his foundation, and in discussing the proposed acquisition, we came up with the idea of inviting a few top scholars to vet the works for us. Wen Fong was galled that we would go to the competition for proof of his eye.

"Come off it, Wen," I told him. "If we get Sherman Lee and Larry Sickman and someone of your choice to pass judgment on these things, then they *can't* bad-mouth us later."

He calmed down, especially after I added that Dillon wouldn't put up any money unless the "committee of experts" helped us out. We decided on Sherman Lee and Larry Sickman of Kansas and Wen's choice, a younger man trained in his discipline at Yale, Richard Barnhart. The three would come to New York and independently study the paintings and grade them from *A* to *D*. Fong or I explained the system to the three, and they all were eager to help, although Larry Sickman complained to me that "it isn't like elementary school grades; these things are too subtle and mysterious." He suggested a grading system which would compare each painting to those in the holdings of Kansas City. He'd write down *AAA* or *A* or whatever, plus a line or two on what he thought.

Sickman told Wen Fong he was fortunate to have gotten C.C. at a weak moment. He thought he might be terminally ill. He marked three paintings *AAA*. He was reluctant to assign grades to many of the others but told Fong what he thought of each, which was highly complimentary. Barnhart wrote, ''Among the 24 works [one landscape said to be by Hsia Kuei was on the road and only a photo was available, so none of the experts cared to give an opinion] . . . are 13 that in my opinion are the finest and most important paintings of their kind and attribution in the United States and among the finest in the world; seven album leaves of excellent quality; two works of problematic date and attribution but of major historical importance; one genuine but minor work by a minor master; and only one painting that I would regard as of relatively little interest.''

Sherman Lee was cordial, remaining several hours and taking the time to go over each painting with me. He gave me a copy of his handwritten notes and followed up with a letter which graded the objects and appended a few remarks on most of the works. He also put a monetary evaluation on each, explaining that he would be assigning lower figures than he supposed the market would bring. I had briefed him on why we had decided to form the committee of experts, and he said he thought it was a good idea. Several times he commented that he was surprised that C.C. had decided to sell. As for the *Summer Mountains*, he commented, ''Grand masterpiece. Probably not by Yen but a superb Northern Sung work,'' adding ''I'd like this one.''

We also obtained comments—all favorable—from the curator of Oriental art at Boston, Jan Fontein, and Thomas Lawton of the Freer. The board voted unanimously to buy the hoard. The blot had finally been removed from our copy book.

Although by this time I had been directly or indirectly responsible for having collected tens of thousands of works by purchase, gift, or bequest, the one piece I had always dreamed of seemed elusive—a spectacular Greek bronze of the fifth or fourth century, something that would stack up to the Euphronios krater. It appeared abruptly, in part through the manipulations of one of the most peculiar curators ever to have served at the Met, Jiri Frel. He was Czechoslovakian and had been studying at Princeton on a grant when the Dubcek Spring collapsed. He had beseeched Dietrich von Bothmer to hire him. I had been able to obtain working papers for him plus a ''Nansen passport''—a displaced person's *laissez-passer* created just

after the First World War to deal with the settlement of refugees. Frel was a bouncy, sometimes naughty, presence in the museum, forever bustling about the galleries, inspecting the art, looking for young girls. It was said that a special bell had been set up in the library to warn young female staff members that Dr. Frel was on his way down. His work was, however, satisfactory and his energy was appealing.

When he walked into my office not much more than a year after we had labored so hard to save him and told me that he wanted out of his three-year contract, I was livid. I had signed the contract only to indicate to Immigration officials that Frel was incredibly valuable and ought to be awarded working papers. He told me that his doctor —who later turned out to be the father of a woman Frel had seduced —advised an immediate move to Los Angeles because of a respiratory ailment. "I have to live and work on sea level, you see."

Manhattan is right at sea level. And Malibu is higher. It turned out that he had been offered a job by J. Paul Getty, the eccentric multimillionaire, an "old friend" whom he had gone to see two weeks before on a trip to Europe we had paid for. I fumed but finally told him to get out. Things calmed down and he confided to me conspiratorially that we should think about buying certain works of art together—"with old Paul's money." When Dietrich von Bothmer told me about a fabulous Hellenistic bronze athlete—perhaps created by Lysippos, the sculptor of Alexander the Great—on the market for the largest sum of money ever asked for an antiquity, fully four times more than the Euphronios calyx krater, I thought, naturally, of Jiri Frel's remarks.

The sculpture had definitely been hot, but it had been cooled to the point where it had become completely legal. Found in the Adriatic off the city of Fano by fishermen, it had been stored in several places near Fano and had been smuggled out of Italy by a former Sotheby's representative in Rome. The piece was partly owned by an art mutual fund, established by the Baron Lambert of Brussels, called Artemis, and by an antiquities dealer in Munich, Heinz Herzer.

The beauty of the treasured bronze was that even though it had been taken illicitly out of Italy, the persons charged with the crime had been acquitted in the court of appeals, for the simple reason that without the bronze in hand as proof, there was no evidence with which to convict the accused.

I examined the work after a skiing trip to Austria and was impressed, though I thought the pockmarked surface caused by immersion in salt water for centuries was unfortunate.

Heinz Herzer, a sinister-looking, charming German, was ebullient about the prize, calling it "in all likelihood a work by Lysippos." Lysippos, the great innovator of the Hellenistic period, was mentioned by ancient historians more often and with higher praise than almost any other artist. The subjects of his works were known, but not one had survived. The discovery of a fine Lysippos bronze would be equivalent to finding the Mona Lisa—if all other Leonardos had been destroyed.

The price was astronomical. Herzer insisted that he—and Artemis—could go no lower than 4.4 million dollars. I took the news calmly, especially when Herzer told me I could try to negotiate the price with the president of Artemis, David Carritt.

Carritt was an arch Britisher who had a right to be arrogant, for his record of discovering stupendous works of art, overlooked by others, was peerless. I called on him in London, and he cheekily told me that he considered most of my grand acquisitions to be banal except for the two tiny pictures by Giacometto da Veneziano which Bobbie Lehman had purchased from Wildenstein. Repressing a strong desire to tell him off, I talked about the "Lysippos" and he confided to me that if I were "a good boy," he'd recommend to the Baron Lambert that the price be lowered to 4.2 million. It was only back in New York that Bothmer informed me that Paul Getty had become enamored of the bronze. It was said he had had it sent to Sutton Place, his grandiose estate outside London, but had bitterly complained about the outrageous price and turned it down. It was also said that he still pined for it.

I had an inspiration. Getty was hypnotized by ancient Rome. His museum in Malibu was a "replica" of an ancient villa near Herculaneum. At the opening I had noticed that the collection lacked Roman wall paintings. Knowing that we had a set of seventeen in storage bought in the thirties from the infamous Count Ciano, Mussolini's son-in-law, which had been spirited out of the Villa of Boscotrecase near Pompeii, I discussed with Dietrich trading the frescoes with Paul Getty for his paying the lion's share of the bronze. Getty could have the frescoes in Malibu on an "indefinite" basis and we could share the bronze every three or four years. Bothmer was keen. I called Charlie Wrightsman for advice on how to handle

the fellow oil man and he told me, "Speak bluntly to him. Don't waste his time. His first impression of you will make you or break you."

I called Getty and described my idea. Getty's voice was clear and decisive—he must have been in his mid-eighties—and he said he was interested but that the price of the bronze should more properly be in the million-and-a-half-dollar range. Why not come over to his place and talk about the proposition? What about in two days? Fine, I said.

I had to rush to gather up the slides of the frescoes, panels of varying sizes all in jet-black backgrounds with scenes of daily life, a slide machine and a transformer, and brown-paper panels, each the exact size of the frescoes I would discuss. I planned to project the slides on the paper and show the old man what he might be getting life-sized.

I sped to London, got instructions on how to drive to Sutton Place from Getty's secretary, and rented a car, the smallest car possible— a Morris Mini—and paid a tip *not* to have the car washed. The drive from the gate house into the palatial house designed by Hawksmoor seemed as long as the drive all the way from London. I guided the mud-splattered Mini through acres of land. When I was climbing out of the tiny vehicle and picking up my gear, I saw the curtains of the front window part quickly and I caught first sight of my quarry, a diminutive man with the longest, most lugubrious-looking face I'd ever seen.

Getty greeted me in his library and introduced me to a handsome red-haired woman in her late forties who quickly left. I set up my machine and immediately the transformer began to smoke and then burned out. Unconcerned, I asked him if I could pin up the brown paper panels over the books and handed him the slides to peer at in a table lamp, explaining that it was just as good as the projector. He devoured the slides, asked some pointed questions about the frescoes—value, condition, transportability, could he have them on a "forever loan"? did I think the "Lysippos" was really Lysippos? Crisply, wanting not to waste his time, I gave him satisfactory answers and lingered on the "Lysippos."

"My person, von Bothmer, doesn't think it's Lysippos," I said. "Nor do I. But it's gorgeous and Hellenistic. Price? I'd say it's in the three-million-dollar range. Hell, it's great. The both of us have never seen anything so strong and sensitive."

Getty listened, his huge face impassive—his upper lip seemed to be three inches long. "Maybe I've been too tough on the price."

I casually added, "Maybe it's worth even four."

"I loathe this Herzer," he said. "He came with this friend and stayed here a few days—didn't even tell me he was bringing this guy. But, you're right about the statue; it's important. So are the wall paintings."

He asked me to spell out the deal, and when I was finished, he said, "Let's do it. You handle the joint purchase in all details, in other words, act for both of us—in everything—bargaining, all. I hope we get this statue and expect so. I like the idea of the sharing. You're in charge."

We went into lunch in an enormous refectory hall, the walls covered with sixteenth-century tapestries, the oak table perhaps ten yards long.

"Where did you get that beat-up car?" were the first words out of his mouth once we were seated.

I laughed and told him about Charlie Wrightsman's advice and renting the unwashed car so I would impress him.

"I'm looking for a director for my museum," he abruptly said. "One guy I interviewed was a chap by the name of Tony Clark and he demanded a full-time car and chauffeur, because he doesn't know how to drive. I didn't hire him."

At lunch he told how he and Wrightsman had teamed up just after the war to dig oil wells in Sicily. The pair had drilled and drilled and had found sand. At the end of the sad adventure, the partners retired to the Riviera for some "R and R" before both went on to more lucrative opportunities.

"I'd noticed that Charlie had this aluminum wristwatch, all banged up and stained. You could barely read the dial. So, I bought the most expensive, solid-gold Swiss watch and had it inscribed 'To my friend' or something. We're sitting on the beach down there on the Riviera looking at the girls when I asked Charlie if I can take a look at his watch and he hands it over. I threw it into the water. Why, Charlie went crazy. He swore at me and jumped up and dove repeatedly to try and find this old watch. No luck. He comes back and sulks. I hand this beautiful watch to him. He reads the inscription and throws the watch into the water! He tells me, 'Mine was a lucky watch' and leaves. Funny, but you know, he's never spoken to me again."

I had expected more trouble pushing Getty up close to four million dollars than in bargaining Artemis down. What I hadn't expected was trouble from Jiri Frel, who complained that the seventeen frescoes were not enough for an exchange and demanded dozens of sculptures and objects of decorative art to be thrown into the bargain. Frel refused to help in the bargaining process, telling me that Herzer was a valuable resource and he didn't want to miff him. I accused Frel of trying to kill the deal Getty and I had made. Only then did he start playing ball. My board finally approved the complicated exchange arrangement, and I started in on Getty.

Dollar by dollar I gently worked Paul Getty up to 3.8 million dollars. He told me that he easily could afford more—certainly the 4.4 million—and, now, agreed with me that the bronze was worth it. But it was a matter of principle: "I'm simply not going to allow that bastard, Herzer, to get four out of me."

The old man was firm about ethics, too. He was disturbed about the legal status of the bronze. We had sent him the court papers and discussed for hours whether, despite the Italian court judgment, the art authorities might be annoyed that the Getty and the Met would parade a sculpture for the world to see that had come out of Italy in a strange way.

I told him that Herbert Brownell would review all legal matters "past and present" with Artemis' lawyers in Rome. Brownell would also be allowed to discuss the legal issues with the Belli Arti, the Italian police, or "any other agency of the government" to discover whether or not there will be any claim on the bronze athlete.

I contacted David Carritt by phone and told him it was 3.8 million "immediate," provided that the legal review proved to be satisfactory. He said he'd talk to Baron Lambert. What about Herzer? I wanted to know. He'd go along, Carritt said. He called the same afternoon and said that Lambert refused to go below 3.9 million. "Agreed," I said jubilantly. I had told him to amend the letter I had sent him with the 3.8 figure. I got in touch with Getty, and he grumbled a bit but, at length, said "good work."

To my astonishment a shocked Carritt called me back in a day to tell me that Heinz had stubbornly refused the offer. Herzer didn't want 3.9 million dollars; he demanded 4.6 million dollars, because the dollar had weakened.

I called Herzer and I explained that Getty had a psychological problem with four million. I said I knew the Getty regularly pur-

chased anywhere from a quarter to a half million dollars' worth a year in objects from Herzer. If he didn't go along with the 3.9 figure, those purchases would stop. If he did agree to Getty's price, I would see to it that Getty would buy more each year. I advised Herzer that he would be unlikely to sell the athlete anywhere else. Every month he waited with the athlete unsold, he'd be losing the interest on the 3.9 million Getty was willing to send over immediately. In a year with the bronze not sold, Herzer would have lost the difference between Getty's offer and his unreasonable demand.

"My way, you actually gain," I said. "Your way, you lose. I can promise you that if this deal does not go through at 3.9—with the yearly additional purchases—neither Paul Getty, nor his museum, nor the Met, will ever purchase anything from you again."

Herzer said coolly, "The price is 4.6 million dollars, and I won't go down a pfennig."

I called Paul Getty and he grunted and said, "Wait a week. Then send Carritt a letter offering 3.8. If that's turned down, wait a week, and offer 3.7. Until you reach 2.5 million, which is what it's worth."

I did. And nothing came of it, though both Getty and I felt better. Herzer tried to sell the bronze everywhere—Australia, Japan, Germany. There were no takers. The dollar continued to diminish on the German mark. In 1975 J. Paul Getty died. Less than a year later in 1976, Jiri Frel saw to it that the "Lysippos" was bought by the Getty Museum for 3.9 million dollars without bothering to touch base with the Italian authorities.

19

DICTATOR
OF
TASTE

In time there was only one member of the staff I could talk to intimately as I had Ted Rousseau. From my sixth year onward Dick Dougherty would frequently drop by for a drink in my office around six o'clock. He was like the friendly bartender, listening patiently, occasionally spurring my thoughts.

What did I want the museum to be? How did I get my kicks from the work? What especially bothered me? What did I want to leave as my legacy?

My goal was to make the Met a people's cultural paradise, full of fun and celebration, an open-book library of the visual arts of the highest possible excitement and controversy, an institution that would stand for the best of popular instruction. I also wanted the place to be efficient, crisp, decisive, and, above all, intellectually honest, telling the truth about the works of art in the collections and continually striving to show the public levels and gradations of quality—the good, the better, the best. I wanted also to make the Met

into a vast stage where all the art of the world could parade, without snobbishness. My kicks? They came from the challenges, the action. I had stopped needing to succeed or to win a work of art or to land a collection or an exhibition. The contest was what drove me. I wasn't bothered by failure, and I didn't mind the criticism of the art press. In fact, what bothered me more was the grinding petty bureaucracy of the Met.

"What do you want to be remembered for?" Dougherty asked.

"Breaking the old mold, driving the deadwood out. And the building program. And the educational programs. But mostly the fact that the place is now owned by the younger people and the general public, not the stuffy elite nor pseudoscholars," I said. "And the fact that the museum is jammed and that it really is the number one tourist attraction in the city. I want things so deeply imbedded that no new leadership can change it. Like the building, which cannot be messed around with, I want the popular spirit, the sense of fun to remain forever."

Deep down I knew that I might have broken the museum free of the nineteenth century by stuffing it with works of art and collections but had been ineffectual in opening the way to the second half of the twentieth century. I had the suspicion that I was going to be driven out. I had come to suspect that the board of trustees was gradually taking me for granted—though they might not even know it—and slowly getting tired of my antics. I worried about wanting to try to stretch the institution too much, of wanting to force it beyond what it was ever supposed to be. I told Dougherty that I was becoming convinced that I was ill equipped for the future the trustees seemed to yearn for—peace and calm. I was definitely not the "consolidator." I felt, at times, like I was out of date or out of style, something like John Lindsay. I was still fairly strong, but the waters were rising and becoming more turbulent.

Still, there were plenty of times when I felt my juices flowing. It was simply that the blows hurt more, and the routine management duties bored me more. But I wasn't ready to bail out, I assured Dougherty.

"When you are, give me a little warning," he said in his raspy voice. "Hell, I want to get the 'obituary' ready for the *Times*."

One contest I particularly relished was the attempt to grab the superb holdings owned by the nettlesome industrialist-conglomerator Norton Simon. He was still undecided about what to do with his

trove of European paintings and drawings, and there were all sorts of rumors. But we were told by the president of his foundations, Dr. Robert MacFarlane—a former Presbyterian minister—that his crusty boss had not given up on the Met. I moved on Simon like a hungry shark.

Simon's goal was to make his paintings available to a broad segment of the American public by showing them in local museums, rotating his holdings constantly. He had been talking about building a grandiose center for his art, one that would combine an exhibition area, a conservation studio, and a packing and receiving facility. Once I heard the idea, I instructed Kevin Roche to design a building and I drafted an aggressive program seizing the only space available in the master plan, a light well near the Watson Library. My letter to him was bold as brass and disgustingly toadying at the same time.

What I was proposing was The Norton Simon Center for Art at the Metropolitan, staffed in part by his own employees but backed by the Met's multifaceted professional administration. The Simon Center was to be a base for his "democratic" loan programs. I did not suggest that his collection be committed to the museum. I was merely offering a handsome building prepared for his needs so that things would run smoothly until he had made certain decisions.

The Center would be a three-story, twenty-eight-hundred-square-foot building with an exhibition gallery of eight thousand square feet. The costs were almost nothing—$2.2 million and $77,375 annually for maintenance and guardianship.

No commitment was needed on his part as to the ultimate disposition of his works. He'd have the full use of the structure to carry out his loan program. He would gain renown by association with the Met. And, finally, it would resolve the ambiguity about whether Simon was running public or private foundations. Clearly, he was worried that if he didn't start showing his art, the IRS might be after him to alter the status of his charities.

Simon called to say that he was intrigued and that MacFarlane would follow up. Thereupon I entered a world of fiddlings and nibblings, stalls and indecisions. Simon was in favor one day, against two days later. He wanted to split every hair and analyze every item. The haggling, of course, was the point. Haggling meant he didn't have to do anything. And haggling held the IRS at bay.

At last he said, "We ought to try out the loan thing in real terms." Simon had invaded the field of Indian and Cambodian art, purchasing

a collection in a few years that the new Met curator for Indian sculpture, Mike Lerner, envied. There were no fewer than fifty works. All were prime, and one, a Dancing Siva, was perhaps the best of its kind in existence. The bronze, four and a half feet tall and weighing a staggering 1,262.8 pounds, depicted the god Siva as Lord of the Cosmic Dance. The figure of the god with three pairs of arms and billowing hair is set under an arch adorned with decorative flaming pots. Despite my suspicions that the Nataraja—and many of the Indian and Cambodian pieces—were smuggled, I nonetheless agreed. I wanted his paintings but resigned myself to the sculptures.

He agreed to send around seventy-five Indian and Oriental works to the Met for storage while the exhibition catalogue was being prepared. The vernissage was expected to open in about two years, which didn't please the impatient Simon, but for a scholarly show, we couldn't move any faster.

Several months before the show was to open, John Buchanan received a phone call from a Mr. Peter Solmssen of the State Department about Norton Simon's questionable right of ownership of the Nataraja. The Indian ambassador had informed the State Department that they considered the Nataraja "stolen property" and did not want the piece exhibited at the Met. I wanted to know if there were someone at the Indian Embassy I could talk to off the record? There was, Minister Mr. E. Gonsalves, who turned out to be friendly, firm, and chilling.

The idol, he said, had been tracked by the Indian government for several years in England and America. There were volumes of evidence that it had been smuggled out of the country. A villager in Sivapuram, once the province of Madras, had uncovered the huge bronze in the 1950s on his property and reported the discovery to the archaeological authorities, who suggested sending the piece away to some provincial museum. The villagers complained. A decree from a local magistrate permitted the work to stay, but the authorities predicted that the Nataraja would soon vanish only to emerge in the international art market.

Within weeks the Nataraja disappeared and fell into the hands of a New York City art dealer, Ben Heller. How Heller obtained the treasure was never divulged. In an advertisement placed in an English newspaper, Heller asked a million dollars for the bronze. Eventually, Simon bought it.

Gonsalves begged me not to exhibit the "illegal" Nataraja, and I

told him I would think it over. I discussed the matter with Douglas Dillon, who ordered, "Don't show it. Ask Simon if we can leave it out of the show. He'll be reasonable."

I broke the news first to Robert MacFarlane, who sounded stricken. He was afraid his imperious boss would go nuts. But Simon didn't. At first. He sounded rational. He chatted to me about negotiating with the Indians about returning the piece. In a day, however, he zigzagged, vowing to fight the Indians. He demanded I write a foreword to his catalogue insisting that he had legal title even if the piece had been smuggled. I was dumbfounded. Before I had time to ponder that nonsense, he changed his mind again, claiming he was willing to talk to the appropriate Indian officials about "some sort of a return." But when he learned that I had already discussed the issue on the phone with Mr. Gonsalves, Simon flew into a rage.

He started talking about breach of contract and threatened to sue us. I was patient with him, urging he play the "Rockefeller card," which had been so successful with Guatemala. Simon kept insisting that the Nataraja was his legal possession. He admitted it must have been smuggled out of India but claimed he was in the right. When he demanded I exhibit the piece no matter what the Indian government or the State Department said, I refused.

That was the last we ever heard from Norton Simon—on that or any other matter. In the end Simon returned the stolen Nataraja to India under humiliating circumstances. The Indian government sued him for 2.5 million, and eventually the gorgeous Nataraja went back to its village.

I was angered not so much by the loss of the Simon collections, but from the realization that he had been gulling me, dangling his will, all along. He had never been seriously interested in giving the Met any significant works, nor was he interested in creating a modern center for loans. He had used us to magnify the value of his possessions.

I feared the same result when Wen Fong approached me about what he called the greatest private collection of Japanese art in the world.

Wen Fong, in the five years since he had come to the museum, had been an irrepressible dynamo. "Tom, you must act!" was his constant refrain. But late one afternoon in 1973, when he came to talk to me about landing the *very* eccentric collector Harry Packard, I wasn't sure I wanted to act or could act.

Packard, a chunky, small man with a wispy beard who affected turtleneck shirts and wore sneakers, possessed something that Wen wanted more than anything on earth. "Others will find him if you do not act. We've *got* to snag him."

Harry Packard was born in Salt Lake City in 1914. As a young, out-of-work civil engineer during the Depression, he got a job in Woolworth. In time he opened his own pair of small five-and-dime stores in San Francisco. But Harry Packard was a restless man with a sharp mind, forever seeking a challenge. In the evenings he began to study Oriental languages at the University of California.

After Pearl Harbor he enlisted in the Navy and was sent to the Japanese-language school in New York. There his interest in Oriental art was born. The Met's eccentric curator, Alan Priest, encouraged him to buy inexpensive Japanese wood-block prints and Chinese ink paintings.

Packard was posted to Okinawa after the island had fallen and was given the task of poring through diaries and letters from dead Japanese soldiers for strategic information. He found only poetry and loneliness. The Japanese soul laid bare moved him deeply. At the surrender, he was sent to China to a repatriation camp near Tsingtao in Shantung province, which the Japanese had used as a luxury summer retreat.

There Harry Packard suddenly encountered his true destiny—Japanese art. In curio stores, in pawn shops, in abandoned homes, he found spectacular paintings, many by some of Japan's greatest twentieth-century masters. All had been sold for a pittance by the defeated Japanese. The Chinese scorned the works and were quite willing to sell them, many for less than a dollar apiece. With the help of a Japanese friend, he acquired everything he could lay his hands on—150 paintings in all.

He was then assigned to Japan and scoured the devastated country for art. When he was discharged, Packard stayed on in Japan and landed a job at MacArthur's headquarters. He studied the language and art and made it his business to meet every scholar and dealer, especially those in the countryside. Hard-driving, blunt, undiplomatic, Packard angered many Japanese but even those who didn't like him had to admit that he was utterly dedicated. When there was a lecture on art, almost anywhere, Packard would attend, sometimes travelling hours by train.

Packard began trading the paintings he had acquired in China for

Japanese wood-block prints. His techniques of rooting out treasures were as unorthodox as his appearance—by now he began to look like a cross between Buddha and Peter Lorre, with shabby clothes and holes in his shoes. Many dealers considered him mad. But he collected the very best. He spurned all prints that were faded and dog-eared, the ones most Western experts thought were the only genuine ones, and instead snatched up the freshest-looking ones. He immersed himself in Japanese pornography. It was not that he was excited by Japanese sexual habits, but pornographic woodblocks had been the least copied or faked. From them he learned invaluable lessons in the dating of paper, the nature of pigments, and the subtle techniques of wood-block prints.

In time Packard's prints amounted to an amazing 230, each supreme in quality and condition. Then all was lost. He was bilked out of his collection by a dealer who claimed he would sell it at a great profit to an insurance company. The prints disappeared. But Harry Packard started all over again. This time he set an almost impossible goal. He would gather together nothing less than a total survey of Japanese visual culture from prehistory to modern times.

He picked the country apart. He befriended scholars. He spent most of his time on the remote countryside and always bought from the primary source. Because he wasn't wealthy, he avoided the well-known dealers. Instead, he singled out the best of fifty provincial dealers. Sometimes he would buy a whole group for one coveted piece. Packard travelled to London and Amsterdam, too, gradually forming a collection of museum quality. And he played the game by strict and honorable rules and showed every piece to the Japanese art authorities to obtain legal export permits.

In only a decade Packard had assembled 421 exceptional works—65 examples of primitive art, 148 paintings, scrolls, and screens, and 129 examples of ceramics from the eighth to the nineteenth centuries and marvelous sculptures, too. There were such treasures as a clay fertility figure from 1200 B.C., a striking head of a deer and a warrior from the Imperial tombs of around 400 A.D., a tiny wooden box with a hidden document on wafer-thin paper, a white satin wedding kimono of the eighteenth century embellished by ink paintings of bamboo foliage, and a magnificent painted hand-scroll of a Buddhist ceremony with accents of cinnabar and malachite.

By 1965 Packard had made up his mind to sell his collection to Los Angeles on the condition that the museum would make the collection

the nucleus of a Japanese study center. Los Angeles tried to raise the needed funds but could not. That's when a frustrated Packard got in touch with Wen Fong.

Wen Fong had set me up perfectly. By the time I had examined the photographs, I was obsessed with the Packard collection. But when he explained the deal, I almost fainted. The price was 11.2 million dollars! I almost threw Fong out of my office.

He laughed, "It'll actually only cost 5.1 million dollars." Packard had agreed to give 6.1 million dollars to the Met as a gift and take a deduction. The gesture was generous, but it still didn't solve the problem of raising the rest. I knew the collection was not expensive —certain single Japanese paintings had fetched half a million at auction alone—and I knew that gaining it would push the Met close to other vaunted Japanese holdings like those at Boston and the Freer. But we had no money. Even Douglas Dillon, who by now had worked up an enormous appetite for Oriental art, made it clear that he was not going to donate funds for Harry Packard.

Weeks of renegotiations with the collector took place, but he wouldn't budge. He told me that he would really like to offer his collection for less, but he wanted to take the bulk of the money and establish a center in Kyoto for the study of Japanese art. Looking at the intense man, dressed so casually in his turtleneck shirt and sneakers, I had to admit that it was unlikely he really wanted to become a playboy and unlikely, too, that he was trying to take advantage of us.

The only way to get the funds to buy the collection, I decided, was to gamble for them. Get the senior curators together, hope that Wen Fong would make the speech of his life, and put the issue to a curatorial vote, by secret ballot. If the five million had to come out of museum funds, it meant, effectively, that no curator could buy anything for half a decade.

Wen Fong was willing to give the dangerous game a try. There would be no tricks, no stacked deck, no hype or fast shuffle. I insisted that the presentation be made to the department heads in the Oriental Department storeroom, all sitting at a long table surrounded by the pick of Packard's works. Let the pieces sell themselves, I argued. And so it was. All I did was to stress that if the funds for the Packard collection were approved, no curator could buy anything of significance for at least five years.

There wasn't much discussion. One curator, clearly opposed, ar-

gued that we didn't need it all. Dietrich von Bothmer, to my surprise, made a spirited defense of the mortgaging of half a decade of future acquisitions. Then came the vote. The ballots were marked. And quickly counted. Twelve in favor. Three opposed. One abstention—Wen Fong. The trustees voted the money out of endowment. It was one of the proudest collecting moments in my career.

When we gained Harry Packard's magnificent works, my zeal to collect began to diminish and for reasons other than having mortgaged our acquisitions funds. Certainly, there were a few great acquisitions to be made, but in general the accumulation period of the Met was coming to a close—the visual encyclopedia had been almost fully compiled. I became testier and testier with the curators about collecting and posed harsh questions about the need for yet another piece. Gradually, the staff became resigned to the new thinking. I turned my full energies to inventing great exhibitions.

I more than meddled in the exhibition program, I became virtually the sole impresario. I wanted to open people's minds to art they hadn't ever heard of. In striving to achieve that goal, I didn't look upon an art show as something linear or scholarly; I wanted to have multiple levels of learning, of education, of popularity. I insisted that all shows possess both a scholarly basis and a public appeal, something profound and something box office. I had become a dictator of taste.

One of the most unusual shows I shepherded was one in which all the works were owned by art dealers. I had always considered art dealers to be unsung curators. They had been responsible for bringing many of the finest pieces into the collections. So, when the representatives of the international art dealers organization, CINOA (La Confédération Internationale des Négociants en Oeuvres d'Art), approached me with a radical idea for a show, I was sympathetic. The idea, which would shake up the place, was to allow the members of the association to assemble an exhibition of their finest works and show them off at the Met. I assigned one of the brightest young women curators in the museum to coordinate the undertaking—Penelope Hunter, a specialist in Art Deco. The CINOA representative in New York was Gerald Stiebel of the distinguished firm of Rosenberg and Stiebel. Many curators were alarmed by the idea. Having works of art for sale might raise another press scandal, they charged. But Philippe de Montebello said that none of the pieces would actually be for sale during the run of the exhibition. He expected that

the art critics would be intrigued by the novelty of the affair, which, indeed, they were.

To emphasize the point that without the art dealer the Met would never have become such a treasure house, we stuffed one gallery with almost four hundred extraordinary pieces the Met and The Cloisters had acquired from the legendary dealers Joseph and Ernst Brummer. The CINOA exhibition was entitled "The Grand Gallery," and the design dripped with an abundance of gold and crimson. De Montebello aptly characterized the event as "an Oriental bazaar—but of a high quality."

The affair helped bring the two realms of art museum and art dealing closer together and made a significant difference from then on with a few key art dealers who had been grumbling that the Met had been slighting them. The organizers became friends, admirers, and, eventually, spouses. The new feeling of mutual trust didn't work, sadly, in every instance. Not long after her marriage to Gerald Stiebel, Penelope Hunter-Stiebel had to leave the museum, in part because it was made clear to her by her boss and others that in marrying an art dealer, she had in some way placed herself in a compromised position.

It was in the heady period of the "Grand Gallery" that we mounted one of the worthiest of all exhibitions, one that never became popular but was a blockbuster nonetheless. It was called "Momoyama: Japanese Art in the Age of Grandeur" and was about a period lasting only from 1568 to 1615, an epoch somewhat akin to the Italian Renaissance. During this short time an unparalleled series of masterworks had been created, especially painted screens. The Japanese government sent us the best of the best—more than a third of the seventy-nine works had been designated in the highest category of national treasures by the state cultural authorities.

Curiously, the delicate and poetic Momoyama style had been created for some of the most bloodthirsty killers in Japanese history. Momoyama was a castle built by Toyotomi Hideyoshi, the most barbaric of the three cruel rulers of the period. Hideyoshi spilled rivers of blood in his crusade to purify Japan of all foreign influences —principally the Jesuit missionaries. The Momoyama style is a mirror of strict and uncompromising nationalism. It is pure, hauntingly reflective of an earlier highly spiritual art, and, like all propaganda art, packaged in a sleek, silken way.

While "Momoyama" may have been one of the most honest shows I concocted, my deliberately crafted blockbuster, "The

Impressionist Epoch,'' was probably the least. It was in part hypocritical, even cynical, and I was to blame. The extravaganza, a celebration of the Impressionist Centenary, invented by Ted Rousseau, was supposed to be the symbol of the cooperation between the Met and the Musées de France. But too many of the paintings came from American collections, and no real attempt was made on our part to communicate to the public what Impressionism really meant. We gave prominent position to such non-Impressionist works as Degas's Italianate *Belleli Family* and juxtaposed a saccharine French academic canvas next to Seurat's powerful *La Parade*. It was difficult to figure out what we were trying to say.

But we had seized upon the show as an opportunity to curry favor with potential donors of both paintings and cash. Every super-rich American who professed an interest in art either owned a bevy of Impressionists or wanted to, and almost every fund-raising target in my sights adored the Impressionists beyond all measure. One was Joan Payson, our grandly generous and commonsense trustee. Another was the Havemeyer family, represented on our board by Congressman Peter Frelinghuysen. The Havemeyers, whose forebears had supplied the museum with landmark Impressionists, still owned some gorgeous pieces, and naturally, I wanted them. A third target was Walter Annenberg, who owned a choice collection of Impressionist works and had agreed to become a trustee at the end of his tenure as ambassador to the Court of St. James's.

Because of my desire to be businesslike, we had begun to prepare hefty legal contracts for exhibitions. The one to be organized by the Louvre and the Detroit Institute of Art was called ''The Age of Revolution.'' There were to be several thrilling paintings by Ingres and Eugène Delacroix, especially his dramatic paean to the revolution of 1830, *Liberty on the Barricades*. The director of Detroit's art museum, Fred Cummings, a shy, somewhat uncommunicative man, was at first dismayed to have to submit to a legal contract. It was not something one colleague institution would force on another, but he reluctantly accepted it. Cummings was to select the show, with the advice of Pierre Rosenberg, curator at the Louvre, and a professor at New York's Institute of Fine Arts, Robert Rosenblum, a man I had known from Princeton days and considered the top scholar in nineteenth-century painting. All details of the show at the Met were to be taken care of by the vice-chairman of European Paintings, John Walsh.

The contract specified that there would be between 150 and 170

paintings and that the Met's share of the budget would not exceed two hundred thousand dollars. But six months before the show was to open in Detroit and shortly before a larger version would begin at the Grand Palais in Paris, Fred Cummings phoned to say, "I think the show's a bit over budget." At first I wasn't concerned, having built in a considerable contingency. But then Cummings stunned me by saying the shortfall was in the vicinity of one hundred fifty to two hundred thousand dollars, maybe more. Maybe the costs could come out to around six hundred thousand dollars instead of the four hundred thousand we had agreed upon.

I was so taken aback I had difficulty saying anything. Cummings, interpreting my silence as acquiescence, muttered, "Well, do you know of any possible donors?"

I exploded. Donors! At this late stage? In the midst of a recession? What the hell had he done? I threw out question after question, tumbling them over one another in my anger. Cummings' explanations—if one can call them that—made me even more annoyed. The number of paintings had soared to 206. Some of them were so big that standard commercial planes were not large enough. Special cargo aircraft would have to be chartered. The additional paintings were "vital" to the show, Cummings said, and although some would describe the artists as not especially well-known—painters like Peyron, Taunay, and Mallet—they were of such scholarly interest that without them the exhibition would fail as an "honest portrayal" of the period 1774 to 1830.

"Read the contract, Fred," I told him through clenched teeth. "Stick to it. I don't care which painters you want in the one hundred and fifty pictures, but the number remains as agreed and the budget sticks at four hundred thousand. I do not have a donor at this late hour, and even if I did, I wouldn't want to waste the money."

Cummings finally agreed that it might be better to go back to our original agreement but warned me that Rosenberg and Rosenblum might be "disturbed."

"Not as disturbed as I'll be if the costs of this thing go out of sight," I said coldly.

I called in John Walsh, who defended the overages, saying that it would be an important scholarly effort. I reminded him that we had suffered for weeks through countless discussions about the show, its content, and the specific pieces and had signed a contract. I told him there would be no additional money. The lanky curator seemed

oblivious to what I was saying. I asked him to help cut the show back to the contract terms, and he nodded. When John Walsh departed my office in a petulant mood, I guessed he was not going to do what I had asked.

I ordered de Montebello and Herrick to review the "new" budget. It was worse than Cummings had made it out to be. I instructed Walsh again to proceed with the paring back of the number of works to the contracted figure, telling him he could work it out with Rosenblum as to the precise identity of the paintings to remain in the show. Soon I heard the shrill voice of Robert Rosenblum, who refused to make cuts. I said, then go raise the money. He couldn't. I told him if he couldn't, then there was no recourse but for Philippe de Montebello and me to make the cuts—fifty pictures. We did. In no substantial way did the cuts abandon either the spirit, the flavor, or the scholarship of the show. And all the cancelled paintings were published in the catalogue and laboriously analyzed. I tried to point out to Rosenblum and Walsh that there was a difference between an art exhibition and a scholarly tome, but that made them even angrier.

I was assailed by Rosenblum in the newspapers for having gutted the show. I had "sacrificed scholarship for predictable box-office appeal," he charged. The article claimed I had cut all twelve of the Russian loans—never before seen outside of the Soviet Union—in order to save insurance costs and had single-handedly vetoed an immense painting by Charles Meynier because it was too big to fit through a cargo plane's door. In a stunning example of revisionism, Fred Cummings had the gall to say, "I have fought from the beginning to have the show as we originally conceived it."

Of course, the press swallowed the bait and made a frenzied attack. In the wake of the press brouhaha and Rosenblum's curious assertions, John Walsh came in to see me one morning and quietly told me that he was planning to resign "in solidarity" with Tony Clark, the Paintings curator, who was, he told me, profoundly disturbed about my "unprofessional" actions regarding the French show and about my dictatorial behavior in strictly curatorial, professional matters. I should have played it cool. Walsh seemed unsure of himself and not absolutely set on leaving. I should have acted the way I would have in the beginning of my directorship or, certainly, during Parks Department days. Then I would have let the insult go by and allowed the tears to well up in my eyes. Then, I would have admitted guilt, confessed to the charge of meddling too much, and

at once sought an opportunity to talk together with Walsh and Clark to iron out what might have been but a momentary flare-up. But having become the "dictator of taste," having been too long on the job, I did everything a chief executive officer shouldn't do. I lashed out at Walsh and compounded the error by viciously criticizing Tony Clark for talking "crap" behind my back—I had heard that he was taking potshots at the list of old master paintings that would be sent to Russia, some of which had been selected before he had arrived.

Walsh told me he would leave without a statement to the press. Not so Anthony Clark, who I had believed would be the ideal European Paintings curator. Hysterical, he attacked me for everything— from destroying the French show to endangering some panel paintings by shipping them for "cheap political purposes to the Soviet Union," to curatorial interference, to "rupturing all sense of trust."

The next day the *Times* carried a front-page story with the headline, "2nd Key Met Museum Aide Quits In Dispute Over Hoving Methods." Clark's attack was a quote from his disturbed letter, which gave the cause of his resignation: "I cannot work with the present administration because its relation to art has become incidental, wrong and even risky. It's also hell on professionals."

The European Paintings Department was in a shambles. Clark had been the fifth head of the division in almost five years—Rousseau, Virch, Fahy, Walsh as acting head, and Clark. I despaired of ever getting that "divine" combination of eye, scholar, executive, leader, and mature human being. Then I began to hear the most fascinating rumors.

It seemed that Sir John Pope-Hennessy, the director of the British Museum and before that director of the Victoria and Albert Museum, one of the most respected scholars of Renaissance sculpture, who had written extensively on Italian paintings from the quattrocento to the sixteenth century, was about to be ousted from the British Museum. The "Pope" was a brilliant, intense man, who often seemed snobbish and arbitrary. According to one of the employees at the B.M., the Pope had "a whim of iron" and had upset more employees throughout all the ranks than I ever had. To many the man was insufferable, yet as a professional I had always found him matchless. He might seem to look down on everyone from the tip of his nose, but I knew that to be an affectation. His voice, high-pitched—a parody of upper-class English—was not a reflection of his character.

His odd image always tainted him and, I suspect, generated many of the rumors about his shaky status at the B.M.

As soon as I began to hear the stories, I called him and was blunt, which he appreciated. "If you are moving on," I said, "I have a grand post for you here. Chairman of European Paintings. You call the shots on acquisitions and installations."

"Tom, I *do* appreciate this. I will be coming to America in a fortnight. I shall call next week for a good time to see you."

The first person I told about the talk was Charles Wrightsman, the Pope's most ardent admirer. I begged him to hold his tongue about it. If one word got out, any hope of landing him would vanish. I wanted Charlie's blessing—and his money—to help in obtaining an apartment for Pope-Hennessy. Wrightsman was quick to pledge a generous amount. Dillon was delighted, feeling, as I did, that the Pope would quiet down the academics. Other members of the staff were less keen. Philippe de Montebello observed wryly that if the Pope were truly being eased out of the British Museum for erratic management, why would *we* want him to run the Paintings Department? He had a point.

Not too long afterwards the Pope called to say that he was coming to the States and would first go to Washington to talk with Carter Brown, who also had made an interesting offer. I fell into a funk at the news, knowing that I couldn't possibly compete with Paul Mellon's money. The Pope breezed into my office and opened the conversation in his startlingly abrupt manner, his voice crackling with high-pitched indignation.

"Tom, Carter Brown just did the most vulgar thing. He wanted to talk to me about heading his center—he got in touch with me before you did and I *do* want to tell you how deeply I appreciate your kind words. Of course, I admire the National Gallery, so I consented to talk. Well, he described the post. And I asked if the duties were not principally administrative. He said, no, no, and promised me that I would have almost no administrative tasks at all. Then he slipped to me across the table a check, made out to me—*without an amount!* How insensitive! I mean how vulgar! I told him I could not possibly work at the center."

My mind had been racing as he talked. And the first words out of my mouth were that the position I had described amounted to pure scholarship and connoisseurship and that he would not have to carry out any administrative tasks at all.

"John, I have no blank check," I said. "This is the Met. But we do need the best paintings and object man on earth. You're it."

I named the salary, which was considerably above the curatorial level, and he nodded.

"I also have an apartment in the vicinity," I went on. "We will pick up the maintenance. The Institute is wild about your becoming an adjunct professor to lecture on anything you want. We will publish any books you want us to. Ah, yes, but there *is* one important proviso . . ."

He arched an eyebrow.

"We demand that you *must* stay in Florence for three months a year for your work there." I, of course, knew about his home in the city and his affection for it.

"Two months will suffice, Tom, ah . . ."

"Wait! I'm not through. This post of chairman carries a retirement of seventy years—with the possibility of an additional five years."

Sir John Pope-Hennessy threw his head back and laughed. "I accept!"

Pope-Hennessy fit in at once. His only weakness was a limited eye for design—his Paintings galleries in the Andre Meyer Wing turned out to be ponderous and confusing. But his acquisitions were triumphant and his executive sense acute.

The turnover in the Paintings Department continued. Sadly, Paintings conservator Hubert von Sonnenberg told me that it had come time for him to leave the United States and return to Germany. He had been offered the top post at the most prestigious conservation laboratory on the continent, the Doerner Institute. Who could possibly succeed Hubert? There was, he told me, only one person on earth, a man who had trained in the same studio and who shared his philosophy about paintings: "Leave well enough alone."

The man was John Brealey, a Britisher who was a commercial conservator with some of the choicest clients imaginable, among them the queen of England and Paul Mellon. Brealey had been responsible for the rehabilitation of the striking paintings by Andrea Mantegna at Hampton Court, a delicate, time-consuming effort called by many experts the single most trying—and successful—restoration of the past fifty years.

Brealey had expressed to Hubert a desire to leave his mark on a great collection, to create a continuity of conservation with the work of someone he admired and with paintings of the highest caliber. He

seemed to have his eye cocked in the direction of the Met, but there was one obstacle—me. He loathed me. Brealey's impression of me was a compendium of all the outrageous things Tony Clark had spilled out, the vilest rumors flying about the art world, and everything written about me as a showman. It took considerable effort to pave the way before he agreed to meet me in London.

John Brealey was a short, plump, gray man, hunched over in a protective and suspicious stance. I told him right off that I knew what he thought of me. "But I am a man of my word," I said, "and if I can get the best person in his field and that person is really good, then I leave him alone."

Brealey was surprised and pleased by my words. By our third meeting, he had the courage to say that he had been fooled by my critics. Anyway, he added, with charming directness, "You may not be there all that long; I will."

Brealey had some stringent demands. The salary was acceptable to him, but he had more important things on his mind. He wanted to retain a few top clients, like Paul Mellon. I agreed, figuring that if Mellon were kept happy, maybe his foundation would give us a conservation grant—it eventually did. Brealey insisted that his conservation studio had to be almost doubled in size. I agreed. No one was to second-guess him, not me, not Pope-Hennessy. Of course, I said. He then agreed to sign on.

I had expected Brealey to have the same unerring eye as Hubert, naively thinking that talent for restoration automatically meant an equal talent in connoisseurship. Hubert had been the final judge for me when it came to deciding many key acquisitions, many outside of European paintings.

Before Brealey moved to New York to take up his duties, I asked him to take a look at an early fifteenth-century French painting representing Christ bound on the Column with an adoring donor kneeling on the side. The work was coming up for auction at Christie's. The small picture seemed in superior shape. Brealey went to Christie's and subjected the work to what he described to me as an extensive examination.

On his word, we won it for fifty-two thousand dollars. A month later, I asked Brealey to give the picture a quick look to see if any minor remedial work had to be done before the flight to the States. I'll never forget the deadened sound of his voice when he called me several days later. He was convinced the painting, on second glance,

was a forgery, so obvious that the cracks in the paint were all hand-painted with a single-haired brush.

Brealey mumbled his apologies, and we never spoke about the incident again. Of course, I never sought his advice as I had Hubert's on desirability or quality or whether something was real or fake. I listened eagerly to his remarks on the condition of paintings—and only paintings—and went elsewhere for that finesse of the eye.

Despite the outcry from Tony Clark and others about sending our best European paintings to the Soviet Union, there was no damage. The show was highly successful as was the exchange show that travelled to the Met. This was the Scythian exhibition, the first fruits of our five-year exchange with the Soviet Union.

To arrange the exchange was at times joyful, at times agony. The Soviet Ministry of Culture seemed unhesitatingly cooperative to us. Our friends in the ministry had become, in a sense, co-conspirators. In several secret meetings Butrova told me that Boris Pietrovsky might block several of the most important Scythian objects just to spite the Ministry of Culture. Butrova advised me to be prepared to make him suffer in the quid pro quo.

Philippe de Montebello, Stuart Silver, and I arrived at the Hermitage to pay homage to and do battle with the formidable Boris Borisevitch Pietrovsky. Pietrovsky was his usual gracious self until we got down to the give-and-take of comparing lists, his Scythian beauties for our old masters. He gave a reasoned preamble about the difficulty of comparing the two groups of apples and oranges. He begged us to be understanding. His voice dropped, and he told me—we were using interpreters—that the ministry had been harsh with him and had not allowed him to place on his list certain Scythian objects *he* had recommended. Ah, I thought, the old Russian two-ends-against-the-middle ploy.

I coveted almost a hundred items, ranging from the golden artifacts, to felt saddles and leather and wooden gilded horse trappings —all of the fifth to the fourth centuries B.C. and all miraculously preserved. It might seem impossible that gorgeous wool tapestries and birds and animals made of stuffed felt could have survived, their colors untouched by time, but the freezing climate in the Pasyryk and Altai mountains had preserved them better than the ancient tombs of Egypt would have. Along with the fabrics, human hides had been "preserved"—entire bodies, dried-out and tobacco-brown, or sections of tattooed human skin, thighs, upper arms, many embellished with cunning, sinuous interlace forms that were every

bit as beautiful as the decorations on the Book of Kells. From this group came a tattooed upper arm of a Scythian lord, which I insisted had to be on the list.

Boris assumed a profoundly sad look, which was devastating, because even when pleased he looked like a depressed bloodhound.

"It is my unfortunate task to inform you that my conservators have informed me, only yesterday, that the great Panther is too delicate to be put on the list."

I smiled benignly.

"And, unfortunate, too," he went on, "but they also advise that the gold comb which, Dr. Hoving, you admire so much—and rightly so—will be unable to come for the same reason."

I kept on smiling. Pietrovsky hesitated and then continued, his voice droning on like a judicial announcement.

"For various reasons I fear that we will never be allowed to send the Elk, the gold bowl, the tattooed arm. I do regret it."

Ever smiling, to the consternation of de Montebello, who was sure he had just witnessed the dismantling of the Scythian show, I nodded my head in complete agreement. Then gently, I retaliated.

"Boris Borisevitch, my colleague, my friend, I compliment you for your candor," I began, sounding a bit more Middle Eastern than I had meant to. "And, in the peaceful atmosphere of this office of yours—we are friends and do understand—I want to tell you how deeply I appreciate what you have to do, knowing that the ministry has been so 'political.' But, this morning in our hotel," I went on, "I got a phone call from an aide in New York—the conservator of paintings, in fact, is that not true, Philippe?"

De Montebello, not one to miss a beat, nodded his head.

"And my conservator decided to examine just once more the Goya *Majas* . . . the picture on the cover of the catalogue . . . Sorrowfully, the painting turns out to be too delicate to travel."

"I fully understand," Pietrovsky said, smiling, his two solid gold teeth placed directly in the front of his mouth like some Scythian hoard.

"But," I paused, "there's more. El Greco's *View of Toledo* . . . I'm told it has some bloom—a minor situation—but, with a tiny bit of bloom in the varnish, we certainly cannot take the risk of . . ."

Pietrovsky's smile became fixed.

"And the *Juan de Pareja* . . . Well, I know you have no Velázquez at all in this country, so I am deeply sorry to inform you . . ."

"Enough!" Pietrovsky thundered. "Let's return to reason. Why

do you have to insist on both the Panther and the Elk? And the bowl and the comb? And, above all, this horrid tattooed arm?''

''Because the show will be a bomb if we don't get these treasures,'' I shouted back at him. ''Listen, colleague, you are going to get a million people to come to our old masters exhibition. What the hell else can people see in this country? But I have to get at least five knockout pieces to make this Scythian show a huge success and to justify the work, the expense. I've got to have all those things I want.''

It took a while for our flustered Russian interpreter to find the right words and then Pietrovsky answered me back. ''Fine. All of the things you want in exchange for all of those paintings we need. But not the Panther—which really is delicate—and not that arm.''

''Yes,'' I said. ''But I will argue on behalf of the Panther and the arm in Moscow, at the ministry.''

''Agreed!'' Pietrovsky said. He'd carried out his orders well.

Then, as I should have when Butrova had worked her shell game on me, I knew that it was Moscow, not Boris Borisevitch, with its foot on the brakes. The most spectacular Scythian golden treasure ever discovered was in Kiev. The object was a necklace in solid gold, some fourteen inches across and six inches high, decorated in bands of twisted and delicately worked gold, with breathtaking scenes of Scythian life—goats an inch high being herded and sheep being milked by tiny men, or horses being broken and trained, and in the center, a magnificent horse in a death struggle with a vicious gryphon. I appealed to the ministry to give permission for it to join the show—it would make every newspaper and magazine in America. The ministry had been eager to have the necklace sent, but only the government of the Ukraine could grant permission.

Philippe and I rushed off to Kiev. We saw the grand necklace out of its vitrine and gushed about it, somewhat to the amusement of our hosts, who told us that if we pleaded personally with Madame Minister Furtseva, we might get the object for the show. A few days later in Moscow, we learned why the Kiev officials had been so amused. When our wives visited the museum, the curators had taken out the real gold necklace—we had seen a replica—and had allowed them to fondle and wear it. So much for Philippe's and my ''infallible eye.''

I expected smooth discussions at the ministry, but Butrova told me that Pietrovsky had changed his mind again and that none of my most desired Scythian pieces would be sent. At last I learned why

the tattooed arm was such a problem—the Russians thought that all America would think them barbarians if they sent a "hunk of human skin." I told them I understood and suggested that I'd give the arm up in exchange for the Panther. No, I was told.

I got up and told my people to come with me. We were going to discuss cancelling the entire exchange program. The Russians needed to be jolted. After a half hour or so we marched back in, looking grim, and Alla Butrova told us with a big smile that she had had a persuasive talk with Boris Pietrovsky and he had bowed to their—and my—wishes. We had won.

Or so I thought. But Under Secretary of Culture Vladimir Popov was not quite ready to play ball. I had approached Pietrovsky for permission to make models of the Elk, the Panther, and a smaller panther whirling around in a tight circle. I wanted to make some replicas in bronze gilt and a few in solid gold in smaller scale to sell at the museum shop. Brad Kelleher and I had decided to find out if we could sell substantial numbers of brooches and pins in the eight-hundred-to-thousand-dollar range. I offered Pietrovsky a share in the profits. He told me that Vladimir Popov would have to approve the plan.

Popov was in the habit of holding conferences with me on the run, dashing from an artists' reception to a literary salon to a dance group's late-night bash—all taking place in filthy, smoke-filled rooms with tables stacked with vodka bottles. On one of these strenuous rounds I brought up the subject of the three brooches. Popov had slugged down a shot of vodka and said, "In exchange for what?"

Money, of course, I said.

"Never!" he bellowed. "Can't take money. The lousy Ministry of Finance would take it. What goods have you got in exchange?"

I suggested trips to the United States—an inflated courier system by which three people might come with each shipment "protecting" the art stored in the inaccessible belly of the aircraft. His eyes gleamed, but he rejected that offer, too. Did I have anything his museums could sell during the run of the "Masterpieces" show?

What about postcards? I suggested. Vladimir Popov embraced me. And then he said casually, "When you have the first casts made of the creatures—in the solid-gold versions—I'd like to examine them to see if the workmanship is up to our standards."

Well, the standards of the Soviet Union, when it came to museum reproductions, were primitive to say the least. I looked stricken.

"Vladimir, when I enter your blessed country I am subjected to

389

careful searches for currency and gold. They make me count how many gold teeth I have. I have to log my wedding band. What's going to happen when I come in with five thousand dollars' or so worth of solid gold animals that look like the real thing?''

"No problem, Tom. Come in with the stuff through Belgium. Sabena. You hear? Sabena. Fly to Leningrad. You will arrive there. An announcement will be made: 'Mr. Hoving, please go to the front of the plane.' All the other passengers will be instructed to remain in their seats. You will go. At the bottom of the runway there will be the usual fat, ugly woman with the roses in the plastic tube. She will give them to you and will guide you to a bus—empty but for you. You will be driven to the VIP lounge where you will meet me. We will hug and kiss each other, and you will give me the box with the Elk and the two panthers—the gold ones. And, Tom, I can virtually guarantee that I shall adore their workmanship.'' He roared with laughter. "Ah, maybe, for our examination I should have two sets!''

"One, dammit!''

"Okay. But no gold, no exhibition.''

Several months later I made the trip, my heart pounding with fear when the Sabena plane came to a halt. But the plan was executed exactly as Vladimir had described. From that time on, all the remaining petty obstacles in the path of the Scythian show vanished. And Kiev decided to send us the great necklace.

Of course, I attended the openings in Leningrad and Moscow of our "100 Masterpieces" show. Had there been free elections at the time, I might have made it into the Politburo. The lines were three hours long, but not a single citizen on line looked unhappy. I had been assigned an artist-writer, "the honored art worker" Igor Dolgopolov, to interview me and, on a trip through the Tretyakov Gallery, to plug the next exchange—"Modern Pictures." I had asked Alla Butrova for advice on how to deal with the writer, and she had remarked with a vulpine grin, "Give them the 'Hoving treatment,' you know—poetry and bull.''

The Scythian show was a breathtaking success, the blockbuster of blockbusters. The first-day attendance was the largest in our history. But even the accolades that accompanied "Scythian Gold" could not compare to another exhibition from the Soviet Union, the costume show which Diana Vreeland had so masterfully stitched together. For this one we decided to maximize our business opportunities, so we contracted with Doubleday & Company for a

major book-catalogue edited by Jackie Kennedy Onassis. She rushed into the work with zeal, interviewing historians and costume experts in America and England. I assumed that the work was progressing smoothly, but there was, it seemed, a hitch. I got wind of it at three-thirty in the morning in my hotel in Cairo where I was on some ticklish business. It was Diana Vreeland.

"Tom, do you hear? The day after tomorrow, be at the Plaza Athenée, in Paris. I have booked a room. You're going to take Jackie to Russia. For the Russian costumes. She demands to see what she's writing about."

I followed out the orders and dashed to Paris. I checked into the luxury hotel, called Mrs. Onassis, and invited her for a modest dinner that evening with me and my daughter, who was visiting with friends. I had booked a table at a restaurant on the Left Bank, and when we left in a cab, I told the doorman the name and address of the place to tell the driver. On the way to the restaurant she was charming, bubbling with enthusiasm to be going to the Soviet Union. She had never been. She was natural, funny, and easy with my daughter.

When the cab turned into the narrow street some two blocks from the restaurant, it looked like a disaster had taken place. Dozens of empty cars jammed the sidewalks, most with their lights still on. Two police cars were parked near the restaurant, their blue lights revolving.

As soon as we alighted from the cab, we were engulfed by a wave of photographers, TV cameramen, and reporters. "Jackie, Jackie!" they screamed as they pressed towards us. The police tried to maintain order but were overwhelmed. Somehow, we made it into the restaurant and the proprietor guided us into the back and flung himself against the door to stop the full horde from rushing in. Flash-bulbs were popping; people were screaming. I thought Jackie was going to crawl under the table. She was shaking. At length the hub-bub calmed down and a couple of pictures were made with her permission and the paparazzi thinned out. If she was going to experience the same thing in the Soviet Union, she wasn't going to go. I laughed and said that the one good thing about Communism was that the state-controlled press would take one photo on arrival and one on departure—both times only after her permission. She gave me a smile.

That evening, after depositing my daughter back at her apartment,

and upon reaching the Plaza Athenée, I said good night to Mrs. Onassis and barged into the assistant manager's office. I explained who I was and said that I was taking Mrs. Onassis to Russia and that unless he fired the doorman who had put us into the cab that evening and then clearly called the press, Mrs. Onassis would never return to the hotel and would urge all her friends never to visit it. Mrs. Onassis had been caused incalculable personal grief. The man choked out the words that he would see to it immediately. Within minutes after gaining my room I received a phone call from an official of the hotel chain with the information that the offender had been sacked. The next day after I told Jackie she drew back startled, "Why, how could you have!" Then she smiled and said throatily, "Thanks."

When Jacqueline Kennedy Onassis travelled to the Soviet Union, she may have been the most famous face and personality on earth. I told her a few days later if she parachuted into the wilds of Madagascar, Murmansk, or Mozambique, crowds would have gathered before she landed, seeking photographs and an autograph. I was flabbergasted at the crowds of photojournalists and reporters and television crews who hounded us as we departed Paris. All the mundane details of checking in at Charles de Gaulle, having our luggage weighed, trudging up the long, flat, black-rubber moving belts to the passport station were recorded step by step. Jackie pasted a smile on her face and toughed it out. I kept turning my head to the side. French and Italian reporters would sidle up to me to ask who I was. By the time we had been in the Soviet Union, I had been characterized "the new mystery lover" in the tabloids.

I have never met anyone who carried the burden of celebrity so graciously. Or who was so driven to learn. On the long flight from Paris to Moscow she asked for a full briefing on everything I knew about Russia—every detail. What she knew about the costumes impressed me. Her homework had been prodigious. She was punctilious when it came to giving credit to every person who had helped her and cited every book. I knew then that after Diana's knock-'em-dead trip and Jackie's impending tour, the Russian Costume exhibition was sure to be one of the most memorable in the history of the Met.

She had a personal agenda also: to convince the Soviet officials to send—or entrap them into sending—something worn by Czar Nicholas or Czarina Alexandra. Vreeland had asked for some things and had been told "Never!" Sending anything once worn by the last

royal family, slaughtered on the direct order of "Saint" Lenin, would be anathema. But Mrs. Onassis was determined to try, even if it meant jeopardizing the show. What did I think of that, she asked. I told her, "Go ahead!" The second item on Mrs. Onassis' hidden agenda was to bring about the immigration of a member of the curatorial staff of the Hermitage, Leonid Tarrassuk, a Jewish dissident and a member of the Arms and Armor Department. I paled, but Mrs. Onassis just smiled with supreme confidence. (Some years later, Tarrassuk did come to America and the Met, mostly thanks to her efforts.)

At the ministry, everyone kept referring to her as "Mrs. Onassis Kennedy." When I told them the names were not in the right order, it was pointed out to me tartly that "Onassis isn't good enough."

"Ah, you want a Czarina," I said.

"Now you understand, Mr. Hoving." And so it was "Mrs. Onassis Kennedy" for the rest of the nine-day sojourn.

Straight off, she raised the subject of a loan of anything related to Nicholas or Alexandra and that was the only time that she got the old Russian, "cold war" faces and the standard phrase, *"Nieltza"* —"Impossible."

Failing that, Jackie kept pressing for a lap robe of green velvet lined with fur with coats of arms in thick gold frogging that once belonged to a member of the royal family, Princess Elisabeth, and had been worn on sleigh rides. The staff searched, they claimed, through the immaculate archives of costumes and came up with the sad information that the piece in question had disappeared—perhaps during the war. But Jackie kept insisting that it did exist.

After a few days in Moscow we entrained for Leningrad on the Red Arrow, one of the rare amenities of the country. The train has a few plush double compartments, leaves Moscow station at midnight, makes its placid way at some thirty-five miles an hour, and arrives at a civilized eight A.M. Our first stop the morning of arrival was to the Hermitage and the ritual meeting with Boris Pietrovsky and Viktor Suslov. Virtually the entire staff had turned out to greet us and Pietrovsky was positively giddy. Tea and coffee were served after charming welcoming speeches, and then Suslov took over. He was a gray, worried man, perpetually pursing his lips and muttering such phrases as "We must define the problems." Life for him was one long anxiety replete with impossibilities. To see Suslov suddenly become almost cute, made me nervous.

"We have a surprise for Mrs. Onassis Kennedy," he said, "and

for you, too, Tom, in a part of the Hermitage even you have not visited. We go.''

We followed him to a doorway I had never seen and down some steep stairs to another door and into darkness. This way, around here, now there. Stop. Wait just a second. It was like being led around in a blindfold. Then a battery of spotlights were turned on. My first impression was an enormous underground chamber filled with ancient carriages and sedan chairs, all eighteenth century or earlier, all shoved hurriedly out of the center of the place. In the center, bathed by the lights, stood a sled upholstered in green velvet with a lap robe on the seat.

Suslov's voice rose dramatically. ''The robe of Princess Elisabeth you wanted, Mrs. Onassis Kennedy—and the original sleigh. We found it—for you.''

It was fabulous. I put my hands under one of the runners and budged it.

''Isn't this about the size of, say, a Volkswagen?'' I asked.

''Yes, yes,'' said Suslov.

''Then why not send it over for the show!'' I said.

''*Da, da!* Why not!''

It was a thrilling moment in détente—and for the Russian costume show.

The next few days included tours of the Hermitage and the Museum of Russian Art, lavish dinners, lunches on the run, a foray to Petrograd, the cruiser *Aurora,* and visitations with everybody from subcurators to the mayor of Leningrad and the head of Aurora Press, the premier book publishing company in Russia, who showed the page proofs of a book Jackie particularly admired.

We also drove out to Pavlovsk, the Imperial ''country'' palace destroyed by the Nazis and lovingly rebuilt by one of the finest restoration teams ever assembled. Before tea we were shown dozens of wooden and steel trunks, storing costumes of every noble and royal member. These original trunks still had the names of their owners in bold Cyrillic letters. Jackie, naturally, spotted two large ones with the names Nicholas and Alexandra.

Over tea, taken a bit nervously because it was served on an eighteenth-century set from the museum's collections, Jackie once again posed the Nicholas and Alexandra question. The director smiled and said that was out of his hands. ''But why not put one on?'' he said cryptically. He motioned her to go into the narrow corridor with one of his curators.

In five minutes a startlingly beautiful vision of a slender, dark-haired woman appeared, clad in a shimmering white ball gown designed to look like a peasant costume, but in silk and decorated with an abundance of white swan's down—hood, muffs, gown, cape. It was Jackie Onassis grinning mischievously from inside the hood with its aureole of swan's down.

"It's Alexandra's," she said in her low, intense whisper. "Made for the opera. Worn once. Oh, can't we have it for the show?"

The director smiled weakly and made the gesture that his hands were tied. He was as overwhelmed as the rest of us at the beauty of the woman standing before us. Photographs were made—three of them—one for Pavlovsk, one for Mrs. Onassis. As for the third, I never knew what happened to it.

The visit helped the catalogue—and the show—immeasurably. Both managed to achieve a balance of scholarship and allure which became the benchmark for all future Costume Institute exhibitions and made it easier for us to plan other exchanges with the Soviet Union.

I insisted that all the exhibitions I was involved in had to produce something permanent for the museum, whether a book or catalogue that became a landmark in its field or another blockbuster or, best of all, rare works of art we didn't have or, of course, donations of money. So, when Karl Katz hinted to me that if we mounted an exhibition of the works of Andrew Wyeth, the collector Joseph E. Levine might reward us lavishly, I listened. If Joe were involved, he might give us his thirty-five Wyeths plus the funds to establish a gallery or two in the American Wing. I urged Katz to be blunt with Levine about my annoyance at the Allen Funt affair.

Joseph E. Levine was the image of the movie mogul—short, paunchy, loud, temperamental, and shrewd. He studied you like a psychiatrist. When Katz brought him to my office to talk about Wyeth, at first he seemed awed to be in the office of the director of the Met, and then, when he saw I was not an "English Lord or something," he showed himself to be a charming raconteur and a crafty connoisseur. Joe had the ability to tell reams about himself—or any subject—in minutes. The story of his life took less than three.

Born on Billerica Street in Boston, he bought his first movie theater when a teenager and in a few years had an impressive chain of nickelodeons. He gained fame by his marketing innovations—being

the first movie distributor in history to use the simultaneous release
—and earned his millions by buying nonentities such as the Italian
Hercules films starring Steve Reeves and *Godzilla,* the Japanese
monster movie, and hyping them shamelessly. His best hype had
been to take the splendid documentary of the aborigines in New
Guinea, *The Sky Above, the Mud Below,* and release it with flamboy-
ant advertisements—"Grisly cannibal rituals" or "So terrifying you
might have to run from the theater." The film became a hit. Levine
made himself a multimillionaire in short order and then set about
producing quality pictures: the Academy Award–winning *Two
Women* with Sophia Loren, and the classic *The Lion in Winter* with
Katharine Hepburn and Peter O'Toole. His greatest success was *The
Graduate.* All this spilled out in the first explosive ten minutes.

"Karl tells me you don't want to show just my Wyeths. And I
think you're right. So, why don't you show Wyeth and anything out
of my collection you want to show or not? Andy listens to me be-
cause he loves movies. I think you can get all the stuff—his draw-
ings, the studies he's never shown anyone. I think you can change
the perception about Wyeth. You should, as a matter of fact. I'll
help. I'll fund the show. All I want in exchange is a gala fund-raiser
dinner opening night, the proceeds to benefit equally New York
University Hospital and the Met. Just think of the meeting of those
two guest lists, Tom. Hell, it's worth doing just to have the two
crowds come together."

And then he dashed away.

With Levine, I made a trip down to Chadds Ford in Pennsylvania
to meet the artist and his wife, Betsy. I was nervous. Several years
before, I had dismissed Wyeth's works, and he knew it. We met
in his farmhouse, and I went out of my way to tell Andy how I
had changed my mind about him, relating the story about visiting
his show at the Whitney with Bobbie Lehman. There were a num-
ber of temperas in the house, and after lunch we looked at dozens
of his "pre-studies," as Andy described them. I was floored. I
had expected a facile near-illustrator, but found a complex artist
whose paintings were not about some kind of dreamland America,
but involved with the urgent and cruel reality surrounding him.
The pictures of the Kuerners, who lived nearby, and the Olsons
of Maine were far from being lyrical odes to some never-never land;
they were as unsentimental as surgical operations. My greatest
surprise was to find so many dishevelled works—paintings and

drawings in which each blade of grass had *not* been "lovingly" rendered.

Wyeth cackled about how funny it was that he was so misunderstood. "I mean, no one bothers to look anymore! You'd just die if you knew how many people write these gushy letters to me about that 'beautiful, young' Christina! Ha! She was a cripple, for Pete's sake. That's what I liked about her. I liked the fact that she was dying before my very eyes. Oh, I loved her, sure, but to me, that body wasting away, well, that was fascinating."

The visit lasted all day. We chatted, gossiped, and sped about in his modern Stutz convertible to the Kuerners and to various houses and places he had painted over the years. I was continually surprised by the man, particularly when he confided that he admired the work of the abstract-expressionist Mark Rothko and vice versa, and that he and Rothko had exchanged letters.

Our discussions came down to how the proposed show could be different from all the other Wyeth presentations. It was Betsy Wyeth who came up with the solution. "Why not call it Kuerners and Olsons and do the show only around the two environments? I can guarantee the best loans from museums and private collectors. I have been preparing a huge book on all the studies in watercolor, dry-brush, and the combination of both. The two places will be the focus, the story line. Most of the cataloguing work has been done; we have most of the photographs."

"That's it!" I shouted.

"I'll pay for it," chirped Joseph E. Levine.

The euphoria of meeting Wyeth, the revelation that Betsy had done most of the work, the fact that the money to mount the show was assured—all of that faded when I returned to the museum to figure out who would be the curator. Certainly not Geldzahler. But, to my surprise, Henry sent me a note, "My reputation to the contrary notwithstanding, I would like to be the curator in charge of the proposed Andrew Wyeth exhibition. He has indicated in the past through his sons that he would like this association. I understand that the financial negotiations are delicate; but when the show becomes a reality, please think of me."

I had him up to the office and I voiced my skepticism about his true willingness to participate. Henry convinced me that, as a professional curator, he felt he had the skills and the right to curate the show of a living artist—after all, that was his department.

Henry and Andrew got along famously. The work of selection went on for several weeks, with Geldzahler making copious notes on the material prior to writing the draft of the catalogue. Then, without warning, Geldzahler asked to see me about "the Wyeth problem." He had to pull out.

I thought he was joking. But Henry meant it. He had to quit because, as he said, "My clique wouldn't like having me associated with Andrew Wyeth." He had built up a constituency for over sixteen years, and belatedly he had decided he couldn't annoy them. I was calm, strangely enough, perhaps only because I was so flabbergasted at his unprofessionalism. I patiently told him that he had put me and the institution in a terrible bind with the publication deadline so close. I tried everything to get him to remain on the job but was unsuccessful. The man was terrified about his reputation.

When I saw that he meant it, then I screamed at him for his pattern of sloth and manipulation over the years, reminding him of his lax performance in the "New York" show, his conduct during the *F-III* affair, his skirting the truth during the deaccessioning when he had made some unfortunate remarks about the *Becca*. I all but threw him physically out of my office.

I called Jock Howat, the curator of American Paintings and Sculptures, but he reminded me he was off on a sabbatical. I was floored. What was I to do? Hire someone in on a free-lance basis? Impossible. Finally, I decided I would have to write the catalogue. Time was short. I knew I could not complete a standard catalogue, so why not publish a unique question-and-answer interview probing his artistic side? I told Wyeth about Henry's decision.

"That poor son-of-a-bitch" was all he said. We agreed to give the interview our best efforts, though Wyeth clearly felt uneasy. When I told him that I had to have five full days, he groaned. As soon as I could round up a tape recorder and tape and had devoured all the books and articles on him that had ever been printed, my wife and I drove down to Chadds Ford and started in.

I had committed to memory dozens of questions and had memorized all the paintings of both the Olsons and Kuerners. We started early one week in the late fall and went on for some three and a half days, spending three or four hours each day, just the two of us in his father's studio. I made sure I didn't ask the questions in chronological order, in order to avoid the monotony that comes with telling a life story. I skipped from his early training to Christina Olson to Anna Kuerner and then to the medium of ink as opposed to pencil,

then to the tempera, to the painting *Brown Swiss,* back and forth all over the lot, keeping a careful checklist at the end of each session about what I had covered.

Wyeth was petrified at first—he had brought two bottles of red wine the first morning, which we promptly opened and drank—but soon he forgot I was an alien presence and spoke lyrically about his work. Some parts of the interview were astonishing. At one moment he was harsh on his father, telling how he resented him for neglecting him while he fussed over the artistic efforts of the other children. The others had been taken into the studio for training, but Andrew had been kept in the periphery. I suddenly cut in and said, "But that wasn't neglect at all; it was recognition of your talent. I'll bet your father was scared he might destroy that exuberance of yours with too early a training." Suddenly, Wyeth cried out, "You're right. I didn't realize it until now. Why, it fits into how he led me along, so gently—but so very persistently."

There were to be many revelations—for me and the artist as well. Eventually, I had six or seven hours of tapes. In the afternoons, Wyeth would either take me to neighbors, like the Kuerners or Dr. Margaret Handy, the owner of a spectacular landscape showing the Kuerners' hill after an early snow, or he would disappear. He would take Nancy off with him to barren upstairs rooms or a crowded attic in a friend's house where he had stashed completed works or some still in progress. It was during one of these ventures that Wyeth told my wife about the new model he had found to take the place of Karl Kuerner who was ill. Wyeth simply had to find a new subject as soon as he realized that an old favorite was dying. He had chanced upon a young local German nurse by the name of Helga Testorf, who took care of Karl Kuerner. Helga had begun to pose in the nude for him, clandestinely. He pledged my wife to secrecy about Helga, for Wyeth explained he hadn't told his wife or family about her. She never said a word, and it was only nearly two decades later when the Helga news broke that my wife showed me her notes about the affair. She also told me that Wyeth had wanted to paint her in the nude but that she had hesitated.

The Wyeth exhibition became the tremendous public draw that one might have imagined. And, of course, the show was slammed by the anti-Wyeth forces. Henry Geldzahler gave several interviews to the press in which he claimed I had forced him to curate the show but that he courageously bowed out.

When Edward Koch was elected mayor, I had the opportunity to

rid the Met of Henry Geldzahler's ineffectual presence. Henry called me at home one evening, slightly out of breath. He was short-listed for commissioner of Cultural Affairs. To my relief he accepted the job.

To replace him I hired the man I had wanted for years, Tom Hess, a brilliant scholar, collector, and writer. He was delighted at the offer and took control with such joy and dedication that the rest of the curators were slightly stunned. Tom Hess would arrive at seven o'clock and work and write until late in the evening. I have never seen such a happy slave to his work. His agile mind was filled with ideas for shows, articles, acquisitions, books. He made it clear that his superb collection of abstract-expressionist paintings would come to the museum. Then, tragically, he collapsed and died one day at his desk. I always thought Tom Hess passed away not from a bad heart, but from a heart too full of joy.

The Wyeth exhibition produced no long-term benefits to the museum, no gifts of either pictures or cash from Joseph E. Levine. The gala dinner did net a sizable sum of money for both New York University Hospital and the museum. Levine soon tired of the Met and sold his excellent collection of Wyeths to a collector in South Carolina who pledged to leave the works to a local museum but subsequently sold the group to a Japanese. The Levine collection, which I had striven so hard and taken so many risks to land, is a permanent resident of Japan.

20

KING
TUT

Ever since the Egyptians had dispatched fifty magnificent pieces from King Tut's tomb material to the British Museum in 1971, in honor of the fiftieth anniversary of its discovery, every ambitious American museum director had made a play for the exhibition. I had given it a try at luncheon with the president of the Organization of Antiquities, Gamal Mokhtar, way back in 1968 and had failed. I knew that Carter Brown had approached Egyptian officials many times through his powerful diplomatic contacts. I thought I had the inside track if only because we had the Temple of Dendur as our link.

But the man who pulled off "Tut" was Richard M. Nixon. On his triumphal visit to Egypt not long before he had to resign in disgrace, the president asked Sadat about getting the show for America. The Tut materials had just been on view in the Soviet Union. Nixon demanded one more city than Russia and more objects. Sadat was sympathetic. The Organization of Antiquities had been dragging its feet. A direct order from Sadat got things inching along.

And Gamal Mokhtar decided that the Met was the only institution that could be trusted to make arrangements and guarantee the safety of the works. When Kissinger's office told us we could have the phenomenal exhibition if we agreed to guarantee its safety, we hesitated. Frankly, we shuddered at the awesome responsibility. But word came back directly from Kissinger to Douglas Dillon that the show was a vital part of the Middle East peace process and all future relationships with Egypt. Unless the Met, with all its resources, became the principal organizer and the guarantor, the federal government would be "disturbed." To Dillon this meant that all federal grants might be lost forever. So, reluctantly, we agreed to take on the duty. The only thing I absolutely refused to do was to select the five other cities. Ron Berman, head of the National Endowment for the Humanities, assumed that burden and apportioned the show geographically. He called to tell me which cities had been chosen and also gave me the terrible news that the show would open in Washington.

I complained bitterly, beefing about Carter Brown doing nothing, taking no responsibility, and winning the prime spot. Berman told me he was under direct orders from the White House. The other cities were to be Chicago, New Orleans, Los Angeles, and Seattle. I simmered down when I realized that being last was actually better than being first—visitors would flood to the final opportunity to see the show.

Then came the job of picking the objects, raising the money, writing the catalogues and books, and ensuring the safety of the precious pieces. I thought it would be pretty straightforward. It really did seem so simple. Go to Cairo, choose several more pieces than the Soviets had obtained, and cut the deal. I had plenty of time before the show was scheduled to open in Washington, November 1976. There would be only fifty or so pieces, forty of which had already been on the road. But then, I had never before worked in the Middle East. "King Tut" became an epic comedy with an indeterminate number of acts, each more frantic and hilarious than the one before.

My first meeting with Gamal Mokhtar was at his half-demolished Rameses Street offices. Dr. Mokhtar was a short, plump man with a cherub's face, a sly smile—with most of the teeth in front missing—and a bald pate. He also adored women and cherished belly dancing, so much so that many of our meetings were held from a late dinner well into the night.

On my first visit to Cairo I brought along Egyptian curator Christine Lilyquist and administrator Richard Morsches. We arrived at Mokhtar's downtown office, passed through the most crowded corridor I've ever seen, and entered a three-ring circus. Gamal Mokhtar sat at the end of a thirty-foot-long room with two roaring air-conditioning units. Behind his desk on a podium stood two ancient phones, both ringing. In a circle surrounding the president's desk were about a dozen half-collapsed leather chairs and sofas. In each sat a gloomy-looking supplicant. When I was seated by the major-domo on Gamal Mokhtar's immediate left, I thought I had been placed in the position of honor and prepared myself to make my initial pitch. I soon learned that I was last.

Each person pleaded his case as long as he wanted. There would be continual interruptions. Mokhtar might reach back to pick up one of the phones and listen, his nut-brown brow furrowing in concentration. Then he would cry out in Arabic, *"Aiouwah!"*—"Yes." He would listen for a few seconds and would delicately put the receiver back on its cradle. Between the incessant, unfinished phone calls, aides would bustle in with dozens of documents for him to pore over and sign. Or a man would come in with a tray and take orders for Coke or tea.

Suddenly, a supplicant would leave and the carousel would lurch forward, one person at a time.

On this first meeting I moved from chair to chair from eleven until one. When at last I had attained the honored position at the president's right, he looked at me in surprise and said, "Dr. Hoving, welcome to Cairo. We must meet tonight, at ten, at the Sheraton, for dinner and a show. We shall decide *everything* then."

The first session, dinner at the Cairo Sheraton, began with some of Mokhtar's staff plus a journalist, Gamal el-Malak, who had been the first person lowered into the pit on the south side of the pyramid of Cheops containing the famous "solar boat" of the Pharaoh. The business consisted of much drinking and, of course, the belly dancers. All we accomplished was to set up another appointment at Mohktar's offices on Rameses Street at eleven, two days later. In the meantime, we could visit the Cairo Museum.

Nothing could have prepared me for the combination of splendor and degradation in this museological gem. The objects from Neolithic times to the Hellenistic and Roman periods were universally stunning. The way they were displayed was disgraceful. The galler-

ies were squalid, the vitrines had cracked glass, the guards, all in black felt uniforms, seemed comatose. Many of the most beautiful statues were splotched with yellow paint because no one had used drop cloths in a recent painting of the walls and ceilings. The thread-bare rugs in some galleries had a pattern of dark-brown stains—the guards chewed and spat tobacco. The office of the director was filthy and had no electricity. But electricity was soon to be installed, I was assured. The general lack of electricity meant there were no fire or burglar alarms. There were, surprisingly, phones, but of course they didn't work very well.

When I walked up the stairs and into the Tutankhamun galleries, I experienced aesthetic overload. We remained there all day. I didn't bring any expertise to the Tut galleries; I selected what looked great. Simple as that. Christine Lilyquist tried to point out what was impor-tant or not from the Egyptological point of view, but I didn't listen. I knew what I wanted. And the choice rather surprised Lilyquist and the Egyptian curator. They expected I'd pick the larger objects—the huge gilded beds or the royal chariot. But I recognized that the finest Tut things were the more intimate objects. Besides, I realized that with six cities, I needed pieces that would fit into domestic aircraft. In addition, since the galleries in the American museums were bound to be crowded, with the visitors inching along, the works had better be small, needing concentration to be appreciated.

I returned to Mokhtar's office—again merely as another suppli-cant. The man before me was English and pleaded with Mokhtar to grant him permission to have the glass case removed from an Old Kingdom statue so that he could embrace it: "Life-giving forces emanate from it, your excellency, and if I embrace the statue, they will flow into me and I will be able to transmit that power to the world with the result that sicknesses will be cured and riches untold will pour down upon mankind." Gamal Mokhtar beamed at him like the Buddha. He would "consider it."

With me it was the same. I presented my list of fifty-five objects—the number fit the years since the discovery of the tomb—and he glanced at it quickly, turning to pick up one of those jangling phones. He would give thought to my list, he said. But first he wanted to know how many people, precisely, would visit the show in the United States and how much admission we would charge and how much of the admissions he would get. I told him there would be no admissions, and he floored me by saying, "Then, there can be no

exhibition. Unless we are guaranteed admissions—more admissions than the British Museum, since America is richer and there are six museums, not one." I told him I'd send him a report.

"No report. You must come to my 'tent,' " he said. "Admissions, please. But, tomorrow I shall escort you to the airport and we shall talk further. Tonight, you must think."

I was up all night trying to come up with the appropriate monetary solution for Gamal. There was no longer any doubt that the show was for rent. By the time he picked me up at dawn, I thought I might have solved the problem. I had conceived not one, but *two* exhibitions. Tutankhamun would tour five prime cities, and a second show called "The Treasure of Five Pharaohs" would travel to nine less-populated centers. The second exhibition would consist, I said, of "thirty-five to forty-five splendid pieces illustrating the art, the history, the personality and the achievement of Egypt's greatest leaders of antiquity, Cheops, Mentuhotep, Akhenaton, Tut, and Rameses II." I had spent the night calculating what revenues might be gained from the sales in both shows of a wide variety of books, calendars, jewelry, reproductions, posters, slides and cassettes, and even a Hermès scarf similar to the one I had had designed for the Scythian show.

I explained to Mokhtar that American museums could not charge admission, but if we were allowed to make casts and molds and models for the jewelry and sell the products, enough revenues would be gained to surpass the British revenues. His eyes glistened as we pored over the figures, which, I said, might amount to as much as $1.4 million. Finally he asked, "May I have a Tutankhamun scarf, too?" I promised him a dozen. He said he'd think about my proposals. "Come back in a month and we'll talk."

The next month, another round of meetings in nightclubs ensued, and this time I felt I had made progress. The two-show idea was dumped. I had made some attendance and sales projections and Mokhtar seemed to like them. And he was very pleased at the overall design scheme of the exhibition. The basis of our design would be to place the pieces in the exact order in which the English archaeologist Howard Carter had discovered them. Once Carter had found the treasures, the Met had sent the brilliant photographer Harry Burton, who captured the drama of each day's discoveries in hundreds of glass-plate photos, all of which the Met owned. We planned to intersperse Burton's photographs with the objects and thereby recreate

for the public the sensation of "finding" each one of four chambers and their stunning array of works.

Although I patiently went over what was obvious to me, he never understood that money would have to be invested to create the product line and the amount invested had to be subtracted from the profits. I had approached the Franklin Mint about creating a special gold coin commemorative set and told Mokhtar that he could count on half a million dollars on signing. His smile became radiant. Later on, I made a similar agreement with Boehm Porcelains for more than a million dollars.

I also promised that the Met would send Kevin Roche to make a plan for the rehabilitation of the Cairo Museum. Lila Acheson Wallace had promised to pay for that. He was delighted. I left Egypt thinking I was down to the short strokes.

Not at all. Gamal Mokhtar's resolve was in indirect proportion to the moment of having to make up his mind. He soon told me he had grave problems. I returned again to Egypt and ironed them out. This time, at last, Mokhtar tentatively approved of the fifty-five objects and hinted he would accept our "firm assurances" that the revenues from the tour would net him $1.4 million or more. He plaintively told me that he really needed to be assured of three million to placate the growing critics of the show, namely the journalist Gamal el-Malak. I had dinner with el-Malak. I smiled and said, "Listen, friend, what about a book contract to write something—anything you like—about Tut, for say, ten thousand dollars?" "Assuredly," he said with his tongue almost flicking out of his mouth. Opposition to the show inside Egypt vanished.

I explained to Mokhtar that in order to make a spectacular catalogue which would generate astounding revenues for him, he had to give us special permission to photograph the objects under studio conditions, removed from their moldy cases, in a room we would construct out of aluminum tubing and black photographers' paper. It also meant, of course, that the electricity had to be installed in the Cairo Museum—finally. Absolutely, Mokhtar assured me. I wanted to bring a team of eight to start work at once on the photography and make the molds for our reproductions.

Mokhtar let me wait three months, then instructed me to bring my team in early January, 1975.

The team consisted of Dick Morsches; Christine Lilyquist; Lee Boltin, the photographer who had produced marvelous shots of the

Scythian catalogue; an assistant; Kevin Roche, who planned to stay three or four days; Christine Roussel for the casts and reproductions; and the model maker, Bruce Hoheb.

Lee Boltin was a tall, slightly stooping, bald man with an infectious laugh and a cutting sense of humor. He adored classical music and brought with him a set of speakers plus tapes with the works of Beethoven, Mozart, Schumann, and Bach and a little Vivaldi. Boltin had his quirks. He cherished practical jokes, especially if they were at my expense. And he was a born haggler. His temperament and personality were perfectly suited for Egypt.

Christine Roussel, an attractive redhead, had acute executive abilities, a talent for walking steadily through the shifting sands of the Egyptian cultural bureaucracy, and a connoisseur's eye for choosing beautiful and suitable objects for reproduction. She soon turned out to run the entire operation, especially search operations through the bazaar to purchase supplies and to change money at favorable rates.

We arrived in mid-January and proceeded to the Meridien Hotel on the banks of the Nile, which I had chosen because it was new and the rates were economical. But we were told that there were no rooms. It seemed that an international conference was going on longer than planned. The assistant manager told me, "They are your countrymen, and other guests are sleeping in the corridors on cots. How can I throw them out? But, do you like boats?"

The assistant manager took me out to the terrace overlooking the Nile and down a steep flight of steps. At a dock was a Chris-Craft, about sixty-five feet, the *Sahar*, which was used for evening cruises.

"You can have the *Sahar*. There are eight staterooms and cabins."

After Christine Roussel entered the bargaining, we got the boat for a week for twenty dollars a room. The assistant manager swore we would have all the service the hotel was famous for.

We settled into surprisingly comfortable cabins. As the sun was setting, we were relaxing on deck when suddenly the forward hatch opened and a small boy, his filthy hair matted, crawled out and smiled at us. I could see that the back teeth on the right side of his mouth were worn down, like a cow's. Seeing us, he dashed into the galley-bar, extracted a Coke from the refrigerator, and whipped off the cap with his teeth. I called the hotel and told them to send someone down to get the child, clean him up, give him a haircut, dress him in a bellboy's uniform, and teach him *never* to open Coke

bottles with his teeth—and give him five pounds a week extra. In two days the boat boy was as well trained as a fledgling English butler.

The next morning we trooped to the Cairo Museum where the director, a gloomy man by the name of Selim, greeted us perfunctorily, with an assistant who would be his liaison, and guided us with our mountain of equipment up to an empty gallery adjacent to Tut. Boltin set up his transformers to provide a constant 110 volts from what we assumed would be a wavering 220 direct current. I asked Selim's assistant where to plug in our equipment.

"It matters little," he said and paused, looking furtive. "You see, there's a little problem. The electricity is running a bit late. It will be fully working in two or three months, or so they tell us. But why not use the natural light?"

My tantrum reverberated throughout the museum and flushed out a squad of rifle-bearing guards. Selim shrugged and turned away.

Back on the *Sahar* my anger turned to fear. How were we going to do the job? I knew of only one man in the country who was smart enough and had the power—and the equipment—to pull off the stunt I needed. I called him at once. He was the director of the Sound and Light at the Great Pyramids, Fuad el-Orabi.

It took only two hours to get Fuad on the phone. "Dr. el-Orabi, I want you to become a consultant at five hundred dollars a week for the Metropolitan Museum of Art—for a minimum of four weeks—if you are permitted by the ministry to do so."

He complimented me on how graciously I had bestowed upon him his "honorarium," adding that he guessed the problem was severe. He listened and gave the most curious instructions: meet him at eleven-thirty on Rameses Street near the back wall of the Cairo Museum with my technicians.

At that hour we went to the deserted roadway. A truck pulled up and out jumped Fuad and four workers who dragged an enormous spool of electrical cable onto the sidewalk. Two of the men began to dig away at the base of a street light. Fuad calmly explained that his men were going to splice his cable to the city lighting system. They would heave the cable, spool and all, over the wall and the next morning run it across the courtyard, up the side of the museum and through the broken skylight into our studio. He reached into a pocket and brandished a "permit."

"Is *my* name on that thing?" I asked. No, it wasn't. Everything was perfectly legal.

"How are you going to hot-splice that 220-volt cable?" I asked.

"Be patient, Dr. Hoving," he said, glancing at his watch. The street light began to dim and went out, as did those several blocks around us. His experts made the splice and the wire was muscled over the wall.

The next day we had our cable snaking into the studio from above and Lee Boltin turned on his transformers—perfect—and then some classical music. The dried-out drum of a Cairo Museum pulsed with the sound, bringing Director Selim, the curators, the guards, and sundry visitors racing up to the chamber. Selim meekly asked us if he could "borrow" some electricity, and we ran a small wire down the stairs into his office where his desk lamp was turned on for the first time in years.

After the first day I knew we'd never make the deadline. For each work of art, a curator accompanied by four armed guards would open a case, remove a number of lead stamps from wires, and log the object in a frayed ledger. The piece would be marched through the galleries to the studio, accompanied by armed guards who would stand around Boltin while he set the piece up against his brightly colored paper and fussed with his Polaroids and the lights before taking a shot. At lunch break the object had to be returned in the same way and the process begun all over again. The museum opened at nine and closed at three.

I talked with Selim about a more efficient system for the removal of works of art. He told us that if we were willing to pay the guards and the staff overtime pay at the end of each day in cash, then we could work until five. At this Christine Roussel disappeared into the bazaar with Lee Boltin and came back with a certain Joseph (dubbed the Snake because of his strikingly hooded eyes and slippery behavior). Joseph was the money changer who got us the cash each day—at the black-market rate, which was more than five times the official tourist scale. The money had to be in Selim's safe by two-thirty each day. What he actually did with it, we figured was his business.

Within three or four days the lengthy process of getting the priceless treasures in and out of the cases solved itself. The guards got bored and started to take long naps in our studio. The curators handed us the keys and the lead seals and told us to go ahead on our own. Our most valued aide was an elderly museum messenger who helped carry some of the larger pieces into the studio. It was up to Lee Boltin and me alone to wheel around the one-hundred-pound solid-gold inner coffin of the Pharaoh.

But, as the work progressed on the photos and the reproductions, surprisingly the final lists had still not been approved by the highest authorities, Gamal Mokhtar, or Sadat. Day after day the haggling would go on. At last we agreed on the fifty-five pieces, from a painted wooden head of the king when he was a child, to his golden death mask. Yet I wasn't entirely satisfied. The show had everything—gorgeous objects, all looking as if they had been made the day before, and the stupendous gold mask—but the show lacked humanity in a way I couldn't quite define. I asked them to substitute for one of the objects one of four gilded wooden goddesses surrounding the huge receptacle for Tut's canopic jars in which his vital organs had been placed. All four were wearing skin-tight "nightgowns."

Absolutely not, it would be "sacrilege!" I was told. The Egyptians thought that the goddesses had been carved out of the same wood as the rest of the huge canopic shrine they protected. I knew from Harry Burton's 1920s photos that the figures were pegged into the shrine. I offered my colleagues a wager. If I could go up to the canopic shrine and could lift out the goddess Selket, could I have it for the show? I offered the group a dinner in the best restaurant in Cairo, the Quichote, if I could and two dinners if I couldn't. They agreed.

Once the glass was removed I donned my white gloves, squatted down, sent up a silent prayer to all the ancient Egyptian gods, and lifted. Selket came free effortlessly. It was obvious, I said, that she wanted to come with me. Back in Selim's office, I was informed that the group had changed its mind. I blanched. But no, it wasn't about Selket; it seemed that there was a finer restaurant than the Quichote.

The bartering with Mokhtar to accept our financial suggestions continued. My last offer was one hundred percent of the profits on all sales in the shops throughout the run of the show and twenty-five percent of the profits from the mail order catalogue with the proviso that the Met would have exclusive, world rights to the reproductions and jewelry we were working on after the exhibition, in perpetuity. I insisted that no one else, no commercial or museum enterprise, could reproduce the same things as we. Since Christine Roussel had picked off every attractive piece of jewelry in the Cairo Museum, whether or not it had anything to do with Tut, I knew we had cornered the market.

Mokhtar balked. It wasn't a bribe he wanted. He was begging me to assure him, for political reasons, a higher profit than the British or the Russians had given. Christine and I worked out some more fig-

ures. "Why not offer him three and a half million?" she said. "My calculations indicate that we'll net five million and up."

I asked for a final meeting at his Rameses Street "tent" to agree officially with the financial plan and the final list. I entered the same circle of supplicants and worked myself around halfway when I decided that I wasn't going to go through that treatment again. I pulled myself up to my full six feet two and a half inches and walked over to each person and told them to leave. In English, French, or German. I took the receivers off the jangling phones and put them on the floor. Mokhtar looked at me in astonishment. I shooed out his aides and the coffee schlepper and bolted the door. I sat down on his right, fixed him with a baleful glare, slapped my last offer on the table, and said, "Sign!"

He did.

Because of the delays the work proceeded frantically, with the team perpetually at the point of exhaustion. Were it not for the presence in Cairo of Christine Roussel and a newcomer, Tom Logan, who turned out to be not only a skilled Egyptologist but a deft organizer with a talent for diplomacy, the show might never have happened. From time to time Roussel and Boltin would beg me to grant them some rest and rehabilitation. Once, I smilingly told them they could join me on a trip to an enchanted land where it was cool and the people far different from the Egyptians. They were delighted, until they heard it was to be Ireland.

During the last mad dash on "Tut," Boltin and I had to travel to Dublin to negotiate another blockbuster, treasures of ancient Irish art, a show which had its own challenges. The rare manuscripts of the sixth, seventh, and eighth centuries we wanted were at Trinity College—a Protestant institution. But the golden torques, the brooch of Tara, the glorious early medieval reliquaries were in the possession of the National Museum, a Catholic institution. I took off on my first trip to Dublin wondering if the two sides would ever come together.

The first joint meeting I had with the academics from Trinity College and the director and curators of the National Museum convinced me there would be no show. Everybody questioned why anybody in America wanted a show of ancient Irish artifacts. All were totally convinced that it would be impossible to make photographs that could possibly capture the spirit of the splendid—and diminutive—works of art.

Suddenly, Lee Boltin sprang to his feet. At the time he was affect-

ing a straw hat and thin cheroot and looked something like a South Seas planter. He cried out, "*Sure* you can! I can prove it," he said. "I have some transparencies of the Tut stuff with me. Take a look at this. And I've got some Scythian samples in my kit. Have a look."

The academic committee squinted at the beautiful slides, impressed by their quality, and from then on things went more smoothly. Boltin's dramatic outburst had come just before "elevenses," a sacred proceeding I was told. Coffee was served in large earthen cups and was wondrously aromatic. I found out why—the coffee was half whiskey, the standard potion.

In the middle of the packing of the "Tut" material, work suddenly stopped because the Egyptian curators found that someone had replaced all the precious stones in the grandiose pieces of jewelry with glass! An inquiry into the theft was about to begin when someone realized that the jewels had never been anything but glass and that Howard Carter had mistaken or exaggerated the nature of the materials.

As the "Tut" organizer, I was to go back to Egypt to meet President Sadat to thank him. On the first occasion, I was phoned in New York to come in two days for the meeting, which was to be held in Alexandria. I was on the next plane—for seventeen hours—and drove all the way to Alexandria only to be told that the meeting had been cancelled because of a political crisis in neighboring Sudan. Months later I rushed over again on a day's notice—this time with my wife—to meet the president at Ras-el-Tin Palace in Cairo. I brought along the reproduction of Selket as a gift for Sadat. I took precautions to alert customs that I would be bringing in a facsimile, made of gilded epoxy.

I was stopped by a customs officer's inquiring what was in the wooden crate. I showed him the customs letters and explained that it was a reproduction—a gift for his president. He demanded I open it. The lid came off to reveal a dense layer of tissue paper. It was like the opening of an ancient tomb. The paper was swept aside to reveal the golden goddess, hands outstretched, face looking out. The customs officer gasped and bellowed, "Impound it!"

I showed him all the documents again and mentioned Sadat.

"Impound it!" he said.

"Sir, you have heard of priceless antiquities being smuggled out of Egypt," I said.

"Yes, yes! I have impounded many and arrested the miscreants."

"But . . . how many times have you encountered someone trying to smuggle an ancient Egyptian statue *into* Egypt?"

"A *very* good point," he said reflectively. "But I have to impound it, anyway."

And he did.

The next morning I told Sadat the story and he broke into laughter. "That's the perfect image of Egypt! The Selket will never show up again. Now, Dr. Hoving, are you happy with what President Nixon and I got you into?"

"Absolutely, Mr. President."

Even so, the "Tut" show almost didn't make it to the United States. The pieces were to be shipped on three Pakistan Airline planes from Cairo to Washington. The costs were minimal—less than fifty thousand dollars. Weeks before the shipment I received the most astonishing request from Gamal Mohktar—could we find and book a 747 jet air cargo plane? I found one, costing half a million dollars. I rushed to Cairo to find out what was on the elusive Mokhtar's mind. He had taken it upon himself to cancel the totally safe and inexpensive flights we had agreed upon and, at Egypt's expense, wanted to book the larger aircraft. Nothing I could say would deter him. He claimed he was under intense internal political pressure.

In dismay I dropped in on United States Ambassador Hermann Eilts and told him about Mokhtar's disastrous decision. He muttered, "Maybe I should talk to Jim Holloway about this. Jim and I went to the academy together."

I quipped that I hoped the academy wasn't West Point. It wasn't, and Jim Holloway was the chief of naval operations. The admiral arranged for a navy supply vessel to ferry the Tut objects to Norfolk —for free.

The exhibition caused a sensation and became perhaps the ultimate blockbuster, causing thousands of people to visit an art museum who had never thought of it before. There was no damage to any of the pieces in the slightest degree. The participating museums made hundreds of thousands of dollars through their percentage of the sales. The Egyptian Organization of Antiquities eventually received eleven million dollars with which to renovate the Cairo Museum and other museums, but to this day none of the money has been spent. Not because of corruption. The reason is far more Egyptian—no one has dared take the initiative. Committee after committee has met and argued, unable to come to a decision in the past

fifteen years. Meanwhile, the Cairo Museum continues to deterio-rate; the fabulous works of art suffer neglect. All our grandiose plans to spruce the place up and reorganize it and train its staff to maintain the institution came to nothing.

Negotiating the "King Tut"—so full of adventures, challenges, and plain fun—was the high point of my Metropolitan career. After-wards, slowly and almost imperceptibly, I became more and more bored with the museum. To watch my still-frantic activities, one would never have known that days before each of the, by now, ponderous and needlessly dull board and trustee committee meet-ings, I would literally break into shivers. Douglas Dillon seemed to relish the rehearsals, followed by the careful preparation of the agenda, followed by another run-through, all leading to the Finance Committee or Executive Committee or the full board. I also began to get the feeling that I was starting to meet myself coming in the mornings, hear myself chattering the same lines in staff meetings. By the eighth year I knew it was time to go; only the contest and the opéra bouffe of "Tut" kept me going. "Tut," and a chap named Walter Annenberg.

21

THE
FINAL
BOW

By the late 1970s the party line in the museum profession was that true masterworks would never show up on the market again. Of course, just as everybody accepted this as gospel, an incomparable marble by Gian Lorenzo Bernini surfaced, followed closely by a masterpiece by Jacques-Louis David.

Olga Raggio raced into my office one morning with a sheaf of color photographs and several sale catalogues. The distinguished London dealer P. D. Colnaghi & Sons was offering us a splendid sculpture by Bernini of a young satyr trying to climb into a small tree in the branches of which a child was nestling, impeding the oaf's progress. It was splendid! How much? Olga looked grim: seven hundred and fifty thousand dollars. I considered the price high but not prohibitive for the artist. After all, we had been eager to buy a lesser piece for over three hundred and fifty thousand dollars, and no other Berninis had come on the market except for an obvious fake and a piece that was clearly hot.

The documents Colnaghi's experts had gathered on the master-piece—it was in matchless condition—indicated that the work had been created by the Florentine genius when he was sixteen years of age, just before being old enough to enter into the sculptors' guild.

I was anxious about the provenance. When did the thing get out of Italy? Was it really legit?

Olga said it was, adding that the proof was "unfortunate, a good-news-bad-news story of art." The good news was that Colnaghi was letting us have first crack. The bad news was the proof of legal title.

She showed me a sale catalogue from the Hotel Drouot in Paris—showing the same piece, listed as a work by a follower of the early nineteenth-century neoclassicist Thorwaldsen, with an estimate of less than two thousand dollars. The sale had taken place only months before. Why hadn't Olga, the sharpest eye in the business, snagged the thing?

Before I could ask, she pulled out another auction catalogue again with the Bernini. This sale had been more recent—in England. This time the piece was called a Thorwaldsen, and the estimate was even less—under two thousand dollars. The piece had sold for almost nothing.

I was halfway out of my seat when Olga said, "We didn't get these catalogues because of the mail strike. But, at least, no one can say that the piece has recently been sneaked out of Italy."

At the Acquisitions Committee meeting, some members were dis-turbed at the huge price until Walter Annenberg barked, "Next time we'll get something for nothing. I'd like to contribute to this one."

Because of Annenberg's support we acquired the piece and it be-came one of the most important pieces in the collections of the Department of Western European Arts.

His contribution enabled Dillon and the members of the Acquisi-tions Committee to dip into purchase funds and seize the Bernini. From that time on, Annenberg and I had a tacit arrangement for me to ask for amounts of money that would guarantee a spectacular work would not get away from the museum. He promised to be a silent standby, to be used when all else failed. In one instance he even pledged several millions in the event I was unsuccessful in "snookering" Charlie Wrightsman into putting up the funds for a world-class painting by Jacques-Louis David.

The Met had a more than acceptable collection of the works of David, the politically opportunistic painter who enshrined the

French Revolution and Napoleon. During David's reign as a member of the revolutionary committee charged with signing the death warrants of those sent to the guillotine, the painter had produced one of history's most memorable portraits. It is full length, representing in their studio a most gifted couple, the scientist Antoine-Laurent Lavoisier, the discoverer of the properties of mercury, and his talented wife, an architect. In the painting the pair are shown in a library, he seated and she standing, looking confidently out at the viewer.

It is a triumph of humanism—or so it appears at first glance. It becomes less so when one learns that David, clearly taken by the beautiful and intelligent Mme Lavoisier, had been a member of the revolutionary tribunal that had condemned her scientist husband to the guillotine. Her life was spared. David then pursued her so tenaciously that she fled the country. David's name does not appear on the death sign-off of Antoine-Laurent Lavoisier—normally, all members of the death squad had to sign before the killing.

The beautiful painting was located in the heart of New York City, in the board room of Rockefeller University on the East River. The university had decided to sell it.

I happened to be working on a Saturday morning, and the operator called to say someone was asking for me and was oddly surprised to find me in the office. The gentleman haltingly explained that he was a lawyer for Rockefeller University and wanted to advise me of the sale of the David. The will of the donor specified that if the university were ever to part with the David, it had to be offered first (and last) to the Met. How much was it? He told me Wildenstein had evaluated the painting at four million.

I cringed, but knew the figure was not far off the mark. I asked how long I had. A "reasonable" amount of time, say two weeks. I thanked him, but not before asking acidly, what if I had not been there on a Saturday? what would he have done? He waffled but I got the distinct impression that the legal responsibility of the university would have been fulfilled as far as the Met was concerned.

I called Wrightsman that morning and his reaction to the masterpiece was disappointing.

"Not for me. I'm overspent on art right now. Maybe this should come out of the funds you have."

"As you know, we don't have any," I said.

"Well, that's too bad."

I let Dillon in on the news and suggested that we buy it together

with San Francisco. Dillon urged me to give it a try. Director Ian White was intrigued, but a week later he called to say that although his trustees had been eager, the money wasn't there.

The Rockefeller lawyer tried to reach me, but I ducked him. An Acquisitions Committee meeting was coming up shortly, and I had to present the picture formally if only to cover my flanks, for there was no chance of buying it. When the lawyer finally tracked me down, I brashly told him that I would ask the trustees to buy it and was confident they would. He told me he would refrain from offering it elsewhere—for the moment. I got in touch with Jayne Wrightsman and carried on despondently about how we were going to miss the greatest French painting in the world. I explained that the university was shopping it around. I neglected to tell her we had first and last crack at it. I thought she was shaken.

At the meeting I projected slides on the wall the exact size of the gorgeous picture. I didn't linger on it, stating only that I thought it was my duty to show the trustees what it was before it disappeared forever. During my presentation I watched Jayne. She seemed mournful. I thought I even detected a tear. When the meeting broke up, I went to my office and waited. I figured it would take Jayne fifteen minutes to get home, another five to get to Charlie, three to cry, and one more for him to call me. I sat huddled over my phone. It rang pretty much on schedule.

"Jayne is pretty broken up about this David. I've decided to free up some moneys and buy it. We can't have those bastards shopping it around the country—it's undignified."

I called the lawyer—I had told him I'd call, come what may. He sighed when he heard that we'd take it for four million. I suppose he expected more. The painting, when cleaned, was twice as dazzling and soon became the centerpiece of the refurbished Wrightsman rooms.

A short time later Charlie attended a full board meeting as an emeritus and sat next to me. He leaned over during one of the duller moments and whispered into my ear, "You know I tried to get you fired—twice."

"I know," I whispered back.

"You've been really great eighty-five percent of the time . . . and the other fifteen percent, really rotten."

"Of course."

"A damned troublemaker."

"Yes."

"Got to ask you. You knew I was after you, but you still helped to put Jayne on the board. Why?"

"I promised. Remember? In better days. On the fantail of the *Radiant,* off Hvar."

"Sure, but so what?"

"Charlie, I guess it's because I'm a man of my word and you're not. Anyway, Jayne's much more qualified. Oh, by the way I trapped you into buying that David."

"You did? I'm glad." He chuckled. It was the last time I ever talked to him.

Walter Annenberg howled at the story.

I had met Walter Annenberg after he became ambassador to the Court of St. James's. Annenberg dotes on accolades and seems to need them, more than he should. His family has been gnawed on countless times by the press—how his father, Moe, served time for tax evasion and how the family wealth was made from the *Daily Racing Form.* He never overcame his sensitivity to the stories. I respected and admired Walter for his sense of humor, his brilliance. I see him as one of the country's true geniuses in communications.

Our first encounter was at a cocktail party in the ambassadorial residence which he and his wife, Lee, had refurbished into a magnificent state dwelling. He seized me when I walked in and gave me a private tour of his pictures. I was impressed not only by his knowledge, but by his passion for each one. He had a dynamic command of the English language, and when he turned an especially telling phrase, he would look up proudly and accent the remark by asking "What?" I found him direct and earthy in just the right way, and funny to boot.

When I visited the ambassador again to ask him to consider becoming a trustee, he made one of the most endearing statements I'd ever heard from a prospective board member, "I'm honored and touched, but I don't want to say yes or no right now. I want to figure out if I can afford the honor."

He accepted the board but turned down a seat on the Executive Committee, pleading that his schedule didn't permit. He did consent to go on the Acquisitions Committee, and it was rare when he didn't offer to donate a significant amount of money for something we yearned for.

He would regale me with stories about his struggles, his triumphs,

and the times he'd blown it. Few people knew he had a severe stutter, and every morning had to go through what he described as setting-up exercises in front of a mirror before he could speak. Certain words he could never accomplish, thus his use of the archaic "refurbish" when asked by a British television correspondent what he planned to do with the residence after presenting his credentials to the queen. At first, there were many snide remarks about "the Nixon Californian, rich Ambassador" but he left England revered. He told me how he had once flown all the way to New York from his estate, Sunnylands, in Palm Springs, to buck up a son of former Mayor Robert Wagner who also had a debilitating stutter.

Not long after he arrived on the board, I showed him an educational film Charles and Ray Eames had created. The Eameses had been hired to execute a new orientation room for the museum. Annenberg had been impressed but said, "Go bigger. Grander." He told me of a dream he had been nurturing for some years. After seeing Kay Clark's *Civilisation* series, he began to wonder if it were not possible to create an entire library of television series on the fine arts.

Annenberg amazed me by writing me a letter, "Why not have here at the Met, a branch of my school of communications—now based at the University of Pennsylvania and the University of Southern California—a school with a faculty, students and a curriculum of how to educate the masses and to train the necessary professionals for the vast recording operation? What I'm thinking of doing is to record all the works of art in the world—why not be ambitious?—and to create programs on the whole history of art. To me the recording of man's accomplishments through modern communications devices is an essential and fundamental stepping stone into the future. This is technology in the service of humanism and education."

I started to work at once to make Annenberg's dream come true. I brought Charles and Ray Eames in on the expanded project and alerted Rosenblatt and Kevin Roche to incorporate into the as yet unplanned southwest wing a communications center, a school, and theaters of varying sizes. Within weeks the plans were in sketch form. The general schema was for a visual arts center of about forty-five thousand square feet, which would include galleries for Western European arts and contemporary art of some sixty-five thousand square feet.

I drafted a scenario for a twelve-part television series in the gen-

420

eral style of *Civilisation* but with a greater emphasis on learning. Each series would have an abundance of film and videotape plus hundreds of photos and color slides to achieve Annenberg's permanent record of all the key art of the world. I wanted sufficient photographs and film stock to be able to cut and re-cut a host of shows, from popular series to specialized scholarship. Books of all sorts were planned for the series. Annenberg put up around one hundred and fifty thousand dollars for planning.

In order to satisfy Annenberg's unusual tax status criteria, the visual arts center had to be a bona fide graduate school—with students, a faculty, and degrees.

In the fifties a wealthy Philadelphia heiress had decided to enter the order of the "Poor Clares" and donate all her wealth to a local college. The IRS investigated the case and charged the woman with a tax violation. It seemed one could not simply give everything away. The heiress explained in vain that her religious vows prevented her from possessing anything material. She suggested giving her clothes and the Bible and prayer book to the IRS. The gesture was spurned.

Annenberg's paper, the *Philadelphia Inquirer,* took up the cause in news stories and editorials. The nation's press soon adopted the crusade. The IRS retreated. A special tax bill was passed—the "Poor Clares" bill. It stipulated that wealthy citizens could opt to hand away to education nine out of ten years' total income and, in exchange, receive without taxes the full profits of any single year. Annenberg created his School of Communications. He could live comfortably on a single year of earnings. His business, Triangle Publications, had become astoundingly successful. The three corporate entities—the *Daily Racing Form, Seventeen* magazine, and *TV Guide*—made healthy profits with low overhead.

Annenberg studied my preliminary programs and sketch plans for the center and instructed Dillon and me to proceed with a presentation to the board. He hinted strongly that if a graduate school could be achieved at the Met, he would fund the costs of the entire new wing plus a hefty sum for operations, some forty million dollars or more.

I took off as a crew member on a biannual sailboat race to Bermuda in a state of euphoria. Just before we were to set off, a fabulous work of art came up for auction. It was a panel painting in excellent condition, a *Calvary* by the trecento Italian genius Duccio di Buon-

insegna. His works were owned by our strongest competitors in America. But we had none. The *Calvary* was from Birmingham University in England, which had decided to sell. The estimate was around four million dollars, which I thought much too high. There was a chance the Duccio might go for as little as a million and a half.

Dillon agreed with me that the picture was perfect for The Cloisters. Because The Cloisters had its own restricted and protected funds, we had money available. Besides, Dillon had convinced his friend, trustee Jane Engelhard, to pledge up to four million dollars. With that amount we had little competition, I knew, because I had contacted our potential American rivals—the National Gallery, Cleveland, the Frick—and found out that none of them would be bidding.

The city was still experiencing aftershocks from the seventies recession. So I called Mayor Beame to see if our buying the picture might be politically dangerous. He told me that this time he had no problem. I had, several years before, bowed out of one sale during the lowest financial downturn.

The five-day race from Newport to Bermuda was a disaster. We got becalmed for a day and a half and finished a day later than usual.

I rushed ashore as soon as we had arrived in harbor and phoned Philippe de Montebello. I wanted to know if everything was set for the sale the next day in London. Was there any late word on unexpected competition? What he told me came as a profound shock.

"I have to tell you that the Executive Committee met several days ago—there was no way to reach you—and voted to override the Acquisitions Committee. We will *not* bid on the Duccio. Gilpatric was fearful that buying such a potentially expensive painting would cause grave political problems with the city."

"Philippe, dammit, Dillon knew I had gotten the go-ahead from Mayor Beame," I raged. "I quit." I screamed into the receiver. "I quit! Call Dillon and tell him I quit."

"Tom, that's something only you can say—*if* you mean it."

I flailed away, heaping abuse on the messenger, as if de Montebello were Dillon and Gilpatric and all the trustees who had turned against me. I told him how betrayed I felt by Dillon and the board. Dillon's enthusiasm for the Duccio had fired me up. I could not imagine why he had backed down.

On the sail back from Bermuda my anger subsided, and I wavered back and forth about carrying through on the threat. When I arrived,

I learned that the Duccio had been sold for under two million dollars and my anger welled up again.

I had a series of agonizing talks with my wife about what to do, how to deal with my propensity to want to quit a job once I had mastered it. She called it my seven-year itch and laughingly pointed to the times I had seriously thought about leaving the museum— early in my tenure to try to go back to city government and then the temptation to bolt to Philadelphia.

"You're obviously bored," she said. "You've been muttering for several years now. And, though you probably don't realize it, you've completed the museum work. I've recognized all your signs of wanting to escape. This slight is a good excuse to go. Aren't you tired of the grind? And these trustees? Are you really going to hang around as a fancy superintendent until the last brick in the building program is laid? I can tell you're in the last stages of talking yourself out of something that's no longer fulfilling. Why not just do it?"

That excellent advice should have strengthened my mind and my resolve, but it didn't fully. Although I had made up my mind to quit, I hedged. I wrote Dillon an anguished and confused letter.

My letter to Dillon pointed out that in less than a year I would be the director for a decade. I told him that the decade of "change, growth and activity" was giving signs of exhausting itself (meaning me) and that another period was about to begin—one that I described as one of "communication, a time of refinement rather than growth or metamorphosis." I admitted that the job had become tiring to me and stated, "There comes a time when a CEO perceives certain parts of the work as more creative and challenging than the complex whole and begins to desire nothing more mystifying than a creative change." In a most extraordinarily egotistical ploy, I started bargaining with Dillon. I submitted him five options. One, I could take a sabbatical. Two, I could become the paid president of the museum—though I observed that a paid president would "dilute" the traditional leadership of the museum drastically. Three, I could return to the study of medieval art—though I shot that down by admitting I was more than a little out of touch. Four, I could get a new job in the museum, a post that would entail scholarship, executive experience, and a creative sense combined with entrepreneurial skills. Such a post had been discussed, running the visual arts communication center associated with the Annenberg School of Communications. Fifth, I could retire and sever all connections.

I argued for option number four. I pointed out that the Annenberg center would have its own sources of revenue and have goals and tasks that would never impinge on or compete with the museum's. I claimed that the advantages of having me as the chief of the Annenberg center would be that the period of transition would be "more flexible."

Dillon was angered by the letter and its confused message. He conferred with Danny Davison and Ros Gilpatric, who both dismissed the idea of my staying on. To them, it would be a disaster to keep a disgruntled director in some amorphous new post while searching for fresh leadership. Dillon was doubly vexed because word of my decision to quit over the Duccio fiasco had reached him. He didn't know that I had changed my mind by the time I sailed back.

The fact that on my return I didn't see Dillon face to face but only wrote or spoke to him on the phone didn't help my cause either. So, by the time I went up to his summer home in Maine weeks later, in August, the atmosphere was tense. Dillon didn't pull any punches. He accused me of flightiness and of "zigzagging" with the museum. About the Duccio, he said in French, "The absent are always in the wrong." Yet, over the two-day visit, painfully, we patched up our differences and became friends again. Dillon told me of Gilpatric's and Davison's opposition to my being involved with the museum after resigning but hinted that he would try to persuade them of the "good sense" of my becoming the chief of the Annenberg center.

Dillon told me that he would have both a paid president and a director after me. "No one, in my view, can do what you did, for the simple reason that you came at a rare moment, so eminently qualified for the specific job." I tried to point out the weaknesses of the scheme, but his mind was made up and he asked me to support the concept. I did, in exchange for Dillon's full backing for my desires.

I sent Annenberg my resignation letter. I told him the contents would be discussed soon with key trustees. He was delighted that I wanted to become the head of his unborn center. From that moment on I played a dangerous game of conflict of interest, still running the museum and trying to get the center off the ground.

I talked almost daily with Annenberg and flew out to Palm Springs several times to refine every detail of his fabulous dream. We were creating ideas for the art films. I had received favorable responses from abroad—especially the Soviet Union and Egypt. We became

closer friends and laughed about how the art community would react the day I announced my resignation as director and announced the stupendous Annenberg gift—and my new post. Annenberg told me privately that he was thinking of giving much more than an initial forty million dollars. I was in heaven.

Annenberg and Dillon approved the new wing, which would provide galleries for the Department of Western European Arts and for Contemporary Art, offices for the Annenberg center, service buildings, a restaurant, and of course a large public theater.

Dillon planned to present the Annenberg package to the full board of trustees meeting in November and expected speedy approval, though he sensed that certain members were opposed. In confidence he told me, "Annenberg might abruptly change his mind—I hear he has that tendency." Although Dillon understood the physical part of the plan, he admitted he had a hard time comprehending the program. He added casually, "I also want your formal letter of resignation—without all those options and with no mention of your hope to run the Annenberg thing."

A few days before the board meeting Walter Annenberg attended the prestigious "publisher's lunch" at the *New York Times*. He treated the dour editors to a rousing description of his great art educational adventure and the preliminary series we had discussed. Annenberg told me about the lunch, and I became anxious the news might leak out prematurely and cause trouble within the museum board. But Annenberg emphasized that the affair had been "in confidence" and that he trusted Punch Sulzberger.

There may have been no connection, but the day after the confidential lunch I received a call from Grace Glueck asking about "rumors" of my impending retirement and my becoming an employee with Triangle Publications. I told her I would resign at the end of December 1977 but declined to discuss my future. Because of that, Ashton Hawkins had to phone the board members on November 4, before the story hit the front page of the *Times*.

Dillon was nervous about the premature announcement of my retirement. Before the board he went into a halting explanation of how I had written him a month and a half before about my growing disaffection. Dillon then gave a detailed explanation of the Annenberg center. He showed slides of the proposed new wing with the spaces allocated for the center, the new galleries for Western European Arts, Contemporary Art, the restaurant, and the service building. If

anything, his explanation suffered from its being too detailed. He asked for questions.

A representative for City Council president Paul O'Dwyer, who had snubbed the board by never showing up even once as ex-officio trustee, asked if Annenberg planned to "pay rent to the city for this place." I could hardly believe the woman and answered tartly, "That's a most outrageous question. Annenberg is going to save the city enormous amounts of money and is about to give something unique in the country and you ask him to pay rent?" I should have held my tongue. The woman became an implacable enemy of the project, helped to turn O'Dwyer against it. Someone leaked information to the press, and I suspected that the leak was in Paul O'Dwyer's office.

Ros Gilpatric was blunt about the perception of conflict of interest. "In view of Hoving's interest in taking on this new responsibility and to avoid any question of a conflict, I have recommended to the president that Hoving not participate on behalf of the museum in further negotiations with the Annenberg School or in decisions affecting the museum in its relationship to the proposed Fine Arts Center."

He talked candidly about the problems inherent in my becoming the director of the center. "I think you all know why Tom would be good for the post. The difficulties may come in the following areas: candidates for the director's post might be chary about the job with him sort of looming in the wings. But, I feel that what the center will be doing is so pleasingly complementary with, yet separate from, the objectives of the museum that no problems will ensue. And if they do, they will be resolved. There are plenty of cultural institutions where jobs mesh and don't mesh—the board just will have to solve the difficulties, if they occur." Gilpatric also described the dual nature of the Annenberg "semiautonomous" board and likened it to the Lehman Foundation board "which has worked out fairly well so far."

Dillon then called for a resolution. A final agreement would be transmitted to the Executive Committee for approval and the board for ratification. Before the vote could be taken, trustee Peter Frelinghuysen lodged a complaint. The resolution was too broad and premature, he said. "I don't know enough—and I'm sure the board doesn't, either—about how this different entity will fit in with the museum and its traditional aims."

"Peter, this is not the final resolution," Dillon said with a calm smile.

"I realize that, Mr. President, but you see *my* concern is that even this takes us too far down the path to final approval. I, for one, want more time."

With guys like him, I thought, uncharitably, we would never have begun the master plan. Dillon gave his characteristic shrug and called for a vote. All were in favor, except for Frelinghuysen.

The *Times* made the Annenberg gift front-page news. Other press stories call it the coup of my career. But by January 15, 1977, my forty-sixth birthday, the program was in deep trouble.

The London *Spectator* carried in its "New York Letter" an attack assailing me for wanting to rupture the stand-off relationship between art and politics and concluded with this scurrilous remark: "For a generation that remembers 'Degenerate Art' in Germany, that hears constantly about artists defecting from Russia, that is becoming more and more sensitive to the 'politics' of cultural exchanges, the Hoving-Annenberg '1984' museum threatens to be a nightmare. . . . It may be that freedom of thought and democratic ideals of popular education are both better served by the passive museum which simply puts the best art it can on display and lets each of us form his own ideas about it."

The conservative art forces had generated a powerful counterattack that I sensed would be effective. I knew all too well Annenberg's hypersensitivity to attack or ridicule.

History began to repeat itself. Almost ten years after Jim Rorimer had been victimized by Roland Redmond, the aging trustee sent Douglas Dillon a ten-page, single-spaced letter condemning the Annenberg project. Redmond circulated the attack to the full board of trustees and to the press. The tone and the content of the letter were just like the hectoring of Rorimer.

Redmond didn't know what he was talking about. But it was too late. A number of board members—Frelinghuysen, Mary Morgan, and even Brooke Astor—began to question the prudence of the new undertaking. The Parks Association, our old enemy, jumped into the fray. Carter Burden launched an attack: "With characteristic contempt for the principles of public accountability and legal process, Thomas Hoving is maneuvering once again—this time to impose the Annenberg Center on the City of New York." He stated that the new city charter provided for a Uniform Land Use Review and

charged that by law the community planning boards and the City Planning Commission had to hold public hearings on the Annenberg Center and the new southwest wing. "It's an open question whether the Annenberg Center would be legal under any circumstances."

Annenberg became concerned not only about Burden but about Redmond's letter and the news that certain members of the board were hesitating to accept his historic gift.

Troubles piled up. Barbara Goldsmith wrote a devastating piece for *New York* magazine. And trustee Mary Morgan was quoted in a piece by James Revson in the *East Side Express*, "Hoving in the southwest wing in the pay of Annenberg will put the museum's autonomy in jeopardy. Sure it's a good idea. A good idea for somewhere else. Not the Met."

Three official investigations were announced—by the Manhattan Borough Board, by Martin Segal, chairman of the city's Advisory Commission on Cultural Affairs, and by Attorney General Louis Lefkowitz.

After the first of what promised to be a brutal series of public hearings, the damage was done. Columnist Pete Hamill wrote a scathing column in the *Daily News* stating that Annenberg wanted to purchase the museum and was seeking to clean up the sins of his family by throwing money at the Metropolitan. Deeply offended, Annenberg called me from California. "Here I'm trying to give the city a fine facility and all I get is garbage. Will it ever stop? What would *you* do, Tom? What should I do?"

"Pull out, Walter," I said. "It's not worth the agony. The climate in this town is such and the climate on the board is such that I honestly don't believe that what you want me to do is possible. You know what I have at stake, so when I say pull out, I guess you can gauge the depth of my feeling."

Annenberg withdrew his offer. Suddenly, there was a sharp reversal of opinion. The *Times* stated that he should reconsider. Politicians lined up to deflect the impression that they had run the millionaire out of town. But Walter Annenberg was profoundly wounded. He withdrew the fine arts center forever.

I was crushed. Not only at the grim finality of the news but at how casually Dillon and others had taken it. I had called Dillon and he simply grunted "too bad," and I heard him bite into an apple. I could see no benefit to sticking around the Met and asked Dillon if I could go on sabbatical for the remaining months in my ten years as direc-

tor. He agreed. So, on June 30, 1977, I left the Metropolitan Museum of Art after sixteen and a half years, having gone from curatorial assistant to landlord to director.

In the spate of parties and receptions that accompanied my departure, there were more than enough opportunities for the staff and the trustees to recount the accomplishments—and, this time with amusement, the disasters—of the Hoving years. Dillon presented me with one of the reproductions of the goddess Selket and likened her—arms out in prayer and a scorpion sitting on top of her head— to the Met begging "Tom Hoving to go away, at last!" "The board voted to give Tom this memento—eighteen to seventeen." I laughed as heartily as the guests. In response I said, "I plan, in retirement, to carry on all the great things Roland Redmond has done for the place," and there was laughter.

The disasters, we all agreed, had been only forty-nine percent of the time. And most of them, I had to admit, descended upon the museum when I had become faint-hearted, had compromised or toadied or had failed to be enough of a troublemaker. Yet the fifty-one percent of the accomplishments had been gratifying. With the creative energy of the trustees who had been on my side and the staff who had supported me, the most sweeping revolution in the history of art museums had taken place.

The Met, once an elitist, stiff, gray, and slightly moribund entity, came alive. The mummies did dance.

INDEX

INDEX

Begin, Menachem, 242
Bell, Elliott V., 29, 31
Bell, Nancy, *see* Hoving, Nancy Bell
Belleli Family (Degas), 379
Berenson, Marisa, 276
Bernhard, Mrs. Richard J., 300
Bernhard, Richard J., 300
Berman, Ron, 402
Bernal, Nacio, 104
Bernard, Samuel, 99
Bernini, Gian Lorenzo, 415–16
Bernstein, Robert, 174
Berry, Duke of, Book of Hours of,
 313
Beyond the Melting Pot (Moynihan
 and Glazer), 176
Bibliothèque Nationale, 352–53
Biddle, James, 26, 27, 40, 66, 76–79
 Acquisitions Committee and, 101
 Roche and, 63–64
Birmingham University, 422
Birthday Ball, 213–14, 216
Black, Jonathan, 224
Black Panther Party, 170
blacks:
 attendance of, 173, 180
 on board of trustees, 272, 276
 "Harlem" criticized by, 166–67
 Juan de Pareja and, 272–73
Blair, Deeda, 108, 112, 115
Blair, William McCormick, 108, 112–
 113
blockbuster shows, 345–48
 insurance and, 346–47
 see also specific shows
Blois, Georgiana, 250
Blum, Stella, 355
Board of Estimate, New York City,
 220, 221, 238
Board of Standards and Appeals,
 New York City, 246
Board of Trade, British, 122
Boehm Porcelains, 406
Bologna, Giovanni, 111
Boltin, Lee, 406–9, 411–12
Bonnard, Pierre, 104, 106
Borghini, Raffaello, 111–12
Bothmer, Bernard, 69
Botticelli, Sandro, 127
Botwinick, Michael, 283, 284
Brandi, Cesare, 154–55
Brealey, John, 384–86
Breuer, Marcel, 228, 229, 230

Brezhnev, Leonid, 198, 289
British Museum, 352, 383, 401, 405
Broglie, Countess de, 158, 298
Brook, Arthur, 229–30
Brown, Frank, 337
Brown, J. Carter, 27, 236, 346, 347–
 348, 383
 Juan de Pareja and, 255, 262, 268,
 269
 "King Tut" and, 401, 402
Brown, Lawford & Forbes, 63, 242
Brown, Manning, 19, 30, 31, 87
Brown, Mother, 165
Brownell, Herbert, 210, 218, 226–27,
 235, 367
Brummer, Ernst, 378
Brummer, Joseph, 378
Bryn Athyn church, 135
Buchanan, John, 217, 278, 324, 332,
 372
Buckley, William, Jr., 89
Buechner, Tom, 228, 229
Buerki, Fritz, 310, 311, 320, 323, 330,
 334, 339
Bundy, McGeorge, 65
Bundy, Mrs. McGeorge, 145
Burden, Amanda, 223
Burden, Carter, 222, 223, 230, 235–
 237, 427
Burnham, Sophie, 345
Burri, Rene, 346
Burton, Harry, 405–6, 410
Bury Saint Edmunds ivory cross, 47,
 186–87, 209, 210
Butrova, Alla, 198, 386, 388–90

Caccini, Giovanni, 111–12
Cairo Museum, 403–4, 406, 408–9,
 413–14
Calvary (Duccio di Buoninsegna),
 421–22, 423
calyx krater, *see* Euphronios calyx
 krater
Cambodian art, 371–72
Campana, Marchese, 339–40
Camp David peace initiatives, 242
Canaday, John, 57, 273, 301–6, 320
Canova, Antonio, 101–2
Capa, Robert, 346
Carolingian ivory book cover, 352–54
Carrara marble, 240
Carritt, David, 364, 367, 368
Carter, Howard, 405, 412

432

INDEX

444

PHOTOGRAPHY CREDITS